A Writer of Our Time

*The Life and Work
of John Berger*

Joshua Sperling

VERSO
London • New York

First published by Verso 2018
© Joshua Sperling 2018

Every effort has been made to secure permission for images appearing herein that are under copyright. In the event of being notified of any omission, Verso will seek to rectify the mistake in the next edition of this work.

1 3 5 7 9 10 8 6 4 2

Verso
UK: 6 Meard Street, London W1F 0EG
US: 20 Jay Street, Suite 1010, Brooklyn, NY 11201

versobooks.com

Verso is the imprint of New Left Books

ISBN-13: 978-1-78663-742-0
ISBN-13: 978-1-78663-741-3 (US EBK)
ISBN-13: 978-1-78663-740-6 (UK EBK)

British Library Cataloguing in Publication Data
A catalogue record for this book is available from the British Library

Library of Congress Cataloging-in-Publication Data
A catalog record for this book is available from the Library of Congress

Typeset in Sabon by MJ & N Gavan, Truro, Cornwall
Printed and bound by CPI Group (UK) Ltd, Croydon, CR0 4YY

For my parents, who were my first teachers,
and for Amy.

We never live only by our own efforts, we never live only for ourselves; our most intimate, our most personal thinking is connected by a thousand links with that of the world.

Victor Serge

Contents

Introduction

The Dialectic and the Pear Tree

Had John Berger stopped writing when he left England in 1962—when not for the last time in his life he gave up one existence to set out on another—he would be remembered solely as the young Marxist art critic for the *New Statesman*. Brash, passionate, outspoken yet terse ('without a blush or an ahem', as one commentator put it),[1] Berger's regular articles for the left-of-Labour weekly provided the most prominent outlet in England for a socialist understanding of culture. And this during a decade of bitter and bruising Cold War polemics—battles that, even as they have since fallen into the shadows, left their mark on a generation.

Of course he did not stop writing. It was only after he moved to the continent, settling first in Geneva (with brief stints in Paris and the Luberon), and then the rural Haute-Savoie, that Berger began along the path he made his own. His subjects traversed nature, politics and art; his tools were a pen, a sketchpad and a motorbike. He wrote novels, essays, folk stories, so-called unclassifiable works of creative non-fiction. He collaborated on films, photo-texts, plays and broadcasts. Berger left England, he said, to get outside the straitjacket of English journalism. By the time he died, in 2017, he had attained the status of world elder.

Not that the English press ever particularly warmed to this new identity, or acknowledged the full scope of his achievements. In their eyes he remained, even a half-century later, the impertinent rabble-rouser he had been when he quit the homeland. On the occasion of his passing, on the second day

of 2017, only months after Donald Trump had been elected to the White House and the British electorate voted to leave the European Union, the more profound connection between his work and the historical realities of its time still went unremarked. The string of obituaries mostly remembered him, in reportorial boilerplate, as 'controversial'. They described an art critic who antagonized curators and professors with his many politicized contestations; a novelist who snubbed the Booker committee in 1972, donating half the prize money to the Black Panthers; and a television presenter who threw down a gauntlet with *Ways of Seeing*, taking on Sir Kenneth Clark in the process. The media always loves a duel, and Berger often obliged. True, they said, he was an incurable Marxist, a self-proclaimed revolutionary who went off to live with peasants, but he also wrote movingly about art. Now dead, aged ninety, he could be eulogized. Once yesterday's battles have been relegated to the historical attic, prior combatants stand to be remembered for their enlivening if impractical ideals. The establishment pats the back of a former opponent. And the past can be painted as distant when in fact its unheeded energies were washing up in that morning's headlines.

This book takes the opposite approach: the past is in the present, its story is alive. Especially for a writer such as Berger, driven onward year after year by a sense of history and the principle of hope, the currents that flowed through his work may still continue to flow. Multiple, connected, overlapping—they reach beyond the work itself. To trace their contours, to see where they came from or where they lead, is also to explore the landscape of a half-century that extends in all directions. However eye-catching, the polemics may only have been switchbacks of a longer journey. Beneath them ran complexities, at once historical and personal, the newspapers tended not to have space for.

The home Berger died in, for example—an airy suburban flat seven miles outside the French capital—belonged to a Soviet-born writer, Nella Bielski, a woman he loved and had co-written plays with, whose novels he had translated. For decades Berger shuttled between here and another home

several hours to the east, a chalet in the foothills of the Alps surrounded by fields and orchards, an old farmhouse he shared with another woman he loved, Beverly Bancroft, an American, his wife of several decades and the mother of his third child. While these pages will not veer too far into the private terrain usually reserved for traditional biography—there will be few to no doctor visits or domestic disputes and only occasional forays into the gap between persona and psyche—the doubleness-of-attachment implicit in Berger's arrangement was emblematic of something deeper. There was far more to his work than provocation. There was also tension and multiplicity, movement and passion.

Speaking of the German-born playwright Peter Weiss (a fellow communist, émigré, and painter-turned-author), Berger once said that his autobiographical novels were 'not concerned with revealing the secret difference between the writer's private and public life but obsessed with the relation between the writer's intimate self and the unprecedented events of his period'.[2] The following chapters are haunted by a similar obsession. They take as their starting point the conviction that works of the imagination can be political just as the work of criticism can be imaginative, and that to furnish an historical lens on the past is also to re-focalize its light towards the future. 'Meanwhile', Berger once said, 'we live not only our own lives but the longings of our century.'[3]

The present book thus looks in two directions. On one hand, it sets out to provide a fuller picture of Berger's development, and of the stakes involved in his many creative metamorphoses. On the other, it explores, through his example and across a series of political watersheds, the larger questions that vexed a generation: questions about the purpose of art, the nature of creative freedom, the meaning of commitment, and the relationship of modernity to hope. These are questions that vex us still. When, aged thirty-four, Berger left England and his post at the *New Statesman*, he entered a field of activity where such linkages—across time, across spheres of intimacy and experience—began to float free from the iron laws of short-term cause and effect. He said he moved to

the continent to become a European writer. He ended up the spiritual lodestar of the humanist left: a keeper-of-conscience and one of the most globally significant voices of his generation.

What is literature? Why write? For whom? Though such questions have gone fitfully in and out of fashion ever since Sartre famously posed them in the pages of *Les Temps Modernes*, German tanks having just retreated from France, the cast of thought and feeling that was their impetus remained a constant for Berger long after the spirit of '45 had otherwise dispersed. Perhaps for this reason, he may be the best guide we have to help answer them. To look carefully at his life and work—but especially the work—is to expand our sense of what it means to be a committed writer in the modern age: a period of unprecedented migrations, immense political pressures, incessant culture wars and the perennial struggle for belief. Throughout the years, such questions were never merely rhetorical.

But nor, for Berger, were they there to be thought through exclusively on the level of theory, much as Sartre himself had tried to do, or, after him, Adorno.[4] There are some choices that cannot be deduced. Commitment was never only about an attitude—like a pose or a position—one could adopt at will. It meant more than being for or against. It required effort, determination, obstinacy, sacrifice. It took place in and through time.

The decision to leave England was the most critical of his life. A good deal of what follows explores the work he did before he made it. 'The forgotten fifties', as it has been called, like a hovering half-recollected parenthesis—after the war but before the sixties came swinging in—was a decade in England suffused by 'the colour and mood of ration books', in the words of the painter John Bratby, 'the general feeling of sackcloth and ashes after the war'.[5] It was an historical moment at once near to and distant from our own, when new taboos competed with new freedoms and, as we will see, art and politics were made inextricable, often frustratingly so, producing a tangle of contradictions that was also the buried

root structure for Berger's towering career once he broke free from native soil. Everything he did in exile would have been unimaginable without it.

If leaving England was the most pivotal decision of his life, running away from school at sixteen to study art was a close second. Born on Bonfire Night in 1926 to middle-class London parents, Berger was a precocious student. Like so many English boys of his background, and given his early academic talents, it was almost certainly taken for granted that he would one day study at Oxford or Cambridge and then pursue a reputable profession like that of his father: managerial accounting. In their youth both of his parents had been idealists. Berger's mother, Miriam, was once a suffragette, and his father, Stanley, originally intending to be an Anglican priest, had enlisted in 1914 when war broke out, serving all four years as a junior officer on the front lines, and even staying on after the armistice to help bury the dead. By the time they started a family, though, the couple were well settled down in the middle-class suburb of Stoke Newington. Miriam was a stay-at-home mother and Stanley had perfected the demeanour of an upright English gentleman—'a man of great integrity and dignity', as his son later put it; but also, by virtue of working as director of the Institute of Cost and Works Accountants, 'a front man for every conceivable kind of shark and crook'.[6] By all accounts Stanley possessed a deep psychic wound from the war. He kept it private, but its indirect presence impressed itself on the imaginations of his two sons (John had an older brother). And the confused feelings Berger likely had as a result, a mixture of compassion for his father's pain and anger at his silence, help to motivate what will become a recurring motif in this book—namely, his uneasy relations, alternately affectionate and conflictual, with a series of English mentors and father-figures, possibly even with England itself. 'I was born of the look of the dead', he later wrote in a poem, 'Self-portrait 1914–1918'. 'Swaddled in mustard gas / And fed in a dugout ... I was the world fit for heroes to live in.'

At age six, he was sent to boarding school, first outside Guildford and then to St Edward's, Oxford. In interviews

Berger was always reticent about discussing his early child-
hood except to stress the loneliness of his home (he often
likened himself to an orphan), and then the 'totally barbaric'
culture of the English boarding schools.[7] Perhaps as a means
to cope, he drew and painted and wrote poetry. If art, as he
was to later claim, was always bound to be used as a weapon,
he at first turned to it as a weapon of self-defence. Through
the imagination the senses expand; through the recounting of
experience the senseless takes on shape.

Berger also read intensely: Hardy, Dickens, Maupassant,
Chekhov, Hemingway, as well as many of the anarchist clas-
sics, including Kropotkin. At fourteen, having come across
three pamphlets put out by the Freedom Press, he even began a
correspondence with the poet and critic Herbert Read, asking
the older writer (a figure with further cameos in the pages
ahead) to comment on some of his first poems. Read wrote
back, critical but encouraging, and Berger carried around the
reply in his pocket for months, long before the two would
duke it out in the letter pages of the press.

We will never know the full extent of Berger's misery at St
Edward's, but he later called it 'fascist training ... a training
for army officers and torturers'.[8] In 1942, as the wider world
warred with fascism at large, Berger left. Needing to occupy
himself for two years (at eighteen he was going to be called
up), and against his father's wishes, he accepted a scholar-
ship to the Central School of Art on Southampton Row in
London. The experience was revelatory. For the first time in
his young life he tasted independence—creative, literary—and
also danger. In a city at war, he lived on and off in a cramped
boarding house with a fellow student—a young woman who
was, he later confided, the first woman he ever loved. 'There
are so many things which overlay one another', he said of
his memories of that year—1942: 'There was the bombing,
which meant that one had a very, very short perspective and
a kind of enormous urgency living in that period. And then
there was the art school, which was a completely new world
to me; and then there was living with this girl. And I suppose
this was ... the first time in my life I could begin to choose
solutions to problems that were posed by myself as opposed

to merely choosing one way of getting through what other people were making me do.'[9]

The art school, the bedroom, and wartime London—these were the three formative theatres of Berger's adolescence. In 1944, aged eighteen, he joined the army. On track to accept an officer's commission, he refused to apply after initial training. In what he later called an act of 'silly little bureaucratic revenge', he was appointed instead to the non-commissioned rank of lance corporal, and stationed in a training depot. [10] Spared from Normandy, he stayed on in Northern Ireland, in the small port town of Ballykelly, where he bunked with working-class men for two years—an experience that would have been unusual for someone of his class background. The contact with what the army called 'other ranks'—recruits who, as Berger later reflected, 'had spent the first eighteen years of their lives very differently from me, but whose company I preferred'—gave him a new reason to write: the men, many of whom, he often said, were near-illiterate, passed along stories for him to transcribe for their girlfriends and parents.[11] Apocryphal or not, the role was one he would cast himself in for much of his life. The mythopoetic roots had set: he was at once a soldier and a scribe; on demobilization he continued to speak on behalf of the working poor. Decades later he sometimes joked that he went to art school to be able to draw naked women all day; but with a grant from the army he attended Chelsea, where he drew pictures of men at work in bell foundries and building sites.

It was the collective spirit of the home front and of postwar reconstruction that nourished his early socialism and cultural convictions. 'God forbid we need a war to make art', he said years later in a radio broadcast, 'but we do need a certain sense of purpose, a sense of unity.'[12] When that unity began to fray, with postwar populism ceding to the paranoia of the Cold War, and the pressures of the early 1950s extending to aesthetic debates—abstraction or figuration, autonomy or purpose, the individual or the collective—Berger gave up painting for journalism. He contributed regular arts reviews to the *New Statesman*, and by the time he was in his late twenties, after a meteoric rise, he was being talked about

as one of the brightest young critics of his generation: elo-
quent and energetic, but also forceful and at times a menace.
Having missed combat in the war, he got a taste of it in the
culture pages of the magazines. 'Whenever I look at a work of
art as a critic', he said at the time, 'I try—Ariadne-like for the
path is by no means a straight one—to follow up the threads
connecting it to the early Renaissance, Picasso, the Five Year
Plans of Asia, the man-eating hypocrisy and sentimentality
of our establishment, and to an eventual Socialist revolution
in this country. And if the aesthetes jump at this confession
to say that it proves that I am a political propagandist, I am
proud of it. But my heart and eye have remained those of a
painter.'[13]

This was the birth of Berger the firebrand, the Marxist
agitator—the Berger commemorated in the official obituar-
ies some sixty years later. It was an identity he inhabited,
often cultivated, over the years; and yet it was only one—the
louder—of his many voices. From the very beginning there
had always been a tension between an outward intransigence
and an inward searching—a tension from which his best
work arose. *But my heart and eye have remained those of a
painter* ... In that about-face was contained all the generative
contradictions of his life project.

Significantly, Berger first wrote for the radio. He was a writer
who came of age working within the modern means of
communication at a time when postwar society was radically
democratizing itself. For the rest of his long career he contin-
ued to write for as wide an audience as possible, and often
appeared on television. The plain style he worked within was
a pitch for broad persuasion and accessibility. The etymol-
ogy of the term 'broadcast' is revealing: it originally meant
'to sow by scattering'. With his work Berger cast as broad a
net as possible. He deliberately wrote in an idiom that could
travel—that could speak to the uninitiated.

And so for many thousands of students since the 1970s,
Berger was simply the man with a Joe Namath haircut speak-
ing to them about art from in front of a blue screen. It is
strange, the power of television. For years *Ways of Seeing*

(1972) was shown in art schools or introductory art history courses as a means of accelerated cultural detox. The intervention, as we will see, proved transformative. So much of what has since become central to the humanities curriculum —Walter Benjamin's essay on mechanical reproduction, the feminist critique of the male gaze, the semiotic deconstruction of advertising, the shift from immaterial genius to a material analysis of culture—all this first hit the nervous systems of students accompanied by Berger's stare and lisp and corrugated brow. His charisma was a kind of radiance.

Throughout his life he was famously a seducer—charm and intellect at once inseparable and entrancing—but he was also a confidant. 'He is the best listener I know', said John Eskell, the country doctor who once helped him through a breakdown, and who in turn became the subject of *A Fortunate Man*, one of Berger's most moving and evocative portraits. 'He listens to everyone', Eskell added, drawing his own picture of the portraitist, 'no matter what their station in life':

> He is as interested in a peasant as he is in an intellectual. He always wants to be very accurate in his replies to any question you put to him. He pauses for quite a long time and eventually comes out with a very definite answer which is strictly truthful. He is never afraid of saying that he doesn't know or doesn't understand. He considers making love to be the most worthwhile thing in life. He is a nervous man in the sense of being highly sensitive to his surroundings, but he is not nervous in a neurotic way. He is very conscious of everything that goes on around him. He disciplines himself to write so many hours a day and he does a lot of research in Public Libraries, and he has the famous 1911 edition of the *Encyclopaedia Britannica* which he reads avidly. Always consistent in his polemical arguments. Against 'the System' in Russia particularly concerning Writers, Painters, Sculptors … Always extremely polite and gentle. Occasional severe temper-tantrums, mainly concerning domestic situations.[14]

Tantrums aside, anyone who has spent an hour in Berger's presence can attest to the electric attention he brought to

each moment, the sense that as you were talking to him he was devoted entirely to you and no one else. As you spoke, you became a more deliberate and consequential version of yourself, his own unhurried, Delphic cadences rubbing off on every exchange. And anyone who has seen even ten minutes of him on YouTube will have at least a partial sense of this: the personal luminance, the mix of self-assurance with professions of humility, the laser-like focus of his mind and eyes. Throughout *Ways of Seeing* it was there for all to see: Berger in his patterned shirt and trousers in the National Gallery, or in a television studio, or surrounded by children looking at a Caravaggio, or the only man in a roundtable of women.

Laura Kipnis once pointed out that because he was so unusually handsome—a leonine beauty he grew into with age—Berger also had to grow accustomed to being looked at. It is no surprise, then, that he became a theorist of the gaze. Or, for that matter, an expert in the arts of showmanship. He wised up to the importance of self-presentation early. The author photographs were always deliberate. The American edition of his first book, for example—a collection of essays released in England under the title *Permanent Red*, but softened for the stateside audience and rechristened *Toward Reality*—showed a man in his thirties full of swagger and purpose, whose looks risked turning self-belief into self-regard and confidence into arrogance: the deep-set eyes, twin furrows on his brow; the cigarette a nod to Brando or Dean; the angularity of his collar sharp enough to cut canvas with. No doubt the marketing department at Knopf knew what they were doing—who knows how many extra copies of books have been sold because of the photographs on their jackets? But Berger did too. Looking and carrying himself the way he did opened doors that would have been closed to a four-eyed Marxist bookworm. He could get away with more.

But he also understood, and on so many levels, how the stares of others could turn into a prison—and how television too, no matter how powerful or ubiquitous a medium, could become just another box to escape. For decades *Ways of Seeing* was synonymous with John Berger, and vice versa. The royalties certainly didn't hurt, but the influence of the

show (later adapted into a mass-market paperback) became something of an albatross. Even today the series continues to stand as the high-water mark for his visibility, but taken out of context it can misrepresent the entirety of his achievements. Like the cropped portrait Berger cuts out from Botticelli's *Venus and Mars* at the start of the first episode—a fragment later run through an industrial printer and disseminated—*Ways of Seeing* was only one passage, albeit the most famous, from a much larger and more dialectical panorama. It is that larger canvas that those who know it find so inspiring.

'It is not enough for us to argue for Berger's name to be printed more prominently on an existing map of literary reputations', argued Geoff Dyer as early as the 1980s, 'his example urges us fundamentally to alter its shape.'[15] The enormous range of his interests was at once central to his identity, and at times an impediment to his career. Berger wrote about painting, of course, but also animals, protests, peasants, revolution, medicine, migrants, the cinema. He was never any good at that high-minded responsibility of the professional critic—canon formation—and so it is perhaps fitting that his own position within it remains inchoate. His stature is undisputed, but the total significance of his work is often misunderstood. He simply produced too dizzying an array of forms for a culture rooted in specialism to come to grips with. Hence, precisely, the odd pressure put on *Ways of Seeing*—as a kind of metonym or placeholder in the meantime.

When not caricatured as a rabble-rouser, Berger has been eulogized as a one-of-a-kind polymath. But this too may be misleading. Academics do not take him seriously enough, while others can lend him a gauzy, unassailable aura that has the concomitant effect of photoshopping him out of history. The sixty-year body of work he left behind is one of the most wide-ranging and beloved of any postwar writer; but it is also (as Dyer again pointed out, this time a few years later) one of the least *worked through*.[16] In the chapters that follow, I will argue that what makes Berger so critically elusive is precisely what makes him so historically significant. To appreciate this we must repatriate him to history, and to his peers. We will

then be able to see that the prolific diversity of his output was less an expression of an individual ethic of experimentalism than it was a prolonged attempt to bridge the philosophical opposites of his time: between freedom and commitment, ideology and experience, word and image. The net effect of the work is to disrupt categorical divisions and disciplinary systems too often taken for granted. It reminds us there is a territory and not just a map. Like the borders between countries, the borders between disciplines are not natural features of any landscape.

And luckily not every reader first comes to Berger through *Ways of Seeing*. The roads leading to his work are often unpaved, the points of entry as diverse as the career itself. A good way to come at him, according to Ben Ratliff, 'is to do it by mistake or serendipity, to discover him in the wrong box ... Individual, unmanaged, unmediated discovery, an outsider's discovery, probably suits him best. Not the kind that happens in a curriculum. He didn't like school!'[17]

I first discovered John Berger's work when I was twenty-two. I had gone to college to study physics, but by the time I graduated I knew I would not become a scientist. I spent a year saving up and then travelling, and it was several months into a long trip to India and Nepal when I bought *About Looking* from a used bookseller in the Freak Street neighbourhood of Kathmandu.

In Berger's essays I found a way of looking at the world that was different from anything I had learned in a classroom. It was a way of writing and thinking and, I presumed, *living* that saw no contradiction between the labours of the intellect and the readiness of experience, or, for that matter, the rootedness of the earth. There was a visceral power to his prose that was at once metaphysical and embodied, of the senses but not indulgent. In a well-known poem published twenty-five years before Van Gogh depicted something similar, the American bard Walt Whitman recounted his experience wandering out of an astronomy lecture and into the 'mystical moist night-air', where he looked up 'from time to time ... in perfect silence at the stars'. After graduation I felt I had done

something similar. It is, I think, not a unique experience. In your early twenties the dichotomy can seem irrefutable. But in Berger I found an astronomer and stargazer both at once.

Over the following years his writing became a point of reference. The essays provided not only a series of critical introductions (to other writers, poets, and most of all painters), but also a model in which the analytic and imaginative impulse—what people call the 'left' and 'right' brain—could coexist in reciprocity. He made great art approachable, writing about Rembrandt and a Polish builder, Cartier-Bresson and a plumber, Caravaggio and woodcutters from the same town of Bergamo. I read his work as I travelled to many of these places, living for several years in Europe, the books I carried with me increasingly sun-faded and dog-eared, Berger's writing a kind of portable guide to the natural world, to history and to the art of the past. He was, as a friend and media theorist later put it to me, an *interface*.

In a widely reproduced lecture delivered at her alma mater (and mine), Joan Didion confessed to what has since become something of a cliché for creative writers: an allergy to the world of ideas. In her characteristic deadpan, she explained why she wrote. 'I tried to think', she said of her time as a student. 'I failed. My attention veered inexorably back to the specific, to the tangible ... I would try to contemplate the Hegelian dialectic and would find myself concentrating instead on a flowering pear tree outside my window and the particular way the petals fell on my floor.'[18] It was that choice—the dialectic or the pear tree—that Berger never accepted as final or absolute. He is the only postwar writer I know of to have so powerfully and obstinately refused to separate a loyalty to both the general and the particular, to what was happening politically and morally in the world and what was happening physically just outside his window. You would have to go back to the interwar generation—to Walter Benjamin or Victor Serge or D. H. Lawrence, and before that to Tolstoy—to trace a lineage.

'Far from dragging politics into art,' Berger said when he was only twenty-six, 'art has dragged me into politics.'[19] The two ran together as the twin spines of his long career, inseparable

even if at times hard to tell apart, and the meaning of that relation always shifting, always undulating and in flux. Susan Sontag spoke of his 'peerless' amalgam of 'attentiveness to the sensual world with responsiveness to the imperatives of conscience'.[20] Geoff Dyer noted the 'two concerns that have dominated his life and work: the enduring mystery of great art and the lived experience of the oppressed'.[21] For Andrew Forge, writing decades earlier, it was not Berger's steadiness that made him such a fascinating figure to follow, but rather his struggle to be steady: 'There are few enough people writing about art who are prepared to shoulder his sort of load.'[22] Berger showed us that, even under intense pressure, you can keep the multiple layers of your loyalties intact. Between being a critical or creative writer there could be a third path. Sometimes you can make your own choices.

'Perhaps "genius" is not the right word', T. S. Eliot (an early acquaintance of Berger's) wrote of Simone Weil in 1951. And what the American poet said of the French philosopher is, I think, true for Berger as well: that our first experience of the work 'should not be expressible in terms of approval or dissent. I cannot conceive of anybody's agreeing with all of her views, or of not disagreeing violently with some of them. But agreement and rejection are secondary: what matters is to make contact with a great soul.'[23]

It has been said that Berger's writing espouses an aesthetic of radical hospitality. The same was true in person for him and his colleagues—especially Jean Mohr and Alain Tanner— who opened their houses to a young American graduate student driving a rented Peugeot around the windy roads of France and Switzerland (so as to obtain, as I later found out, two Swiss speeding tickets I still have yet to pay thanks to cameras on the Autobahn—an unconscious homage, I've since decided, to the spirit of my subject, and his lifelong love of speed). The afternoons I spent with Berger and his friends and collaborators helped to make vivid, however indirectly, the many hours of discussion they must have had behind so much of their own work. In conversation Berger would zoom forward and then switch into neutral, riding the clutch for a moment, nodding in silent concentration, until his thoughts

once again found their line and he set off chasing the distance. It was like the two temporalities of writing itself: the quick and flow of experience, and then the settled particulate at the bottom of the stream, gathered up in books and boxes and held in archives.

'Life passes into pages if it passes into anything', James Salter once said.[24] I wonder whether Berger would have agreed. I think so. At any rate, this was the third term in my research for this book: there were the people and the places, and then all the words put down on paper. Berger was often accused of being aggressive in print, but his handwriting was a mellifluous cursive, a felt-tip trace. I spent months reading it in archives—notes and drafts and unbound manuscripts—and I say this only partly to defend the rigour of my method, but also to confess to a certain glow I have seen emerge out of the sediment of time. To research is also to resuscitate. As anyone who has spent a significant amount of time in an archive can attest, there is something odd and numinous and uncanny that starts to happen after about a week. You begin to keep company with the past.

Many writers let their literary agents auction off their papers to the highest bidder; Berger donated his (or rather the archive his wife, Beverly, kept on his behalf) to the British Library, provided simply that they haul it out of his country shed like a once-in-a-lifetime paper harvest. As Tom Overton, who organized it all, pointed out, the gift was a kind of homecoming. Berger may be buried in the earth above Geneva, but his life's notes are now held in the national library across the street from St Pancras Station, a short walk from the art school where he first opened himself to the possibility of his future.

Even after he left London, Berger was essentially Europe-bound, and famously afraid of flying. London, Paris, Geneva, the Vaucluse, and the Haute-Savoie were the five principal stations of his life. And yet—such is the magic of literature—I have run across his books in locations far and wide: a cabin belonging to timber framers in Maine, a young painter's studio in Barcelona, my grandmother's sitting room in San Diego, the sprawling bookshops of London or New York

or Delhi. Near the end of his life he seemed increasingly to write with the knowledge that his words would one day become their own palimpsest, a hall with reverb, where a single line can set off a thousand reminders and echoes. It was as if he intuitively knew his work could fan out to find its fellow-travellers.

'To be a polymath', Susan Sontag once said, 'is to be interested in everything—and nothing else.'[25] Berger was similar. 'If I've written about a lot of different kinds of things,' he put it more simply, 'it's because I'm interested in a lot of different kinds of things. So are most people.'[26] But the quality of that interest, the tone and tact of it, branched off, as we will see, in the mid 1970s from the main trunk of metropolitan intellectual discourse. (So much so that when Sontag and Berger met up for a televised conversation in the early 1980s, what might have been a philosophical love-in turned into something of a struggle for common ground: Berger's Confucian slogans seemed to slide right off Sontag's New York bearing.) 'One of the functions of writing stories', he once said, 'is to take people out of the ghetto that other people have built around them.'[27] In retrospect, the abiding concerns of his late essays may have been the same as those of the postmoderns, from Derrida to Deleuze; it was just his *style* that was so different. Instead of solecistic punning or gleeful spirals of metaparadox, his written prose could progress like a trundling walk, as if he was pushing a wheelbarrow. What he said of his friend Romaine Lorquet's site-specific sculptures in the hills of the Vaucluse was also true of his essays: they belonged outside in both a literal and figurative sense. People talk about outsider art; Berger was an outsider theorist. Of all the philosophers to have emerged from the New Left, he was perhaps its only plein-air practitioner.

One of the charges this book sets itself, then, is to live both in the library (or archive) and the open field, to chart the connections between the texture of experience, the weight of politics, the power of art, and the way history bends and doubles back and moves fitfully forward. What I lay out is a triptych: the three lives of John Berger. The first section unearths his early career as a journalist and cultural

combatant in 1950s England—a period of Cold War frustration that produced the knot of antinomies he never stopped trying to disentangle. The second section reconsiders Berger's transformative middle-period—an exuberant, sensuous, and enormously prolific decade-and-a-half. Though nominally based in Geneva, Berger travelled Europe by motorcycle and 2CV, riding the wave of the 1960s until its revolutionary force crashed into the breakers of the decade to follow. The third and final section follows him to the hills of the Haute-Savoie. By this point, our era of neoliberal globalization on the rise, Berger refashioned himself as a resister (no longer a revolutionary) and a chronicler of peasant experience.

The book as a whole considers a range of media: painting, television, literature, photography, film. Each chapter examines a central philosophical question that preoccupied Berger for years, or sometimes decades. Each chapter also circles around a distinct *form*—art criticism, the modernist novel, the documentary photo-text, the narrative film—and a distinct solution to the problem of contradiction, whether through polemic, confession, intermediality, montage, the process of collaboration, or the physical experience of work. Berger's was a rare and special trajectory: he went from the archetype of an angry young man to become a travelling modernist and then, finally, a storyteller for whom obstinacy and compassion were inextricable.

For most of us, the twin poles of hope and despair are defined and experienced privately. For Berger, at least as refracted through his work (itself a prism of the public and private), they were often tied to the imagined fate of the broader body politic. The Polish poet Czesław Miłosz once referred to a 'peculiar fusion of the individual and the historical' that sometimes takes place such that 'events burdening a whole community are perceived by a poet as touching him in a most personal manner'.[28] Though Berger primarily wrote prose (he said he only turned to poetry when he could do nothing else), the burden and the touch were the same even as his community shifted over the years, at once settling down and growing ever more global and multitudinous. The emotions preserved in his writing can thus be read as a gauge,

almost an archaeological record, of leftist hope—a movement that is doubly mirrored, as, for him, the art he most admired and wrote about worked in just the same way: as a mediator between hope and despair, the past and the future, backwards and forwards.

Berger certainly meant to combine art and politics, but he also moved on a dialectic of change and continuity. Around every corner he seemed to reinvent himself and yet stay true to the same basic set of principles and sympathies. (These were sympathies, it should be noted, not parts of a well-oiled system. What W. G. Sebald found in Peter Weiss was also true for Berger: that his politics were not merely a wish for the next victory but an 'expression of the will to be on the side of the victims at the end of time'.)[29] Over his sixty-year working life, there were no renunciations or born-again conversions. What there was instead was a near-constant response to historical situations as they changed around him. For Berger, experience was the truest fund of knowledge—and knowledge, in turn, for it to be worth anything, had always to lead back and into experience. It had to be put to use. Knowledge is there to help us enter, however brashly or modestly, the historical process.

1

The Battle for Realism

—You certainly raised hell as a young art critic.
—Well it wasn't difficult to raise hell in that polite world.
 Interview with John Berger, 1989

In early 1952, the same year a twenty-five-year-old John Berger joined the ranks of the *New Statesman*, the London-based Institute for Contemporary Arts announced a competition. Artists from around the world were encouraged to submit proposals for a public monument to be built in commemoration of the Unknown Political Prisoner. The prize amounted to £11,500, and a site had been set aside in West Berlin. The selection committee featured several prominent artists and critics, including Henry Moore and Herbert Read.[1]

The theme of the well-publicized contest was chosen to 'pay tribute to those individuals who, in many countries and in diverse political situations, had dared to offer their liberty and their lives for the cause of human freedom'.[2] By this point the Cold War was in full swing. Stalin still ruled in Moscow; the Korean War had entered its second year; and the United Kingdom was only months away from testing its first nuclear bomb off the western coast of Australia. In such a climate the neutrality professed by the ICA was a hard sell. The committee spoke of the universal significance of its subject, but no Soviet or Eastern European entries were received, and two architects of the prize were prominent and influential Americans. Both were later discovered to have covert connections to the CIA.[3]

A year later, when Reg Butler's model was chosen and displayed at the Tate Gallery, the politics that underwrote the prize burst into the aesthetic realm. Butler's maquette featured three miniscule, Giacometti-like human figures dwarfed by a large tower resembling an antenna. For many on the left the insectile sculpture (not to mention the high-minded fanfare that accompanied it) smacked of pretension and hypocrisy. For some it was a show of out-and-out disrespect. On a Sunday afternoon in March, a young Hungarian refugee, Laszlo Szilvassy, walked through the museum doors, grabbed the model, twisted it in his arms, and threw it to the floor. 'Those unknown political prisoners have been and still are human beings', Szilvassy said in a prepared statement he handed to the museum guards at the time of his arrest. 'To reduce them—the memory of the dead and the suffering of the living—into scrap metal is just as much a crime as it was to reduce them to ashes or scrap. It is an absolute lack of humanism.'[4]

A young Berger seized the moment. He had been railing against the postwar avant-garde for the better part of a year ('pointless', 'confused', 'produced by guesswork'),[5] but now he was furnished with a symbol. His article for the *New Statesman*, becoming a touchstone in the controversy, characterized the ICA contest as 'a total failure' which proved that 'the "official" modern art of the West is now bankrupt'.[6] 'Imagine', he said, 'on one hand the most cogent, truly contemporary and relevant human symbol of our time—the Unknown Political Prisoner; on the other a plinth in the Tate Gallery on which were arranged three screws, some bus tickets, a few matches and a crumpled paper bag. Within that contrast can be seen the enormity of the failure of the admired, so-called progressive art of our time.'[7]

That many subsequent visitors took the trash that had come to replace Butler's maquette as seriously as if it were the actual winning sculpture only proved, in Berger's view, the farce of the entire competition. While a readymade of scraps might fit in at the Tate, its inadequacy in a serious political context was 'absolute'.

As important as Berger's indictment of the contest's

handling was his rejection of its premises. The pretence that the monument and its selection would be ideologically neutral was not only false in practice, but impossible in principle. Aesthetics could never wholly free itself from politics, and to presume otherwise was itself an ideological ploy. 'All works of art', Berger wrote, 'within their immediate context, are bound directly or indirectly to be weapons: only after a considerable passage of time, when the context has changed, can they be viewed objectively as *objets d'art* ... Valid art, in fact, because it derives from passionate, fairly simple convictions about life, is bound, in one sense, to be intolerant.'[8]

Berger's rhetoric—as well as a comparison he made between a 'trade-unionist imprisoned in Spain' and a 'counterrevolutionary in Siberia'—enraged a liberal public. First an artwork had been defiled; now their values were being vandalized. The ICA went on the offensive. Herbert Read, having publicly attested to the neutrality of the committee, portrayed Berger as a Soviet apparatchik. The abstract painter Patrick Heron, Berger's rival at the *New Statesman*, caricatured him as a small-minded propagandist. The controversy spilled over into the letter pages of the press. For the first time in his life, Berger found himself at the front lines of a culture war. 'I think that Socialist realities mean more to Mr Berger than universal ones', wrote one reader. Another accused him of distorting his criticism to 'conform to a preconceived art theory based on a political formula of art as propaganda'. The apostate communist Philip Toynbee took it one step further, as if sounding the alarm. 'This is the embryo of Newspeak', Toynbee wrote, 'with which we have been so long familiar.'[9]

But how long is so long? Only a few years earlier none of this would have seemed familiar. *Nineteen Eighty-Four* may have been published in 1949, but it was not until its many publicized adaptations in the 1950s that Orwell's tropes and neologisms took on widespread currency.[10] Before Cold War paranoia kicked in, a global cultural discourse mounted and the Truman Doctrine was brought to bear on art, labels such as 'Social Realism' were not yet so fraught or

triggering. People had other things on their minds: 80 million dead; maps and borders redrawn; entire neighbourhoods reduced to ruins; old generals tied to the stake and executed.

If anything, de facto socialism was what got Britain through the war. And having now got through it, what had buoyed their victory translated almost directly into a new spirit of populism. In the summer of 1945, only weeks after VE Day, the Labour Party won a landslide victory over Churchill's Tories—the first time the Conservatives had lost a general election since 1906. Many on the left saw in Attlee's victory the partial realization of socialist ideals: the founding of the National Health Service; the nationalization of large sectors of the economy; the expansion of social security, education, and affordable housing. (Of course, in Labour's increasing factionalism, and ultimate defeat in 1951, the same leftists saw in the painful arrest of that process before it was complete the betrayal of those ideals.)

For Berger, too, the years coming out of the war represented an enlargement of possibility. If he later rose to prominence *as a critic* amid the fractiousness of the cultural Cold War, he first came of age *as an artist* during a period of postwar unity; the years separating these phases of his career were deceptively brief. London had been scarred, but the shoots of herbs were growing in the rubble. The late 1940s were strangely halcyon years—a time Berger later remembered as a calm between storms, when he was comparatively *un*involved in politics. Having just turned twenty, he was painting what he felt like painting and spending afternoon after afternoon at the cinema.

In 1946, Berger enrolled at the newly reopened Chelsea School of Art (then Chelsea Polytechnic), where he stayed for three years. Many of his classmates had seen combat; some had been POWs; others, like him, had served on the home front. He belonged to a committed yet lively cohort which, freshly released from military discipline, embraced a new kind of independence. After the armistice they could now make up for lost time. But at Chelsea they also encountered a new kind of rigour. Life-drawing and life-painting—what was called composition—were mandatory. Students would

be presented with a subject and then asked to render it on paper, while teachers came around to evaluate their progress. Berger was a talented draughtsman. And though not as severe as their crosstown rivals at the RCA or Slade, Chelsea's professors still hewed to the age-old principles of figuration far more than to cutting-edge experiment. The faculty in painting included Ceri Richards, an energetic Welshman, Harold Williamson, a war artist and poster designer, and Robert Medley, an affectionate mentor to Berger whose nearby house became a gathering place for students and artists. Even those tutors who had once fitfully followed the avant-garde emphasized a strong grounding in technique. Medley, for example, had once exhibited with the surrealists, but was known to instil in his students a love for the classical: his heroes were Poussin and Watteau. One of Berger's friends and classmates, Harry Weinberger, later recalled that a film of Matisse sketching his grandson was shown to students as an example of how *not* to draw.[11]

Chelsea's campus was, and still is, a short walk from the Tate Gallery, guardian and symbol of British art; and though Berger was in fact intrigued and impressed by many of the reproductions he saw from France—Picasso especially—the school still moved very much within the orbit of the home-grown. This tendency was even stronger when, after the war, patriotic sentiment held sway. Reconstruction meant the recovery of local currents: Lowry, Sickert, Spencer. Particularly influential for many young painters, including the young Berger, was the Euston Road School, a short-lived prewar academy that had favoured tradition, naturalism and the 'poetry in the everyday'.

Berger's own paintings grew out of this general tradition, but were not as wistful or private: he preferred popular, more robust themes. In 1950, when the South Bank was being prepared for the Festival of Britain—itself a celebration of national culture and resilience—a twenty-three-year-old Berger went day after day to draw the builders. (One of his canvasses, *Scaffolding*, depicting the Royal Festival Hall in the early stages of its construction, was later acquired by the Arts Council.)[12] From these and similar studies—of fishermen

in Brittany, foundry workers in Croydon—Berger worked towards finished paintings. He also drew ballet dancers at Sadler's Wells and, during a formative trip to Italy (and evidently under the influence of Chagall and Soutine), painted street performers and jugglers. Like most young artists, Berger was trying on a number of hats. But across a range of moods and subjects he returned again and again to a common premise: the connection of a group of people sharing in a mutual activity.

Though Berger later credited a charged geopolitical atmosphere for his abandonment of painting—with journalism, it stood to reason, more could be done, and could be done more quickly, than with art—this was a simplification: the imposition of an older, retrospective awareness onto a younger, more tentative self. The arts of storytelling he later came to adopt apply also to memory, and move forwards and backwards in time. At twenty-five, he was still very much finding his way.

After finishing his studies, Berger took a part-time job teaching life-drawing. In 1948 he married the illustrator Pat Marriot, a classmate. The couple lived together in a small two-bedroom flat in Hampstead, but the marriage soon ended in divorce. Though he continued to paint and exhibit, the response to his work was minimal. 'Every painting was an enormous struggle', he later remembered. 'I had no facility and at that time I tended to think that this total lack of facility meant that I really wasn't a painter.'[13] But through his speaking and writing, Berger attracted fast attention. Alongside his work as a tutor he took a second job as a lecturer with the Workers' Educational Association. In order to prepare for his classes, he began, for the first time in his life, a serious exploration of art history. In the midst of this, he was also becoming re-politicized, shedding his early anarchism for something recognizably partisan and communist. His position became, as he later described, 'more Leninist, more orthodoxly Bolshevik, if you wish, and less anarchist'.[14]

Berger's first book and exhibition reviews appeared in the *Tribune*, a democratic socialist paper (for which Orwell had once served as literary editor). In 1950 he was invited by a

friend who was a producer to talk about paintings in the National Gallery for the BBC World Service. On the basis of these radio scripts, which he sent to the offices of the *New Statesman*, Berger came to the attention of Kingsley Martin, the magazine's famously well-connected and tempestuous editor. In 1951, Berger started publishing short reviews for the journal, and by 1952 he had been taken on as one of its principal art critics. At first there was a boyishness to his early articles—an enthusiasm in search of a purpose. But once he found it, he was off.

The name of his cause was *realism*; opposing it was *modernism*. In one corner, art that was accessible, popular, rousing; in the other, art that was difficult, esoteric, often misanthropic.[15] At the start of the century modernism had been on the up and up. 'On or about December 1910, human character changed', was Virginia Woolf's famous remark. But after the bloodshed of World War I, it seemed to change again. Much of modern art appeared to go off the rails: Dada, De Stijl, Surrealism. The flurry of interwar avant-gardes had produced, in the minds of many postwar critics, something of a muddle. Old dichotomies were newly felt. Should painting depict the physical world or the physical trace of its own making? Should art move within or against institutions? What constitutes a proper subject for the artist: dreams, shapes, nature, society?

After World War II, such questions left eddies of mixed emotion in their wake. The whole dilemma of the modern— What was it? How to remake and reimagine it?—seemed to be up for grabs. People were looking around for answers. And though Paris was still thought to be the bellwether of taste (only later was it registered that New York had usurped that distinction), what was emerging from the French capital struck many in England, not just Berger, as uninspired.

Consider a 1951 review of the École de Paris by Anthony Blunt. 'What, one is always hearing asked, are the young French painters doing?' Blunt mused as he took the measure of the work that had crossed the channel to Burlington House. What he saw let him down: 'The dominant tendencies seem to be as follows: an eclecticism which aims at combining the qualities of Picasso and Matisse; a strong movement towards

pure abstract painting; and a leaning towards Expressionism, principally in colour, but to a smaller extent in the choice of grim and disagreeable subjects.'[16] Harbouring no a priori objections to any of these avenues, Blunt was still dissatisfied. 'That they produce ... often sensitive variations on the familiar themes is undeniable', he said. 'But is this enough?'[17]

Berger thought not. In his first articles for the *New Statesman* (1951–52), he continued the line of thought but pushed it further, and was less tentative. In the wake of modernism, he declared, artists and critics were lost. 'The fact is that the modern movement—with all its sub-divisions—has now disintegrated; partisan discipline has disappeared and most of the theories have finally lost their precision in practice.' In its place there reigned an 'incredible confusion' in contemporary painting, 'a confusion of methods, aims and standards' evident in the extreme eclecticism of gallery taste.[18] The contemporary painter, Berger said, still anxious to appear up-to-date, could only superficially imitate the 'personal mannerisms of those he admires'. The result was a meaningless and confused groping.[19]

From the start, Berger styled himself a voice in the wilderness. But early in 1952, visiting the Young Contemporaries exhibit at the RBA galleries, he found company—and an alternative. The new realist work he saw on display filled him with exuberance. Though the six hundred paintings did not uncover any 'unexpected genius', they nevertheless revealed a 'common attitude' shared by the young. This was a generation of students, Berger said, whose 'gruff' and 'urgent' paintings sprang 'without the slightest trace of rhetoric from the only source they feel they can trust—their everyday, almost banal experiences'.[20] Out of the tired dichotomy of the academic versus the avant-garde (or naturalism versus abstraction) came something altogether different: a renewed tradition of *social realism*. Depicting an environment more often passed over than noticed—'the back garden, the railway, the wharf, the street, the herring fisheries, the deck chairs on the pier'—these painters rendered mundane scenes with clarity and care.[21] The title of Berger's review radiated hope: it was called 'For the Future'.

The new realists, Berger said, went back to Courbet instead of Cézanne—and in some sense so did his criticism. He stressed the importance of the contemporary, the tangible, the commonplace, the drab. He called on artists to project themselves out of the studio and onto the street, into the social commons, and to look at what they found without preconceptions or recourse to adornment. To be a painter, he said over and over again, meant to observe, to receive, to let in, to be open to discovery. 'Art is a means of communication', he wrote, 'but it is essentially an imaginative means; and imagination in art consists of the ability to discover and disclose that which exists.'[22] (The same point was present, in negative form, in his vocal distaste for the work of Francis Bacon, the first artist he truly singled out for attack, and who remained for decades a *bête noire*. Bacon was 'a brilliant stage manager', according to Berger, but not 'an original artist', precisely because there was 'no evidence in his work of any visual discovery, but only imaginative and skilful arrangement'.)[23]

The idea of realism today may have an academic ring to it; at the time it stirred deep feelings. It had already become a 'fighting word' in Italy and France, where the aesthetic was championed by the Communist Party in both countries. But in the postwar decade the Communist Party of Great Britain (CPGB) lacked influence and a developed cultural programme, allowing Berger (who was independent of the party but sympathetic to it) to fly, at least for a time, under the political radar.[24] The sentiments he expressed struck a chord far beyond the left. A postwar public was eager to see itself and be seen, and within months Berger's reviews were being widely read and discussed. He quickly gained an impressive—and impressively loyal—readership, so much so that all of a sudden doors were opening and by the summer of 1952, through a fortuitous mix of timing and happenstance, Berger was given a rare chance (almost unheard of for someone so young) to curate his own exhibition.[25] Most critics, no matter how zealous, usually must rely on what is already being shown in order to express, in turn, what they personally want to see. Having been granted *carte blanche* by the Whitechapel Gallery,

Berger could for the first time present, by virtue of his own selection, the visual correlates and contours of his aesthetic. 'I knew myself what a powerful, and yet vague, word "realism" can be', Raymond Williams later said of the period. 'It is easy to declare in favour of it, yet difficult to say what exactly is implied.'[26] Now Berger could be explicit.

The result was *Looking Forward*, a 'manifesto exhibit' that proved one of the most influential of the decade, running at the Whitechapel from September to November 1952, and touring England the following year with a grant from the Arts Council.[27] For much of the autumn, the East End gallery became a meeting place not only for the work of Berger's friends—many included in the show were recent graduates of Chelsea, Slade and the Royal College of Art, while others had been former teachers—but also, it seemed, for the new public he was trying to reach. 'Nothing is more heartening', began the review in the *Observer*, 'than to see the street-vendors thoughtfully perambulating the Whitechapel Art Gallery.'[28] To Myfanwy Piper, *Looking Forward* promised a 'blessed release from the stand-offish complexities' of 'so-called modern art', much as *Lyrical Ballads* had once promised to 'unclutter works of imagination'.[29] ('An artist returning consciously to the language of the common man', she said, 'must always express it in a state of heightened emotion'.) 'So far the movement has hardly got going', conceded Benedict Nicolson, Berger's colleague at the *New Statesman*, 'and has naturally produced—as no movement can in its earliest stages—no great artist: but I am convinced that this is the turning art will now take.'[30]

Many programmers and gallerists were similarly won over. For a few years, thickly rendered paintings, full of impasto and brownish-grey in palette, came into vogue: pictures of northern industry, men at work, football, street and domestic scenes. One exhibition in this vein, held in 1953 at the Walker Gallery, was called *Paintings for the Kitchen*. The following year, David Sylvester (Berger's arch-rival and an ardent supporter of Francis Bacon) wrote an article for *Encounter*, 'The Kitchen Sink', gently parodying the trend: 'Everything but the kitchen sink? The kitchen sink too. The point is that

it is a very ordinary kitchen, lived in by a very ordinary family ... nothing to hint that the man about the house is an artist or anything but a very ordinary bloke.'[31] The image stuck, becoming one moniker—the more derisive—to refer to the new school of English realism largely deriving from Berger's intervention.[32] And though he would later express disappointment at what he saw as a depoliticized turn in the development of the so-called Kitchen Sink painters (just as the artists would in turn reject his calls to politics), Berger had nevertheless helped conjure into being one of the more significant movements of postwar British art. Not bad for a twenty-six-year-old.

Berger's great strength as a journalist lay in his ability to articulate complex positions within the limited space of a weekly review—and then to charge those positions with passion. He had an almost preternatural ability to make art criticism breathe with moral fervour. 'What is interesting about John', said the film editor Dai Vaughan, 'is that you don't have to agree with his judgments all the time ... but what remains admirable is the sheer intensity of his gaze. He never wavers, he never goes off and his formulations never, or very seldom, slip their moorings. They don't become, as I think they do for some academics, counters to use in a casino.'[33] There was never any scholarly gargling or displays of erudition. Berger's articles sounded as if he was speaking directly at you even as he was talking to a range of publics at once: artists, critics, administrators, politicians, professors, and (most of all) young readers eager to feel they had a growing stake in culture. All of these were his gifts—and by the end of his first year at the *New Statesman*, he was being talked about as one of the brightest young critics of his generation.

In one year Berger had accomplished more than most critics could hope to in ten. But 1952 was unusual. Culture and politics were very much in flux. The equation of modern art with democracy, and of social realism with totalitarian rule, was yet to be installed as a centrepiece of American discursive strategy. In the late 1940s, with conservative populism still

domestically ingrained, the United States was more concerned
with convincing Europe that it possessed an artistic sensibil-
ity at all than with parading its newly budding avant-garde.[34]
Even as late as December 1952, the chairman of the Museum
of Modern Art, Alfred Barr Jr, wrote an article for the *New
York Times* whose title reflected a widespread assumption:
'Is Modern Art Communistic?'[35] (His purpose was to prove
the reverse: it was realist art that was the problem.) In this
somewhat pre-politicized context, Berger's first articles did
not flaunt so easily recognizable an allegiance. A populist and
moralizing subtext ran through his attacks on the anomie of
contemporary painting, but it remained just that: populist
and moralizing. In certain respects it even resembled con-
servative prejudices still widespread in the West, and notably
held by Truman, Eisenhower and Churchill.

In 1953 everything changed. All intermediate space dried
up. Berger's campaigns had first come on the heels of a waning
hope for an independent socialist bloc in Western Europe.
The *New Statesman* had been the locus of this belief—their
influential pamphlet *Keep Left* had called for a 'third force'
between Moscow and Washington—and Berger's calls for
realism proceeded according to similar premises. It should
not be necessary, he once said, for a 'West European artist
to cut off his right hand and paint as though he were an old
academician in Moscow, nor to cut off his left to feel at home
in the Museum of Modern Art, New York'.[36] Realism was not
supposed to be radical; it was supposed to be a middle road.
But soon there were two—and only two—choices left. And
as Berger's attacks on western-liberal taste intensified, many
of those who had initially welcomed his purposeful criticism
were coming to view him as dangerous. Accused of sullying
art with political dogma, Berger was forced to defend both
his aesthetic and political positions on more general grounds.
'All my life I have been passionately concerned with painting',
he wrote after his article on the Unknown Political Prisoner
brought down the wrath of the gods. 'Besides practising as a
painter, I have tried to think about and *for* art. But I have tried
to think beyond the tip of the painter's brush; and, as a con-
sequence, it has been my concern for art, which has largely

led to my general political and social convictions. Far from dragging politics into art, art has dragged me into politics.'[37]

In Britain, 1953 was the year when the Cold War became a full-fledged culture war. Battle lines were drawn, and the ICA controversy marked the true start of combat. Instead of any universalism, what the contest demonstrated was how quickly matters of aesthetic judgment, once ideology was broached, became political. And ideology was soon unavoidable. Disagreements about art gave onto questions of allegiance, quickly reverting to first principles. Was aesthetic experience timeless or historical? Should artworks inspire or console? Should the state 'protect' or 'promote' culture? How—and where—should the line be drawn between art and propaganda?

Berger's interventions revealed a sharp divide at the heart of British cultural life. On one side were the liberal critics. They believed art should not be subject to political control, that aesthetic experience was autonomous, and that putting art in the service of politics not only debased art but set society on a path towards a totalitarian dystopia (references to Kafka and Orwell were a regular trope of the period). Intellectuals in this camp included Herbert Read, Patrick Heron, David Sylvester, Stephen Spender and many others. Their most vociferous mouthpiece, *Encounter*, first appeared in October 1953 (only months after the Unknown Political Prisoner controversy); it was a journal conceived specifically to offset the influence of the *New Statesman* on the British cultural left. The magazine's regular conflation of communism with fascism—the first issue equated Hitler, Mussolini and Stalin[38]—was a global discursive strategy that worked on both political and aesthetic grounds: Barr's influential article, for example, published less than a year before *Encounter* was launched, placed visual examples of Soviet and Nazi art side by side, to establish a persuasive connection between them.[39] Social realism was corrupt by association. The avant-garde, by contrast, was held up as a metonym for the freedoms protected by liberal democracy: the so-called politics of apolitical culture. By the end of 1953, even the Artists' International Association (originally conceived in the 1930s as a radical

left group) had removed the political clause from its charter.
All the air was being sucked out of aesthetic debate. Soon,
any hint that art either is or ought to be tied to social devel-
opment was quickly flagged as potentially dangerous, as part
of the 'messianic arrogance of the spirit, which has blithely
perpetrated so many hideous crimes against the flesh'.[40]

One of the central ironies of the period was that, for
all their talk of individual liberty, the liberal critics repre-
sented a well-organized and powerful alliance. For his part,
despite his calls for social solidarity, Berger was unusual for
England. He was independent of the CPGB; many of his
intellectual mentors were Central European; and his great-
est contemporary influence came from Italy. Though he
did enjoy a tacit alliance with two other young reviewers
—the film critic Penelope Gilliatt and the theatre critic
Kenneth Tynan, both of whom wrote for the *Observer*, and
were, like Berger, hailing a new, coarse energy in their respec-
tive mediums—Berger was by far the more politically minded
of the three.[41] Later in the decade—in 1955—he established
the Geneva Club, an informal salon-style gathering that met
intermittently above a pub near Oxford Circus. The club
brought together a diverse array of left-leaning artists and
intellectuals, including Lindsay Anderson, Isaac Deutscher,
Eric Hobsbawm, John Willett, Paul Hogarth, Doris Lessing,
and many of the realist painters and sculptors Berger had
championed.[42] But, again, this was an informal gathering—
and one that Berger, at least according to one source, wished
to see politicized against the more restive impulses of the
group.[43] It must be remembered that, before the rise of the
New Left, which was partly inspired by the Geneva Club,
Marxism was out of favour in England.[44] 'It really wasn't
possible', Berger said of the fifties, 'except in rather simpli-
fied terms within the Party, to talk about Marxism. It wasn't
possible. There were not books about it except books pub-
lished by the party press. There were three possible attitudes.
Either it was evil and you were a Russian agent. Or … it was
outdated and totally irrelevant to the modern world. Or, the
most charitable, "Well I suppose that's your form of religion."
With the birth of the New Left all this changed.'[45]

At the height of the disputes over realism and the purpose of art, while London could boast an impressive density of first-rate art critics, Berger was its only outspoken Marxist. There was simply no one else who shared both his prominence and his politics.

The philosophy he articulated ran unswervingly counter to *l'art pour l'art*. At one point he even had plans for a manifesto-like book to be titled *Art for Our Sake*.[46] 'Art must serve', he wrote, 'for the sake of its own health.'[47] This was his central premise. To connect art to social growth and political hope, to causes larger than itself, was in fact to strengthen art, to give it the conviction and purpose from which great works, when they do occur, are made. The liberals invoked autonomy as their theoretical lynchpin: propaganda as a means, art as an end in itself. But Berger consistently rejected this line of thought. 'No tradition or single masterpiece has ever been produced without such a sense of service', he wrote. 'It is significant, for example, that Picasso has never surpassed *Guernica*, nor Henry Moore produced such profound drawings as those he did in the tube shelters during the war.'[48] 'Cultural achievements are a by-product', he said, 'the by-product of a people's general aims, interests and values.'[49]

As part of this belief, Berger returned again and again to the idea of tradition. If *freedom*, *individual* and *expression* were the talismanic words for the liberals, the words for Berger were *purpose*, *realism* and *tradition*. And, like realism—or, for that matter, freedom to the liberals—tradition was a concept that was expansive, unstable, possibly contradictory, and utterly central to his thought. What did he mean by it?

It is important to distinguish Berger's understanding of the term from a more overtly conservative or reactionary one. At times he did speak of a young generation 'robbed' of tradition, of a tradition 'dismantled and destroyed'. His decision to emphasize the word, whether calculated or otherwise, likely reflected a desire to occupy the centre: to appear moderate and remain persuasive to a large swath of British society. But in his hands 'tradition' soon gained a markedly socialist inflection. It almost always meant a direction-giving force that was communally built and maintained, not an inheritance to be

politely respected.[50] War had revealed the kind of collective mobilization of which society was capable. The creation of the welfare state had seemed to corroborate that ability in peacetime. Berger's calls for a broad realist tradition must be understood in this context. The artist, in his mind, was always to *pass on* (tradition: from *tradere*, to deliver) an experience contained in his art to his public: and because those experiences (at least in what he would call a 'healthy' tradition) were to be drawn from the social commons, his art would in turn reinforce what was shared. Originality, for Berger, was never to be put on display for its own sake; nor was it to be found in the personally esoteric or extreme. It was instead a question of discovering and extending common ground.

Tradition, then—and here we notice the first step from the aesthetic towards the moral and political—was a bulwark against individualism. The lack of any central tradition 'either to work within or rebel against' had led to the worship of genius, and what Berger called 'the abuse of talent'.[51] It had led artists to think in terms of 'excessive individuality and complexity', to inhabit a solipsistic world in which each developed a private language. (The animus towards exceptionality explains Berger's uneasy relation to the category of genius—a tension that runs throughout his long career.) In order to build a broad realist tradition, he repeatedly discounted 'brilliant eccentricity' in favour of collective effort and more reasonable achievement: reasonable in the sense of both rational and modest. In 1952 he wrote: 'Only a shared sense of purpose, or outstanding genius, can now preserve a painter from the taint of exhibitionism.'[52] In 1953: 'The only way out of our predicament—and I am well aware of the dangers of artiness-and-craftiness—is that we again consider that the duty of the artist is to carry out a particular job as well as he can; not, as happens today, to give us the key to the universe. The genius and the masterpiece can look after themselves.'[53] Later he put the matter more bluntly: 'There will be no such victory until reasonable talent, as opposed to genius, can produce satisfying works of art—and that means an alive, teachable tradition, a confident society and a broad cultural public.'[54]

What victory meant was a living context for the purposeful making and experiencing of art: the meaning of an altarpiece in a church is very different from that of a canvas up for auction. Berger's thought was essentially anthropological in this regard—but it was an anthropology directed at contemporary life and overlaid with judgment. A strict division between natural and artificial habitats for culture ran through his thought from the period. He derided many of his patrician elders as 'museum critics' who 'failed to understand the difference between a work of art in its live context and an *objet d'art* under a glass case'.[55] The museum was a space that was insular, timeless, rarefied, decontextualizing. It was a cross between a zoo, a sanctuary and a safe. For art to thrive, it needed rougher, wilder, more popular soil. 'Ivory towers are usually civilized and gentle places', Berger wrote. 'But they are not ... the strongholds of humanity.'[56]

Well into the 1950s, Berger called for something akin to a cultural New Deal in England. He spoke out on the need for public sculpture and murals, advocating projects such as 'Pictures for Schools', run by the Society for Education through Art.[57] He called on state institutions to employ rather than mythologize the nation's artists. Many young painters, he said, 'would prefer to paint a large mural in a hospital, a concert hall, a school, and be paid an ordinary wage than sell ten small pictures to the elite'.[58] They would prefer to connect with 'an audience sturdier and more inspiring than the official art market—a trade union and working class audience without so many deep cultural preconceptions'.[59] He likewise attacked what he saw as the timid apathy of the Arts Council. 'The council is open-minded and passive', he wrote in a controversial 1955 article. 'It ought to be partisan and active. It should not be a charitable advisory aunt to the arts, but a standard bearer of an altogether new conception of public art.'[60] (Herbert Read shot back: 'Why should the whole cultural scene of this country be turned into a high-powered propaganda factory directed by some frothy-mouthed Goebbels?')[61] The more that genius, fame and private property were fetishized—the more that art became a 'snob commodity' to be bought and sold—the less it could fulfil its proper

social role. And, again, the state-funded museum was not an adequate corrective. Great works, Berger wrote, 'have never been consciously produced for the museums of the future'.[62] They were, in one of his many arresting metaphors, more like stones in a bridge that can help a people move in a certain direction.

As a student Berger spent countless afternoons at the cinema, where films such as *Rome Open City*, *Paisan* and *Bicycle Thieves* left a lasting impression. The connection to the south was partly ancestral (his paternal grandfather had come to England by way of Trieste), but it was cemented through postwar Italian art and culture, especially neorealism. On his first trip to Southern Europe, in 1948, after a chance meeting on a train, he forwent his intended tour of classical and renaissance art to spend a week in a working-class suburb of Turin, helping out in a garage. It was an environment, he later recalled, that could have been straight out of a neorealist film.

What Berger brought back to London from Italy was its partisan ethos and the mythic image of its patron saint: Antonio Gramsci. Though caricatured as Soviet or fascist, Berger was in fact drawing on ideas Gramsci had first elaborated in the 1920s, but that only gained widespread currency in Italy after the war: that art should be put in the service of social development, that it could help build a road to socialism, and that the artist could participate in the creation of a broad popular culture. Such ideas were not only anti-liberal; they were also new to Marxism. Gramsci was one of the first Marxists to see culture not as a passive ideological mirror but as something far more complex and alive. He was likewise sensitive to the nuances of cultural identity: he thought of the intellectual as someone whose role was to *give voice* to the uneducated, rather than simply to argue on their behalf. And whereas orthodox Marxism spoke of a supranational alliance of the proletariat, Gramsci appreciated the importance of local customs. This led him to articulate the concept of the 'national–popular'.[63]

Even though no translations were available at the time,

and (with one notable exception) the first articles on Gramsci did not reach the English press until the mid 1950s, the impact of the Sardinian theorist on a generation of Italian artists and intellectuals, many of whom Berger knew well, was immense.[64] Extracts from the *Prison Notebooks* began circulating in Italy as early as 1944. When they were published in full, between 1948 and 1951, they generated active speculation on the Italian left about a possible 'cultural road' to a Marxist society. At a time when Gramsci's work was still more or less unknown in Anglo-American circles, Berger called him 'one of the greatest intellectuals of this century'.[65]

It is clear why Gramsci would have exerted such appeal. The Sardinian political thinker was almost a legend: at once affectionate and indomitable; physically disabled from childhood, yet a man whose power was demonstrated when the prosecutor at his trial famously declared: 'for twenty years we must stop this brain from functioning'. His example breathed belief into Berger's own campaigns. The problem of public participation in the British arts, he said, had nothing to do with 'what dreary pedants call Bad Taste: the problem is that the majority of people never look with any personal interest at any paintings or sculptures at all because they have been led to the conclusion—quite understandably on the whole—that such works as do exist have nothing to say to them'.[66]

Gramsci had traced this problem back to its root, where he discovered a social fact: intellectuals and so-called ordinary people inhabited totally segregated spheres of life. The solution was to break down the barrier, to remove the intellectual from his 'antiquated world, narrow, abstract, too individualistic or caste-like'.[67] In the late 1940s, when the Italian Communist Party (PCI) was at its height, it had even put into practice such bold initiatives as the *andata al popolo*—a kind of school-busing programme for artists, which encouraged painters to work for a time beside ordinary labourers.[68] Berger's own training had included similar experiences: the two years in Northern Ireland among working-class cadets, the months spent making drawings of welders, fishermen and builders. (His ultimate resettlement in a French peasant community can also be viewed in this light.) Underlying Gramsci's

appeals, the PCI's policies, and Berger's own formation was a similar longing: for the artist and the worker to meet.

The ultimate goal was to bridge the gap between a national culture and the working class, both as subject and audience of aesthetic experience. Such a vision was behind most of Berger's cultural activism from the 1950s and beyond. One early radio script for the BBC's *Woman's Hour* was emblematic: he asked the afternoon listener to look at her own home—dirty dishes, gas metre and all—as if John Constable had just walked through the door, and with the painter's eyes. In the autumn of 1952, on the eve of his *Looking Forward* exhibition at the Whitechapel Gallery, Berger even penned an awkward editorial inviting an uncultured readership to come to see the work for themselves: 'I planned this exhibition not for the critics and the Bond Street art-financiers', he told them, 'but for you, and all your friends who can't stand modern art. For the fact of the matter is that I don't believe you're a Philistine at all. I think it's modern art, and not you, that's to blame.'[69] (The cringe-making tone of the letter, however well-intentioned, demonstrates a more general conundrum of asymmetric dialogue: how to avoid patronizing didacticism without resorting to give-'em-what-they-want commercialism.) Several years later, working as a presenter for Granada Television, Berger would continue the effort. In shows such as *Drawn from Life* he invited ordinary Britons into art-filled television studios for them to comment on which paintings they felt closest to.[70] Though short-lived, the experiment was a near-literal enactment of his deeper aspirations: for the visual arts to be in contact with working people, and for that contact to *matter*. Each show took its cue from a catchphrase: 'Every picture, every work of art, is about some human experience.'

The sophisticates snickered, of course—the *Times* spoke wryly of Berger turning 'the culture club into a civic park', and Doris Lessing called him 'the Wilfred Pickles of the National Gallery';[71] but, by and large, the historical conditions of the 1950s proved amenable. Under the canopy of postwar populism several agendas could coexist. The growing readiness on the part of state and media institutions to adapt to the

changing makeup of civil society—the weakening of the aristocracy and aristocratic modes of belief; the redistribution of wealth and political power; the expansion of literacy and education; the rise of new, more democratic forms of media—presented an opening for left-wing critics such as Berger to reach a broad audience, build a case for an anti-elitist understanding of culture, and play a role in shaping what Gramsci called the 'creative popular mind'. Berger was not alone: the Angry Young Men, the Free Cinema Movement, and the more scholarly work of E. P. Thompson, Richard Hoggart and Raymond Williams all played their part.[72] The late 1950s were in many ways a renaissance. Thompson's biography of William Morris appeared in 1955; Hoggart's *The Uses of Literacy* in 1957; Williams's *Culture and Society* in 1958. Before Jarvis Cocker could sing of class tourists and common people, or Noel Gallagher of not looking back in anger, Tom Maschler first had to gather the anthology of voices for *Declaration*.

In 1957 Berger published his first book—a now all-but-lost monograph, released in East Germany, on the Italian artist Renato Guttuso.[73] On the first page he called Guttuso the most significant living artist at work in Europe. What Guttuso demonstrated, according to Berger, was that a rift between a specialist and popular appreciation of the arts was neither necessary nor inevitable. Prizing painting out of the hands of a minority did not mean turning it into arts-and-crafts. Guttuso had absorbed all of the latest discoveries of his medium—his work was clearly influenced by Picasso, whom he counted as a friend—but his pictures were also copied (as Berger so often recounted) onto the wheelbarrows and sheds of peasants.[74] By helping to reactivate a European tradition dating back to the Renaissance—one that passed from Michelangelo to Caravaggio, Poussin, David, Gericault, Courbet, Van Gogh and Picasso—Guttuso helped make visible the long march of progress: out of feudalism came capitalism, and now socialism.

Though such claims were overblown, what a critic says of an artist is also a projection of himself. And one aspect of

Guttuso's mythos revealed something that would stay forever central to Berger's own: the significance and particularity of place. Guttuso's native island animated all his work. A Sicilian beloved by Sicily, he was not at home, as Berger put it, amid the air-conditioned truisms of the *weltbürger*. (The painter himself spoke of his inspiration going back 'to my child-hood, to my people, my peasants, my father land-surveyor, the garden of lemons and oranges, to the gardens of the lati-tude familiar to my eye and my feeling, where I was born.')[75] His art, along with neorealism as a whole, demonstrated that 'not only every nation, but every province has its own songs'.[76] This was something non-Italians often missed about the movement, but inside Italy it was crucial. Italo Calvino famously remarked that neorealism could not be considered a unified 'school', precisely because it contained within it so many different Italys, so many dialects and regions, each one previously unknown to the next.[77]

Weather aside, the parallels back home were evident. Just as Gramsci wrote of a divided Italy in 'The Southern Question', Berger later spoke of an acute separation in England. Painters such as L. S. Lowry, whom he praised, held such importance because they had brought into the visual arts the shared experience of a place—the industrial north—historically underrepresented in national culture. Excepting certain East London districts, the world of the working class, Berger later said, more or less began north of the Trent. Almost all the galleries were in London; a few were in Oxford and Cambridge; a couple in Bristol—and that was it. ('I feel that the wilderness starts ten miles from the centre of London in any direction,' confessed Jack Smith, one of the realist painters of the period.)[78] In his *Looking Forward* exhibition, Berger meant to draw a wider map. When the show toured England, it passed through small towns in an attempt to stimulate a fresh awareness of visual culture that was locally rooted, heterogeneous and national all at once.

Against this idea of culture as locally specific was that of a free-floating commodity guarded and possessed by a similarly free-floating elite. The style Berger most associated with this was abstraction, not only because it was the latest fashion in

a fashion-prone world, but also because the very aesthetic reflected the deracination of art from any local context. Extreme formalism was, he said, a logical consequence of cosmopolitanism. While American-friendly critics likened the avant-garde to liberal democracy, Berger tied it to a homogenous globality. Realism was an heirloom seed; abstraction the monocrop invading the local species.[79] 'I'm not pleading for anything "folksy"', he said in a lecture to students. 'But there is a difference between "folksiness" and the present situation where artists in Oslo, Buenos Aires, Tokyo and Toronto all paint as though they lived in Paris.'[80]

Abstraction was both cause and symptom of a vicious cycle. It not only turned the medium in on itself, but also pushed working artists further into a state of alienation and social redundancy. This in turn fed into the climate of 'nihilism, egocentricity, confusion and formalism' Berger railed against.[81] As the space for art became more international and more highly concentrated within an elite stratum of festivals and galleries, the general public mistrust of the value of art increased. Such cynicism fed on itself, turning art into either an embarrassment or a glamorous fantasy, and often both at once. More and more people were choosing to become artists for what Berger saw as the wrong reasons, while others chose not to for the right ones. 'Many of our most serious unrecognised artists', he said, 'are so sickened by the preciousness, snobbism, ignorance, bluff and blatant commercialism of the "art world" that they prefer to remain outside it, not even to break in.'[82]

The newfound currency of that coinage—the art world—represented everything he hated. It implied, first, that art was at risk of becoming its own cordoned-off universe, a separate world; and, second, that artists would be driven more by a desire to enter its exclusive milieu than by any fundamental need to communicate. 'In front of picture after picture', he said in one of his 'Round the Galleries' reviews, 'one asks why is this person a professional artist, why did he paint this picture? ... not necessarily because the works are incompetent or tasteless—often they are extremely skilful and "sensitive"—but because they lack even the minimum urgency or

compulsion, because their artists clearly haven't the essential creative imagination to have anything to say.'[83]

As the 1950s wore on, the British arts could not live up to what Berger hoped for them. The tirades multiplied. 'It is many years since the book *Art Lies Bleeding* was published', he wrote in 1955. 'Art now lies dying.'[84] In one article he cited a town hall amateur art show curated by a seventy-five-year-old pensioner named Mr Griffiths as a model for art's intended human context.[85] In another he quoted Van Gogh: 'Oh that each town, each village had a little public art gallery where the inhabitants could enjoy good, strong, lively pictures of themselves ... What do you think—sane or mad?'[86]

Sane or mad? Healthy or sick? This was the choice, and a very personal one for Berger. In 1955 he was at the height of his fame and perceived influence. But inside he was cracking up. In the autumn of that year, he entered into an improbable second marriage with an aristocrat twenty years his senior, Rosemary Guest, the daughter of the 1st Viscount Wimbourne, and ex-wife of the 6th Lord Kilmarnock. There is a peculiarly robust tradition of upper-class leftism in England, but the contradictions of the arrangement must nevertheless have been especially sharp and confusing. This was the beginning of a hard chapter for Berger. He was approaching thirty. Leading up to the politically concussive year of 1956—an event horizon for the postwar left—his writing grew convoluted and frenzied. There were tantrums. His editor Kingsley Martin, with whom he already shared a volatile relationship, was increasingly hard of hearing, and this made for a combustible mix. It was as if Berger was arguing with a deaf public, or with himself. He would lash out one week and then proclaim impending triumph the next, swinging from one desperate pole to the other. 'Because every tradition has broken down', he wrote of the state of arts education in England, 'students are presented with the work of half a dozen civilisations and then told to get on with it ... The majority simply flounder and their flounderings are called "experiments".'[87]

Was he simply a spoilsport? Was he nothing but the latest in a long line of English scolds dating back to Matthew

Arnold, maybe even to Wordsworth? He was certainly just as self-righteous. To his credit, unlike so many embattled moralists, who fret over the media diet of a population (and what kind of cultural products are 'good' for them), Berger spent most of his time staring up the cultural ladder rather than down it. He regularly portrayed members of the museum class as con men—their own cutting-edge products merely photonegatives of kitsch. (It was an intuition he took with him into later life: a 1972 essay famously compares Francis Bacon to Walt Disney.) And if Berger's evaluations of his contemporaries were regularly wide of the mark—often wildly so, seeing genius in overwrought sincerity, while condemning artists for the very reasons they are now loved—his attacks on the *system* of art proved to be remarkably prescient.[88] Hemingway famously said a good writer needed a built-in, shockproof, bullshit detector. This Berger had. As a social echelon, the art world, from Basel to Miami, has only grown more wealth-obsessed and star-struck—a holographic hall of mirrors, almost too easily satirized.

What is more troublesome, however, and what Berger did at root share with the cultural moralists of his day (the left-Leavisites most of all) was a degree of vertigo in an age soon to be dispossessed of absolutes. The tradition of Western painting that was in his blood was largely made on behalf of religion, and the modern religion of socialism was beginning to falter. The 'essential fabric' his vision of culture seemed to depend on was fraying. When the liberals did not dwell on his political menace, they painted him as a nostalgist—obsolete and antiquarian. And Berger had his own doubts, and questions he asked himself: 'Does the need for naive art only exist in a village society? What exactly does the machine destroy and what craft opportunities does it create? Will there finally be a spontaneous popular art of the cities—as Léger suggested?'[89]

At a time when a modern pessimism was being philosophically codified, it came as no surprise that Fernand Léger was the artist to whom he turned, the modern master he most vocally admired, whose work became a compass during crisis. When there was a need to outrun the spectre of nostalgia, the

Frenchman pointed the way. 'If you want a picture of the future', Orwell had famously said, 'imagine a boot stamping on a human face, forever.'[90] But Léger's pictures were bright, full of camaraderie and tenderness, 'emblems for something permanent and yet … as full of movement as pennants in the wind'.[91] While other avant-gardes had fetishized the machine, imagining it as an all-powerful god or Frankenstein, only Léger, in Berger's view, had seen it for what it was: a 'tool both practically and historically in the hands of men'.[92] All of this made him 'the most modern painter in the European tradition … our most experienced guide into the future'.[93]

Such identification between critic and artist contains a wager—and a double wager, in this case given what Berger saw as the prophetic nature of Léger's art. Berger identified with Léger, who identified with the future of the worker. But outside France his work was not appreciated the way Berger thought it should be, and certainly not in the Soviet Union. When Léger died in late 1955, he wrote an obituary in the intimate second-person: a moving sign of comradeship, but one invested with the isolation of a loss.[94] An art of nihilism can feed off its own obscurity; expressions of fraternal hope work differently.

A similar dynamic turned out to be at play between Berger and the British painters he had once championed. In 1952 he spoke of a new spirit of cooperation, but in the years that followed rivalries and feuds broke out. Many of the Kitchen Sink painters came to resent Berger's paternalism. Even approval can be grating. 'One has to take the trouble to appreciate individuals individually', their gallerist, Helen Lessore, wrote in tacit admonishment. 'Short cuts by classification are superficial'.[95] The success of the Kitchen Sink painters, as well as their unity, proved fleeting. Most consider 1956 to be both the pinnacle of their fame and the pivot of their decline.[96] That year the British Council chose the Beaux Arts Quartet (John Bratby, Jack Smith, Edward Middleditch and Derrick Greaves) to represent the nation at the Venice Biennale, an official endorsement of the status they had achieved within only a few years. But then, almost overnight, and certainly by the end of 1957, 'drab' or 'gruff' realism became a fad to

be moved on from. Greaves later spoke of being a 'teenage social realist' the way someone today might talk of having once been into skateboarding.[97] And though Berger refused to 'retract' anything he said about his earlier protégés, he damned their separate trajectories. 'My conclusion', he said a couple years later, 'is that their works are useless, because I am unable to see how they help or will help men to know and claim their social rights'.[98] Soon no one wanted to be the cousins of Courbet any longer. 'Then suddenly', remembered Bratby, 'the veils were drawn over the paintings of the war's aftermath, for people and paintings wanted to smile again'.[99]

In retrospect we can see British realism as a vanishing mediator between austerity and pop, its short life a testament to an historical moment. For a few years the two schools of postwar Europe—socialism and existentialism—vied for dominance (and were sometimes hard to tell apart) before a hip version of the latter won out. When Berger first sounded his calls for tradition the ghosts of the war were still young. But as an American market dream of self-expressive freedom took the place of wartime ideals all of that went the way of ration cards. Instead of struggle, there was neurosis; instead of unity, lone rebels. At every turn Berger wrote ruefully of a 'refusal to connect' he saw in the precincts of culture. The preface to an influential exhibition of American painting spoke volumes: 'John Donne to the contrary, each man is an island'.[100]

Abstract Expressionism was the real turning point. When the exhibition Modern Art in the United States appeared in January of 1956 it was like a *deus-ex-machina*: in the middle of a family argument New York City swooped in from stage left to steal the show. (Donne was again invoked: 'O my America! my new-found land'.) From 1952–56 the aesthetic debates in England had been fiercest *within* figurative painting: Bacon or Bratby, Sylvester or Berger, screaming popes or kitchen sinks. Only with the Tate exhibit did the whole question of figuration turn obsolete. As Sylvester later remembered, the English press (save Berger) was 'well softened up' by then to be disabused of any lingering anti-Americanism. All it took, as he later put it, 'was a straight left from Pollock's

Number One of 1948, a right cross from Rothko's *Number 10* of 1950, and an uppercut from de Kooning's *Woman 1* of 1950–52'.[101]

Sylvester was floored. So were most visitors. For Berger, though, it was sickening: 'slashed, scratched, dribbled-upon, violated', he said of the paintings.[102] While others experienced an erotic knockout punch Berger saw only 'dead subjectivity' and 'suicidal despair'.[103] In exhibition after exhibition he soon had to reckon with what he came to see not only as the demise of social realism but the death of painting as such. 'This is neither a lost nor a betrayed generation,' he said of the Young Contemporaries show, the same annual exhibit that had years prior set him on his way, 'it is one making do with what has been left them after a wholesale robbery.'[104]

By September 1956, at the height of the Suez crisis and only a month before Soviet tanks advanced into Hungary, Berger had reached the end of the line. In an article published that month titled 'Exit and Credo', he announced he would be taking an extended leave from the *New Statesman*. Reviewing artworks had become meaningless if the corresponding context for the work could not be improved. It was no longer a question of 'getting the tones right or the forms sculptural' but of repairing the 'shameful public role' the artist was forced to play in society.[105] No matter what a critic said or published, there would remain the 'essential problem of popular participation in the arts—which is a civil servant's phrase for the electric, mysterious process by which men can help each other to grow'. And this, he concluded, 'can only be altered—though it hasn't always been—by Five-Year Plans'.[106]

In his mid twenties Berger had stormed the British establishment through the sheer force of his intellect and personality. He arrived at the right time for his gifts. It is hard to think of another postwar critic who was as fearless, who struggled as tenaciously, or who brought such moral fervour to bear on the visual arts. Somehow he managed to steamroll through the halls of institutions and the pages of the press while never quite relinquishing his status as an outsider. It all happened

so quickly. But as he wrote, the world around him was also changing just as fast or faster, and the skirmishes he was stepping into were turning out to be proxy wars for something geopolitical in scale. When he was curating *Looking Forward* during the fall of 1952, the United States was testing its first hydrogen bomb. When he announced his leave in 1956, the Soviets had recently tested theirs. And if Berger was a young man who had quickly got in over his head, he was also one of the first and only English critics to sense the shuddering new scale of the postwar world and remain uncowed. The sun was setting on the British Empire. Now on the rise was a brave new world of American power, both hard and soft, and the irony of course is that Berger was caricatured as a propagandist, but it was his enemies who were on the payroll. The CIA was behind the ICA competition; it was behind *Encounter*; it was behind the American exhibition at the Tate.

A five-year plan can also be personal. Berger published sporadically during his year off, including an essay for the newly launched journal *Universities and Left Review*. In this he encouraged a generation of students to write about art, but also warned that criticism on its own should never become a lifelong profession. 'All criticism has in it ... an element of claustrophobia', he said, 'and in the long run this can prove fatal.'[107] What he recommended instead was a 'bout of five or so years ... and the image of a bout is not carelessly chosen'.[108]

Berger's own bout would soon be over. He had fought well, but he had lost. After a year away from the *New Statesman*, he returned for three additional years at the magazine; but when Kingsley Martin stepped aside as editor at the end of 1960, Berger left his post—and England—for good.

2

The Crisis of Commitment

A smooth forehead
Is a sign of insensitivity.

Bertolt Brecht

Renato Guttuso's *Death of a Hero* (1953) depicts a man lying on a spartan cot. His head is wrapped in a bandage and his body covered by a white sheet whose folds are treated in heavy chiaroscuro. The theme and composition of the picture, as well as the foreshortened perspective, all make reference to Mantegna's *Lamentation of Christ*. On the metal bed frame beside the man—the dead hero—hangs a red cloth.

In late 1956, Guttuso's painting was included in a London retrospective of recent Italian art. As Berger had already announced his leave from the *New Statesman*, John Golding, then a graduate student at the Courtauld Institute, reported on the show in his place. Golding praised Guttuso's skill, but spoke regretfully of the unforeseen significance the painting had acquired in light of recent events. 'This was one of the best paintings in the Guttuso exhibition at the Leicester Galleries a couple of years ago', Golding said, 'although it looks rather uncomfortable in its present company, and the treatment of the subject, over-emotional at the best of times in its conventional use of Communist symbols, is at the present moment doubly distasteful.'[1]

A month prior, demonstrators had been fired upon in Budapest. The world watched as workers and students took to the streets. For a week Hungary appeared to be on the cusp

of revolution, until Soviet tanks surrounded and retook the capital. The brutality of the Politburo's response sent shock-waves through the West. Golding had all this in mind. 'One cannot help hoping that a painter of Guttuso's intensity will be led by the events of the last weeks to disentangle himself from the rigid Communist orthodoxy in which his talents are enmeshed.'[2]

Berger could not resist an interjection. His monograph on Guttuso was soon due out in Dresden. The letter he wrote to the editor the following week was meant to disabuse his replacement of any presumption. 'Like nearly every other English critic', Berger said, 'Golding praises Guttuso's talents and regrets the way he uses them':

> He said that the picture of *The Death of a Hero* was 'over-emotional' in its 'conventional use of Communist symbols'. I challenge him: what symbols? Does he count the piece of red drapery? If so, has every communist painter to forswear the colour red in order to escape this charge? And what other symbols? There are none. As for the austere work being over-emotional, if Golding remembered that Guttuso is a Sicilian and that the generally acknowledged fault of most 'official' Communist painting is that it is dull, mechanical and not emotional enough, he might be able to justify his personal opinion more convincingly.[3]

Guttuso's work had 'ignored all Soviet examples', Berger added, and developed independent of party control. And so it was perhaps the painting's fervent sense of purpose, and not its politics, that made it appear 'uncomfortable' in the anaemic company of the others on display—an unintended compliment. 'What enmeshes Guttuso', he remarked, 'is the living history and tragedy of his own country.'

At a politically volatile moment Berger had stuck his neck out. The letter provoked a reply from an acquaintance and rival, Philip Toynbee. Years earlier Toynbee had seen in Berger's writing 'the embryo of Newspeak'; now he saw an opportunity to press the critic at a time of self-questioning on the left:

Mr John Berger thinks it 'ignorantly impertinent' of Mr Golding to hope that Guttuso will leave the Communist Party. We are to take it, then, that Mr Berger is himself undisturbed by recent events in Hungary. But will he, on an ignorant and impertinent invitation from me, be even more precise in publicly defending the party's present analysis of these events? Will he answer the following quite simple questions:

(1) Does he think that it would be reasonably accurate to describe the Russian military forces in Hungary as an army of liberation?
(2) Would he agree that the Kadar regime represents the real will of the Hungarian workers and peasants?
(3) Is it correct to describe the so-called 'Workers' Councils' in Hungary as the agents of fascism, counter-revolution and western imperialism?

It seems important, at times like these, that opinions on events in both Hungary and Egypt should be expressed with the utmost clarity, so that they shall not be obscured by the carefully generated fogs which lie ahead of us. Would Mr Berger please give us as straight answers as he knows how: and it would be a real courtesy if he could avoid using the words 'objective' and 'objectively'.[4]

Toynbee's letter was published on 22 December 1956. By then the initial uncertainty on the left over the events in Hungary was turning into grim acceptance or recoil. Sartre had broken with the PCF; the PCI was split in two; in England, thousands were leaving the CPGB. The *New Statesman*, long seen as sympathetic to Stalin, was having to recalculate.[5] In its letter pages, alongside the exchange on Guttuso, a steady stream of lifelong communists professed shame and horror at the actions in Budapest.

Berger was not one of these. In the following issue his friend John Willett, a scholar and translator of Brecht, responded on his behalf. 'Perhaps blunt, simple questions like Mr Toynbee's could be put to all correspondents conducting discussions in these pages', Willett suggested. 'Does Mr Toynbee believe that critical discussion is impossible without

all concerned making a public exposure of their views "on events both in Hungary and in Egypt"? Or is this a new kind of Christmas quiz?'[6]

But the implication that Toynbee was a McCarthyist bully did not make Berger's reticence any less conspicuous. Many Stalinists outside the USSR (Garaudy in France, Togliatti in Italy) still refused to acknowledge the severity of the Soviet response. The autumn and winter of 1956 were seasons of 'intolerable tensions', as Berger's friend, the historian Eric Hobsbawm, recalled some fifty years later, a time of 'doomed and feverish argument' in which comrades turned against each other in a state of perpetual anxiety.[7]

Three weeks after Toynbee's initial letter—three confusing weeks when the Hungarian and Soviet water polo teams left blood in the water at the Melbourne Olympics, when Elvis dedicated 'Peace in the Valley' to Hungary on the Ed Sullivan show, when Sartre declared that socialism could never be brought by bayonet point—Berger finally broke his silence. 'I do not want to be callous and I respect those who can be moved by the use of their imagination,' he said.

> But the ignorant and irrelevant exhibitionism, that has recently distorted debate after debate amongst the so-called intelligentsia here, is depressing indeed ... I originally wrote about a specific painting and its artist's politics. Now Truth, Christianity, Suez, Budapest and my soul have all been dragged in with as little respect for accuracy as the passage of Golding's that first provoked me into writing ... As for Toynbee, it is easy to see why he finds the word 'objective' discourteous. There is an arguable case to be made against certain aspects of Soviet policy (it has been well argued long since by men ranging from Gomułka to Deutscher), but Toynbee, like all professional anti-Communists, is the victim of an obsession. He merely uses my letter as a pretext for asking three questions, whose trap (Softee, Softee, Catchee Red) is so childish that it is not worth considering as such. Hence, my straight answers are (1) No, (2) No, (3) No. If Toynbee now wants fuller information about my views, I suggest he subscribes to the publications of the Communist parties, to whom my own

political allegiance remains unbroken, and where if I have anything further to say I will say it.[8]

Multiple ironies and a sinking bitterness are entangled here. Berger at once denies support for the Soviet intervention while expressing his allegiance to those parties that condoned it. The statement of loyalty was all the more striking as it came from an independent critic who had always prized his independence, who had in fact *resisted* official membership— and doubly so because it came at a moment when so many of those who *had* joined were themselves leaving. It was as if Berger were rushing headlong into a burning building while everyone else was running the other way.

Beyond the apparent incongruities, though, was a far more upsetting reversal. Berger's entire critical project had been predicated on *opening up* discussion, on following the threads, 'Ariadne-like', as he had put it only months before, connecting art to questions beyond aesthetics. Now his own methods were being used against him. Once accused of dragging politics into art, now he accused his opponents of doing the dragging. Something fundamental had shifted. Though likely seen by his opponents as more of the same, the begrudging, impudent tone of his reply, much like his reluctance and delay in writing at all, speaks volumes. The polemics at the start of the decade had breathed life into his campaigns; the exchange over Guttuso marked his exit from the scene. He was silent in the press for many months afterwards. As he ended his letter by stating: he had nothing left to say.

Identity crises are often produced by double-binds. The individual is attached to something—a relationship, for example, or a belief—that has become an affliction. Either side of an apparent choice is wrong. Their messages negate each other. The result is extreme stress, of course; and yet out of these situations there can also sometimes come a new brokered settlement that could not have been foreseen: the arrival of a third term where only two had been thought possible.

One of those confluences was opened up in 1956, 'a conjuncture, not just a year', according to Stuart Hall.[9] Bounded by the Soviet invasion of Hungary on the one side and the Franco-British invasion of Sinai on the other, 1956 marked 'the break-up of the political Ice Age', the loss of socialist innocence that was also the birth of the New Left.[10] Ambiguity and free discussion were finally admitted into a field more traditionally structured by iron laws.

'You didn't tell me there were any doubts', says the son of a fervently socialist mother in Arnold Wesker's 1958 drama, *Chicken Soup with Barley*. 'All my life', she replies, 'I've worked for a Party that meant glory and freedom and brotherhood. You want me to give it up now?'[11] Many did give it up—some, such as Doris Lessing, famously so. (She later referred to joining the party as 'probably the most neurotic act of my life'.) For Berger, who never officially joined, the collective nervous breakdown on the left—an agglomeration of many individual breakdowns—was unsettling but cleansing.

He had to change. The back-and-forth with Toynbee had been humiliating. He was being whittled down to a one-note cuckoo: *No, No, No*. Of course he had more to say, but what he most needed to get off his chest could never be voiced in the public speech he had had so much practice with. 'If you have to cry', one of Berger's closest teachers and mentors told him when he was just a teenager, 'and sometimes you can't help it, cry afterwards, never during! Remember this. Unless you're with those who love you, only those who love you … if you're with them you can cry during. Otherwise you cry afterwards.'[12]

The scene was reconstructed in a memoir-like collection Berger wrote in his late seventies—one of his last major books, and one of the only ones to venture anywhere near autobiography. In interviews he was never forthcoming about his childhood. He would mention the 'lunatic boarding school' he was shipped off to as a child—the same school where he met a replacement teacher, Ken, a New Zealander, who showed him so much. But the school and its barbarism (as he put it) he would touch on only in passing; it was a time best passed over, sooner forgotten.

In fact the culture of the all-male boarding school explains a lot about left-wing London, as well as Berger's one-foot-in, one-foot-out relation to it. The Victorian-era academy was a place of homo-social (at times homoerotic) affection, whether peer-to-peer or mentor-to-student. But it was also the site of bitter power struggles, sadism, bullying and humiliation, all in the name of cultivating stolid English gentlemen. Practically the entire cast of the 1950s culture wars attended these privileged if brutal institutions: Toynbee had been at Rugby School, Warwickshire; Berger at St Edwards, Oxford; John Willett at Winchester; Patrick Heron at St George's; Lindsay Anderson at Cheltenham; and so on. The ritualistic clash of male egos, the sublimation of aggression into manners, the art of verbal gamesmanship—all this formed an unquestioned social reality for middle-class boys.

For Berger the experience was traumatic. 'I wasn't victimized', he later said, 'but they were crazy places, mad and vicious.'[13] When he was sixteen he ran away. In 1956, now thirty, he ran away again, disappearing from London to stay in rural Gloucester, where his second wife had an estate. What he had written up until that point, bounded as it was by the unspoken rules of English argument, was not all that he was. There was something still far more complex hiding beneath the salvos of the culture pages, something only self-imposed silence could bring out.

London had been the arena in which Berger made his name. In the 1950s the capital could be an exciting place, with public debates and gallery openings, but it was also socially compact, class-ridden, snobbish and clubby. Toynbee, for example, belonged to the Gargoyle Club, an elite, males-only society in SoHo that counted Francis Bacon and Lucian Freud among its members. With the art historian Benedict Nicholson (an Eton graduate and one of Berger's colleagues at the *New Statesman*), Toynbee later started the Wednesday Club, a drinking group. Berger, for his part, convened his own salon-style gathering with the Geneva Club, drawing artists and scholars to a pub above Oxford Circus. However grey it may seem next to the swinging decade to follow (or the capital of cafés and existentialism across the channel),

postwar London could nevertheless boast an astonishing density of talented people—all in one place, all emerging from shell shock together. But the insularity of the city could also quickly turn claustrophobic. Ideological skirmishes operated on a social world of overlapping patrician cliques— a milieu of gossip, feuds, and fallings-out—that often only compounded their ruthlessness.

Berger needed time and space away from the bursts of acidic sarcasm, the curt intransigence, the overall mood of confusion, anger and paranoia. Many writers have spoken of the crisis of Marxist faith collectively experienced during these years. What has been called 'the pain of losing it and the pain of clinging to it' was written all over his articles from 1956, however stiff-lipped or suppressed.[14] And pain, it becomes clear in hindsight, was at the heart of the matter. How to process it in public? How to show vulnerability with so many rivals present? Here was another double-bind, and one that likely sowed the seeds of Berger's eventual expatriation. As he reflected years later, a note of lingering resentment still ringing, the expression of pain was then con-sidered by English definition 'undignified'.[15] The refugees he met from Europe, however, had an alternate hypothesis: that the experience of pain was, in fact, 'at the source of human imagination'.[16]

Cry afterwards, never during, he had learned. Berger left London to metabolize his pain. What came out of that process was a novel.

In the wake of the 1956 Hungarian uprising, a middle-aged Hungarian painter, long-exiled in London, vanishes. Janos Lavin leaves behind him an English wife, a studio of paint-ings, and a journal. That document, the diary Lavin kept from 1952 to 1956, is *A Painter of Our Time*, Berger's first work of fiction. Written on the cusp of his own leave-taking, it remains the charter document—part philosophical meditation, part *roman*-à-*clef*—for his entire subsequent trajectory as a criti-cal and creative writer in exile. It gets down on paper almost all of the circles he would spend a lifetime trying to square.

The novel consists for the most part of Lavin's fictional

diary entries as read and annotated by John, a young art critic bearing all essential similarities to Berger. The entries vary in length and subject. Occasionally they relate dramatic scenes. More often they have other purposes: the day-to-day account of Lavin's artistic progress, stray observations about life in London, reflections on his marriage, memories of an exuberant youth in Berlin. Every so often John interrupts to provide further commentary.

These paratexts, printed in italics, set out the contours of Lavin's biography. A committed socialist, he had studied to be a lawyer in Budapest but turned to painting after fleeing the White Terror. During the twenties and thirties he lived in Berlin, where he moved in avant-garde and revolutionary circles. In 1938, arriving in London from the mainland of Europe, 'where a world war had been fought, the first Socialist revolution achieved and Fascism unleashed', he married Diana, a younger Oxford-educated social worker who saw in Lavin the romance of political experience.[17] From early on we sense the disappointment of the marriage, the emotional as well as financial austerity both have come to endure and, in Diana's case, resent.

Lavin is not a successful painter. He has a small circle of admirers at the art school where he teaches—he is close to John and to George Trent, a 'New Young Realist', and his pictures are appreciated by his working-class neighbours, the Hancocks; but otherwise he works alone and lives in obscurity. Many of John's paratexts reconstruct his own attempts to find Lavin a dealer. The tenor of these scenes—and the patronizing, snobbish attitudes of the gallerists—is high satire. In one lengthy anecdote, John narrates an afternoon he and Lavin spend at the private collection of Sir Gerald Banks, a cartoonish caricature of Sir Kenneth Clark. 'It is the collection of a big game hunter', Lavin says of the paintings hung in the library. 'All these works in your house were alive once. Now they seem dead.'[18]

Naturally, I have changed all the names, John writes in the prologue. The gesture is ironic: readers were meant to see through the disguise of fiction. The score-settling extends well beyond Clark. Like other novels to come out of the

period (notably Lessing's *Golden Notebook*, her own tor-
tured, diary-like farewell to politics), *A Painter of Our Time*
functions as a thinly veiled blind item. The plump, unctu-
ous Marcus Aurelius is an exaggerated send-up of David
Sylvester; George Trent a stand-in for the young, 'northern'
realists Berger had championed; Diana the very essence of the
long-suffering wife who married down (a trope of the Angry
Young Men); John, of course, an alter-ego for the author;
and Lavin, as Berger was later to acknowledge, inspired by
the Hungarian artist and sculptor Peter Peri, whose dry-
point provided the frontispiece to the book's first printing.[19]
It was like a warped looking-glass: the novel was a way to
get outside London (its schoolyard quarrels, its hidebound
polemics) in order to peer back in, only through the periscope
of fiction. Outer voices become inner ones, and a commu-
nity that was once so alive becomes embalmed in the act of
writing. The novel's climactic set piece is thus symbolic: at the
opening night of a fashionable gallery (not as Lavin describes
it but as narrated by John), the ensemble cast convenes for
a last group portrait, and Lavin, with bemused detachment,
wanders out of his own party.

Why the move to fiction? It was a question Berger was to
have put to him decades later. 'If I look back now', he
replied, 'it seems to me that I was always very closely con-
nected to stories. Even when I talked about painting. When
I was an art critic my approach was always that of a story-
teller.'[20] Fair enough. But the reverse was also true: even when
he was telling stories he was often still talking about painting.
 This was certainly the case for *A Painter of Our Time*, the
bulk of which contains insights, both practical and philo-
sophical, about putting colour to canvas. In his often testy
correspondence with Secker and Warburg, the novel's pub-
lisher, Berger wrote that he planned for Lavin to be 'the
mouthpiece' for his own ideas. He spoke of his aim as two-
fold: first, 'to try to clarify what it means to be an artist in the
modern world', and second, 'to attack the falseness of what
amounts to the art racket'.[21] Sections of Lavin's entries cer-
tainly read like Berger's earlier polemics. His canvases borrow

from Guttuso and Léger: they are of swimmers, waves, men at work, and, in Lavin's most ambitious composition, *The Games*, a scene of Olympic athletes. Like Berger, Lavin despises *l'art pour l'art*, believing that art should inspire and aid in the development of a classless society.

The similarities are impossible to miss. Far more nuanced—and revealing—are the freedoms fiction grants. Fiction, unlike polemic, thrives on layers of doubt and ambivalence. Lavin gains a certain autonomy from his author through his own inconclusiveness. In *A Painter of Our Time*, one finds recapitulation, but also self-critique. (There are even moments of triangulated self-parody through Lavin's discussion of John 'always coming in after he has been round the galleries, indignant and furious about what he's seen'.)[22] If Berger's recent criticism had been fulminating, Lavin's journals are tortured and unsure. He is constantly anxious, constantly suffering an 'agony of conscience' that has become part of daily life. His sentences are by turns self-lacerating, self-pitying, self-aggrandizing and self-aware. Aporias that would undermine an argument now elicit imaginative sympathy before the pain of their experience. In one late entry he tallies his credits and debts:[23]

To my credit	Debt
200 paintings	Desertion
A few etchings	Disloyalty
Still being alive	Dependence

The space of a novel allows for such horizontal juxtaposition more than vertical reasoning. The abstractions of rhetoric exist side by side with the telephone bill, the downsized art school, the failed marriage. Everyday observation can ground the intellectual voltage if the metaphors get too precious.[24] Lavin sometimes has a clipped sense of humour. He will commit a mawkish line to paper one evening only to write the following morning that he had too much to drink the night before. 'You play with words', he writes to himself, admitting 'how coldly' his theories strike him when he is outside his studio (the studio like a metaphor for the brain).

'Any talk', he confesses with chagrin, 'soon makes nonsense of monologues.'[25]

Like Berger, Lavin is caught in a network of vexed dichotomies: the gallery and the city, art and Marxism, England and Europe, theory and practice. The status of abstract thought, in particular, was at once a bugbear and a compulsion for Berger. Despite his own propensity for high-flown analysis, the word 'abstract' always carried an air of suspicion, as if to over-theorize were a trap. As for Lavin, it was central to Berger's self-understanding that he *began* as a painter, and only over time embraced the world of ideas. And painting, as Berger so often stressed, is rooted in the experience of sight, in the local and particular, in what is directly in front of you. You cannot draw an idea.

And yet so much of Berger's politics relied on personification: the future, the people, the worker, man.[26] 'Naturally', John writes of Lavin, 'he had his abstract words and, like all of us, he gave them his own intonation ... He spoke of justice as if it were a presence—as you might speak of a girl who had just left the room or town.'[27] But personification as figure of speech is not the same thing as personification as literary device, which Berger was exploring just then to great effect in his own switch from philosophical thought to allegorical fiction. One effect of the novel's hybrid construction is to create a strange, at times ironic mirroring of these two levels.[28] Almost all of the characters in *A Painter of Our Time* are defined by their social position, from which flows their attitude about the purpose of art: the effete connoisseur, the philosopher, the collector, the befuddled shopkeeper. A similar tendency in relation to class belonged to the plays of the period, and belongs today to our contemporary novel-of-identity in relation to race, ethnicity and cultural assimilation. In all of these, heroes are often torn between two worlds, not quite fitting into either. Lavin, like Berger, is neither a pure Marxist nor a pure aesthete. Hence the double-bind; hence the identity crisis; hence the novel.

Within Lavin's own consciousness, however, the impulse to cross the threshold between the personal and the conceptual works very differently. It exists in the private register of

the diary, where discourse becomes a dialogue with the self and, most acutely, with the abiding ghosts of memory. 'The past can be described in two separate ways', observed Fredric Jameson in relation to Sartre's *Huis Clos*. 'It is that which can no longer be changed, which has passed out of reach, still felt as ourselves but fixed forever; and yet at the same time it is constantly subject to change and renewal at our hands: its meaning is as fluid as our freedom and every new thing we do threatens to revalue it from top to bottom.'[29] The re-evaluations Lavin pursues relate most powerfully to his own life choices—the decision to go west instead of east, to pursue painting over law—which he compares to those of his friends who, in his journals, become internalized imagos by which he can measure his own success and failure.

The most important of those living absences is Laszlo, a poet who was once Lavin's best friend but who strayed when he chose politics over art. 'Laszlo developed—or perhaps changed—far more dramatically than I did', Lavin writes. 'He became very sober. Speculation was no longer free.'[30] The pathos of lost friendship hangs over the novel, as do shadows of guilt. Lavin remembers Laszlo as forbidding 'because he was so obviously hard on himself', and in turn introjects that self-judgment, seeing his own life and work with his friend's severity. But when he reads a speech by his old friend he balks at the heavy Communist jargon, the 'centralized, organizational words'. He cannot fathom Laszlo's current life, an incomprehension deepened when, partway through 1952, he learns of his friend's execution for treason at the hands of the Hungarian Communist Party. The news is shocking. It prompts a series of extended ruminations on the vagaries of fate and the painful choices that faced their generation—a generation, he writes, 'of unfinished stories'.

The debates with the hardliner imagos of Lavin's conscience go on for pages. While his in-person confrontations with the aesthetes are clarifying, the friction he imagines with Laszlo strikes a much deeper, more conflicted chord. The heart of the novel turns in a labyrinth of theoretical mirrors, where sophistry becomes truth and then reverts. 'Now I hear my old teachers arguing. And the class struggle? And our Marxist

understanding of the connexion between the superstructure of art and the economic base? Comrade Lavin, they ask, Have you accepted the comfortable illusions of the bourgeoisie with whom you have surrounded yourself?'[31] Whereas Laszlo shouldered heavy responsibilities, renouncing art for struggle, Lavin feels he is indebted for his frictionless existence. The German word for debt, *Schuld*, is also the word for guilt. But how to assuage one's conscience in a studio?

What these lengthy ruminations demonstrate is the extent to which the true contradictions for Berger, beneath the storms of the cultural Cold War, were internal rather than external. The more significant and harrowing tug-of-war was not between socialist and formalist criticism, but between the divergent logics of art and politics as such. Sartre had spoken of writing as an act in the world, an offering with consequences. But how to read backwards from that formulation to any actual aesthetic criteria, and how to encourage moral art without imposing artificial inhibitions, were far less clear.

Of course, the whole question of leftist aesthetics has a long and contested history. Engels famously preferred Balzac to Zola, and in his letters defended the integrity of the artist. Lenin, on the other hand, argued for the subordination of the artist to the Party, calling for art to become 'a small cog and a small screw' in a larger apparatus. The two poles have played themselves out in countless debates, and continue to play themselves out in contemporary discussions over free speech and political correctness.[32]

For Berger this dilemma was not going to lead to a firing squad, but it could nonetheless feel like a matter of survival. Political commitment was at the root of his identity and fed into real-life decisions he made under immense and very real pressures. Much as Lavin was left with questions about Laszlo, we are left with questions about Berger. Why did he never join the Communist Party? He always refused their solicitations (which were at times quite aggressive), but he spoke at their events and published in their journals. It was almost a kind of *passing*.

Berger wrote *A Painter of Our Time* when he was barely

thirty, but it does not feel like a young man's novel. The Cold War had aged him: from enthusiasm to fame to crushing disappointment in only five years. Berger once said that, when he would visit the art historian Frederick Antal (a Marxist mentor and another Hungarian), he would feel 'like a messenger reporting to a general'.[33] And yet in less combative contexts he spoke of the 'immensely complicated relationship between art and politics' that was still little understood.[34] If his advocacy for politicized art was militant, his comprehension of how politics could be manifest in the work of any given artist was much more nuanced, acknowledging that 'Marxist analyses of art have often over-simplified to absurdity'.[35] He praised the sensuality of artists such as Matisse and Bonnard. In noisier rooms, of course, he spoke with the assured intonations of a missionary.

The more protective you are with your ideals, the less likely they are to be stolen from you; but if you are too protective you become a hypocrite. This paradox—and paradox as such—was the great repressed in Berger's intellectual system. Outwardly he refused to acknowledge it; inwardly it was likely the furnace that kept him going. 'There have been dichotomies all along between his longing for a systematic statement of values, a law, and the anarchic impulses of his heart', wrote Andrew Forge, one of Berger's best contemporary critics: 'He has never quite been able to iron out the stress between how he would like to account for all works of art and how these works, individually, make him feel. No doubt a fellow Marxist would tell him that he is still compromised by bourgeois subjectivity—but the fact is that if this internal stress were not reflected in his writing it would be unreadable.'[36]

It was not Berger's steadiness that made him so admirable and interesting to follow, Forge pointed out, but rather his *struggle* for that steadiness. Likewise, faith is often nothing but the longing to possess faith. If it were easy, it would not be worth the effort. And so—like most religious texts—*A Painter of Our Time* is at once a confession of doubt and a *profession de foi*. At the heart of the novel, the long entries move between the twin terms of art and action, trying again

and again to sublate the contradictions, to enter a higher plane of truth.[37] 'You think and talk all the time about the artist', Lavin writes to himself. 'What of the people, the working class, whom he should serve? I believe in the greatest potentiality of their talent and understanding. But I cannot serve like a waiter.'[38] In one of the boldest passages, he offers a kind of catechism:

> There are three ways in which an artist can fight for what he believes:
>
> (1) With a gun or stone ...
> (2) By putting his skill at the service of the immediate propagandists ...
> (3) By producing works entirely of his own volition ... in which the no-less-strong force he works under is his own inner tension.[39]

Lavin is committed not only to the third option, but to a world where the premises behind the third option hold ground, where his own inner tension will reveal some further imaginative extension by which a truer purpose will be discerned. It is as if the philosophy of art Berger sets out allows for contradiction in the present, but sees imaginative and political commitment as the parallel tracks of a railway converging at the horizon.

Liberal critics would no doubt call this a mirage. Neither Berger nor Lavin can prove it to be otherwise. But what is the alternative? To become a connoisseur? To give up politics for art? To resort to political violence? More likely it is to acquiesce to irony. Lavin's old friend Max embodies this last attitude. A lapsed radical, now a dandy and charmer who has turned his exile into an affectation, he is the negative image of Laszlo and, as Lavin writes, 'the other side of my coin'. 'Nothing can ever be like Berlin was. Nobody can ever appreciate him as he was appreciated then. And so everything that happens now is absurd, and he performs with one hand in his pocket.'[40] Max performs rather than expresses; he seduces rather than believes; he has given up.

Not to give up is, for Lavin, *to work*. This is the abiding

note the novel strikes again and again, page after page. Work as the only real solution—however temporary or slight—to the pain of contradiction: the only alternative to words, to thought, to self-consciousness. Lavin begins his journal precisely to 'guard time more jealously', so as to work harder, and what we read is above all else a record of exertion: 'Janos said to me once, "This working, it is always the same. At nine o'clock in the morning you are full of plans and ability and the truth. At four o'clock in the afternoon you are a failure".'[41] These are the best quotations from the novel—the ones worth fixing above your writing desk or in your studio: 'To be free of this slave-driving necessity to work. Is that why I strive to finish—in the illusory hope that it will be the end; that after this canvas I will lie in the sun and be blind for a week?'[42] Never before had a novel captured so forthrightly the phenomenology of sustained creative labour: the fragile yet compulsive nature of routine, the hour-to-hour exhaustion and exhilaration, the way one's every concern can suddenly condense around the details of a brushstroke or passage. The closest cousins of these pages are not the fanciful biographies of great men but the actual notebooks of real-life painters, great or not.

'Separate the idea of fire from the fact of fuel', Berger wrote in 1957 (while at work on his novel), 'and you are left with a miracle.'[43] The occasion was Vincente Minelli's biopic *Lust for Life*. Everyone interested in art should see the movie, he said, in order to better appreciate the kind of mythic superstitions bred by the suppression of work from the mystery of creation. Van Gogh was at the centre of the myth: he was the patron saint of the religion of art but also, for Berger, the most misunderstood artist of the nineteenth century. What Berger hated in *Lust for Life* was its glorification of madness: illness as inspiration, disturbance as genius. There are countless crazy people whose art is bad. Everyone knows Van Gogh cut off his ear; what is less known is his almost Christ-like devotion to the day-in, day-out toil of painting, or that the 'moanings and rantings and madcap schemes', as Julian Barnes memorably put it, may have only been 'background noises to a process of artistic heroism, of determination in the

face of discouragement—determination, indeed, in the face
of his own character. Art is a matter of daily, hourly grind.
At the same time, that grind is complicated and layered, a
mixture of hard practicality and intense dreaminess.'[44] That
mixture is Lavin's—and Berger's, too.

A longside the antinomies of faith and doubt, work and
thought, the novel proposes a final question, almost
hidden to itself, which it cannot fully answer. Can we ever
truly know another person? Do our closest friends reveal
themselves to us, or do they remain forever hidden?

Lavin's uncertainty before Laszlo parallels John's uncer-
tainty before Lavin. The journal we read, as a record of
self-consciousness, is a testament to how little any of its
author's inner circle really knew of his private thoughts or
demons. The difference between politics, understood as col-
lective struggle, and art, understood as individual struggle,
gives onto the difference between the social and the psycho-
logical. The entire progression of the European novel from
nineteenth-century realism to the psychological novel and
then the novel of consciousness can be seen, as several critics
have argued, as a similar movement away from social reality
towards the autonomy of individual psychology and sensa-
tion. There is a similar case to be made for the movement
of the artistic medium away from world-reference to self-
reference. Lavin is a committed social realist, but his diary,
and by extension the novel that frames it, is a work of mod-
ernism, possibly even expressionism. It is a document of
alienated urban self-consciousness.

The alienation of the self—from the world, from others,
from history—is a phenomenon *A Painter of Our Time*
figures as exile. 'I have made myself doubly an émigré', Lavin
writes. 'I have not returned to our country. And I have chosen
to spend my life on my art, instead of immediate objectives.
Thus I am a spectator watching what I might have partici-
pated in. Thus I question endlessly.'[45] Lavin is trapped in the
personal; he cannot experience, which is to say participate
in, the political. 'I need to see myself again', the first entry
reads. 'In the past I recognized myself in the critical events in

which I took part. But now for ten years in this secluded and fortunate country my life has been eventless.'[46] To recognize the self in what is beyond the self—this is the model of personhood *A Painter of Our Time* proposes. It is also Berger's model for the health and purpose of art. Art derives its power when it is most organically rooted in historical processes that exceed, and by so doing encourage, its own development. The same is true, the analogy goes, for an individual's human potential.

On the one hand, we are each separated by our individual life experiences—and not all experiences are commensurate.[47] Diana, unlike Lavin, 'had never been hungry. She had never been interrogated. She had never been smuggled over a frontier.'[48] The same disparity applies to John. When he drunkenly makes a toast—'To Budapest!'—Lavin 'just perceptibly' shakes his head. The meaning of that gesture, we are to presume, derives from everything that separated the two men. In his essay on Peter Peri, written after the artist's death, Berger makes the same point even more strongly: 'He considered that our experience was inadequate. We had not been in Budapest at the time of the Soviet Revolution. We had not seen how Bela Kun had been—perhaps unnecessarily—defeated. We had not been in Berlin in 1920. We did not understand how the possibility of a revolution in Germany had been betrayed. We had not witnessed the creeping advance and then the terrifying triumph of Nazism. We did not even know what it was like for an artist to have to abandon the work of the first thirty years of his life. Perhaps some of us might have been able to imagine all this, but in this field Peri did not believe in imagination.'[49]

On the other hand, the novel suggests that art, when it does work, can reduce if not surmount that gap, precisely through the tactful acknowledgment of its existence. In the autumn of 1953, Lavin makes a portrait of John. For a series of afternoons the two men sit in silence as the older draws the younger: a profound and private act of masculine tenderness. When it is finished, Lavin offers the drawing to his friend as an act of generosity and disclosure—as a *gift*. 'It represents a modern man thinking', he writes in his diary. For John it

becomes a 'source of great encouragement' when beset by doubt, a memento he keeps above his desk as he works on the book we are reading.[50]

'All that interests me about my past life are the common moments,' Berger said the year he turned sixty.[51] And yet *A Painter of Our Time*, his first novel, emerged out of the contradictions brought about by the absence of that possibility and the continued hope for it. Hence the ambiguity of its climactic act: Lavin's sudden decision, in the wake of the Hungarian uprising, to leave England.

Both unexplained and overdetermined, the disappearance is at once a social suicide and, as we are led to believe (Lavin was last seen in Vienna heading eastward), a return to nativity and the province of historical participation. 'It is the paradox of our generation', Raymond Williams wrote at the time, 'that we call for community and yet praise the escape from it, call for the feelings that unite yet find that unity only in the common desire to get away.'[52] The usual Victorian novel ends, he pointed out, with a series of stabilizing settlements, while the modern novel ends with just the opposite: a man going away on his own, 'having extricated himself from a dominating situation, and found himself in so doing'.[53]

Such a description applies both exactly and strangely to *A Painter of Our Time*. Lavin's departure is a real breaking-away, but also a hypothetical reintegration, the ambiguity a finely wrought surrogate for very real political confusions. Berger began his novel just after the first spring meetings of the Pétofi circle in 1956, and finished it only months before the execution of Nagy in 1958. Lavin's presumed involvement in Hungarian politics remains uncertain. The journal is as much a frame around his disappearance as vice-versa, but one does not explain the other. Each character has their own theory as to Lavin's fate, each reflecting their own philosophical needs. Diana supposes he was shot; George Trent is convinced he became a freedom fighter; Max believes he fled because he could not face commercial success in the West; John would like to believe that Lavin is now with

Kadar. Lavin meant different things to different people. The journal, if anything, is an explanation of what he meant to himself.

A Painter of Our Time rests on the dividing line of 1956. Lavin's entries belong to the years just beforehand, while John's italicized interpolations look back over that divide. The journal records the deaths of Stalin, Léger, De Staël and Laszlo—the personification of a generation's socialist ideals. The formative experiences of that generation had been war, revolution, counter-revolution, fascism, a second war, and resistance. The political terrain of the fifties in England was more opaque. 'There aren't any good, brave causes left', Jimmy Porter famously announced in a play that belonged as much to the moment as Suez or Hungary.

And yet, for western Marxists, the crisis of postwar faith was both painful and cleansing. It led to disillusion for some, but for many it led to clearer-eyed reaffirmation. Seen in hindsight, the seeds of 1968 took root in the months and years immediately following 1956. Out of the first new left came the second. And if Berger was (whether naively or dishonestly) on the wrong side of history the first time around, he would atone for his wrong in 1968, when he travelled to Prague in the spring of that mythical year to write of the Czech student resistance. If he had once felt he had to bite his tongue, he was free by then to write what he should have earlier: 'The Russians have been able to create by force a reality to confirm their lies.'[54]

At the time of its publication, however, *A Painter of Our Time* was still read in the harsh light of the initial crisis to which it was a response. Tens of thousands of Hungarians had been arrested; ultimately hundreds of thousands fled. Nagy had just been executed. In one review, 'Mixing Politics with Paint', Stephen Spender (a former communist and contributor to *The God that Failed*) singled out the sentence where 'John' implicitly throws in his support for Kadar—a line that was too much for him to stomach. Lavin, he wrote, was a 'killer … an advocate of judicial murder', and Berger was reminiscent of the young Joseph Goebbels, author of

Michael.[55] Both books, Spender said, called to mind 'the smell of shootings and prison camps'. ('The whiff of the concentration camp is there all right', wrote Arnold Kettle in *Labour Monthly* some months later. 'In what serious novel of the Europe of our time could it be absent?')[56]

In a review published in *Encounter*, the Hungarian refugee Paul Ignotus was not as hostile. Ignotus recognized the authenticity of Lavin. 'The type thus represented is real. I knew him well, and in many places: according to changing opportunities offered by changing governments, in Berlin's Romanisches Café, in Vienna's Museum Kaffee, in the Café Dôme in Paris, and possibly even in London where Mr. Berger encountered him or his shadow.'[57] But if the novel's politics 'ought not to be taken too seriously', they were 'expressed too obtrusively to be ignored'. Ignotus saw in Berger, conscious or otherwise, an apologist for state terrorism. '"My politics is a lightning conductor", Janos Lavin writes. Millions may perish but he wants his lightning to be conducted.'[58]

Shortly after its publication the novel was remaindered. Berger later suggested that, because of Spender's review and Secker and Warburg's connection to *Encounter*—itself an organ of American cultural policy—his first novel became a 'dead letter' almost overnight. His version of events may be an exaggeration, but even personal myths contain kernels of truth. The reasons for the book's short life were commercial as well as political, but the two can work together, and together they were nudged along by a cultural agenda that probably saw no place for a heartfelt socialist on a publication roster. *A Painter of Our Time*, like Lavin at its centre, was thus fated to disappear, falling victim to the very polarizations it was wrestling to escape. And though immediate reviewers painted the novel as dogmatic, contemporary readers are more likely to sense its maturity, in both its sorrow and its hope. To metabolize is to change so as to live. From the experience of pain came a novel, and from that novel Berger was able to set some part of himself free.

Meanwhile, *A Painter of Our Time* has had a second and third life. In the mid 1960s Penguin acquired the rights for a reprinting; in the 1990s Random House released an edition

with a special afterword; more recently Verso followed suit. The novel continues to find new readers. It looks back on a time that is not our own, yet the paradoxes it circles around have stayed with us. The book endures as one of the most deeply felt explorations of commitment in a cynical age devoid —whether rightly or wrongly—of heroes.

3

Art and Revolution

The work of art holds our creative powers in a crystalline suspension from which they can again be transformed into living energies.

Max Raphael

Every second of time was the strait gate through which the Messiah may enter.

Walter Benjamin

What makes a revolution? And what follows in its wake once one has been made? These are questions that may strike the contemporary Western reader as nostalgic. They are redolent of a past age, before history was said to have ended, and entered overtime. We continue to speak of revolutions in business, in style and technology; but rarely in politics does it mean what it used to mean. Or, for that matter, in art. It has become easier for us to imagine a disaster so vast as to make the planet uninhabitable than to see far beyond the capitalist world order that everywhere surrounds us. Only after some great cataclysm will we be able to press the reset button and start afresh. This is the latent utopian content of so many summer blockbusters.

But to go only two generations back is to inhabit a different world with a different conception of the future, a different sense of the possible. The crucial dates for the European left—1789, 1848, 1871, 1917, 1968—attest to a radical lineage in which revolution occupied a central and recurring position

in its psyche. History was shown again and again to be a living, writhing force. Popular energies would erupt, lose control, be put down, re-emerge, and be put down again only to reappear, often spectacularly. This was the stop-and-start of the long nineteenth century. And in those revolutionary moments—windows of mass disruption and seemingly irrevocable historical change—the political vanguard can be said to have been *living the dream*, convinced in the moment that a second coming was near at hand.

For Berger, who began not as a dreamer of the maelstrom but a campaigner for tradition, the very concept of the total transformation, sudden and exhilarating, was something he came to only later, after his hopes for postwar unity had dissolved. His early taste of political disappointment was in this sense unusual. It was not that the revolution of his youth had gone wrong or failed to come, but that the revolutions that *did* come, whether cultural (from America) or political (in the Eastern bloc), were of the wrong kind, from the wrong quarters. Meanwhile, the artistic New Deal he tried to encourage, as if brick-by-brick, was buckling under the weight of its own ambition. Like a rising tide, middle-class prosperity brought with it a host of new attitudes and aspirations: so-called 'ad-mass' culture, 'never had it so good' Macmillanism, the Americanized cult of cool. The year 1956 saw, in the United Kingdom, the birth of Pop Art as a practice, cultural studies as a method, and the 'Angry Young Men' as a generational signifier. By the following year two myths had given way: the myth of the Soviet Union and the myth of 'the people'.[1] In January a donnish Kingsley Amis could complain of a whole generation of young men 'shopping' for causes to believe in—only to find the larder empty; while in a more can-do mood Anthony Crossland urged the Labour Party to shed its dreary populism and get in step with a jumpin'-and-jivin' new England.[2] It was only three years before the Beatles started playing clubs in Liverpool.

Having staked his sense of self to larger historical forces more imagined than real, Berger had to confront defeat. 'In the end we must await new men for a new integration of the arts', he said in 1956, 'and in the meanwhile we can only

struggle to improve the separate component parts.'[3] With the perspective of a few years, he could analyse his failure. He had misunderstood, as he put it, 'the contemporary, social role of the visual arts in Western Europe', mistakenly believing that painting and sculpture 'could develop in as broad a way as the other arts'.[4] As new technologies (radio, cinema, television) usurped the role of popular communication, the visual artist was left entirely dependent on the bourgeoisie. 'Consequently', he said, 'we socialist realist critics were wrong to demand or expect artists to produce direct, urgent social comment. This was to imprison them in the most frustrating contradiction. They became disillusioned either with their medium or with their content.'[5]

But what remains of our hopes, Berger also said, is a long despair that will engender them again. Sometimes it is not so long.

Out of the crisis of 1956 came a period of self-examination and renewal that went by the name of the New Left, and then, following on its heels, the cultural big bang more widely known as 'the sixties'. The explosive rearrangement, first within English Marxism and then as part of a globalized mood of rebellion, meant that Berger was free to reinvent himself. A new marriage to the Russian-born translator Anna Bostock and his more or less concurrent departure from England signalled a rebirth: this was the beginning of his prolific, peripatetic middle period. As he wrote in a 1962 poem published in *Labour Monthly*, less than a year into exile:

> Men go backwards or forwards
> There are two directions
> But not two sides.

For Berger, forwards meant the continent, and it meant a new kind of writing. It meant living out as an artist the possible syntheses he had only glimpsed as a critic.

Though based in a suburb of Geneva, he spent much of the decade on the road. And as the generation of '68 spread its wings his work similarly broke free of all established models. He produced an awe-inspiring array of forms: photo-texts,

broadcasts, novels, documentaries, feature films, essays. It was a sensual yet heady decade-and-a-half. Riding from museum to museum on his motorbike, staying with friends in country homes, painting landscapes in open fields, making pilgrimages to altarpieces and monuments, seeking out the buried manuscripts of the interwar left, speaking at marches and teach-ins: all this went into his new identity as a European— rather than English—writer. If Berger first made his name in the polemical blood sport of London, the figure that emerged as the New Left rose to a crescendo was a theorist in transit, a critic writing back to his homeland. A total transformation indeed.

The late fifties were an exit ramp. After his leave from journalism, his time spent away from London, the publication of his first novel, the dissolution of his second marriage, the collapse of his social realist project—after all this, Berger returned to the *New Statesman* for three final years. From 1958 to 1960 he once again contributed articles on exhibitions, but his focus had changed profoundly. Any interest in contemporary art shrank to the point of dismissal or indifference. A review of the 1958 Venice Biennale was titled, succinctly, 'The Banale'.[6] The only serious attention he gave to a postwar painter, other than to a couple of friends, was to Jackson Pollock. But even here there was a new outlook. Pollock had recently died in a car crash, and Berger no longer protested against the 'hard sell' of New York modernism. In an essay still widely read, he argued instead that Pollock's immense talent (which he had come to admit) could only reveal itself *negatively*—in vivid testaments to its own waste, graffiti on the prison walls of a jettisoned mind. 'Having the ability to speak', Berger wrote, 'he acted dumb.'[7]

Pollock's failure, he concluded, stemmed from an inability to 'think beyond or question' the cultural situation to which he belonged. As if heeding his own cautions, Berger's writing grew in historicity and scope. Of course there had always been, interspersed with the polemics, studies of masters: Courbet, Goya, Kokoschka, Chagall. But he now studied the art of the past with a more synoptic lens. He asked larger

questions. What can painting tell us about the development of human consciousness? How might our senses be coloured by civilizational belief? What place do artists occupy alongside thinkers from other fields? He wrote of Velazquez in relation to Galileo, Poussin in relation to Descartes, and Picasso in relation to Heisenberg. When he appeared on Huw Wheldon's *Monitor*, he spoke of four Bellinis separated by the revolutions of Copernicus and Vasco de Gama. The parallels were of course more evocative than rigorous—he was aware of the pitfalls that came from treating art as merely an adjunct to the history of ideas (a criticism often levelled at the iconographic school of Erwin Panofsky); but he held firm to the fundamental premise. 'One must remember that neither scientific nor artistic developments are independent', he reminded his readers. 'The questions that scientists and artists put to themselves have been created by the same history.'[8] (It was an insight, itself historical, that seemed to be self-consciously borne out, as thinkers as dissimilar as Thomas Kuhn and Michel Foucault concurrently arrived at their own versions of constructivism.) All fields both condition and are conditioned by the ideological possibilities of their time. Or, as Heinrich Wölfflin, the godfather of modern art history, put it some fifty years earlier: 'People have at all times seen what they want to see'. 'Vision itself has a history', he proclaimed. And the 'revelation of these visual strata' was the primary task of the scholar.[9]

The two primal scenes for Berger (not a professional scholar but a critic and writer) were the Renaissance and modernism. As philosophical revolutions, each stood comparison with the other, but the second, more recent lineage deserved special attention. And with good reason: for years it had been off-limits, the visual equivalent of *samizdat*. But as the fog of the Cold War lifted Berger could see further afield. Soon he was transfixed.

The pictures that so engrossed him were by painters now familiar to all of us: Manet, Monet, Degas, Cézanne, Gauguin, Van Gogh, Matisse, Picasso. Much of it made in Montparnasse, the canon of French modernism become his own Mount Parnassus: a massif to be visited and to lose oneself in. 'It was

like being roped together on a mountain,' Braque said of his time with Picasso—a metaphor Berger loved.[10]

At the summit was cubism. Berger viewed the paintings Picasso, Braque and others made on the eve of World War I to be a seminal break in Western Art. In itself the idea was nothing new—all art historians view cubism as a threshold; but what he said of the movement deviated wildly from art-historical convention, in both shape and method. Cubism was not extended by abstraction, Berger said, but betrayed by it. Even as its *stylistic* legacy was ubiquitous, discernible in everything from office buildings to coasters, the *revolutionary promise* of the work remained frozen in historical amber. Could there be a prelapsarian modernism? A modernism before the fall? As he pursued such questions, Berger let go of his identity as a crusader (the Holy War was over) to refashion himself as an art-historical *searcher*: a reconnaissance pilot flying above a lost geography of promise. And yet the missionary zeal of his early campaigns never entirely left him—it simply changed forms. No longer championing the coming art of the future, he now championed what was lost but revolutionary in the art of the past.

Even the most radical ideas to appear in adulthood can often be seen, in retrospect, to have their origins far earlier in our lives.

In fact Berger had long been drawn to cubism. He had simply been unable to make sense of his affinities. At twenty-five, for example, in a review of a travelling exhibit organized by the Congress for Cultural Freedom, Twentieth Century Masterpieces, Berger declared that the only work truly deserving of the title was that of the original cubists. 'To go from Cézanne's 1900 still-life of a skull to Picasso's portrait of William Uhde is a profoundly moving experience', he wrote; and he praised the Juan Gris painting, *The Sideboard*, as his favourite of the show. It was a picture, he said, 'so downright' in its construction that 'one feels it was made on a bench rather than painted'.[11]

None of this was very analytical. Berger was simply giving voice to personal impressions that, within a year or two, no

longer fitted within the Cold War freezer. Any doubts about the wholesale rejection of modernism by the party had to be kept to himself. The silence lasted years. Only in 1956 could his reservations break to the surface. In the summer of that year, on the eve of the New Left, Berger expressed his own misgivings, speaking of 'The Necessity of Uncertainty'— the title of an article he wrote for the party journal, *Marxist Quarterly*, in which he urged a militant readership to question their knee-jerk dismissals. Uncertainty, he argued, need not always be a sign of weakness. At the right moment it could be a tool for transformation.

The article began by tallying a syllabus of errors: the 'muddle' over Picasso's Stalin portrait, the eventual alienation of Léger from the French Communist Party, the failure of the CPGB to recruit the growing number of young working-class artists to its ranks, and the needless inhibition and destruction of talent by Soviet bureaucracy. Behind all these frustrations was a more fundamental confusion: What makes a work of art socialist? Here, Berger argued, Marxist critics had all too often simplified their answer to the question. He called on the party to make 'a more precise distinction between effective but probably ephemeral propaganda, and the artist's right in our present uncertainty to conduct his own experiments in what he believes to be his more permanent works'.[12] It was a matter of patience and trust. 'We must stop expecting quick results from art', he said. 'And this means believing in the artist.'[13]

At root the problem derived from an oversimplified dichotomy between form and content. 'If an artist is painting a chair', Berger pointed out, 'he does not automatically make it a Socialist painting by placing a copy of the *Daily Worker* upon it.'[14] Correspondingly, if an artist is experimenting with form, that does not automatically make him a formalist.

Taking this insight to his comrades, he tried to tell a different story. The traditional narrative of nineteenth-century modernism follows the rise of the avant-garde away from mimesis towards an aesthetic of subjectivity, abstraction and pure sensation. Both liberals and Marxists shared this view; what they disagreed over was whether it was good or bad.

Berger presented an alternate picture. The great painters of modernism, he wrote,

> were all in their various ways aware of the feebleness and corruption of bourgeois art and values, and they all sensed that the twentieth century would produce a new type of man whom they wished to welcome even though they did not necessarily understand him. They knew that they lived on the eve of a revolution, and they considered themselves revolutionaries. But because they did not understand the social and political nature of this revolution, they put all their revolutionary fervour into their art considered as art. Because they did not see how to make a revolution in the streets they made one on their canvases.[15]

Even as their work did little to bring about social change, their *discoveries*, technical as well as philosophical, could still be of tremendous use. Their extremism, in this sense, was constructive rather than despairing. The same could not be said of postwar painting. Behind the early modern masters was a fervour desperate to imagine a new future; behind the contemporary avant-garde was 'the desperation of despair'.

The key distinction Berger made—or, rather, was beginning to shade in—was between *affirmative* and *negative* modernism. It sounds simple enough, but the first step towards any recognition is often painfully simple. At the time it verged on heresy. The following issue of *Marxist Quarterly* featured two long rebuttals. Ray Watkinson, a party illustrator, expressed shock at what he saw as his friend's about-face. Berger's reappraisal, he said, 'means what he of all our critics surely does not believe—that art is a substitute for life, a compensation for frustration in the real world. Add a few more names to the list and the absurdity grows. How much Pissarro, the noble-minded old anarchist, would have despised the thought: Signac, too, and Käthe Kollwitz and Courbet. And no less, the others who were in the opposite political camp. Imagine Cézanne's rage when offered this gem of thought! Imagine, too, Cézanne on the barricades!'[16]

Another letter from an anonymous source was less hysterical but just as contemptuous. 'The root and core of the struggle is in the factories', this writer reminded everyone.[17] Why confer upon the artist a special privilege denied the militant worker?

Reports of the essay even reached Moscow. An article by the party-line professor Vladimir Ivasheva, published in the journal *Oktiabr*, labelled Berger a revisionist and 'obsequious apologist of Modernism'.[18] The Soviet critic also made a point of scolding the more devout Marxists in England for demonstrating 'an unnecessary, and at times incomprehensible politeness and restraint' in the face of Berger's ideas. By asking otherwise loyal adherents to assimilate 'the Modernists' on the grounds that 'the obscurity which characterizes their work is one of form only, not of content', Berger had outed himself as a closet aesthete, corrupted by a 'secret longing for his beloved "pure art"'.[19]

However stupid, the attack from Moscow went to show how little clean air there was to breathe. When a translation appeared in England, it added to the confusion: Berger even received phone calls from the staff of *Encounter* ready to welcome his presumed 'conversion' to the camp of anti-communism. (He snubbed the invitations and wrote a letter to *Oktaibr* reminding them of his credentials.) But what the backlash demonstrates so self-evidently is how, given the terms of the period's debate, Berger's essay *was* confusing. Modern Art was simply off-limits for a Marxist. For the foremost realist critic in England to speak favourably of its experiments was to flummox both sides of an entrenched divide. It was to touch a taboo.

'To accept an orthodoxy', observed George Orwell in the 1940s, 'is always to inherit unresolved contradictions.'[20] And to challenge an orthodoxy, as Orwell knew well, is often to go it alone. Berger's ideas made no one happy (including him: it was around this time that he took his leave from the *New Statesman* to lick his wounds). But what if the diametric opposition between realism and modernism had been overdone? Or at least oversimplified? 'True originality', Berger later wrote, 'is never something sought after or, as it were,

signed; rather it is a quality belonging to something touched in the dark and brought back as a tentative question.'[21]

The debate in *Marxist Quarterly* thus bears witness to a critical opening in Berger's thought. By the time a second article appeared, some months after his initial essay and the controversy it provoked, he had already gained a manifest confidence in his intuitions. He could at least articulate the questions:

> At exactly what stage did each of the modern move-ments—cubism, expressionism, surrealism—betray their revolutionary origins? And was such a betrayal implicit in their origins, or not? We do not yet know. We can see how bourgeois and imperialist outlooks limit and destroy an art-ist's vision; we can see the destructive tendencies. But we cannot yet see, and therefore must remain uncertain, about which tendencies are going to lead to the greatest contribution ... *Were the early modern masters aware of the corruption of bourgeois values, and did they sense that the twentieth century would produce a new type of man?* Many quotations could support that most of them were and did. Certainly they were revolutionaries because they were original *painters*. But why was so much originality necessary then? And would that originality have been so extreme had the social revolution been achieved?[22]

Those questions—and that originality—mark the terrain Berger set about exploring over the following decade. He started drawing a map.

The New Left was a game changer. The air cleared. The kind of synthetic thinking Berger was already individu-ally moving towards became possible on a large scale. Neither Stalinist nor capitalist, new journals such as *Universities and Left Review* rejected the stale dynamic of binarism. Out of the age of 'declining political orthodoxies' they called instead for the 'regeneration of the whole tradition of free, open, crit-ical debate'.[23] What was once so hard for Marxists to think or see or say became easier.

One of the first things Berger wrote on returning to the *New Statesman* signalled the true start to his project. 'The Star of Cubism' appeared (fittingly) in spring, occasioned by a Juan Gris retrospective at the Marlborough Galleries. Already many of the political ideas he would later develop are present, and it is telling in this respect that the review begins with quotes from Marx and Gramsci. If in the party press Berger had first to liberate art from the clenched grip of ideology, here his movement was the reverse: to free the artwork from the impressive taint of commercialism. Commodification was regrettable but inevitable. 'Even the highest intellectual productions', Marx wrote, 'are only recognized and accepted by the bourgeois because they are presented as direct products of material wealth and wrongly shown to be such.'[24] The dazzling cash value of the paintings, in other words, need not blind us to the humanistic significance of the art. Berger then turned to Gramsci to clear the ground for his coming assertions: 'Is humanity, as a reality and an idea, a point of departure or a point of arrival?'[25]

The point of departure for Berger was the work of Gris who, he says, was 'as near to a scientist as any modern painter'.[26] Disciple rather than innovator, the Spanish artist worked from a formula derived from the discoveries of Picasso and Braque, and so became, in Berger's words, 'the purest and most apt of all the Cubists'. From his canvases more general principles could be gleaned. 'The real subject of a cubist painting is not a bottle or violin', Berger hypothesized, 'the real subject is the functioning of sight itself.' The transposition had profound philosophical implications. The static empiricism of fixed appearances had given way to a new union: the Cartesian categories of mind (self-consciousness) and matter (extension in space) were brought together by the painters in their work. As in phenomenology, sensory experience was both *in* and *of* the world. As in post-classical physics, measurement and nature were now entangled in a kind of quantum dance. Looking at a cubist painting was, for Berger, like looking at a star. 'The star exists objectively, as does the subject of the painting. But its shape is the result of our looking at it.'[27]

No one had ever quite said this before. Certainly not a Marxist. Even a nuanced art historian of the left such as Max Raphael, a critic who had written approvingly of Picasso's *Guernica*, was nonplussed by the artist's cubist phase, and found in cubism nothing but a degenerate and confused style. (As one scholar has pointed out, Raphael was probably swayed by Carl Jung's concurrent essay that found in cubism proof of Picasso's latent schizophrenia.)[28] Raphael had trained under Heinrich Wöllflin before developing his own critical method. He was by no means a party-liner. But like many other critics, Marxist or otherwise, he had dismissed cubism as essentially irrational.

Nothing could be further from Berger's thesis. To him, cubism was a 'modern rational art'. Its spirit was scientific. This was behind a set of intuitions he developed further in a second article from 1958, this time on Jacques Lipchitz. Berger praised the Russian-born artist as a visionary ('one of the few possibly great sculptors of our time'),[29] but the essay was less a review than a pretext for a larger philosophical project. 'Critics should look their hobby-horses in the mouth', it began. 'Yet despite this warning, the more I think about the art of the last and the next forty years (which is the minimum time-span with which any critic should concern himself) the more I am convinced that the question of Cubism is a—and probably the—fundamental one.'[30] As an art of multiple viewpoints, an art of processes rather than substances, cubism freed the visual arts from anachronism. Like parallel developments across science, psychology and politics (but unlike the 'distortions' of expressionism, or the 'worship of the accident' Berger saw in Action Painting), the cubists were concerned with 'establishing' rather than 'destroying' knowledge. Discovery, a concept central to his earlier definition of realism, was thus lent a grander inflection. What the cubists saw in nature was no longer local, personal or provisional (what Zola called 'a corner of nature seen through a temperament'), but something that was fundamentally, ontologically *true*. It pertained, in the manner of science, to the very nature of things.

At once prophetic and poised, the cubists spoke to Berger in a new language, revealing the philosophical horizons of art-making itself. That a painting could jump so powerfully yet discreetly across a chasm of forty years to speak in the present or even future tense was to warp the usual contours of a critical method: it was as if the passion of his newborn perceptions were mirrored in, as much as prompted by, the buoyancy of the art. ('One sees every critic in the likeness of a certain work of art', wrote the painter Andrew Forge. 'I think of Berger lodged in a late bronze of Lipchitz.')[31]

The energy of this new beginning propelled Berger through a series of appreciations of cubist and post-cubist artists during his last two years at the *New Statesman*. It was a kind of intellectual packing, stuffing premonitions into the ruck-sack of print before heading out on a journey. He praised Léger as the true inheritor of cubist confidence. He called Zadkine's Rotterdam monument a 'dialectical masterpiece'. ('It engages time', he said. 'And the reason for this is that its whole conception as a work of art is based on an aware-ness of development and change.')[32] Even when he was not writing directly about the modern, his new vocabulary was at play. In one article Berger spoke of his experience touring the newly reopened Capodimonte Museum of Naples: walking from room to room through the passing centuries, he suddenly intuited the ever-widening alienation of modern life, the way culture and nature had somehow taken differ-ent paths. It was a stark vision that only raised with even greater force the significance of those twentieth-century artists who believed, as Berger put it, that 'a new union was possible'.[33]

At the end of one of his last articles for the *New Statesman*, published shortly before he was to quit England for good, he spoke of his belief in the revolutionary significance of the cubists: 'Here is the beginning of the proof that the best art of our time is not arbitrarily the result of personality and temperament. I hope that others, better equipped than I, may now take the argument further. I am convinced that it is a crucial one.'[34]

In 1961, Berger followed Anna Bostock to Geneva, where she had been offered a job at the United Nations. The couple started a family. In 1962, a daughter, Katya, was born, and in 1963, a son, Jacob. For years Berger stopped writing art criticism. He published two further novels, *The Foot of Clive* and *Corker's Freedom*, but neither received much attention. In a letter to an older author he spoke of his struggle: 'It *is* a struggle', he said, 'because I made so many enemies as an art-critic; I have now offended the sense of order by abandoning art criticism; and I have exiled myself here seeing nobody except a few cherished but powerless friends. But meanwhile one must write and hope.'[35]

Save for the novels, the first years away from England represent a time of relative silence. Archival traces are scant. For several years Berger lacked the anchor of a regular publisher. He appeared intermittently on British television and stayed abreast of intellectual currents in England. But Geneva was a quiet city, and compared to his life in London he was very much cut off.

At the same time, the quiet of exile has its benefits. One is less beholden to social masks; those few relationships held onto intensify; new languages enter the bloodstream; voices a metropolis would drown out can be heard; a séance with the past becomes easier; projects unfurl with greater patience.

Such transformations were perceivable on the public level of Berger's prose, but at their private centre, like the hub of a turning wheel, was his new wife. Born Anna Zisserman, Bostock had been personally marked by Europe's violent past, having first fled the Russian Revolution for Vienna and then the Nazis for England, where she won a scholarship to study modern languages at Oxford. By the time Berger met her, in the late 1950s, she had already been married and divorced (keeping the surname Bostock) and was working as a translator from Russian, German and French.[36]

There is a long, unfortunate tradition in Western thought of brilliant women subordinating their own intellectual ambitions to those of their husbands. About the division of intellectual labour in the Berger–Bostock marriage we can only speculate. What is undeniable is that her influence, to

say nothing of her support, was critical to her husband as he forged a new European identity. By way of her work and erudition, the long line of continental thought from Novalis and Hegel to Heidegger was merging with his own outlook, colouring the way he looked at art and nature and wrote about the world.

The scope of her accomplishments still unjustly unsung, Bostock was a translator of tremendous importance to the New Left. Along with a handful of others, she helped to bring a dormant Marxist tradition back into the mainstream. During her marriage to Berger she produced a number of important first translations, including books by Walter Benjamin (*Understanding Brecht*), Georg Lukács (*Soul and Form* and *The Theory of the Novel*), Ilya Ehrenburg (the first volume of his memoirs, from 1891 to 1917), and Wilhelm Reich (*What is Class Consciousness?*). Together with her husband, she also translated a book of poems by Brecht.

The great interwar effervescence of Central Europe was like a mythical land. In London, through friendships with émigrés such as Frederick Antal and Peter Peri, Berger had learned of Budapest's legendary *Sonntagskreis*, or Sunday Circle, and the formidable intelligence of its most prominent member, Georg Lukács, the philosopher and critic whose ideas had in large part conditioned his own early support for realism. But now, through the exhumation of buried polemics, new perspectives were emerging. Each successive translation, particularly of Brecht and Benjamin, seemed to challenge, or at least complicate, the supremacy of Lukács's thought. Years before New Left Books introduced the Lukács–Brecht debate to a generation of students, Berger was encountering the same texts in his living room.

During their marriage Bostock also translated the work of the Austrian dissident communist Ernst Fischer, who became, for a time, a friend to Berger. Fischer's early political activity and escape from fascism resembled the personal histories of so many refugees Berger had looked up to over the years. During World War II, Fischer had lived at the Hotel Lux in Moscow, where he was wrongly implicated in a plot against Stalin, and so experienced with personal immediacy the

fright of totalitarian paranoia. Later he held cultural posi-
tions in the Austrian Communist Party. To Berger he would
have represented the embodiment of an organic intellectual:
a man of both action and letters who lived close to historical
events. By hosting Berger and Bostock in his summerhouse in
the Alps, and accompanying the former on long, ruminative
walks, Fischer became something of a father figure to the
younger critic.

The case of Fischer is peculiar. He is now largely forgot-
ten. (Fredric Jameson mentions him at the start of *Marxism
and Form* as a critic more at home in a night school than
a graduate seminar—a comment Fischer might have taken
as a compliment.)[37] At the time Berger knew him, though,
his books were widely read. When Bostock translated *The
Necessity of Art*, in 1963, it was released in both England and
America by Penguin. On the basis of that book and others,
Fischer became one of the most visible and outspoken exam-
ples of the period's so-called 'Heretical Marxists'.

What Fischer opened up to Berger and others on the left
was the confidence to embrace an independent, anti-Soviet
form of Marxism that recruited rather than rejected the art of
the modernists. 'We ought not to abandon Proust, nor Joyce,
nor Beckett and even less Kafka to the bourgeois world',
Fischer announced at a Czech literary conference in 1963.
'If we permit it then they can be used against us. If we do
not permit it, these writers will not help the bourgeois world,
they will help us.'[38] Such views produced an uproar, especially
among hardliners in East Germany, where Fischer's work was
banned. When one GDR critic said that he saw in the reap-
praisal of Kafka not a coming spring but 'only bats coming
out at nightfall', Fischer reportedly shot back full of mockery:
'Are you going to give Kafka a permit to stay?'[39]

Impudence had never been a problem for Berger. Still,
kicking up dust among the aesthetes was one thing; shit-
stirring in communist circles quite another. Even as late as
1961, he still possessed a certain trepidation about the polit-
ical validity of his new ideas. In a little-known but telling
article from that year, 'Problems of Socialist Art', published in
Labour Monthly, he effectively repeated his argument about

the need for a tolerant reconsideration of visual modernism on the left. Of course, his *theoretic* stance had deepened, but he still tiptoed with great care around the spectre of apostasy.

'This is a very difficult article to write', he began. 'It may easily be misunderstood. I am, however, determined to take the risk because the possible gains are very large.'[40] After a prefatory assurance of solidarity, Berger returned to what he saw as the nub of the problem: 'Can we dismiss the work of the Impressionists and those who followed them as little more than an expression of the decadence of bourgeois culture—which is roughly what Plekhanov did? Or can we find in such works, arising dialectically out of their contradictions, positive and progressive possibilities which once revealed cannot be ignored?'[41]

The rest of the article, which Berger still conceded should be seen as 'no more than the beginning of the beginning of a discussion', expressed his new research into the process-orientated perception of the modernists and the 'dialectic that inevitably exists' between subject and object. Such a wholesale shift in ontology—from substance to process, object to event, being to becoming—turned out to be surprisingly in line with the emphasis Marxist philosophers traditionally placed on totality (the apprehension of a total reality) over particularity (the presentation of isolated facts). What was so often dismissed as fragmentation could be seen as the reverse: the opening of the canvas to the complexity by which all modern experience arises. It was not a question of trading in nature for the mind, but of recognizing that neither could be understood without the other. To drive the political corollary home, the article even began with an epigraph from Lenin: 'Truth is formed out of the totality of all aspects of a phenomenon of reality, and their mutual relationship.'

In effect, Berger's essay represented an early attempt to integrate the art-critical ideas he had outlined during his last two years at the *New Statesman* into a patently Marxist framework. That project, it was becoming clear, would entail not only a re-evaluation of the work of the modernists (that was only half of the picture), but also of the Marxist critics who had dismissed them. In particular, the problem—to invoke

Berger's language—led back to Lukács, the great theorist of
totality and realism, and the way his own conceptual innova-
tions had been applied, or misapplied, in practice.

Lukács was a much more versatile critic than Plekhanov or
Zhdanov, but his position on literary modernism was similar.
Berger's article in *Labour Monthly* took tacit but clear issue
with several strands of his thought. 'The Realist work must
portray the typical rather than the incidental', he granted.
'But when the painter has found the typical—has found the
right subject, the right characters, the right actions, the right
mood—does he then paint his picture in just the same way
as if he had never got beyond merely portraying the inciden-
tal?'[42] 'In effect', he later said, 'realism has been treated by
theoreticians, ministers of culture and planners as though it
were what naturalism ought to achieve but doesn't.'[43] Berger
was growing dissatisfied with the schema; soon he would
totally reject it.

'It would be sheer nonsense', Brecht famously pointed out,
'to say that no weight should be attached to form and to the
development of form in art ... We build our houses differently
from the Elizabethans, and we build our plays differently as
well.'[44] Merleau-Ponty approached the same point the other
way around: 'It is certainly right to condemn formalism, but
it is ordinarily forgotten that its error is not that it esteems
form too much, but that it esteems it so little that it detaches
it from meaning.'[45] In *The Necessity of Art*, Fischer repeat-
edly echoed such ideas, quoting large swathes of Brecht and
Benjamin while conspicuously neglecting to mention Lukács
once. Noting that Fischer's book appeared in England 'hard
on the heels' of *The Historical Novel* (1962) and *The Meaning
of Contemporary Realism* (1963), the British literary critic
Stanley Mitchell called for a confrontation between Lukács
and the other theorists of Western Marxism, whose work was
only then appearing in English—and a 'further confrontation',
he added, between the many strands of that newly exhumed
tradition and the native lineage unique to England.[46]

It should strike us now that what Mitchell was calling for
was exactly what Berger was doing. His reconsideration of
modernism rose precisely on the fault lines of those face-offs.

And if his reading now holds little sway among contemporary scholars, this is only because it functioned less as a work of scholarship than a prolonged act of philosophical *ekphrasis*—the paintings acting as portals through which new syntheses could be reached. In front of cubism, Berger experienced what Rilke said he felt before the work of Cézanne: a conflagration of clarity. To follow his essays on modernism through the rise and fall of the New Left is to witness the long tradition of the European oil painting dissolving in the heat of a new metaphysics. *All that is solid melts into air.* Was this not also a description of the paintings?

'Reality changes', Brecht wrote in the 1930s. 'In order to represent it modes of representation must change.' 'Realism can only be defined within a given situation', Berger said in implicit homage. 'Its methods and aims are always changing.'[47]

And change was undeniably in the air. During the sixties the very concept of the zeitgeist returned with force. The children of prior avant-gardes announced their presence, while intellectuals hailed cosmic transformations: the switch from print to electronic civilization, written to visual culture, patriarchy to sexual pluralism, classical music to rock 'n' roll. Sea changes of a similar magnitude were occurring in geopolitics: the Cuban Revolution, the liberation of the Congo, Algerian independence. As the New Left grew to encompass the counterculture of the West, the cultural thaw of the East and the anti-imperial movements of the South, Berger came back to the modernists with a newfound certainty that the historical ice age separating past and present was melting. The invisible tectonic shifts of a half-century suddenly revealed themselves as increasingly hollowed-out social structures gave way. 'The genius of Einstein', Picasso once pointed out, 'leads to Hiroshima.' But did it have to? Or, as Victor Serge asked in *From Lenin to Stalin*: 'To judge the living man by the death germs which the autopsy reveals in the corpse … is that very sensible?'

There was thus always a double exposure at work for Berger, and the Marxist-modernism of his middle phase

charts a double course. On the one hand it looks forward to, then confronts directly, and finally looks back on, the chimerical revolutions of 1968. On the other hand, his writing exists in the already past: it swims imaginatively upstream to the headwaters of the grand socialist and modernist projects (to Bolshevism and to cubism) in order to test the true composition of the source, before the waters had grown murky and toxic. The twin histories were never far apart in Berger's mind. And it slowly dawns on us that what he will not consent to say of the fate of communism in the twentieth century he will say of the fate of modern art; and what he cannot yet hope for in art he will hope for in politics.[48]

Published by Penguin in 1965, *The Success and Failure of Picasso* marked Berger's reappearance on the scene. Dedicated to his wife Anna, Ernst Fischer and 'the memory of Max Raphael', the book sought to clear the nimbus from Picasso's reputation to explore both his achievements and shortcomings. This was an audacious project. Most of the coverage in the press focused on Berger's gall in departing from the kind of hagiography such a master usually elicits. 'Berger writes as though bristling for a fight', said one reviewer—as if ringside. 'He has stalked Picasso like Macduff prowling after Macbeth, bent on puncturing the charmed life his prey has been permitted to live too long.'[49]

In truth the book was not so combative. It was not Picasso the man Berger circled around so much as what he symbolized: the immensity of his talent, the vagueness of his politics, the distortions of his wealth and fame. In each of these departments the painter became a stand-in for Modern Art as a whole. ('Because Picasso holds the position he does', Berger had written years before, 'every misinterpretation of his work can only increase contemporary misunderstanding of art in general.')[50] *Success and Failure* thus served not only as a soapbox but also as a forum for clarification. It featured long digressions into the nature of twentieth-century aesthetics, what constitutes a natural context for art, the 'placelessness' of pure abstraction, and so on. Most important of these excursuses was a thirty-page section, about

halfway through the book, on the political and philosophical meaning of cubism—what Berger calls 'the great exception' to Picasso's working life.

The art of cubism, Berger says, remains the most advanced yet produced. The only comparison is with the Renaissance. And if the art of the Italian fifteenth century can only be understood in light of concurrent developments in science, philosophy and the new humanism, cubism only makes sense in light of quantum physics, the process philosophy of Alfred North Whitehead, and the revolutionary prophecies of Marx and Lenin. (The last correspondence was the most unexpected; fittingly, it is what he pursues most ambitiously.) To motivate the comparison further, he places Picasso's *Still-life with Chair Caning* (1912) beside a Fra Angelico altarpiece from the fifteenth century. The apparent contrast is, of course, flagrant. *The Vocation of St Nicholas* portrays a religious scene treated in geometric perspective; Picasso's mixed-media collage appears 'more like that of a landscape seen from the air'. But in both he finds a sense of newness and discovery: a delight in formal clarity and a fresh objectivity, all resulting from the apprehension of new truths. Just as the Fra Angelico reflects 'the promise of the new humanism' of the Italian city states; Picasso's still-life was born of what Berger calls 'the promise of the modern world'. 'There is nothing comparable in the five centuries between', he writes.[51]

The significance of the cubists, according to Berger, is almost impossible to exaggerate. What he sees is nearly biblical in scope. Assembling a range of parallels—historical, art-historical, and ultimately philosophical—he builds a sustained case for cubism to be recast not as the parent of painterly abstraction, but as the orphaned child of revolutionary dreams. Parallels once hastily silhouetted in the pages of the *New Statesman* are now given greater heft—although the tempo remains brisk. He tallies the accelerations at the turn of the century: the mass production of new materials; the invention of the automobile, the aeroplane and cinema; the new urban sensorium and the transformed experience of space and time; the consolidation of monopoly capital; the rapid expansion of colonial empire; the proposal of 'action

at a distance' and the concept of 'the field'; the scientific revolutions of relativity and quantum mechanics; the birth of modern sociology and psychology; the rise of a confident Socialist International.

All of these formations circumscribe the emergence of cubism as they do, of course, the emergence of modernism across the arts. Berger recognizes the impossibility of naming such novelties without also thinking of the destructions wrought in their wake: two world wars, genocide, fascism, totalitarianism, the atom bomb. 'The magnitude of the Cubists' achievement is unappreciated in the West', he says, 'because of our overpowering sense of insecurity and *Angst*.'[52] ('It is unappreciated in the Soviet Union', he adds, 'because there the official view of the visual arts is still that of the nineteenth century.')[53] But he asks the reader to envision a countervailing utopian potential. This he places historically and delineates in explicitly Marxian terms. 'By 1900 or 1905 the scale of both our hopes and fears were fixed', Berger writes. Monopoly capitalism involved 'planning on an unprecedented scale, and it suggested the possibility of treating the whole world as a single unit. It brought men to the point where they could actually see the means of creating a world of material equality.'[54]

According to Marx and Engels, industrial capitalism was a necessary stage in the inevitable progression towards communism. It would lay the structural groundwork for socialism (a concentrated, organized workforce) at the same time as it engendered the crises (of unemployment and overproduction) needed for revolution. Berger's point is not to endorse this famous bit of determinism, but nor is it to sanction the resignation of hindsight: the eternal discouragement of leftist melancholy. What he argues for is an imaginative space that can, however provisionally, suspend the in-built pessimism of a merciless half-century. The argument is roughly as follows: though revolution failed to come on schedule even where conditions for it were thought to be ripest, the anticipation of its imagined arrival produced a spark, now distant, whose indirect preservation in art can prevent us from accepting the present as immutable. The paintings may have been like an

ark: vessels built to store the hopes of a century before the flood of war.

B erger's map of modern art was a hand-drawn sketch, not an atlas and gazetteer. It was partial in both senses of the term: simplified for clarity, and politicized for effect. Perhaps because of its blunt, unexpected force (unexpected after years of Cold War conditioning), it was also tremendously persuasive. From the depression onwards, a Western public had been taught to see modernism as politically inoperative or elitist, and salt-of-the-earth realism as the only true house style for the left. By jettisoning this framework and setting off on an entirely fresh tack, Berger's paperback opened the eyes of a generation to possibilities long overlooked, or just as often repressed. It was a possibly overstated first pass; but precisely in its overstatement it helped to clear the ground for the more sophisticated political modernisms that were on the way and the kind of scholarly reappraisals that have appeared ever since. Only recently, for example, did T. J. Clark propose more or less the same parallel as Berger, just with dourer subtlety: both modernism and socialism, he suggested, were engaged in a 'desperate, and probably futile, struggle to imagine modernity otherwise. And maybe it is true that there could be and can be no modernism without the practical possibility of an end to capitalism existing, in whatever monstrous or pitiful form.'[55] Although Clark was writing with refined fatalism in 2001, and Berger with millenarian zeal in the mid 1960s, both proceed from a remarkably similar intuition. The questions Berger asked in 1956 remain openly debated still: *But why was so much originality necessary then? And would that originality have been so extreme had the social revolution been achieved?*

The historical parallel prompts but does not answer the question. To abut Apollinaire and Lenin, as Berger does, is to make a clear rhetorical point. Both speak in oracular, sweeping terms; both express a feverish trust in the future. But what of modernist *aesthetics*? What of the revolutionary content of cubist *painting*? Here Berger draws directly on a line of thought suggested by the interwar critic Max

Raphael, who, in one scholar's summary, postulated that 'the great artistic problem handed down from the 19th century to the 20th was that of combining materialism with dialectics'.[56] Raphael identified Courbet as the torch-bearer of the first and Cézanne of second but, writing in 1933, he believed the advent of a properly Marxist aesthetics was still a long way off.

Berger essentially restates Raphael's account. But whereas Raphael thought the problem of aesthetic transvaluation unresolved, Berger saw cubism as the very synthesis the German critic thought lacking. Speaking of Courbet and Cézanne, Berger writes:

> Today both examples *are* followed up separately. Most painting in the world is either banally and mechanically naturalistic or else abstract. But for a few years, from 1907 onwards, the two were combined. Despite the ignorance and philistinism of Moscow in its Stalinist and post-Stalinist pronouncements about painting, and despite the fact that none of the artists were in any way Marxists, it is both possible and logical to define Cubism during those years as the only example of dialectical materialism in painting.[57]

Even with its caveats and careful wording, the conclusion was meant as an agitation. Some reviewers were infuriated, others exhilarated. What made the definition so divisive was exactly what made Berger's assertions about Picasso so controversial: the controversy in both derived from the canonicity of the subject. As the ur-text of twentieth-century modernism, if cubism flipped to one camp or another, the whole lineage of modern art would need to be re-examined.

Nobody disputes the importance of cubism. What has been disputed, at times with great fanfare, is its precise meaning. The prevailing consensus remains twofold. The emergence of cubism, it is thought, signalled the irreversible dismantling of geometric perspective: the system at work in Western painting since the Renaissance. At the same time, it also heralded the rise of pure abstraction and medium-reflexive 'theatricality' in twentieth-century art. In effect, it flattened the canvas and

made it self-aware. Different critical schools have inflected these modalities to their own ends. Part of the reason—or mechanism—for cubism's seminal status derives precisely from its hermeneutic malleability. The pictorial fluctuation so fundamental to the work is mirrored on the level of criticism. Much art can be said to be a Rorschach test for the critic or critical school in question; for cubism, this is almost literally the case.

'Painting, of all the arts, is the closest to philosophy', Berger said at the height of his fascination with the cubists; and cubism in turn made him into a philosopher.[58] He acknowledges the semiological and performative aspects, the use of new materials, the mix of high and low registers, the invocation of African motifs, the jokes, the comic flaunting of bourgeois taste. But these are touched on rather than pursued. His analysis instead circles around questions of perception and ontology. Running alongside the text, reproductions provide a visual testimony to the argument, as if he were relying on the images to corroborate his speculations or to fill out what borders on the ineffable. The effect is a creative form of counterpoint in which the prose reaches for syntheses, often remote in their complexity, while the paintings provide a mute and incontrovertible ground. Unlike other avant-gardes known for their verbal bombast, the cubists remained silent about their work. Berger's friend, the painter Peter de Francia, put the paradox well: 'Their uncertainty derived from the fact that the premises implicit in their paintings could only be tested against the paintings themselves.'[59]

At one point Berger's text gives way entirely to a chronologically ordered sequence of images. From Cezanne's *Les Grandes Baigneuse* (1898–1906) and *Les Demoiselles d'Avignon* (1907) we flick silently through a series of nudes, landscapes and portraits made at the height of analytic cubism, before landing on Picasso's mixed-media collage, *The Violin* (1913). As a curated visual essay, it means to capture the revolution in image-making that separates the twentieth century from the nineteenth. Like a stop-motion sequence, it shows the incremental development of an *idea*—one whose full implications we see spread, intensify, take root. But what

was the sense of that idea? How could it be articulated? And how could it match the world-historical sweep Berger meant for it?

The answers return us again to Georg Lukács and the many contested currents of post-Hegelian thought. After Marx, who analysed the commodity fetish, Lukács greatly expanded on the nature of reification, or 'the transformation into a "thing" of what, originally, does not have the mode of being a thing'.[60] He viewed this tendency to be the governing trademark of middle-class consciousness: the mistaking for eternal and objective a social reality that was in fact the living product of human relations. The gift of Marxian dialectics lay in its ability to reveal the constituent network of social forces beneath what was presumed to be solid. As Lukács writes in a climactic passage of *History and Class Consciousness*:

> Thus the knowledge that social facts are not objects but relations between men is intensified to the point where facts are wholly dissolved into processes. But if their Being appears as a Becoming this should not be construed as an abstract universal flux sweeping past, it is no vacuous *durée réelle* but the unbroken production and reproduction of those relations that, when torn from their context and distorted by abstract mental categories, can appear to bourgeois thinkers as things.[61]

The apperception leads him to an epiphany. 'If, in Hegel's terms, Becoming now appears as the truth of Being, and process as the truth about things, then this means that the developing tendencies of history constitute a higher reality than the empirical "facts".'[62]

And it was not only Lukács. A remarkably analogous anti-positivism can be traced through the other great anti-Cartesian treatises of the 1920s, notably those by Alfred North Whitehead and Martin Heidegger. Each in his own way was attempting the philosophical equivalent of what Berger was forty years later reading out of cubism: the dynamic liberation of thought from the static abstractions of the intellect— Lukács through *dialectics*; Whitehead through *creativity*; and Heidegger through *dasein* and *being-in-time*. For Lukács,

becoming was seen as historical and political; for Whitehead it was cosmic and scientific; for Heidegger it was personal and sacred. But all aimed to displace a nineteenth-century scientism they viewed to be fixed, stagnant and alienating—out of touch with the integral truth of deep experience.

Throughout the 1960s, Berger repeatedly spoke of a similar revolution: 'a revolution in our mode of general thinking and interpreting. Process has swept away all fixed states; the supreme human attribute is no longer knowledge as such, but the self-conscious awareness of process.'[63] The cubists painted, in an uncharacteristically awkward phrasing, all that was *interjacent*. They existed at a point of 'startling coincidence' when other thinkers in other disciplines were similarly challenging 'the other fixed categories into which reality had been separated'.[64] Such categories, he wrote, 'had become prisons of the mind', preventing people from apprehending 'the constant action and interaction' between phenomena and events.[65]

Helped along by the paintings of Picasso and Braque (and Cézanne and maybe De Staël too), Berger was beginning to take seriously what vision, the raw sense of it, was showing him, as it had others who had stopped to sift through what poured in from the optic nerve, sorting through it the way prospectors once panned for gold. 'We must take literally what vision teaches us,' wrote Merleau-Ponty, 'namely, that we come in contact with the sun and stars, that we are everywhere all at once.'[66] It was a kind of trip, a reopening of perceptual accounts, as anyone who has experimented with psychedelics can tell you. ('The word and sense of "poignance" flooded over me during the walk through the garden', Michael Pollan recently wrote of his experience ingesting psilocybin. 'One's usual sense of oneself as a subject observing objects in space—objects that have been thrown into relief and rendered discrete by the apparent void that surrounds them—gave way to a sense of being deep inside and fully implicated in this scene, one more being in relation to the myriad other beings and to the whole.')[67]

Properly primed, cubism—though Berger himself eschewed drugs—could be like an acid trip or an awakening: a journey

to a molten layer of truth. It helped not only to disperse the ego but to *de-reify* the visual world. It was the only art, Berger said, to have touched totalities, to have revealed this deeper substratum of perception. The flattening and fracturing of space, the discontinuity of planes within the picture, the apparent two-dimensionality of the canvas, the montage of spatial perspectives. In all this we recognize the *madeness* of the image (what most critics have focused on), but we also enter into a visual field that exists in a state of perpetual arrival, objects forever emerging and renewing themselves, before our perceptual faculties of organization have been able to snap everything back into solid place. 'But reality is not,' Lukács said, 'it *becomes*.'[68] Or, as Berger wrote: 'Rather than ask of a cubist picture: Is it true? or: Is it sincere? one should ask: Does it continue?'[69]

Berger left England, he later said, to become a European writer; in the process he also became a new kind of thinker—more metaphysical and yet nearer the earth. It was a paradox that came with his chosen place of exile, and how he imagined it. Though based in a suburb of Geneva, he spent much of the mid 1960s in the hills of the Vaucluse, especially the village of Lacoste, where two painter friends, Peter de Francia and Sven Blomberg, had houses, and a short walk further east in Bonnieux, a town perched on the slopes of the Luberon, where he and Bostock for a time had their own. The France Berger came to know was a land of sun and lilac, but in his mind it was also always the home of Camus, Sartre and Merleau-Ponty. Phenomenology was the hinge between the sensual and conceptual: the visible and the invisible. 'The landscape', Cézanne said, 'thinks itself in me, and I am its consciousness.'

In 1965, the same year the book on Picasso came out, Paul Barker, then the deputy editor of *New Society*, invited Berger to become a frequent contributor to the growing arts and culture section of the magazine. He could write on any subject of his choosing. Once again Berger was given a platform. But unlike his days in the galleries in London, the distance of exile imbued his prose with a more patient, personal, often poetic

spirit of inquiry. There were fewer axes to grind—although several never went away—and more pathways to explore, and mysteries to unravel. The word *essay*, as has often been pointed out, derives from the French verb *essayer*: to try out or try on.

Almost all of Berger's most beloved writing, since anthologized in his many collections, first appeared in the pages of *New Society*: the famous meditations on photography, on the look of animals, on Paul Strand and Courbet and Turner. In one he simply speaks of the experience of being in a field: 'Shelf of field, green, within easy reach, the grass on it not yet high, papered with blue sky through which yellow has grown to make pure green, the surface colour of what the basin of the world contains, attendant field, shelf between sky and sea, fronted with a curtain of printed trees, friable at its edges, the corners of it rounded, answering the sun with heat.'[70]

The evocation almost belongs to Whitman. But then, having coloured the field with the palette of a painter, he goes on to diagram the experience with the rigour of a logician. The interconnectedness of all things felt and heard proves that 'every event is part of a process' and that each can only be defined in relation to another.[71]

It was this hybrid style—sensual yet cerebral—that won Berger not only recognition but also affection, and a loyal following far beyond the confines of the intellectual class. His language was never redolent of the seminar or symposium. A field was, for him, a literal place.

At the start of the decade, it had been as if Berger was shifting his weight from one foot to the other, testing the balance of a new, more Mediterranean bearing—further from the chattering classes but closer to the land and to history—before making the final jump. As the sixties swung towards its apogee he made the jump: he committed to it. He passed weeks in a stone hovel in the shade of the Luberon mountains, among fig trees, fruit orchards, chickens, dogs, cicadas and owls, working the land in the morning and reading philosophy in the afternoon. It was a new life of continental thought and feeling—the feeling of thought—he had found (and curated) for himself, a life of lavender and onions, terra

cotta and shared meals. He took philosophical modernism outdoors, letting it bronze his skin. In the process, he tried to live out what Heidegger had called for but may never have personally achieved: the return of philosophy to life. The revolution had to be lived all the way down.

To look at a cubist painting, Berger once wrote, was to be pulled into a series of immersions: 'We start from the surface, we follow a sequence of forms which leads into the picture, and then suddenly we arrive back at the surface again and deposit our newly acquired knowledge upon it, before making another foray.'[72] It is also a metaphor for his many writings on the movement. Just as the cubists approached a vase or guitar from a range of visual angles, setting the still life in motion, his essays on their paintings attest to the dynamism of the New Left. He too writes from a range of angles, this time historical: 1958, 1961, 1965, 1967, 1969.

Berger's last essay—his final foray—was 'The Moment of Cubism'. Until his death, it remained the most sustained piece of theoretical writing he ever produced. The prose is both swift and dense: it wants to be read in a single sitting, to electrify the mind.

Written in 1967, revised over the following year, and republished in 1969, the text should be seen as the capstone of Berger's philosophical investigations and the fullest expression in his body of work of that mythical year in the middle: 1968. In their way of seeing everything as immanent, nothing as fixed, the cubists laid out a philosophical primer for the twentieth century, expressing desires, still unfulfilled, that the new student and worker movements seemed to be rushing forward to meet. The photographs were coming in from all over the world: the march on the Pentagon, the flags of the Prague Spring, the riots in the Left Bank, the demonstrations in Mexico City, the March of One Hundred Thousand in Rio de Janeiro. In the faces of the young there was an absence of fear and a will to act. It was a year of assassinations, teach-ins, marches, self-immolations—a year whose intensity we are told it is hard to conjure, and yet whose reverberations can be heard in every word of Berger's writing. The pages

of the 'The Moment of Cubism' carry the smell of tobacco and tear gas; when the essay was adapted from its initial printing in *New Left Review* and turned into a book, new epigraphs (slogans) were added, as well as images. In one spread, two cubist portraits appear on the verso page (one by Léger in 1912, another by Braque in 1911); on the recto page we see a photograph of the dead body of Che Guevara and a Vietnamese peasant being interrogated at gunpoint. Berger could not have said it any more clearly: the moment of cubism was *now*.

That the cultural and conceptual revolutions from earlier in the decade were turning into direct and often violent confrontations with the state seemed to validate the whole circuit Berger and others were trying to solder together: from intellectual, historical and imaginative labour back around to the labour of revolution. And so it is fitting that, while Berger showed up at some of the events of the period—he delivered a rousing speech at Oxford Vietnam Week in 1967, reported on the Prague Spring in 1968, attended the Bertrand Russell conference in Stockholm in 1969—the thing he did most when the left was at a fever pitch was write. It was fifty years since the October Uprising, and two moments were touching. With this in mind, Berger combed the past for clues, hoping to see where things had gone wrong, when past energies had been betrayed, and how to bring them back. 'I must insist on the sensation I have in front of the works themselves', he wrote at the start of his last essay on cubism, 'the sensation that the works and I, as I look at them, are caught, pinned down, in an enclave of time, waiting to be released and to continue a journey that began in 1907.'[73] What had changed, then, between *Success and Failure* and 'The Moment of Cubism', published only two years later, was not any analysis of the art (that had only developed the way a photographic plate develops, its contours growing more deeply etched), but rather everything else the art was attached to: the nature of revolutions, the political potentialities of the present, the workings of historical time.

It was precisely during these years that Berger produced a series of written portraits of Central European figures from the

generation above him: Victor Serge (b. 1890), John Heartfield (b. 1891), Max Raphael (b. 1889), Walter Benjamin (b. 1892). All of these men belonged to what Berger once described as 'that unique international fraternity' of Marxist intellectuals. 'In every photograph from 1910 onwards you find their faces. They are short-sighted from reading and they are often frail in physique. But they have known they can change the world.'[74] Benjamin, in particular, was special—his importance itself an emblem of the left's return to first principles, its growing distrust of established ideologies and supra-historical laws, what Berger called its *interregnum*.[75] 'The interregnum exists in an invisible world', he wrote, 'where time is short, and where the immorality of the conviction that ends justify means lies in the arrogance of the assumption that time is always on one's own side and that, therefore, the present moment—the time of the Now, as Benjamin called it—can be compromised or forgotten or denied.'[76] Especially in Benjamin's later essays, the entire medium of history undergoes a disorienting, almost hallucinatory, rearrangement. It ceases to be imagined as a ladder of successive stages, becoming instead a non-linear, quasi-mystical field, lit up by flares of revolutionary possibility. History, for Benjamin, was 'an ever-present arena', in the words of Stanley Mitchell, 'never (as with Lukács) merely the "preconditions of the present"'. The battles of the past had to be fought and refought; if not they might be lost again.'[77] The rediscovery of his work seemed to corroborate the point. In an essay titled 'Past Seen from a Possible Future', Berger quotes Nietzsche to similar effect: 'We can have no idea what sort of things are going to become history one day. Perhaps the past is still largely undiscovered: it still needs so many retroactive forces for its discovery'.[78]

The same was true, it followed, for the art of the past—and for criticism and for knowledge too. 'What does knowledge *do*', asked the literary critic Eve Sedgwick in a similar spirit, 'the pursuit of it, the having and exposing of it, the receiving again of knowledge of what one already knows?'[79]

'All is possible everywhere and with everything', wrote the cubist poet André Salmon. Or so it can seem at certain explosive, revolutionary moments. With hindsight, and in periods of political stasis, we are more likely to be aware of the contradictions.

Berger ends his essay—as if beginning his descent towards the earth—with two reservations. The first is a reservation about what he felt was a need to discuss cubism 'as though it were pure theory'. The second concerns 'the social content of Cubism—or rather, its lack of it'.[80] He treats the two as if they are separate, but together they point to a more fundamental tug-of-war, a variant of the old dichotomy between form and content he wished so much to surmount. Or, put differently, the dichotomy between self-consciousness and consciousness *of* something. How can my perception of a chair be the same thing as my perception of my perception of a chair? If cubism was about vision itself, how could it also be about *what we see*?

The question soon cedes to others: Were the cubists of their time or ahead of it? Was their art exceptional or exemplary? Were they visionaries or jesters? How to distinguish between a work of true affirmation and one of enforced optimism? Or between 'intuitively real prophecies' and 'utopian dreams'? Does the revolution have room for sorrow?

Nothing less than total transformation was what so many on the left demanded, and yet it was a mode of thought that often neglected the slow, daily, grudging exertions and compromises that will not go away even on the far side of the socialist mountain. This is not to excuse the centrist alibi that all progress must be incremental, but to recognize that victories, whether in art or politics, can be small as well as large. Nothing is ever so simple as a final cure. As Berger told his comrades all the way back in 1956, in the midst of his own crisis, even socialism cannot prevent the artist from suffering periods of crippling doubt and despair. This is what it means to be human. Twenty years later he made a similar point. Looking back on 1968 he spoke of the 'desperate force' that belonged so brilliantly to Guy Debord (whom he compared to the young Lukács) and the Situationist International as

a whole. But what they had failed to consider was 'the eve-
ryday fact of tragedy'. And 'to live through catastrophe', he
said, 'requires endurance, which is the only positive form
of patience'.[81] The owl of Minerva, Hegel wrote, only takes
flight at dusk.

The stop-and-start of history works on the hope and misery
of individual lives. It produces countless casualties. The same
was true for the New Left. For a time contradictions were
tolerated, even welcomed, because everything was in flux,
nothing set in stone. But when the contradictions exploded,
as Godard put it, they took part of a generation (and their
ideals) with them. And this was true even in the First World,
where the failed revolutions had left so few dead. 'At the time
many of us tried to shield ourselves from the harshness of
the truth', Berger later reflected; but after a few years it was
evident.[82]

And yet in politics, as in our personal life, every present
moment also contains a projected future. If that future does
not come to pass, that does not mean it did not, in some
sense, already exist. It existed in the moment of its intimation.

At a time when young people everywhere were marching
on the streets, the theoretical settlement Berger had pursued
for over a decade could finally be brokered. 'Outrageous art
has many early precedents', he wrote near the end of his last
essay on modernism. 'In periods of doubt and transition the
majority of artists have always tended to be preoccupied with
the fantastic, the uncontrollable and the horrific.'[83] But the
future need not be equated with disaster, nor modernity with
a shipwreck. 'The modern tradition, based on a qualitatively
different relationship being established between man and the
world, began, not in despair, but in affirmation'.[84]

Fifty years on, the line has a bittersweet ring to it. When it
appeared it was like the QED of a proof.

4

Divided Loyalties

Somehow I too must find a way of making *things*; not plastic, written things, but realities that arise from the craft itself. Somehow I too must discover the smallest constituent element, the cell of my art, the tangible immaterial means of expressing everything.

Rilke to Lou Andreas-Salomé

In 1962 John Berger, newly arrived in Geneva, asked his friend Alain Tanner if he knew any photographers. He wanted to make a book that combined words and photographs about a country doctor in the Forest of Dean. Tanner gave him the phone number of Jean Mohr, a photojournalist he knew as part of a Geneva ciné-club. Berger called Mohr and the two agreed to meet. Mohr had worked for the Red Cross in Palestine during partition (much later he would collaborate with Edward Said on *After the Last Sky*), and was then working as a freelance photographer for the World Health Organization. Berger was impressed when shown some photographs Mohr had taken of miners in Charleroi.[1]

When they met, Berger explained his idea for the project. He wanted to spend several weeks observing a general practitioner who worked in a rural forested community in the west of England. He had lived there himself, had been treated by the doctor, and had since become friends with him. (In fact it was a mutual friend, the Indian-born writer Victor Anant, who first suggested the idea of the book.) Berger explained to Mohr that he had good relations with Penguin, and that the

two men would split the profits equally. The doctor, whose name was John Eskell, had consented to the project—to be observed along with his patients—and would put them up during their stay. Mohr agreed and they made plans to travel to England.

There were precedents for this kind of work. In 1948 *Life* had published a photo-essay by W. Eugene Smith, 'Country Doctor', which portrayed the everyday rounds of a rural physician. Berger also admired James Agee and Walker Evans's *Let Us Now Praise Famous Men*, and was certainly aware of the other documentary photobooks from the 1930s and '40s—not only those by Evans, but also Lewis Hine, Dorothea Lange, August Sander and Bill Brandt. In 1954 Sartre and Cartier-Bresson collaborated on *D'une Chine a l'autre*, and in 1955 Paul Strand worked with Cesare Zavattini on *Un Paese*, a portrait of a small village in the Po Valley. But in all of these books the pictures and words kept their distance from one another. *Let Us Now Praise Famous Men*, for example, begins with Evans's photographs presented as a kind of visual preface to Agee's text. Most often—as with Sartre or Zavattini—the writer would comment on and around the photographs as a kind of postscript.

Berger and Mohr departed from this model in two key respects. First, they planned to travel to the Forest of Dean and observe their subject together, as a team, writer and photographer, notepad and camera, for several weeks. Second, the subsequent making of the book—what might be called its post-production—was going to be a collaboration through and through. The pictures and text were meant to work together on the page, much as Mohr and Berger were planning to work together in the field.

From the modest meeting in Mohr's Geneva apartment came a new kind of book. The photo-text coupling the pair ultimately invented sought out new grammars of expression in order to say new things about modern experience. Taking inspiration from the documentary film and film essay, but translating the form from the screen to the page, they turned the apparent limitations of the print medium—its stillness and silence—to an imaginative advantage. In so doing, they

quietly reconceived the experience of reading. The three paperbacks they went on to make together—*A Fortunate Man* (1967), *A Seventh Man* (1975) and *Another Way of Telling* (1982)—were all about sociological themes: rural medicine, migrant labour and mountain peasants. But their *aesthetic* discoveries touched reserves of empathic potential still held within the form of the book, still waiting to be fully explored. Their innovations remain a horizon for artists. If colour is the place, as Cézanne said, where our brain and the universe meet, the photo-text may be the place where the different currents inside us—the verbal and the visual, faces and landscapes, desires and ideas—can gather and cohabit.

People talk about being 'right brained' or 'left brained' as if you can't be both. Such categories, of course, are not only cognitive but cultural, the constitutive divisions of Western philosophy—mind and body, vision and language, feeling and reason, image and word—having long since migrated into our everyday professional lives. We take it for granted, for instance, that the visual arts will be taught in one building while the humanities (what used to be called *belles lettres*) are taught in another. Or that the editorial department of a publisher will be housed in one office and the design department somewhere else. People who are good at accounting are not supposed to make good poets. Nor are philosophers meant to tell stories about real people. Among fiction writers, especially, there seems to be an unshakeable tendency to pit the abstract against the tangible, so as to do away with the first. The division between 'critical' and 'creative' is now so entrenched at an institutional level—each professor assigned a tag, each class allotted a domain—that it can seem to students as if such categories were pre-existing in nature.

In his own time Berger was certainly one of them. Throughout his boyhood he experienced what he would later call a 'divided loyalty': a powerful inner tension between the world of appearances and the world of concepts. His first journals were full of sketches and poems, side by side, in equal numbers. In his twenties he made his money putting

words to paper, but had been trained to put paint to canvas, and he never gave up drawing. 'As the difficulties of thinking and writing became my primary conscious concern,' he said, 'my primary reality became the visual one.'[2]

Reviewing painting both harnessed and exacerbated this division. The literary critic can sidle up to her object of study: the two share the same medium. The art critic, by contrast, is always to a certain extent operating synaesthetically, using language to evoke and evaluate what is fundamentally non-linguistic. When Berger gave up art criticism his early fiction stalled precisely because he seemed unable to corral his unusual double talent into the traditional forms of literature. It was as if he was standing on one leg rather than walking with the two he had.

Then, in the early 1960s, he began to work in television. The experience proved definitive. Television not only helped him pay his bills and expand his influence; it immersed him in technical methods whose intrinsic means of composition reconciled the very schism he had struggled with. By writing scripts with a special awareness of how his voice-over would be paired with the image-track, his skill with words could be put in dialogue with a new visual dimension. Image and language formed a fresh circuit on the screen: early television was often called 'radio with pictures'.

Television suited Berger in another way. As a presenter he had presence. Arriving in leather and zips at Lime Grove Studios in West London, he was handsome and magnetic and could speak in a direct way to a coveted new audience: the so-called 'average man'. When the BBC's monopoly was broken up, and Granada Television formed, he hosted two shows for the network, *Drawn from Life* and *Tomorrow Couldn't Be Worse*, in which he talked to ordinary people about art. Later in the 1960s, he worked closely with Michael Gill (the director, subsequently, of *Civilisation*) to make special episodes for Huw Wheldon's influential arts magazine, *Monitor*: one on Léger and another on the postman-architect Ferdinand Cheval, both filmed in the south of France. In other episodes Berger would be asked to share his thoughts on painters of the Western canon, from Bellini to Picasso.

At the *New Statesman* Kingsley Martin had been his mentor; at the BBC he had Wheldon. An imposing Welshman and the 'philosopher king' of British arts programming (he was later knighted), Wheldon encouraged an impressive roster of young intellectuals to embrace the medium. 'I fantasized this notion', he later said, 'that if Freud and Marx and Darwin lived in the 1950s and 1960s, instead of the 1850s and 1860s, we would have had an occasional television series from them as well as books.'[3]

Wheldon's entire philosophy, though, derived from the axiom that television, when successful, was wholly different from a book, that it should instead represent (his motto and mantra) 'an individual and indivisible marriage of word and picture'.[4] The workflow he supervised—scriptwriting, drafting shot lists; then filming, selecting, cutting, assembling, reassembling, and dubbing—was laborious, but allowed for new experiments to flourish. The open arrangement proved especially favourable for art critics. What had been a near-timeless practice for art historians—to lecture in front of a slide or painting, drawing a group's attention to this detail or that—took on new technical life. 'I have often been puzzled as to why the painting, even in monochrome, seems so vivid on television', Wheldon said at one of his lunchtime lectures. 'Perhaps the actual act of scanning, invisible to the naked eye, is in some way energizing the otherwise so still, still picture. It is uncompromisingly not the picture. It is undeniably a reproduction, but a reproduction like no other.'[5] If the programme was successful the result was a preternatural unity. 'It is as if the words are in the picture; and the picture itself speaks through the words of a man who cares for nothing during that time but what is, and only what is, relevant to that picture.'[6]

Through his work for television Berger became creatively conscious for the first time of a more general possibility— what he called the 'speaking image'. He realized the idea of his divided loyalty was false—and, what's more, that it was precisely by moving between forms, whether materially or imaginatively, within the same work or from work to work, that his disparate talents could most fruitfully find expression.

(Tellingly, Berger's best-known polemic, *Ways of Seeing*, is both a TV broadcast and a book, the second adapted from the first.) The expanded media environment of the postwar years was thus doubly formative: it raised the subject not only of cultural democratization, but also of media translation and difference. By making television programmes about painted or sculpted artworks, critics such as Berger faced the question on an everyday working basis. It was a question, in turn, they often made central to their programming.

Berger's first television appearance, for example, occurred alongside Kenneth Clark as part of Clark's ATV Midland series *Is Art Necessary?* The episode was predicated on a question: Could painting still fulfil a popular purpose in the age of mass communication and modern art? During the live broadcast (which remains essential viewing for those interested in the Berger–Clark relationship),[7] the pair discuss a trio of images: Picasso's *Guernica*, a beach scene by Guttuso, and a printed advertisement for Guinness.

'Several forms do nonetheless remain hard to explain to the average man', Clark says of *Guernica*. 'I mean, this can have an impact on an ordinary person but it cannot be popular, it can really only be understood by people who've trodden the long hard road of modern art, don't you think?'

'Yes, yes, yes, possibly', says Berger. They move to the Guttuso painting. The broadcast cuts between the two men and close-ups of the painting as they look at it. What they say becomes an inquisitive frame around what we see.

'Guttoso is a Communist', Clark remarks. 'What difference does that make? Why do those painters who are endeavouring to bring back storytelling in art belong either to the communists or to the left? Is that because they seek to make people think a certain thing?'

'Yes', Berger replies, 'as soon as you have this purpose which is shared by both the likely public and the artist you'll begin to get communication. In the West, of course, the only art used for a purpose is commercial advertising.'

Programmes like these were self-reflexive, combining filmic representations of the art in question with conversations about what it meant to film art, and what art could do or not

do in the age of film. Technically, they moved on two levels: image and sound. The production team would be tasked with visually conveying a painting, usually through an establishing shot of the whole work followed by close-ups strung together through either panning or cutting. Meanwhile a second aural layer added sound and language to the artwork's silence. As Berger later noted in *Ways of Seeing* (the book, not the programme): 'When a painting is reproduced by a film camera it inevitably becomes material for the filmmaker's argument … The painting lends authority to the filmmaker. This is because the film unfolds in time and a painting does not. In a film the way one image follows another, their succession, constructs an argument which becomes irreversible.'[8]

At the same time that television presenters were finding new ways to capture the arts, artists were exploring new ways to lay out the page. The great enthusiasm in postwar design was for the explosions of interwar modernism: photomontage, constructivism, the Bauhaus, the new Swiss typography. Figures such as Walter Gropius, Alexander Rodchenko, El Lissitzky, Herbert Bayer and László Moholy-Nagy were all being taken up and written about by a crop of young designers.

What these Central and Eastern European figures represented was a modernist lineage that praised the mixing of forms rather than their purity. In *Painting Photography Film*, Moholy-Nagy wrote that a new 'visual literature' formed of photography and type would render the other fine arts obsolete. 'Eyes and ears have been opened', he said in 1925, 'and are filled at every moment with a wealth of optical and phonetic wonders. A few more vitally progressive years, a few more ardent followers of photographic techniques and it will be a matter of universal knowledge that photography was one of the most important factors in the dawn of a new life.'[9] Many others were arriving at their own versions of the same conclusion. Even Ansel Adams, no techno-utopian prophet, expressed something similar when he wrote: 'Photography next to the printed word instructs, interprets, clarifies and modulates opinion more than any other medium

of expression; and therefore is deserving of attention and respect equal to that accorded painting, literature, music and architecture.'[10]

Adams's quotation circulated widely—appearing at the entrance to a photography exhibition held at the Whitechapel Gallery in 1954. Berger reviewed the show. The article he wrote, though rarely anthologized, marked the beginning of a line of thought that would last for decades. What Adams said forced him to think back to first principles. 'Photography may deserve as much or more respect as painting or literature', he wrote, 'but it is essentially a different sort of activity. Literature and painting are concerned with recording the artists' *experience* of an event. Photography is concerned with recording a selected aspect of *the event itself*.'[11] The fundamentally inscriptive nature of the medium—the photograph as physical trace, like a fossil—was a truth Berger was just beginning to make sense of. 'The camera intercepts images', he posited, 'the paintbrush or the pen reconstructs them'.[12]

Several years later, in a 1963 article for the *Observer*, he echoed the distinction: 'The photograph *intercepts* … The painter *re-creates*.'[13] But now it was set out as a choice: the article was titled 'Painting—or Photography?' In the interim years Berger had grown more enlivened by what he thought the newer medium capable of. 'Photography', he said, with echoes of Moholy-Nagy, 'will probably do for the future what sculpture did for the Middle Ages or painting for the Renaissance.'[14] Alongside the excitement, an emergent interest now lay in what he saw as the photograph's essential *ambiguity*. Its inscriptive nature was what made it so transportable, but also malleable. Berger spoke of the same photograph (an image of a white woman in Elisabethville weeping as Belgian troops leave the Congo) being paired with three different captions to elicit three different meanings. Photography in this sense seems to *invite* language. Once adjoined to text, the printed photograph, unstable in itself, becomes a remarkably solid new compound: the cell of a new art. As Wilson Hicks, the first picture editor for *Life*, put it: 'The basic unit of photojournalism is one picture with words.'[15]

Berger's article in the *Observer* attracted the attention of an

old acquaintance, the graphic designer Herbert Spencer, whom he had met on a cultural tour of the Soviet Union in 1953. Spencer had since launched the design journal *Typographica*, responsible for popularizing the graphic modernism then so much the rage. Spencer and Berger began to correspond. The subjects discussed by the two men were those with which any layout or picture editor would have been familiar: the relationship between photograph and text, the cumulative effect of a set of images in a sequence, the question of arrangement on the page. But the two approached these concerns without the common criteria of impact and clarity; instead they had an eye for unexplored aesthetic freedoms. Berger expressed an interest in publishing a 'PS' to his earlier essay. 'I agree with you about the importance of pictures in sequence', he told Spencer, 'and maybe too this is just at the beginning of its possibilities. As soon as you have a sequence, you have time passing, and as soon as you have that—you have the necessity for poetry.'[16]

The 'PS' Berger contributed to *Tyopgraphica* consisted of a personal essay, 'Words and Images', and a smaller book of photo-poetry, *At Remaurian*. 'The image and the word are breeding', he declared. It was a procreating energy, he said, that was exploding the confines of traditional disciplines. (To get a sense of the aesthetic mood: the same issue featured studies of Rodchenko, the photography of Herbert Bayer and a profile of the French designer Robert Massin, the art director of Gallimard, whose modernist credo was 'preserve, renew, invent'.) Berger called for new relations between writers, photographers, illustrators and designers. 'A great deal of what passes through our mass media is trivial and false', he said. 'The possibility of new relations between words and images is seldom pursued on a constructive public scale. No editor yet thinks of a photographic library as a possible *vocabulary*; nobody dares to place images as precisely in relation to a text as a quotation would be placed; few writers yet think of using pictures to make their argument.'[17] Clearly having just put down Marshall McLuhan's *Understanding Media* (1964), Berger wanted to reimagine the act of reading as an organic verbal–visual experience. 'As in so many other

fields, the technical and productive means which have been achieved now demand new attitudes and values', he concluded. 'The institutional walls between files and appearances are slowly crumbling; the young begin to ask themselves whether they like *the look* of what they are told.'[18]

The same issue of *Typographica* featured a small 5″×6″ supplement tied around the bind with a string. This inset was *At Remaurian*, a chapbook composed of black-and-white photographs Berger had taken in an estate to the north of Nice and at his friend Sven Blomberg's house in the Luberon mountains.[19] The pictures—of stone walls, shadows on the grass, his wife's naked body—are overlaid with diaphanous paper on which short poems are printed. Each poem corresponds to a distinct photograph. The design, the idea for the delicate paper, was Spencer's, and meant to signal not only the simultaneity of language and image but a more haptic, amorous object: the inception of the aesthetic.

Though *At Remauriam* remains an isolated experiment in Berger's larger body of work, the movement of image and text into deeper layers of experience continued. At the end of his article in *Typographica*, Berger gave some indication of his own ambitions. 'At present', he wrote, 'I am working on a new book in close collaboration with a photographer—Jean Mohr—about the life and philosophy of a country doctor. In this book what can best be said in images is said that way; what can best be said in words is written. Together they make the picture of a man as we both understand him.'[20]

Berger and Mohr spent six weeks in the Forest of Dean, a wooded region in the west of England. They stayed in two extra rooms the doctor, John Eskell, had in the house he shared with his wife. During the days Eskell would take the men on his rounds. Rarely did Berger and Mohr talk to each other when they were at work. Each was engaged in his own means and methods of observation. And together they managed to see a great deal: pregnancies, surgeries, check-ups, house visits, as well as local gatherings, town hall meetings and dances. One night an elderly couple came to the doctor in the throes of despair. Mohr at first hesitated out of

respect; Berger said nothing. But it was Eskell who pushed the photographer to snap away. 'I thought you were here to describe what was going on', Mohr remembered Eskell telling him. 'So why don't you take any pictures?' The photographer demurred. 'Cover everything,' the doctor said.

Back in Geneva, some time went by before Mohr and Berger met to compare their material. When they did they were taken aback by how much each had tried to accomplish in his own medium what the other could express far better in his. When Berger saw Mohr's selection of photos—about two hundred were first developed—he found that a single picture did the work, as is said, of pages. But the reverse was also true. Berger was certain that many of the photographs, especially those that veered towards the literary or expressionistic, were stepping onto turf best left to language. Each of them, they concluded, had tried to write the book on his own. And what they went about innovating over the meetings that followed—and then in collaboration with Gerald Cinamon, a designer for Penguin—was a creative totality in which text and image were woven together: a single, indivisible dramatic event.

A Fortunate Man begins as if it were not a book but a film: an establishing shot shows a car on a provincial road curving beside a field. Turning the page, we find a title card that names both the man we see in a doorway and the object we hold in our hands. In the first two spreads, both crossing the bind, there are no margins. In both, too, there is a sense of absorptive depth: depth through recession, but without a horizon line or sky. The slight opening of the door corresponds to our opening of the book. Our entrance is into a space at once real and imaginative: the rural world of Gloucester.

'Landscapes can be deceptive,' the text reads above a placid country scene. 'Sometimes a landscape seems to be less a setting for the life of its inhabitants than a curtain behind which their struggles, achievements and accidents take place.'[21] The next spread shows a hill at nightfall sparsely dotted with homes. 'For those who, with the inhabitants, are behind the curtain, landmarks are no longer only geographic but also biographical and personal.'[22] From day to

dusk, then, and from space to time. Planar in composition and photonegatives of each other, the pictures work like a set of curtains going up on a performance.

Landscapes can be deceptive. So can photographs. Photographs are full of information but lack narrative, explanation, memory. Hence the role the text can play. Language can help us 'enter into' what we see. One role of the doctor is to discover the relation between symptom and disease; the role of the documentarian is comparable. While a tourist might mistake a book for its cover, the artist means to connect outward appearance to inner logic.

The first act of *A Fortunate Man* discloses a shifting vocabulary of interconnection. At first Mohr's photographs do not feature a single human face. They instead depict storms, sunlight, rivers and the evanescent traces people leave behind on the earth: a hovel, a fence, the wake of a boat. Berger's text, for its part, narrates events of profound human significance: a tree crushing a woodsman's leg, a daughter made infirm by emotional stress, the death of an elderly woman to pneumonia. The prose is unadorned and direct. Berger does not yet thematize the limitations of language, nor does he introduce himself, as a narrator–observer: he could not have been present at the events he describes. The key signature is one of short fiction rather than the essay. The doctor (always referred to as 'the doctor') remains a literary construct. In the opening vignette of the mistaken felling, Berger describes how the mist changed the colour of the tincture, 'making it look yellower than normal'.[23] Here the techniques of fiction—the telling detail, free indirect observation—are marshalled for greater vividness. But none of the events are actually pictured. The texts narrate the 'struggles, achievements, accidents' of members of the community, which we must *imagine*; the photographs present the physical world, which we can *see*. Each belongs to a distinct time-scale. In their combination, landscapes become landmarks.

It is not until some forty pages into *A Fortunate Man* that we first meet John Eskell, now given a (fictional) name: Dr John Sassall. From a distant view of his office, we move into the waiting lounge, and then the operating room. Sassall is

performing surgery on a patient, handling forceps and squinting closely through a magnifying glass. In this second act, the interplay of vision and narrative has shifted again. Here we see the person, but must imagine the life.

Berger's words and Mohr's photographs together make a portrait of an exacting man. Whether absorbed in work ('his hands are at home on a body') or lost in thought (his pipe appearing to be another tool), the creases on Sassall's forehead become emblems of a resolute life. The text dwells for a time on his development: the rebellion against his middle-class parents, the fascination with Conrad and his 'ethic of service', his time during the war in the navy. But the focus is probing. Like a surgeon, Berger searches under the skin of biography to reveal more fundamental anatomies: the archetypal role of the healer, the timeless experience of illness, the metaphysics of grief, the frustrations of a poor community.

As a general practitioner, Sassall exists outside the division of medical labour. He responds to almost every human crisis in the village; only in rare cases would a patient be sent to see a specialist. Such generalism, Berger says, is fundamental to Sassall's vision of himself: the same dialectic of adventure he found in Conrad. 'He has an appetite for experience which keeps pace with his imagination and which has not been suppressed.'[24] (Berger adds a social argument to this: 'It is the knowledge of the impossibility of satisfying any such appetite for new experience which kills the imagination of most people over thirty in our society.') The tradition of the GP has a long and contested history in British medicine. It is alternately revered as an institution and scrutinized as an anachronism. Berger even speaks of Sassall in relation to the ideal of the universal man once prized during the Renaissance.

A Fortunate Man enacts its own anti-specialism. The multiple registers of the prose (dramatic, biographical, rhetorical) and the different forms of photography (landscape, portrait, decisive moment, and so on)—as well as their interrelation —all work against the ways in which knowledge is so neatly compartmentalized into aisles and stacks. Much later Berger would theorize the rise of photography in relation to

nineteenth-century positivism, the way images could become naturalistic fragments of evidence divorced from holistic experience. At the time when he was making *A Fortunate Man* such ideas were still inchoate, but what he later said of the 'uses of photography' retroactively applies to his and Mohr's method: 'A radial system has to be constructed around the photograph so that it may be seen in terms which are simultaneously personal, political, economic, dramatic, everyday and historic.'[25]

As with the artist, the doctor's role, beyond any technical prowess, is also a human role. 'We give the doctor access to our bodies', Berger notes. 'Apart from the doctor, we only grant such access voluntarily to lovers—and many are frightened to do even this.'[26] What the doctor can offer, most fundamentally, is *recognition*. In a community as remote and isolated as the one where Sassall works, the doctor can function as a kind of living archive. 'To some extent he thinks and speaks what the community feels and incoherently knows. To some extent he is the growing force (albeit very slow) of their self-consciousness.' Sassall becomes, in Berger's phrase, 'the clerk of the foresters' records'.

As if to make the metaphor explicit, the book gives way to a series of portraits. The foresters smile and announce their presence to the camera—these are the first posed portraits of the book—while Berger's text pivots to an analysis of the region, which he bluntly characterizes as 'backward and depressed'. The foresters, we are told, distrust intellectuals, with their tool of *theory*. But Sassall is different: he is accepted and valued. After a series of discoveries (such as one where a woman in a couple was shown to be transgendered, a fact which the couple ignored and denied), Sasall 'became aware of the possibility of his patients changing'.[27] He too, in turn, changed. 'He began to realize that imagination had to be lived with on every level: his own imagination first— because otherwise this could distort his observation—and then the imagination of his patients.'[28]

In the book's final act, the tension between imagination and observation, text and image, intensifies. When Berger begins an analysis of grief, we see pictures of grieving people—the

photographs Eskell had pushed Mohr to take. The counter-point is strange and powerful. We are not likely to share the state we witness: it is the very alienation of anguish, the sense of isolation within the self, both physical and emotional, that Berger points to. Photography can only do so much. As one critic has written, 'photography cannot, like language, "look out of" its subject, adopt his/her/its perspective; it can only "look in"; and ... it cannot, like language, "look into" its subject in a penetrative way ... *unless the photograph is part of a narrative*'.[29]

And yet Berger's purpose is not narrative. The couple remain strangers to us. We know they are old, and that they care for one another—that is plain to see; but we are not told their names or what they do, let alone what is wrong or the reason for their sadness. Berger's text turns abstract when we least expect it. 'Anguish has its own time-scale', he says. 'What separates the anguished person from the unanguished is a barrier of time: a barrier which intimidates the imagination of the latter.'[30] By acknowledging the limits of empathic projection, and by writing of a *common experience* rather than subsuming the couple's own within a personal history, the authors invite us to consider the losses that belong to our own lives while simultaneously responding to the sight of emotional nakedness in an elderly man and woman. The gaps between the many layers are left intact. The grieving couple receive multiple frames—including, crucially, their own spread with no overlaid text. The design is to produce an interval of absolute silence and contemplation. The tact is not only personal; it is that of language before what cannot be expressed in words.

Loss provokes both deep feeling and deep questioning. Berger notes that Sassall suffers from periods of severe depression: 'Do his patients deserve the lives they lead, or do they deserve better? Are they what they could be or are they suffering continual diminution? Do they ever have the opportunity to develop the potentialities which he has observed in them at certain moments? Are there not some who secretly wish to live in a sense that is impossible given the conditions of their actual lives?'[31]

As one reviewer, a practising physician, pointed out, Berger was probably influenced by Rieux, the fictional doctor in Camus's *The Plague*, as well as the real-life examples of Albert Schweitzer and Frantz Fanon.[32] Fanon, in particular, helps to shed light on Berger's swift politicization of Sassall's very personal doubts. In 1956, after the Algerian revolution and the outbreak of war, the Martinican psychiatrist resigned in protest from his medical post in Blida-Joinville. 'Monsieur le Ministre', Fanon wrote in his resignation letter, 'there comes a moment when tenacity becomes morbid perseverance. Hope is then no longer an open door to the future but the illogical maintenance of a subjective attitude in organized contradiction with reality.'[33] Fanon was surely a model. And while the deprivation in England was not as wretched as in the colonies, it was, Berger insists, deprivation nonetheless. The picture that emerges (like that of the 'left behind' regions of England and America today) is one not only of material poverty but of wholesale ethical and cultural dehumanization, and its attendant anomie. We all, in Berger's words, 'live in and accept a society which is incapable of knowing what a human life is worth. It cannot afford to. If it did, it would either have to dismiss the knowledge and with it dismiss all pretences to democracy and so become totalitarian: or it would have to take account of this knowledge and revolutionize itself. Either way it would be transformed.'[34]

The fork in the road returns the reader to the doubts generated by the stalemate of the postwar period—and the many pieces that have gone adrift: the 'mustn't grumble' attitude of the working class; their homespun ideology of common sense; the apathy, indifference and impoverishment Berger finds everywhere around him; the moments of human crisis that intersect our lives; and the untenable social contradictions as articulated in the theoretical language of the professional intellectual. The title, *A Fortunate Man*, thus cuts both ways. Sassall is fortunate because he is living a life of purpose and service. He is revolutionary in the Maoist sense of learning from and serving the people. But he is also fortunate because of his privileged position, his education, the fact that his being with the foresters is a choice that rests on his position

within a social hierarchy from which he benefits. How to resolve this?

The solution for Lavin, the hero of *A Painter of Our Time*, came in the abandonment of art for direct political action; for Berger it came in writing the novel. *A Fortunate Man* has no such resolution. It ends on a note of political disgust giving way to agnostic resolve. It is as if Berger is speaking both loudly and softly, both to a room and to himself. His essay— and he repeatedly emphasizes the term—is only a foray, a first pass, an attempt. 'I do not claim to know what a human life is worth', he says, 'the question cannot be answered by word but only by action, by the creation of a more human society.'[35] Until that society has been created, the worth of a doctor 'who has surpassed the stage of selling cures' is, he says, 'unassessable'.[36]

Upon its release *A Fortunate Man* garnered largely favourable reviews, and a bemused attention to its form. The editor Tom Maschler wrote that Berger and Mohr had produced 'a total account' of Sassall, and compared the book to Bresson's *Diary of a Country Priest*.[37] Philip Toynbee, once an enemy, was positive but stopped short of full praise, hesitating before the category of 'Enhanced Documentary'. 'The portrait which emerges', Toynbee says, 'is a sympathetic and deeply interesting one. But has John Berger enhanced his documentary too much? Has he, in the manner of some of his predecessors in the field, merely used his documentary material as a starting-point—as an airstrip from which to make high flights of speculation and highly coloured sky-reflections of an altogether duller and terrestrial reality?'[38]

Has the space between image and text—the space of empathy —become too stretched? Is humanity, Gramsci asked, as a reality and an idea, a point of departure or a point of arrival?

You could've written a novel, couldn't you? Berger was asked by a BBC interviewer in 1967. 'Yes', he replied, 'but a novel has a different kind of tension. Traditionally the tension of the novel is in the narrative.' In *A Fortunate Man*, however, it was in what he called 'the tension of actuality'. 'It

is the tension that one does not know the end of the story, for example. It is the photographs which reveal people.'[39]

The *tension of actuality* is a pregnant phrase that goes some way in explaining the power—and risk—involved in what Berger and Mohr were doing. John Grierson, the grandfather of the documentary tradition in Britain, spoke in similar terms when he defined the genre as the 'creative treatment of actuality'.[40] More recently, the documentary scholar Bill Nichols has used the phrase 'discourses of sobriety' to delineate its domain.[41] *A Fortunate Man* was certainly both creative and sober.

But we may flip the question, and ask why Berger decided to make a book. Why not a film, a documentary proper? In the years leading up to the project he was in fact effusive about cinema in general and documentary in particular, seeing the work of the British Free Cinema movement as a kind of revelation. The 'imaginative connecting power' of films such as Lindsay Anderson's *Every Day Except Christmas* overturned, he had said, the stereotype that documentary was a sedate and, in his words, 'chauffeur-driven' vehicle.[42] Just a couple years later, at the start of the 1960s, the explosions of American direct cinema and French *cinéma vérité* (whose influence on Berger remains evident) made the stereotype obsolete.

In many ways, Berger and Mohr's project did resemble a film: the collaboration between photographer and writer, the time spent 'in the field', the subsequent editing and layout of the raw elements. The correspondence was not just in process but in structure. The image–text pairings on the page often evoke the audiovisual synchronicity of film. On several occasions Mohr's photographs do look like stills of an imaginary documentary, with Berger's text as the voiceover. That Mohr was not an artist of international reputation when the book was released added to this sense: the photographs would not, perforce, be seen as a portfolio of work, as finished works in themselves, but as elements of a patterned whole. Most photographers only attain canonical status once they have produced an iconic image (Lange's migrant mother, Arbus's twins, Strand's blind beggar, and so on); Mohr was different —more of a collaborator from the start.

A Fortunate Man was, of course, not a film. Out of the difference came a range of effects. For one, Mohr's small Leica reflex allowed for nimbler proximity to intimate events; the spring-wound Bolex was mobile, but still substantial and intimidating—to say nothing of a boom mic. A more essential contrast lay in the huge ontological divide between still and moving image, what Roland Barthes called the 'ontological desire' of photography 'in itself'. ('I decided I liked Photography *in opposition to* the Cinema', Barthes reflected, 'from which I nonetheless failed to separate it.')[43] This was a question Berger's hands-on work translating painting into the flow of television had already broached in reverse. Unlike a painting, however, the printed photograph foregrounds its own discontinuity from the flux of life out of which it has been removed. It captures a moment, so that it can be stared at indefinitely. A similar freedom applies to the form of the book. Unlike a movie, a book can be skimmed, read quickly or slowly, picked up and put down. It does not require electricity; it simply requires light. It can circulate widely and variously. It can be carried in a pocket.

Then there is the silence of the book. The book features text (language) but lacks speech, music and sound. We can be told what someone said but not the timbre or tone of their voice. We can see, for example, what Eskell looks like (we never see a photograph of Berger or Mohr), but we do not know what he sounds like. The same is true of the foresters. In one spread, divided into quadrants, three images reconstruct a town hall meeting while Berger's text in the top-left theorizes about theory-makers as understood by the underprivileged. Those who are photographed remain utterly fixed and silent. The result is a strange lifelessness that shifts the burden onto the text, the consciousness of the author, the imagined voice-over, thus inviting Toynbee's critique of Berger's over-embellishment. At times Berger is literally talking down to the foresters on the page.

The contract between documentarian and subject can resemble the contract between doctor and patient. Both involve questions of access, witnessing, tact and recognition; both also raise concerns about confidentiality and violation. It

was only because Eskell was a friend that Berger was granted the kind of access he was, and that he felt confident in his descriptions. At one point near the end of his text Berger meditates on how he would have approached his subject had he not been alive. The hypothetical is likely to haunt the contemporary reader. Many years after *A Fortunate Man* was published, Eskell entered a period of depression, and, following the death of his wife, he shot himself. Knowledge of his eventual suicide risks tinting Berger's psychological scrutiny with an air of unwitting violence. The forcefulness of the sentences and ideas can resemble, at times, acts of domination.[44] Berger speaks; Eskell and the foresters are spoken for.

But books, just like their subjects, also go on to new lives. In the years following its release, *A Fortunate Man* found an unexpected set of readers: students. For many undergraduates of the sixties and seventies it was the book that first made them realize they wanted to become doctors. 'If I could choose only one book on the planet', said Iona Heath, herself a practising physician and writer, 'it would be this book'.[45] Just recently, the *British Journal of General Practice* called Berger's and Mohr's phototext the most important book ever written about the field.[46] The *Nation* suggested it be used as an entrance exam for medical schools.[47] It is a testament to the book's power that it continues to be reprinted and seen as a touchstone for both photo-textual design and documentary as well as medical ethics. The questions of the latter are inextricable from those of the former.

'What the Photograph reproduces to infinity has occurred only once', wrote Barthes, 'the Photograph mechanically repeats what could never be repeated existentially.'[48]

As a study of the contradictions facing committed medical professionals, *A Fortunate Man* remains a singular achievement; when situated back into Berger's own trajectory, it is a transitional work. It anticipates his coming interest in collaboration, rural experience, and the combination of metaphysics with registers of empathic imagination. But it is set apart from his subsequent work by its Englishness. Like Berger's first three novels *A Fortunate Man* concerns an

individual bounded by English society. Its nearest points of aesthetic reference were the films of British Free Cinema, its ambit decidedly regional and national.

After *A Fortunate Man*, Berger would effectively stop writing about England. The transition followed his own expatriation, of course, but not immediately; politics was just as important. By the middle of the 1960s Berger's attention, like that of much of the left, had moved from domestic socialism to global anti-imperialism. The Cuban revolution, the Tricontinental struggle, and a string of publications from thinkers as diverse as Frantz Fanon, Mao Zedong and Che Guevara transposed the Marxist divide between capital and labour onto the split between the North and the South. 'The division of labour among nations', wrote Eduardo Galeano at the start of *Open Veins of Latin America* (1971), 'is that some specialize in winning and others in losing.'[49]

On one level, then, Third Worldism was simple. It set out a stark equation, seeing the world as a Manichean struggle between oppressor and oppressed. On another level, however, the transistor circuits of globalization seemed to bring a near-indecipherable complexity to modern systems. For Fredric Jameson, writing the very same year as Galeano, the 'sticky cobwebs' of the postmodern economy meant that there was 'no tactical or political question which is not first and foremost theoretical … Not whether the street fighter or urban guerilla can win against the weapons and technology of the modern state, but rather precisely where the street *is* in the superstate, and, indeed, whether the old-fashioned street as such still exists in the first place'.[50]

Had the classically Newtonian laws of Marxism become, in the overdeveloped economies, new Schrödinger waveforms of derivatives, securities, futures, and their corresponding ideological distortions? Was multinational capitalism black and white, or was it a convoluted black box? In short, was globalization simple, or was it complex?

Such questions went to the root of Berger's thought. He had always written in the plain style ('to choose words as though they were arrows which had to find their target');[51] yet the forms he was adopting as the New Left took off flaunted their

intricacy: cubism, dialectical montage, the so-called art of interruption. In *A Fortunate Man*, written before such transitions fully took hold, he had already rejected 'the false view that what people cannot express is always simple because they are simple'.[52] At the end of his book on Picasso, written as they accelerated, he imagined what he called 'another kind of success': 'a success which will operate in a field connecting, for the first time ever, the most complex and imaginative constructions of the human mind and the liberation of all those peoples of the world who until now have been forced to be simple'.[53]

The divided loyalty between word and image was now abutting a very real political dialectic: a sharpening of the contradictions between economic theory and personal experience, abstract flows and common sense, the new anti-humanist Marxism with the old socialist humanism. It was also a dialectic at the root of Berger's next serious collaboration with Jean Mohr, the book he remained proudest of until his death: *A Seventh Man*.

During the second half of the 1960s Berger's writing was powered by a new sense of continental European identity, and a growing political globalism. He spent five solid years at work on *G.*, his neo-modernist world novel (more on that later), and on regular essays for *New Society*. When he was asked to write a monograph on the Russian dissident sculptor, Ernst Neizvestny, Mohr provided the photographs. The two friends (and now they were friends) travelled to Moscow, Mohr studiously photographing the art while Berger and others did the talking. Quiet, dependable, focused, often unassuming, Mohr was trusted by Berger. The two of them, as well as their families, had grown very close.

By 1971, having finished *G.*, Berger now had time to throw himself into fresh projects. Some of these, such as *Ways of Seeing* (1972), made with Mike Dibb, became unexpected landmarks; others, such as an experimental film made the same year about Zola's *Germinal*, remain regrettably little seen. Mohr, for his part, had been travelling as a freelance photographer throughout Europe, often being sent further

afield: to Algeria, the Central African Republic, Sri Lanka, the Philippines. He was busy building a career for himself, amassing a vast personal catalogue of photographs in the process.

One day in Geneva, Berger talked about an idea he had for a project on migrant labourers. Berger thought Mohr could help. 'I know the theme fascinates both of us', Mohr remembered him saying. 'You already have a collection of pictures on the subject. Why not put a book together?' Penguin was amenable. Berger's fame was at its height. The first printing of *Ways of Seeing* sold out in a month; within two months almost 60,000 copies had been sold.

In 1973, the two began work on the project. Mohr started culling images from his own archives and made a series of trips to Turkey, Spain, Germany and Italy. The more dispersed nature of the subject—not an individual but a phenomenon and demographic—led to a more dispersed collaborative process. Mohr gathered his photographs; Berger gathered his text; later they would gather as a group, including the designer, Richard Hollis, and a mutual friend, Sven Blomberg, to arrange the book. The rapid influx of migrant workers (in the 1960s the early *Gastarbeiter* programmes were expanding) also meant they frequently did not have to travel far at all. When Geneva announced plans to build a new sewer system, the city hired almost entirely foreign labour. Men from Yugoslavia, Greece, Andalusia and Calabria were far cheaper than the native Swiss. In the country on temporary work visas, they were also more compliant. When a group of Spanish workers demanded better conditions they were sacked and sent back to Spain. The photographs Mohr took of the tunnels—men in helmets, gas masks and headlights— along with an excerpt of Berger's text about the incident, appeared in the *New Left Review* under an unambiguous title: 'Directions in Hell'.[54]

From the start, *A Seventh Man* was conceived to be at once epic and intimate, a montage of perspectives. The finished book combined aerial photography with portraits, macroeconomy with the minute rendering of everyday experience. Alongside its theoretical assertions the text narrates

an archetypal journey from south to north undertaken by an unnamed male hero, 'He'. The jargon of economics thus shares the page and is often cross-cut with the sights, sounds and feelings of the migrant as he travels, works, sleeps and remembers. The emphasis is on the commonality of the experience; the implication is that 'He' could be any one of the migrants we see photographed. (Gender was an acknowledged if glaring blind spot: in an introductory aside, much as he wrote off Sassall's wife and family in a footnote, Berger explains that his focus is on male migrants, especially those from southern Europe and Turkey.)

The epic usually connects a hero's mythic saga with the foundational myth of a civilization or nation. Understood in this light, *A Seventh Man* functions as an epic not of a given national culture but of our collective globalized modernity— of modernization itself, what Berger calls, in the book's preface, a 'dream/nightmare'. On one level, the dream/nightmare is the personal ordeal of migration, stretched between the twin poles of hope and fear. On another level, though, it is the universal passivity we all share before a global economic system so complex, reified and powerful it can seem like a force of nature. While the migrant may, once he arrives, live on the margins of the city, he is, in Berger's view, the figure most central to an understanding of our situation. 'To outline the experience of the migrant worker and to relate this to what surrounds him—both physically and historically—is to grasp more surely the political reality of the world at this moment. The subject is European, its meaning is global. Its theme is unfreedom.'[55]

Through a series of interruptive shocks (and Brecht was certainly a model), Berger and Mohr try to wake the reader from the dream. At times the photographs depict entire shanty towns that do look as if hit by some catastrophe: the so-called 'storm of progress'. Others present a much more human register. We see faces of migrants, pictures of their children and families back home (a kind of collective 'family album'), the tedium of the assembly line, the blandishments of the urban visual environment, and, in the book's most impactful visual passage, a line of aspiring Turkish workers standing in their

underwear to be weighed by medical inspectors like cattle.

The text, for its part, is also a stream of shocks. Freestanding paragraphs appear in boldface, a textual mix of the personal and anonymous, poetry beside statistics. As in Homer, there are lists and incantations: 'They come here. What do they come for?' 'He. The existence of the migrant worker.' Authorship is multiple. We encounter a collage of sources—Marx, Joyce, Raymond Williams, Henry Ford—only tallied in an afterword. As Attila József tells us at the start of the book: 'If you write and can afford it, / Let seven men write your poem'.

The most significant criterion for an epic is of course that of the hero, and Berger's unnamed male migrant exhibits the courage and resolve of a warrior. In one sense the heroism is acknowledged by the community he left behind (Beowulf was made king of the Geats); but economic prestige—itself a goad for young men to leave the village—is not what Berger endorses. Nor does he celebrate the protestant virtues of industriousness, thrift or prudence. This is not a migrant story with a happy ending. (The possibility of final assimilation was not yet widespread at the time Berger was writing; most migrants, he says, entered with temporary work visas.) Instead, the migrant's heroism derives from his stoic capacity to endure exhaustion, exile, even abuse in order to provide for his family.

At one point the text considers the theoretical intersection of race and class—the argument that migrants, on the one hand, put pressure on the indigenous workforce and add to the economic (and sexual) insecurity of the native proletariat, while, on the other hand, they remain the most exploited of all, the first to be made redundant and to perform the most menial of tasks. Berger refers to this contradiction as a 'first calculation' and a 'second calculation'. Out of these comes a third—less a dialectical synthesis than a Brechtian interruption against itself, the collapse of distanciation into its opposite. The text reads: 'Third Calculation. That he will save enough soon enough. That his woman remains faithful to him. That in the meantime he can arrange that some of his family join him. That when he once has set himself up at

home, he will never have to return here. That his health holds
out.' This is the most telling contradiction of them all. The
migrant must sell his life in order to live.

O ver the course of the 1970s, owing partly to his work
with Mohr but more directly to his many essays on the
subject, Berger became increasingly well known as a theorist
of the photograph. To this day he is often grouped alongside
Susan Sontag and Roland Barthes as one of the trinity of
essayists to have brought an analytic curiosity in photography
to the mainstream. Many contemporary commentators place
Berger alongside Sontag in particular. The perceived dialogue
between the two was aided by the pair's friendship and cor-
respondence (an affectionate blurb by Sontag appeared on
most of Berger's American books for a time) and by Berger's
influential essay, 'Uses of Photography' (1978), which was
dedicated to Sontag and stated at the outset that it was an
extended response to her own collection on the medium.

The fundamental point of contention between Sontag and
Berger centred on the status of the photographic image in con-
temporary culture. According to Sontag, photography turns
the world into 'a series of unrelated, free-standing particles'
and history into 'a set of anecdotes and *faits divers*'.[56] Like
other intellectuals responding to the rise of a deeply spectacu-
lar and ideological visual environment (Debord, Baudrillard
and others), Sontag viewed the photograph as a kind of *sub-
stitute*. The photographic picture, in her view, replaced the
organic unity of lived experience with a comprehensive, sim-
ulated, vicarious, anaesthetic and ultimately surveilling web
of images. The camera was, in Sontag's words, 'the ideal arm
of consciousness in its acquisitive mood'.[57]

For Berger it was also something else. In his response to
Sontag he drew a fundamental distinction between its public
and private forms. The private photograph, for him, was
'appreciated and read in a context which is continuous with
that from which the camera removed it'.[58] When used in
these instances, the camera was not simply acquisitive; it was
also 'an instrument to contribute to a living memory', the
photograph it made 'a memento from a life being lived'.[59]

The corollary was clear. For the public photograph to be re-invested with meaning, a comparable context had to be built around the image so that its significance could be felt in relation to a more unified whole. (Such a context was precisely what Berger thought missing in the Vietnam War photographs of Don McCullin—whereas, for Sontag, McCullin was an exemplar of the 'photography of conscience'.)

Individual photographs can have their effect on us, but their deeper meaning, according to Berger, is best understood in relation to the ways they are reintegrated into a living context—like frames in a film. If done successfully, the kind of universal family album Edward Steichen attempted but failed to achieve would again become an approachable ideal. Whereas so many anti-humanist critics of the 1960s and after threw out the baby with the bathwater (rejected universalism along with the ways universalism had been misused to construct normativity), Berger wanted to hold on to the fundamental premise. 'What is saved in the cinema when it achieves art', he said of a related medium, 'is a spontaneous continuity with all of mankind.'[60] The neorealist screenwriter Cesare Zavattini had said something similar: 'The powerful desire of the cinema is to see and to analyze … for truth is a kind of concrete homage to other people, that is, to all who exist.'[61]

Perhaps the truest model, then, for *A Seventh Man* was not the poem (as per József), but, as for *A Fortunate Man*, a film-in-book-form. What had changed between the two books, was simply the conception of the cinematic. If *A Fortunate Man* grew out of the neorealist tradition and its extension into the documentary, *A Seventh Man* was built on the newly rediscovered tradition of montage: the Marxist modernism of the left-wing film essay.

'The essence of cinema', Eisenstein had said, 'does not lie in the images, but in the relation between the images!'[62] Pioneered in Berlin and Moscow in the 1920s, only to be suppressed by fascism and Soviet edicts, the art of montage broke free again as part of the political modernism of the 1960s. In 1968 Godard and Jean-Pierre Gorin formed the Dziga Vertov Group (and sections of Vertov's *Man with a Movie Camera*

appeared four years later at the start of *Ways of Seeing*). In 1969 *Cahiers du Cinéma* embarked on the Eisenstein translation project. The same year saw *The Hour of the Furnaces*, a cornerstone of montage-inspired Third Cinema, electrify the left. What montage promised so powerfully was a revolutionary technique that not only aligned the artist with the worker (*montage* from *monter*: to build or assemble) but one whose very form seemed to resemble the dialectical process. As with cubism, the world was no longer seen from a single viewpoint. As with Marxism, reality was understood as a confrontation of opposing forces, classes and perspectives.

By the early 1970s, growing partly out of his interest in cubism and participating in these broader trends, Berger adopted the method of montage for both thought and composition. His essays began to move outward from conjunctions: Turner *and* the Barbershop, Francis Bacon *and* Walt Disney, Seker Ahmet *and* the Forest. 'The model', Berger said of Marx, 'is no longer an edifice constructed stone by stone or phase by phase, but a pivotal balance like that of a pair of scales or a see-saw … From paragraph to paragraph one proceeds by leaps from point to point … The mode of discontinuity demonstrated by Marx's thinking has now become an essential part of the modern means of communication. Discontinuity is now intrinsic to our view of reality.'[63] A work like *A Seventh Man*, itself a conjunction of media, gained its force not from the inherent meaning of any individual element, whether a paragraph or a photograph, but from *the collective shape of their arrangement*. Only through that shape—that pivotal balance—could a new totality be perceived.

The relationship of system to experience was at the heart of the matter. At its origins the New Left in England had been buoyed precisely by a shared belief in 'the singleness of human life'.[64] Fifteen years on, though, the pendulum was swinging in the opposite direction. By the time Berger was at work on *A Seventh Man*, the more academic left was mounting a critique of its elders. Even Anthony Barnett, a close friend of Berger's at the *New Left Review*, spoke of the error involved in overvaluing experience as a route to political knowledge. Experience, for Barnett, may be 'a valid

check on theory', but 'the laws of motion of capitalism as a global system', he said, could only be grasped through 'arguments of the abstract kind'.[65] The consequences of those laws of motion 'will be experienced', he clarified, but the workings of the system 'cannot be uncovered by experience'. Some years later the division became almost axiomatic, so trained had the First World been in a 'deep cultural conviction', to quote Fredric Jameson again, that 'the lived experience of our private existences is somehow incommensurable with the abstractions of economic science and political dynamics'.[66]

It is this dichotomy—theory versus experience—that *A Seventh Man* broaches, refuses to accept, and means to subvert. Hence the montage; hence its alloyed form. It is neither an argument nor a story, but a hybrid of juxtapositions. The dualities at its heart are thus geographic (north/south), psychological (thought/feeling) and ontological (system/life-world); but the means by which they are brought into focus is *aesthetic*. Through a literal scissors-and-glue method, the book dismantles and reassembles our compartments of cognition. The strategy is to appeal alternately to the intellect and to the emotions, to connect the two, to see one through the other, and to explore the ways in which the contradictions of global capitalism manifest themselves in the very division between thought and feeling.

'We asked for workers', the Swiss playwright Max Frisch wrote of the *Gastarbeiter* programmes, 'and we got people instead.'[67] And yet the division of labour among nations has rent the inner continuity on which any meaningful personhood can rest. (Just as we get only one male half of the picture, only one section of *A Seventh Man* documents the possible gaiety of exilic communities, the dance and drink—but even here the mood is melancholic.) The migrant being brought to the metropolis as a *resource*, his subjectivity is divided not only culturally and geographically but in its very essence: a split symbolized in the powerful image of the torn portrait, appearing in the narrative just before he is stripped and inspected at the frontier. One half of the photograph is kept by the smuggler as proof that he has met his side of the

bargain; the other half the migrant will mail to his family once he reaches the metropolis—his absence made full.

Aristotle spoke of all stories deriving from two archetypes: either a hero setting off on a journey or a stranger coming to town. The second, we notice, is simply the first seen in reverse. It is also the only way native citizens receive immigrants. Those who have made the voyage see it the first way. For them it is an epic journey to a new life. This is the dialectic, binocular vision of Berger and Mohr's project. Stretched between the storms of progress and the search for home, the migrant's suffering is entirely his, and yet it is also more than his. It belongs to what the Brazilian photographer Sebastião Salgado called, in a conversation with Berger some two decades later, 'a tragedy the size of the planet'.

'The image and the word are breeding', Berger had said in 1964. He was right. The following decade saw a series of revolutions in design, layout, film form, aesthetic experience, and much else besides. By the mid 1970s, however, the procreating storm was dying down.

The road *A Seventh Man* took from composition to publication was far from smooth. There were a number of obstacles internal to Penguin. Berger's close friend, the editor Tony Godwin, had been transferred to New York, and the new staff in London were against the project. Neil Middleton, who had replaced Godwin, wrote to Berger of the 'bad feeling' generated by the demands placed on the production department. He likewise complained of the 'lack of professional care and the failure to understand a lot of the simple mechanics of book production' on the part of the book's designer, Richard Hollis.[68] (Hollis later went on to become one of the most celebrated designers of his generation.) Because of a series of mistakes attributed to their unorthodox layout, a correction bill was set against royalties. *A Seventh Man* was a commercial failure. It marked the end of Berger's relationship with Penguin.

In 1982, Berger and Mohr collaborated on a third book, but the close attention to image–text pairing was gone. *Another Way of Telling* featured a densely argued, at times

overwrought, essay on the inherent ambiguity of the photograph, its ontological difference from drawing, and the way it can be paired with words to create a new syncretic meaning. Berger's essay, simply titled 'Appearances', was a kind of capstone: beginning with his chapbook for *Typographica*, it traced two decades of thought, the rise and fall of the New Left, and then, with a kind of Doppler delay, the rise and fall of structuralism.[69] With its 'love of closed systems', structuralism, in Berger's view, had lost the visual for the linguistic. In his later essays Berger would refer again and again to the mystery, enigma or miracle of visibility—the sheer astonishment that the visible world could come into existence at all.

It is revealing, then, that the only photo-sequence contained in *Another Way of Telling* lacks words. The sequence at the centre of the book, to which the title presumably refers, features a series of about 150 uncaptioned black-and-white photographs taken by Mohr and arranged by Mohr and Berger. The prefatory note suggests the sequence 'attempts to follow an old woman's reflections on her life'.[70] The old woman, however, is a fictional woman. We are told she is a peasant; she is unmarried, lives by herself, and has survived two world wars. The correspondences of the photographs to her memory are not literal. 'We are far from wanting to mystify', the text begins. 'Yet it is impossible for us to give a verbal key or storyline to this sequence of photographs. To do so would be to impose a single verbal meaning upon appearances and thus to inhibit or deny their own language.'[71]

How are we to read this abdication of the verbal to the visual? Berger's two previous collaborations with Mohr had been predicated on just the opposite—a kind of mutually fructifying tension meant not to fix but to contextualize and condition our vision, to help us move around, beneath, beyond the photograph while never quite relinquishing its undeniable presence. In *Another Way of Telling* the text and images keep their distance from each other. It is as if the aesthetic of *tact*—the space between the conceptual and the imagistic—has widened to such a degree that it has collapsed back into the traditional forms Berger originally tried so hard to surmount. Most commentators expressed a residual

disappointment that the photo-sequence could not carry what was implicitly asked of it—that, in effect, this other way of telling was also a lesser way.

Perhaps Berger and Mohr's first two books are more deserving of the third book's title. *A Fortunate Man* and *A Seventh Man* truly innovated a powerful and haunting new form. If *Ways of Seeing* became so influential as to seem now, in retrospect, almost out of date—its influence disseminated, internalized, and since moved on from by the culture—*A Fortunate Man* and *A Seventh Man* were not picked up in the same way. They remain beacons on the horizon. Today we are awash in documentary films; the documentary photo-text remains a largely unexplored proposition.

It was only in the expanded media environment of the postwar decades that Berger found a resolution to the divided loyalty he had felt since he was a boy. In the last half-century our media environment has expanded beyond all predictions. Film photography is all but extinct; television is soon to be extinct. We inhabit a new digital world of signals, antennae, satellites, selfie-sticks, smartphones, VR goggles, and, most of all, *screens*: at gas stations, in the back of taxis, on aeroplanes, in our pockets. It is a platitude but it is true: we have never been more connected, and yet we have never been more alone.

With the digital transformations of the twenty-first century, Berger returned to his first love: drawing. His childhood journals combined poems and sketches; one of his last books combined drawing and metaphysics. Inspired by the life of Benedict Spinoza, *Bento's Sketchbook* (2011) reminds us not only that the seventeenth-century philosopher believed the split between the mind and body to be false, but also, less famously, that he liked to draw. The sketchbook Spinoza was said to have kept captured Berger's imagination. 'I wasn't expecting great drawings in the sketchbook were it to be found,' he said. 'I simply wanted to reread some of his words, some of his startling propositions as a philosopher, whilst at the same time being able to look at things he had observed with his own eyes.'[72]

5

A Toast to Modernism

One minute in the life of the world is going by. Paint it as it is!
Cézanne

Towards the end of *G.*, its author's best-known novel, the title character takes a Slovene peasant girl to a ball. All of Austro-Hungarian Trieste is there, including the banker husband of a woman he plans to seduce. It is a calculated offence—a humiliation. Within minutes, 'everybody was recounting or discussing the scandal ... A Slav girl from the villages, dressed outrageously in pearls and muslin and Indian silk.'[1]

On the evening of 23 November 1972, John Berger attended the black-tie award ceremony for the presentation of the Booker Prize. The event, held in central London at the Café Royal, was to be hosted by Roy Jenkins, then a Labour MP known for his position in the party's 'radical centre'. Sitting alongside Berger, at one of the ballroom's many round tables, were Anna Bostock; Walter Bgoya, his guest and the Tanzanian founder of the African Books Collective; the influential publisher Tom Maschler and his wife; the editor Tony Godwin; Huw Wheldon's widow; and the literary critic George Steiner (who, along with Cyril Connolly and Elizabeth Bowen, had made up the selection committee).[2] At the end of the evening's proceedings the announcement was made: Berger's novel had won.

What came next has since become part of Booker lore. When he took the stage Berger denounced the prize for its

distasteful competitiveness, its obsession with winners and losers, the way the contest reduced writers to racehorses. But he saved the brunt of his scorn for the award's patron, the Booker-McConnell corporation, whose immense fortune rested on extensive holdings in the West Indies. Berger remarked on the irony that, should the money he was offered go towards his next project on migrant workers, the book would be financed by the exploitation of the relatives of its subjects. 'One does not have to be a novelist seeking very subtle connections to trace the £5,000 of this prize back to the economic activities from which they came,' he said.[3]

The speech generated immediate hostility. Many guests began to clink their glasses. Others shouted over him. Berger, who had been tipped off earlier in the week that he would be awarded the prize, had been on television the day of the gala to announce his plans. He was going to give half the money, as a gesture of solidarity, to the London-based Black Panthers.

The provocation is there from the start. 'Since you have awarded me this prize', he began, 'you may like to know, briefly, what it means to me.'[4] At one point Rebecca West apparently shouted back: 'We don't want to know what you're going to do with the money. Shut up and sit down!' Another comment reportedly came from the playwright Max Gebler—'If you're so intent on giving money to murderers why don't you give it to the IRA!'—before Jenkins interjected: 'Let him speak.'[5]

'First, let me make the logic of my position really clear,' Berger said:

> It is not a question of guilt or bad conscience. It certainly is not a question of philanthropy. It is not even, first and foremost, a question of politics. It is a question of my continuing development as a writer: the issue is between me and the culture which has formed me.
>
> Before the slave trade began, before the European dehumanised himself, before he clenched himself on his own violence, there must have been a moment when black and white approached each other with the amazement of potential

equals. The moment passed. And henceforth the world was divided between potential slaves and potential slavemasters. And the European carried this mentality back into his own society. It became part of his way of seeing everything.

The novelist is concerned with the interaction between individual and historical destiny. The historical destiny of our time is becoming clear. The oppressed are breaking through the wall of silence which was built into their minds by their oppressors. And in their struggle against exploitation and neo-colonialism—but only through and by virtue of the common struggle—it is possible for the descendants of the slave and the slavemaster to approach each other again with the amazed hope of potential equals.[6]

The Booker speech remains Berger's most searing piece of rhetoric. Along with *Ways of Seeing*, which premiered on the BBC the same year, the denunciation helped to make 1972 the high-water mark for his fame. The scandal continues to be a hallmark of his legacy, having all but eclipsed the book itself in the public's memory.

Like a moon circling around a planet, the speech has a curious relation to the novel that occasioned it. The two share a connection, but it is not a straightforward one. The speech was almost a lived-out coda to the book, the uproar it produced like a scene contained within it.

Berger had left England a decade before, but now he was back. And the whole *mise-en-scène* of his return—the revolutionary writer alone under the lights, looking out over the cultural establishment—embodied the very problematic his novel had tried to work out. *The issue is between me and the culture which has formed me.*

The flustering of institutions—literary, sexual, political— was part of the novel's DNA, built into it from the start. Recounting episodes from the brief but varied life of its hero— never named, but denoted 'for the sake of convenience' by a single initial—G. is, among other things, a biography.[7] Born in 1886, the illegitimate son of a Livornese merchant and his capricious American mistress, G. is sent as a child to be

raised by his aunt and uncle on a derelict English manor. His boyhood is recreated in a tableau of phenomenal events: a precocious infatuation with a governess; a frightening twilit encounter with two poachers; an injury that knocks out his teeth; a visit to Milan, where he wanders out of a hotel and into the riots of 1898; and then, finally, at fifteen, the transgression into adulthood through an incestuous encounter with his aunt.

G. was billed as a retelling of the Don Juan myth, and its second half veers into a series of picaresque seductions. We find G., now a wealthy and aimless traveller, seducing a maid in Switzerland as aviators compete to make the first crossing of the Alps. We find him next in Domodossola cuckolding a car manufacturer. Later, on the eve of the Great War, he appears in Trieste, where he flirts with the wife of a Hapsburg official, and, suspected of espionage, is followed by a cell of Italian irredentists. On the novel's last page G. is struck on the head and dropped into the sea.

'The struggle has been a long one', Berger said in 1968, 'but during the last few years the right to write openly about sex has been won.'[8] In G. he certainly writes openly about sex. The 'cloacal obsession' H. G. Wells complained of in Joyce is everywhere in abundance. When it wants to be, the writing is melodramatically vivid. The floral image seems to have been a favourite. 'Thus a cyclamen opening … the sensation of his penis becoming erect again and the foreskin again withdrawing from the coronal ridge.'[9] At one point the text gives way to a drawing of the male and female genitals. A few pages later there is a gleeful sketch of an hermaphroditic phallus with breasts, lips and an eye with lashes.

The confluence of frank sexuality, aesthetic experimentalism and public scandal forms a particularly robust and laurelled lineage of modernism.[10] In the heyday of the 1860s there was Manet's *Olympia*; a year later Courbet's *L'Origine du Monde*. Berger's own ornate renderings derived partly from Picasso. In the artist's portraits he had noted the sexual disfigurations of the face (the nose as phallus, the mouth as vagina), and spoke of *Les Demoiselles D'Avignon* as a 'raging frontal attack'. At the height of literary modernism

there were Joyce, Lawrence and Miller. Then, in the 1950s and 1960s, Nabokov, Roth and Vidal. What has been called the aesthetics of obscenity has proved an impressively deep creative well for artists, not to mention an obliging fountain for publicity. Artistic and sexual rebels both perform in order to provoke. Both set out to shock the same people: the self-appointed defenders of good taste.

Berger was around forty when he began *G.*, and still had much to prove. As a young man he had riled the establishment in London, breaking the taboos of the Cold War; but when he left, London seemed do fine without him. His first three novels sold poorly. It was as if, to do his best work, he needed an opponent. With the book on Picasso he had found one, but as polemic it was a regression into his old identity as a critic, not a step towards his new one as a writer. 'I wanted to change my role', Berger later said of his thirties, 'to write imaginative works of one kind or another. I found that nervous energy was spent trying to escape from role-placing. From early childhood on I've been curiously at odds with the categories by which things are sorted out, judged, assessed in England. I felt like rolled out pastry on which shapes were being pressed: there was a lot left over which wasn't being used.'[11]

He worked quietly on *G.* for half a decade. The novel became the gathering place for all his many ambitions, those both coming and going—a monument to ambition itself. Like someone encountering a modernist sculpture, you have to walk around it to appreciate its many sides. It is at once an experimental refashioning of the bildungsroman; an attempt, as one reviewer put it, to 'translate Cubism into literary terms';[12] an alignment of sexual, political and aesthetic revolutions; and the coordination, often in counterpoint, of the phenomenal flow of lived experience with the totality of the historical process. If Berger's debut, *A Painter of Our Time*, was a means to write his way out of political despair, *G.* reflects a period of tremendous self-belief. The syntheses it proposes reveal the faith Berger at one time placed in the form of the novel—its capacity to cover huge areas of history and experience—and in the neo-modernist aspiration for

truer and as yet uncharted regions of expression. 'Everything I have written', he said in 1971, 'has been no more than a preparation for the work of the last five years on G.'

The tradition of the totalizing novel reached a series of pinnacles in the great modernist monuments of interwar Europe, and G. patently flaunts its debt to this lineage. On its release it was compared to Joyce, Musil, Mann, Svevo, Dos Passos, Lawrence and Gide. Joyce in particular was a reference. G. was signed 'Geneva Paris Bonnieux / 1965–1971'; Ulysses 'Trieste Zurich Paris 1914–1921'. Since his youth, Berger had been fascinated by the Irish author. Like Odysseus, Joyce was imagined to be an epic, exilic hero, traversing oceans in his work. In a late essay Berger described his first encounter, at fourteen, with Ulysses—a book he did not so much read as 'sail into' and 'navigate'.[13]

It was also a book that, on the most personal and practical of levels, stoked middle-class fears. Part of its appeal was that it had once been banned—the aura of illegality was inextricable from its literary prestige. In the autumn of 1941, a war raging, Berger's father, anxious about his son, confiscated the novel and locked it in his office safe. 'I was furious as only a fourteen-year-old can be,' Berger later remembered. 'I painted a portrait of him—the largest canvas I had done to date—where I made him look diabolic, with the colours of Mephistopheles.'[14] But the idea of Ulysses locked up in a safe, set beside his father's classified documents, also captured Berger's young imagination. Great literature could be—ought to be—dangerous.

'The brushstroke is not simply a record,' Alex Danchev wrote of Cézanne. 'It is a unit of experience: calibrated, targeted, cogitated, yet pulsing, vexing, responding to its neighbors like a rhythm or a beat. The building of the painting is both planned and extemporized. The sensations are in sync.'[15]

As with a painting, a novel. As with a brushstroke, a paragraph. The stanzaic structure of G.—unindented blocks of prose set at varying intervals on the page—allowed for the angularities of a modernist canvas: from close-up to

panorama, from the taste of a cherry to the outbreak of war. It was also a personal breakthrough. Berger's writing had always tended towards the compact and aphoristic; now a longer work could be built up through the sequencing of shorter bursts. G. was quite literally a montage project: Berger and the designer Richard Hollis spent several days laying out the manuscript with scissors and tape. Intercut with the fiction are reproduced quotations, newspaper clippings, drawings, poems, a scrap of sheet music. In metafictional asides, Berger discusses his process, his dreams, the nature of language and sex. Time distends and contracts. Perspectives spiral around each other. Different tenses—then and now—compete for dominance, as though the fundamental cubistic distinction between flatness and depth were playing out in a stereopsis of time: writing as the evocation of a past reality, but writing, too, as the trace of an act.

Throughout the novel, but particularly in the sections set during the 1898 Milan uprising, the 1910 crossing of the Alps and the 1915 outbreak of war, Berger pressurizes a related dualism inherent to historical fiction: the blurring of fact and fantasy. A staple of the genre (from Balzac to *Forrest Gump*) is to insert an imagined character into historical events, so that intimate dramas crosshatch the public record. Lukács praised Tolstoy as the master practitioner. Berger's technique is similar—though jagged rather than smooth. The juxtaposition is even remarked on within the drama, as when Weymann, a straitlaced American aviator, upbraids G.'s 'childish' antics. 'We are pioneers', he tells G., now a seducer by trade, on a night flight above Brig, 'how can you compare what we are doing—the early birds like us—with a twenty-four-hour infatuation with a little Swiss waitress whom you haven't even spoken to. How can you put one before the other like that.'[16]

The method is Berger's own. In one of the most dazzling passages, only pages later, he crosscuts between Géo Chávez's legendary flight over the Simplon Pass (a set-piece of *aeropittura* in prose) and the revelatory sexual union of G. and the girl Weymann refers to. 'Never again', the text reads, 'will a single story be told as though it were the only one.'[17] The

declaration works like a hinge: the bed on the one side, the aeroplane on the other.

'Behind all creative criticism,' Berger wrote when he was not yet thirty (and not without a touch of the sad grandiloquence of youth), 'there is doubt and a tragic contradiction ... great creative criticism only occurs when a hope, a theory of art, promises more than the practice of it, when the writer has a vision of art in his mind which no painting, nor poem, nor song can altogether equal in largeness, generosity, brilliance ... In all great criticism one finds the vision of a New State, and yet not a brick laid towards directly building it.'[18]

In the same article, Berger cites a journal entry of Delacroix: 'Criticism follows the works of the mind as the shadow follows the body.' But he reworks the metaphor in relation to Tolstoy, Ruskin, Baudelaire and Morris. What if criticism, he asked, was the shadow *preceding* the body? What if it was less an evaluation than a *plan*?

This was certainly the case for Berger's essays leading up to *G*. 'We hear a lot about the crisis of the modern novel', he said in 1967:

> What this involves, fundamentally, is a change in the mode of narration. It is scarcely any longer possible to tell a straight story sequentially unfolding in time. And this is because we are too aware of what is continually traversing the story line laterally. That is to say, instead of being aware of a point as an infinitely small part of a straight line, we are aware of it as an infinitely small part of an infinite number of lines, as the centre of a star of lines. Such awareness is the result of our constantly having to take into account the simultaneity and extension of events and possibilities.[19]

Rooted in the spatialization of narrative time, the geometric metaphor reappears in several passages of *G.*, fragments that readily announce themselves to be hermeneutic master keys, ruminations on how the novel was made, and should in turn be read. In one Berger defends the peculiarities of his style. 'But I have little sense of unfolding time,' he writes. 'The relations which I perceive between things ... tend to form in my

mind a complex synchronic pattern. I see fields where others see chapters.'[20]

Perhaps Berger insists too much. Perhaps the shadows were also projections. Though David Caute accused him of 'employing and rather overtaxing' the devices of the *nouveau romanciers* (Caute's review mentioned Sarraute, Sollers and Butor), what one feels in *G.* is not the annulment of story but rather its expansion into as many dimensions as possible.[21] While the French Structuralists staged an attack on the very concept of narrative—its sentimentality, conventions, bogus psychologism and so on—Berger's method seems to derive if anything from a more deeply felt humanism, the belief that supporting characters are always the heroes of their own lives. It was a sympathy that ran all the way through his work to the end: the title of one of his final fictions was *Here Is Where We Meet: A Story of Crossing Paths*. 'The number of lives that enter our own', he said, 'is incalculable.'[22]

How to express such plenitude? If the novel is an ocean (and the reader a sailor) then what defines its shores? Or, to flip the metaphor, if each moment is a star, then how to place things on the page? How to touch infinity?[23]

The formal solution Berger seems to have worked out is a narrative cubism: the undermining of monocular perspective, the unsettling of partitions between foreground and background. When *G.*'s aunt is taken to South Africa she brings the novel with her. For several pages we shuttle through this otherwise minor character's perceptions: the mute exchange of glances shared with a Zulu rickshaw driver, the colonial dinner party full of silver candelabras and, finally, her own unmooring and 'tilt' into psychosis. Then, just as abruptly as we have been brought to Durban, we find ourselves back in the English country manor where *G.* is now fifteen and his aunt, thirty-six and returned home, invites him into her room to sleep with her.

This is narrative whiplash with a vengeance. Other disjunctions recur in time as well as space. *G.* was born four years after the death of Garibaldi, we are told, prompting a discussion of the general's campaign in Naples. Another chapter begins with a description of a public statue in Livorno of

Ferdinando de Medici flanked by four chained slaves (in his Booker speech, Berger called this 'the most important single image of the book').[24] As we move through the novel we are offered passing historical facts, as if to our left and our right— often in parenthesis, almost always measurements of human toll. The earth, it is implied, contains shale-like deposits of memory. *Never again will a single story be told as though it were the only one.* The maxim has since become Berger's most cited and transportable, practically a credo for the post-colonial world novel. (Michael Ondaatje and Arundhati Roy, two of the genre's premier practitioners, both friends of Berger's, have duly acknowledged their influence: the declaration appears as the epigraph to both *In the Skin of a Lion* and *The God of Small Things*.) As in the diasporic fiction *G.* did so much to help usher in, any single character, in miniature, bears the imprint (and often the scars) of a globalized history. 'To understand just one life', in Rushdie's now well-travelled paraphrase, 'you have to swallow the world.'[25]

And yet there is a problem. As most serious critics of the novel have noticed, G. is not really a character. He barely speaks. He is not described. He is never given a name. He is quite literally a man without qualities, or, as Ian Fleming said of James Bond, 'an extremely dull, uninteresting man to whom things happened'.[26] G. is a desiring and travelling and seducing machine. But he is not a self.

Neither are the secondary characters, but in the opposite sense. While G. is an existential blank slate, everyone else is so socially fixed as to verge on stereotype. They all represent their nation and class, and are analysed as such: the gruff Italian capitalist, the prim Victorian gentleman, the feckless American heiress, the repressed French housewife, the stiff Austrian banker. Robert Musil, whose essayistic fiction was such an inspiration, nicknamed himself 'Monsieur Le Vivisecteur', and Berger's intent was similar. There is an almost medical register at times: Beatrice's face 'tends to be laterally overstretched—as though her ears are constantly pulling her mouth into a smile'.[27] The relation of author to character, at least with this secondary cast, is one of examiner

to specimen. The sociocultural insights can be animated, but the characters are taxidermied artefacts: they were never alive to begin with.

All of these roads lead to a startling conclusion. After Umberto and Laura make love, G. is born on the page: 'What has been conceived are the essentials of the character about whom I wish to write.'[28] When Chávez and his plane reach the precipice of the Gondo Gorge, his engine stalls. So does the text: 'Here there could have been no question of conscious decisions. Here I cannot calculate as I write.'[29] There is a compelling reversal enacted in these passages, as in others. The shadow of the writer, which is to say John Berger, becomes the hero of the book, so immersed is he in the experience of its composition. G. is, in this sense, doubly a bildungsroman, eliding its own formation as a novel with the novel of formation. The five years Berger spent working on G. were five years he spent using the novel in much the way protagonists of novels (from Tristam Shandy to Stephen Dedalus) are said to use life: as a fund of experience, an 'adventure of interiority', a means to test questions of value and fate. Berger was writing himself into a long tradition. 'I continue to live the life for which Joyce did so much to prepare me', he said a half-century after his boyhood copy of *Ulysses* was taken from him, 'and I have become a writer. It was he who showed me, before I knew anything, that literature is inimicable to all hierarchies and that to separate fact and imagination, event and feeling, protagonist and narrator, is to stay on dry land and never put to sea.'

For Berger, 1972 was a watershed year. He was forty-five. First his novel appeared across London—the enlarged initial (a masterstroke of design) overflowing its cover; then the Booker controversy engulfed the literary establishment. His act of repudiation at the Café Royal reverberated in the press for weeks. The papers went back into standard Berger mode: 'Why Berger bit the hand that paid him'; 'Biting the hand'; 'Berger's Black Bread'; 'Money Talks'; 'Don't Shoot Santa'.[30] The headlines were foolish but revealing. After a decade abroad, Berger was back playing an old role. In turn,

the English press could relax back into *its* old role. This way everybody was happy—which is to say, at each other's throats.

A reporter from Berger's old paper even phoned up V. S. Naipaul, winner of the previous Booker. 'Ignorant, absurd, not just rubbish but damaging', was what the West Indian author had to say about his antics.[31] 'Most of the Black Power writers are only speaking to white people ... It's a nightclub turn, it's television, it's wearing of pretty clothes.'[32] Three weeks later, Berger shot back. 'Quite simply, I am not ignorant of West Indian politics', he said; and as for the larger argument, this was 'worse than ignorant, it consists of lies'.[33] (He likewise pointed out that Lord Campbell of Eskan, for years the chairman of Booker McConnell, also owned the *New Statesman*.) Here we were again—back on the polemical merry-go-round. 'Inglan is a bitch', wrote Linton Kwesi Johnson (himself a Panther), 'dere's no escapin it / Inglan is a bitch / dere's no runnin' whey fram it'. In his own peculiar (and relatively privileged) way, Berger seemed to be learning something similar. The orbit of the homeland is strong.

Solidifying a reputation often takes two blows—a one-two punch—and 1972 had both. In the same year as *G.* and the uproar it provoked, Berger tossed another grenade into a separate wing of the British cultural establishment: the museum. Like his novel, *Ways of Seeing* (of which more will be said) was a time bomb of political modernism, a calculated incendiary device. Most shows simply air, but by the end of 1972 *Ways of Seeing* had detonated.

The press portrayed it as a prize fight. And when they were unable to depict it, they imagined it: 'Deep in the heart of John Berger's *Ways of Seeing*', read Caroline Tisdall's review in the *Guardian*—published on the very same day as the Booker gala—'is an altercation between art historians that would have made a marvellous piece of television'.[34] Tisdall fancied Kenneth Clark pronouncing stolidly on the Gainsborough portrait of Mr and Mrs Andrews, speaking of the 'sensitively observed cornfield', only to find Berger ready at the attack: 'none of the whitewash of Rousseauism and the contemplation of Nature: Mr and Mrs Andrews are

landowners, and the attitude is nothing more than the depiction of property.' Then 'up steps' Lawrence Gowing to the rescue: '"Before John Berger manages to interpose himself again between us and the visible meaning of a good picture"', Gowing says in Tisdall's imagined scene (itself a kind of history painting), it must be pointed out that the English couple were simply 'engaged in philosophic enjoyment of "the great Principle" ... the genuine Light of uncorrupted and unperverted Nature.'[35]

In reality, the adversarial nature of the series was more sublimated (and triangulated) rather than actually acted out in front of us—but it was there nonetheless. Berger picks fights throughout the show. The American art historian Seymour Slive—then taking a sabbatical year away from Harvard to occupy the Slade Professorship at Oxford—is quoted only to demonstrate that he is a spouter of filigreed bullshit. Slive pontificates on two group portraits by Franz Hals, so as to mask, according to Berger, the pictures themselves, 'as though he fears their directness and accessibility ... as though he doesn't want *us* to make sense of it in *our* terms.' Meanwhile, what Kenneth Clark has to say about the European nude only demonstrates that while he may know everything about painting and sculpture and Roman history, he knows next to nothing about women. To be naked is not simply to be without clothes: it is to be oneself. To be nude, by contrast, 'is to be seen naked by others and yet not recognized as oneself'. Charles II of England kept a painting of his mistress, we are told, not as a memento of her presence but as a sign of his dominance—and her 'submission to his demands'.

As with *G.*, Berger's targets were pedigreed gentlemen: belaurelled professors and grand dukes and colonial spectator-owners. Windmills or not, the cast of enemies was large. These were all the sort of men, Berger says, 'for whom painters painted their paintings', who went through life 'convinced the world is there to furnish their residence in it'. It was all about respect, envy, ownership and power. In a word—ego. And as with *G.*, Berger cast himself as a liberator. Like a 'vertical invader' (as he once described Picasso), he was storming the castle. The backlash was brewing, but, as

Manet once said to Zola, 'someone who can fight back as you do must really enjoy being attacked'.[36]

Even before the Booker, G. stoked controversy. 'Intellectualized porn'. 'Porn with graffiti'. The insults multiplied: 'fashionable trickiness'; 'enigmatic drivel'; 'pretentious rubbish'; 'a trendy mockery'; 'imbecilic'.[37] The combination of sex and metaphysics especially offended two sturdy tenets of the English national character: modesty and empiricism. 'One thing one must hand Mr Berger straight away', a review in the *Observer* began, 'he is not inhibited by the fear of being pretentious.'[38] There seemed to be a wilful reflex on the part of the British press not to take the novel seriously. 'G-strung' was the title of the review in *New Society*, Berger's own outlet. 'Both unpleasant and indigestible', complained Roger Scruton in *Encounter*, as if he had a bib sticking out of his collar and was staring down at a meal.[39]

The hostility worked in the book's favour: the logic of the *succès de scandale*. G. not only won the Booker Prize, but also the *Guardian* fiction prize and the James Tate Black Memorial Award. Even as its sales disappointed, it became a conversation piece. 'The novel has received more analytical media exposure than almost any other I can recall in recent years', observed a critic late in 1972. 'Why all the fuss? Anyone would think that Berger had descended from a mountain with the thing.'[40]

In a sense, he had. But even in the hills of France there was always the imago of England. To write against the establishment had been, and still was, a central mode of self-definition. In the 1950s he had been caricatured as a puritanical Marxist boy scout; now he was cartoonishly drawn as an incontinent Marxist satyr. ('All things considered it is natural that art historians would scorn Berger', Eunice Lipton wrote perceptively in *The Fox*. 'The expert senses a threat to her power, and Berger becomes an enemy.')[41]

In G., sex is the primary site of retaliation, but it is much else besides. It is a source of pleasure, confusion, affirmation, freedom. It is where the private and the public can be brought into most startling relief. It is an experience that tests the

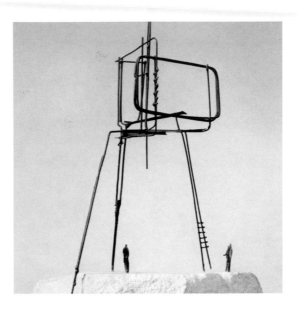

Reg Butler, *Final Maquette for the 'Unknown Political Prisoner'*,
1951–52, model, Tate Gallery, London.

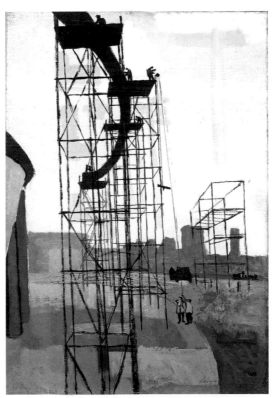

John Berger, *Scaffolding – Festival of Britain*, 1950, oil on
canvas, Arts Council Collection, London.

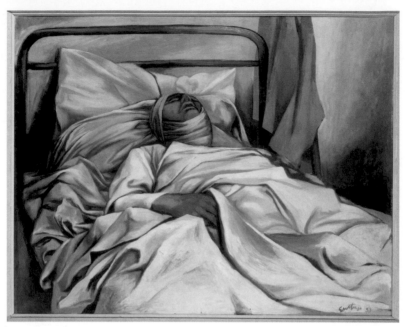

Renato Guttuso, *Death of a Hero*, 1953, oil on canvas, Esoterick Foundation, London.

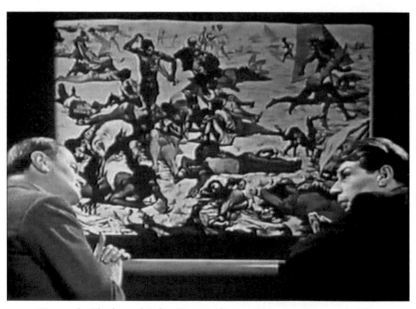

Kenneth Clark and John Berger discuss Renato Guttuso's *The Beach*, 1958, television broadcast.

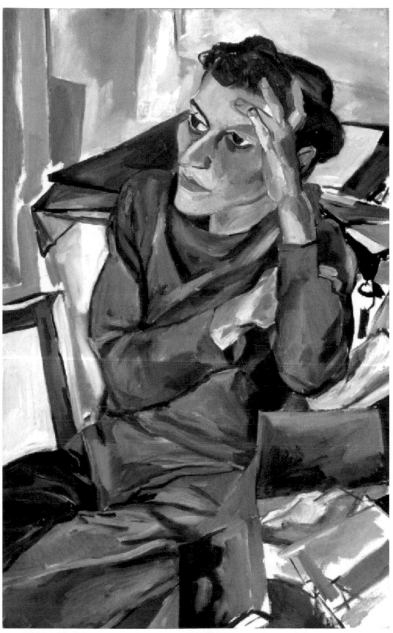
Peter de Francia, *Anna Bostock 2*, 1954, oil on canvas, Estate of Peter de Francia.

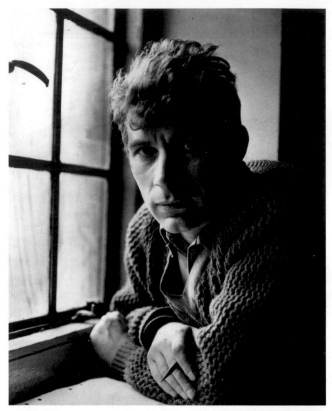

Author photograph from *Toward Reality* (1960). The book 'has been edited to make an argument', Berger wrote, 'not a self-portrait.'

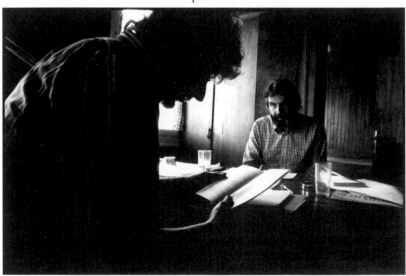

Berger at work with the Swiss filmmaker Alain Tanner. Photograph by Jean Mohr, c. 1975.

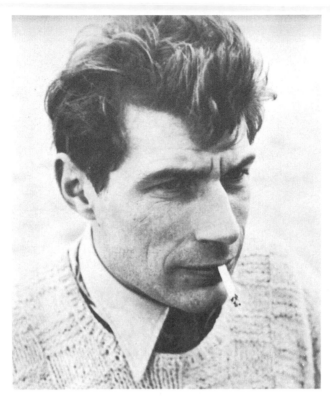

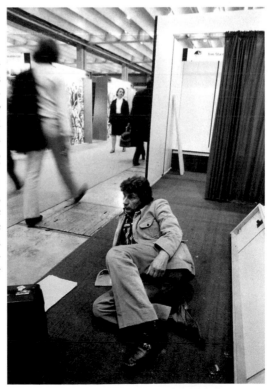

Above, author photo-
graph from Berger's
first collection of cri-
ticism, *Toward Reality*
(1960). It was a book
'edited to make an
argument', he wrote,
'not a self portrait.'
Below, at the 1973
Frankfurt Book Fair,
Berger was at the
height of his fame
and about to form
important new attach-
ments. Photograph by
Jean Mohr.

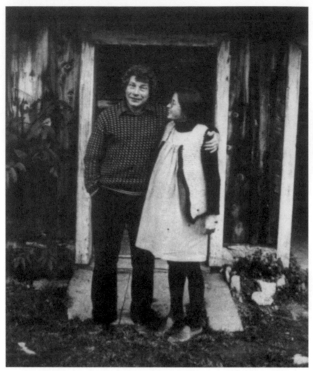

John Berger and Beverly Bancroft, pregnant, in the mountains of the
Haute-Savoie. Photograph by Jean Mohr, 1976.

Father and son moving hay in Quincy. Photograph by Jean Mohr, 1987.

Berger with friend and co-translator of Mahmoud Darwish, Rema
Hammami, outside of Ramallah. Photograph by Jean Mohr, 2003.

Above, at home in Anthony, a Parisian suburb. Photograph by Eric Hadj, 2016. *Below*, an afternoon espresso *Chez les Berger*, Quincy. Photograph taken by the author, 2012.

limits of language and our ordinary understanding of time. It is the union of opposites, the sublater of all antinomies, the felt apprehension of a totality—an entire metaphysic. Berger was always deliberate with the dedications of his books, and *G.* was curiously dedicated to his wife: 'For Anya and her sisters in women's liberation'. The suggestion is of a presumed solidarity of purpose between the sexual modernism of the novel and the broader historical struggle against patriarchy. Once there was first-wave feminism, now there was second-wave feminism; once there was the Parisian avant-garde, now there was the French New Wave.

But, again, there is a problem. G. is a sexual *picaro*, a Robin Hood of the libidinal economy, a liberator who can recognize the unique souls of the women he seduces in a society that otherwise treats them as property. But the contemporary reader is likely to see a fallacy: all of the women G. seduces appear to us as interchangeable. The paradox, as one reviewer rightly noted, is that Berger 'reads like an involuntary male chauvinist who is on the side of woman's liberation because he is on the side of revolution'.[42]

G. is more fundamentally about male desire than female struggle.[43] Read in this way, it garnered a certain number of fans. The Yugoslav filmmaker Dušan Makavejev was so enamoured by the book that he wanted to adapt one of its sections for the screen. What he liked in *G.*, he told Berger in a letter—and it is worth quoting because it so comically, unabashedly, and of course *problematically*, expresses what many other male readers on the left probably also thought—was the main character's fidelity to his own desires:

His sex (his cock), his soul, his mind, his morals, are the same being. I do not know of another book that identified someone with his own cock in such a positive and poetic way. I like the fact that he fucks women because he respects them and his own feelings about them. Respect was always used against emotions. Genuine connection between sex and respect is what makes this book revolutionary.[44]

I fuck you to affirm you! What Makavejev found so inspir-
ing was, it turns out, just another male fantasy—all the more
fantastical for its seeming radicalism.

The New Left has been roundly criticized for its latent
and often not-so-latent misogyny—at the very least, it was
a blind spot. *G.* was written from behind a deeply sexist
astigmatism that had a generational dimension; but it was
also steeped in the reading list of the counter-culture, with
stretches of the novel certainly bearing the residue of Herbert
Marcuse, whose *Eros and Civilization* and *One-Dimensional
Man* were required reading for the young and liberated. Just
as Marcuse drew a parallel between social oppression and
sexual repression, *G.* suggests the knowledge of freedom may
have its origins in sex. (There is throughout a persistent met-
aphorical association between orgasm and revolution, where
crowds are 'spasmodic' and popular passions 'erupt'.) Other
passages suggest the influence of Wilhelm Reich. According
to the mythically eccentric Austrian doctor, whose essays
Bostock was translating, sexual frustration bred personality
types more acquiescent to fascism: in the strong patriarch
the frustrated citizen found a sexual surrogate. Many of
Reich's theories were beyond wacky—he famously posited
the existence of a sexual energetic substance, the *orgone*,
that could be measured and amassed, even building cloud-
busting devices to extract it from the sky—but the essential
confluence of sex and politics had something to it. In itself
it was nothing new. Seen from a certain vantage point, the
New Left was pursuing exactly what historical fiction had
always been interested in: both projects sought to coordi-
nate the personal with the political, the libidinal with the
social.

In Berger's novel, though, the mercurial nature of sex seems
to militate against any stable or straightforward analogy.
When asked in a television interview about the equation of
sexual and political revolution, Berger drew back. He said the
two spheres in *G.* were not so much equated as 'juxtaposed'.
But juxtaposition is a formal technique. It is a description of
how they are related on the page, not a description of what
that relation means.

The novel's *problem*, to follow this line of thought, is not that it was too heavy-handed but just the reverse: it was too elusive, too coy in its politics.[45] And yet a 1970s British public was so primed to read anything Berger wrote as political they tended not to look for more. The reviewers hit the three talking points: the sex, the modernism and the Marxism. What they neglected—and what might be the real blind spot in the novel's reception—was the way each of these three spheres, both separately and together, can all be traced back to work of another historical figure: an Austrian doctor who opened his first medical office the year G. was born.

Freud was the father figure Berger never publicly adopted. But his impact on G. is self-evident. There are Oedipal triangles from start to finish, beginning with G.'s original conception: Umberto stares at Laura's vagina and marvels that this body part was not there to serve 'his function' but to accommodate 'the outward journey of a third person'.[46] Later, when G. is breastfeeding, we are given access to Laura's feelings: 'In this mirror the child is part of her body, the number of all her parts is doubled: but equally in this mirror she is part of the child, completing him as he desires.'[47] As in Freud, early psychosexual experience determines adult behaviour: G.'s mother abandons him when he is still an infant; he has a series of governesses; each one leaves. 'Lacking parents, he is still searching for one single person to represent all that he is not, to confront him as his other half and his opposite.'[48] When G. discovers 'the burning mystery of his own body', he is also discovering his own original trauma: the trauma of maternal neglect. When he does lose his virginity it is to the aunt who has been the closest figure to a mother his adolescence has offered. The serial cathexis, the obsession with sexual difference, even, intriguingly, the figure of the ocean and what Freud called the 'oceanic feeling': the more one looks at the novel through this lens, the more conspicuous the framework becomes, both inside the book and out.

As for most male writers, Oedipal reactions are there throughout the career if you look for them: from his father's confiscation of *Ulysses* and his sparring with Herbert Read or Kenneth Clark (both subsequently knighted) to his contested

relationship with England itself. The reactions are also there in reverse. One of the only young critics Berger ever adopted as a kind of protégé, Peter Fuller, famously came to reject his mentor, deciding to emend the title of an early hagiography, *Seeing Berger*, to an attack, *Seeing Through Berger*.[49] (As Fuller later complained: 'It was as if either I had to be Berger's other leg, or his deadly enemy.')[50] One of the family tragedies of Berger's adult life was his estranged relationship with his first son, Jacob. Though they were eventually, if only partially, reconciled, the trauma ran deep for both of them. It was a pain that Jacob, with the perspective of time, was able to historicize: not only was his father an overpowering presence in the home, but he belonged to a generation of political 'alpha-males', 'megalomaniacal' in their belief they could remake society from scratch.[51] Such a mind-set had no room, he said, for the physical and emotional needs of an infant, who would always be a kind of intruder. *The issue is between me and the culture which has formed me.*

Berger was of course aware of Freud. As a painter he once rented a studio above the offices of the English psychoanalyst Donald Winnicot, whom he would pass going to work on the stairs. Even more strikingly, Bostock and her family, when in Vienna in the 1930s, had lived next door to Freud himself. (Her girlhood stutter, as one story went, was cured after a visit to the doctor.) But it still makes sense—perhaps even more sense—to say that Freud was the great repressed figure in *G.*, and maybe the great repressed figure throughout Berger's entire middle period. Marx was brandished while Freud was covered up.

The elision is complicated to explain. Every radio has both a front and a back. It may have been a calculated bit of self-fashioning—the suppression of circuitry that did not fit with a personal brand; but it just as likely issued from an intuitive revulsion Berger probably felt as he beheld the speed with which Freud so quickly filled the void left by the great Marxist god that was said to have failed. The crisis of postwar Marxist faith led directly to Freud on several counts. First, the crisis of communism (as Doris Lessing made so vivid in *The Golden Notebook*) was often also a personal breakdown

to be treated by psychotherapy. More generally, though, the loss of faith in politics *as such* (a loss also traced in Lessing's novel) would seem to contract the domain of actionable influence—the place where change happens—from society to the individual and the family. Third, and more generally still, for those social critics who persisted in their task, who continued to diagnose and prescribe, the extent to which the masses appeared complicit in their own oppression was a grim paradox of false consciousness that would always lead back to mass-psychological explanations. As the Frankfurt School so adeptly described: cultural manipulation more than brute force.

All of these bows to Freud, whether self-pitying or condescending, smacked of a leftist melancholy that Berger always resisted: the acceptance of political closure. And yet it seems inarguable to say that Freud was behind much of G., just as the dynamics he described were behind much of what Berger was still getting out of his system even as late as his forties. What the latent psychoanalytic schema suggests, then, is that the metaphorical mapping of the sexualized body onto the revolutionary body politic was, as in any metaphor, a two-way street. That G.'s seductions can be read so straightforwardly today as a series of Oedipal de-thronings (the cuckolds always older businessmen), and that G. was read the way it was in the early 1970s, imply the extent to which so much of the energy of the Freudian left, especially among its young male warriors, can be chalked up, at least partly, to generational rebellion: the perennial struggle between fathers and sons. What are the first two words of Berger's novel? 'The father.'

There was much in G. that Berger would leave behind: the aggressive modernism, the clinical austerity, the fixation on orgasm and revolution, the Oedipal feuds, the blind spot of misogyny. His later fictions—importantly stories, not novels— give up the revolutionary individual for other concerns: the loving couple, the threatened community, the complications of prolonged care, convalescence after loss. Unlike so many aggressive male writers, who curdle into old curmudgeons

with age, Berger grew softer. Love took the place of sex as the site and origin of resistance: no longer revolution, but resistance.

But *G.* was not only a phase to be outgrown: it also registered the influx of new currents. In the years following its release, the novel played a minor role in another drama. Its tell-tale attributes—metafiction, parody, historiographic recombination—led a number of critics to consider Berger in relation to what seemed to be everywhere: *postmodernism*. All of these critics came to the same conclusion: he was in fact outside the mould. His writing lacked the hall-of-mirrors quality, the punning, the 'non-referential play of signifiers' so typical of the postmodern canon.[52] 'Even as it admits its own fictitiousness', wrote David E. James, *G.* 'still asserts the fiction'.[53] For Geoff Dyer, *G.* was not 'anti-naturalist in the interests of a displacement of "reality" but in the interests of a more exact rendering of that reality'.[54] 'An awareness of language's limitations is a key feature', observed another critic, 'but the text does not undermine language altogether.'[55] History was repeating itself. Though such arguments were articulated during the theory boom of the 1980s and '90s, they were in fact rehearsing the very same polemic that marked Berger's early years in London. The 'twin dangers' of naturalism and abstraction were being rewritten for the age of deconstruction: between the 'swindle' of illusionism and the 'prison-house' of language.

The text is a made thing, just as a painting is a made thing, but it does not follow from this that it can then only speak of its madeness. For Berger there must always be the insistence on an *outside*. Even in the most buried purlieus of the mind (or of a book or painting), there are filaments of a process that connect us to the world. In *G.'s* strongest moments the writing is charged with an awareness so intense before the feeling of experience that it becomes almost haptic, the prose equivalent of impasto: not so much in the evocations of sex (which have admittedly aged on the paper) but in the evocations of the corrugated feel of bark, the whirl of somersaults, the vertigo of flight. In these passages and others, the novel belongs to the 'primordial perceptual world' that Cézanne

was also after, or that Merleau-Ponty was trying to get at when he said: 'We must rediscover a commerce with the world...which is older than intelligence.'[56]

The great maxim for existentialism was that existence precedes essence. For Berger, it may have been that experience precedes language. His thought here moves unequivocally in opposition to Saussure, the godfather of structuralism, whose ideas so animated a generation of academics. Saussure's fundamental axiom was that language was not a nomenclature referring to pre-existing things but the very means by which reality itself could be recognized. Nothing could be further from Berger's position, including his emphasis on the faculty of sight—as the titles of his books make plain: *The Look of Things, The Sense of Sight, About Looking, Ways of Seeing.* 'Seeing comes before words', he says at the start of the last. 'It is seeing which establishes our place in the surrounding world; we explain that world with words but words can never undo the fact that we are surrounded by it.'[57] Berger's thought in this regard is spatial. Language approaches experience, but it can never replicate it or take its place. There is in each of us a vocabulary of what we have lived that can never be fully expressed. Therein lies not only frustration, but wonder.

Tolstoy famously said that the artist's task was to make understood and felt what in argument would be incomprehensible. In a pivotal vignette near the end of *G.*, Berger narrates (*in propia persona*) his visit to a friend's house to look at photographs the friend had brought back from North Africa. While concentrating on the pictures, he was interrupted by an apparition: a ten-year-old boy with the face of an old man. For a moment he was shocked. Before he could rationally explain what had happened—that the boy was his friend's son and that he was wearing a mask—he felt the shape of a larger mystery: 'I recognized him as the figure in the infinite company of the unknowable. I had not once, long ago, summoned him up in the light of my knowledge; it was he who had once sought me out in the darkness of my ignorance.'[58]

For all of his emphasis on sight and the visible, it is this corresponding focus on the *unseen* that forms the other half of a dualism so many of Berger's critics, perhaps fittingly, overlook. 'The way my imagination forces me to write this story', Berger says, 'is determined by intimations about those aspects of time which I have touched but never identified. I am writing this book in the same dark.'[59] A later novel, *To the Wedding*, is narrated by a blind Greek seer. The more recent collection, *Bento's Sketchbook*, returns again and again to a mantra: 'We who draw do so not only to make something visible to others, but also to accompany something invisible to its incalculable destination.'[60]

In 1972 no critic mentioned the novel's measure of mysticism, but many spoke of its overall inscrutability. The word 'baffling' recurred in reviews. There was an irony here. At the start of his career Berger was condemned for proposing a vision of art that sucked the mystery out of the artwork, that reduced it to a political tool. With *G.* he was accused of mystification.

To be baffled is not always a bad thing. It is often to be humbled, to be in rapture, to see for a moment an alternate future, to behold with astonishment a miracle: *when black and white approached each other with the amazed hope of potential equals*. The egalitarian image at the heart of the Booker speech was not only a political dream. It was also an allegory and refracted self-portrait. On the stage at the Café Royal, the artist and the revolutionary saluted each other in the mirror. As Berger confided to his friend Eva Figes the year it was published, '*G.* isn't a political book; what I'd like to believe is that writing it was a writer's political act. But maybe that's another solipsism.'[61]

6

The Work of Friendship

We each have to choose what is inconceivable for us. As artists—and this is the curse that is upon us—we must each visualize our own city, ourself as its centre. It is bitter for me to admit this, I who, as a man, believe in the collective, in the revolutionary class not the revolutionary individual.[1]

When Berger wrote those lines he was thirty. All culture wars produce contortions, but some are more painful than others. For years he had called for communion in the British arts, but his was often a lone voice. Set against him, a well-organized (and well-funded) liberal choir sang of the primacy of the individual. The particular irony reveals a more general paradox. The socialist writer believes in the collective, but at his desk he works alone. His message is for his peers, but his success is individual.

In the 1960s, after he left England, Berger worked on a series of books about lone men: a doctor, a painter, a Don Juan. As he built a new life for himself his recurring focus was on the relationship of character to fate. 'The reason why the novel is so important', he said in his Booker speech, 'is that the novel asks questions which no other literary form can ask: questions about the individual working on his own destiny; questions about the uses to which one can put a life—including one's own.'[2]

In 1971, after five solid years at work on *G.*, Berger threw himself into a slew of new partnerships. With Mike Dibb, an arts producer at the BBC, he made *Ways of Seeing*. In 1972,

he travelled to a mine in Derbyshire to make a short film with the Open University. In 1973, he worked with Jean Mohr on *A Seventh Man*. The same year he spent a month with Dušan Makavejev writing a scenario for a possible film. After a half-decade inside the solitary vessel of fiction, it was as though he had *surfaced*. He had finally achieved official recognition as a novelist (what he had been after for years) and international renown with *Ways of Seeing*. But *G.* was a kind of summing-up, while *Ways of Seeing* was a *ne plus ultra* of critique.

At forty-five and suffering a crisis, he began a series of transformations. He left Anna Bostock for an American, Beverly Bancroft, then an assistant at Penguin who had been charged with shadowing Berger at the Frankfurt book fair. The couple soon moved to a valley outside Geneva where they had a son and would stay for the rest of their lives. Having achieved so much individual fame, Berger was in search of those grounding attachments: the web of relationships that confirm a self. In 1974 he applied to be a fellow at the Transnational Institute, the newly formed Amsterdam affiliate of a progressive DC-based think tank. Having largely shunned institutional life, Berger now found the prospect of a collegial network attractive, or at least beneficial. 'It is a paradox', he wrote in his application, 'the more global one's concern, the more one is threatened with isolation today.'[3]

It was around this time—the early 1970s—that Berger stopped thinking of himself as a novelist. He became a *story-teller*, and, alongside that, a *collaborator*. Collaboration was at once a method, an idea and a powerful metaphor. On a very human scale it worked out, in microcosm, the problems of collectivity: the sharing of ideas, the delegation of tasks, the transition from argument to consensus. Any recognition was shared. It was anything but solitary.

In themselves the demands of teamwork were nothing new—in television, it was part of the job; but in his forties Berger sought out those bonds with more intention. As community replaced the individual in his work, the work became more communal. Over the following decades he made a name for himself as one of the most generous—magnanimous but also stubborn—collaborators in Europe. He worked with

playwrights, filmmakers, photographers, painters, sculptors, poets, musicians, dancers. Almost every artist on the European left came to be related, to some degree, through Berger. From his valley in France, the correspondence was active: so many handwritten notes of encouragement; so many friends.

At the centre of his transformation into a collaborator, one collaboration stood out.

In 1971, the year he finished *G.*, Berger agreed to help a long-time friend, the Swiss filmmaker Alain Tanner, on a screenplay. The resulting film, *La Salamandre*, premiered at Cannes and travelled widely. It was screened as part of MoMA's New Directors series, and received a lengthy, generous review by Penelope Gilliatt in the *New Yorker*.[4] A comedy about the ungovernable whims of a rebellious working-class woman and the two men she fascinates, the film introduced audiences to the abrasive charm of what soon became known as the Nouveau Cinéma Suisse. On the heels of its success, Tanner made another film under Berger's indirect influence, *Le retour d'Afrique* (1973), and then, in official partnership, two more in close succession: *Le milieu du monde* (1974) and *Jonas qui aura 25 ans en l'an 2000* (1976). It was a tremendous burst of concentrated collaborative energy. Berger later spoke of the work as developmental: 'It's not easy for me to define that development in very precise terms', he said, 'but I think that from each film we learned something which we tried to apply to the next.'[5] At a time when the European left seemed to be at sixes and sevens, each film in the Berger–Tanner partnership was like a point on a graph: a place you could turn to see where the movement might go, where its conflicted passions were heading.

Films often testify to the conditions under which they were made, and *La Salamndre*, Berger and Tanner's first film, was itself about two friends who decide, however tentatively, to embark on a collaboration. In need of money, Pierre, a part-time journalist, begins a television script about a local *fait divers*: a young woman has been accused of shooting and injuring her uncle. At a loss for how to proceed, he calls his friend Paul, a bohemian of a different stripe, for help. Pierre

(like Tanner) is loud and gruff, while Paul (like Berger) is at once gentler yet fiercer with his ideals. Pierre explains the project to his friend and asks if he is interested. Paul stops to think. It depends on how we work, he says, 'c'est pas facil de travailler en deux'.

The line does not announce itself portentously, but there it is at the start of the Berger–Tanner partnership like an allegorical epigraph. Working as a pair is not easy: hence, precisely, its importance. And what is worked out over the course of *La Salamandre*, as the two friends learn to share their gifts—the one his irony, the other his empathy—are successive models for collaboration itself: collaboration as the division of labour; collaboration as the union of opposites; collaboration as tonal complementarity; collaboration as friendship.

In a recent monograph the art critic Sebastian Smee spoke of the constructive rivalry implicit in artistic pairs: 'not the macho cliché of sworn enemies', but rather something more porous and volatile, a limited period of mutual exchange, of 'yielding, intimacy, and openness to influence'.[6] The exchange becomes even more intense, the stakes higher, when two friends agree to work together. Berger of course worked with numerous artists over the course of his career, but the partnership with Tanner was unique. Once asked to describe his role in their process, he offered an analogy: 'When two people have collaborated on, let us say, three-and-a-half films, in addition to being very old friends, that question is a bit like asking a married couple, "What is your role in your marriage?" It is possible to do so, perhaps after you've had a divorce, although even then it may not be the truth.'[7]

The metaphor is oddly revealing, yet it moves across several levels, both within and around the films the pair made together, and as part of the larger historical conjuncture to which they belonged. At the tail-end of the New Left, when the hippies and the radicals were struggling to stay in alliance, two men of powerful yet distinct temperaments came together to make a series of films, themselves amalgams. Not only were the films products of a collaboration: each one enacts the problem of alliance-building on screen. They view

community as teamwork and friendship as dialectics. 'Marx was right', the American playwright Tony Kushner has said. 'The smallest indivisible unit is two people, not one; one is a fiction. From such nets of souls societies, the social world, human life springs.'[8]

In his twenties and thirties Berger kept close friendships, particularly with painters. When he visited London from Newland (where his second wife had a home) he would stay in Hampstead with Peter de Francia, a leftist painter of history canvases. De Francia had spent time in Rome working for Renato Guttuso, and it was through his friend that Berger absorbed the influence of Italian neorealism, made the acquaintance of several important Italian artists, and was able to formulate his own realist intervention in the manner he did. (There was an exchange of more than ideas: Anna Bostock was with De Francia for close to ten years before she moved from one friend to the other.) When De Francia bought a home in Lacoste, in 1957, Berger bought a house in Bonnieux, just to the east. The two remained friends until the 1970s, but for a time in the 1950s De Francia was more than a friend: he was a courier, a source of influence, a confidant.

Then, throughout the 1960s and 1970s, Berger was especially close to another painter, Sven Blomberg, a tall Swede who had left Stockholm for Paris in the 1940s before moving to the Vaucluse (also Lacoste) to live off the land. Berger and Bostock would spend weeks with Blomberg and his then wife, the sculptor Romaine Lorquet, the two couples gardening, painting, mending rooves, cooking, and walking around naked. Unlike De Francia, Blomberg never made a name for himself (De Francia went on to teach at the Royal College of Art), but he remained connected to philosophical and artistic circles in Paris, especially those around Garaudy and Merleau-Ponty. Many of Berger's essays were dedicated to his friend, and Blomberg was even brought in as an outside eye on both *Ways of Seeing* and *A Seventh Man*. (Wildly temperamental and pig-headed, he would apparently rearrange a spread in a mad dash before walking out of the room in a huff.)

And then, of course, there was Jean Mohr. After their first

collaboration Berger and Mohr remained lifelong friends, making two further books together. But the longevity of the working relationship seemed premised on a clear-cut division of labour, each with his own medium, and the intermittency of the work, each book separated by a decade. By nature courteous, formal, reserved—'modesty itself', as Berger said—Mohr was the opposite of temperamental.[9] His photographs possess a quiet force, but they are not forceful. If their books were films, Mohr would have been the director of photography, Berger the screenwriter and director.

The working relationship with Tanner was different—more magnetic and volatile from the start. Both he and Berger were on the left, but each had a unique ideological profile. Berger's sympathies lay with the worker, Tanner's with the youth. Berger's roots drew from the tradition of postwar humanism; Tanner's worldview was a product of 1968, self-evidently more anarchist. The contrast was reflected in a difference in tone. Berger's rhetoric was precise and serious; Tanner's freewheeling. Berger never liked to think of himself as a bohemian; Tanner had wild hair and a beard. But each had something to fill out what the other lacked. Tanner moved with a light touch, a youthful flair for deadpan irony. Berger came with deep reserves of cultural knowledge and a preternatural analytic intelligence. Tanner would speak of 'picking John's brain', as if it were a mining operation. Berger, for his part, spoke of Tanner's sense of style.

It was like an improvised dance, the shifting weight of influence never quite settled during the few years the two moved in step. While it was Tanner, for example, who first asked his friend for help on *La Salamandre*, two years later, with international success under his belt, the roles were reversed. Cinema, and especially French cinema, was the place to be, and, in late 1973 it was Berger who did the approaching. Authorial fingerprints were always going to be blurred. Their films were made in Switzerland, in French—and as director Tanner was bound to have the more dominant presence, however grateful, often indebted, he was to his friend. But as co-screenwriter, Berger's personality was also palpable. He worked as something of an

in-house philosopher, a cultural attaché, connecting each film to history and ideas.

The films they made together remain prophetic relics from the seventies. Revisiting them is like wandering around a house once shared by two very different friends whose friendship was itself of a moment. In one room a poster of Lenin; in another, Jimi Hendrix.

Berger and Tanner seemed fated for friendship. The two first got to know each other not in Geneva, but in London. After a stint at sea in his twenties, Tanner arrived in the city, penniless, in 1955, renting a room in the filmmaker Lindsay Anderson's house. It was a fortuitous arrangement. Anderson hosted regular Sunday salons, and even though Tanner was an unknown boarder, working odd jobs (including selling shirts at Harrods), he befriended many central figures of England's postwar cultural renaissance, including Berger.

It was in London that Tanner made his first short film, *Nice Time*, co-directed with a Swiss friend, Claude Goretta, and produced with a small grant from the British Film Institute. When the documentary, about the burgeoning nightlife around Piccadilly Circus, was included in the 1957 Free Cinema Programme, Berger took notice. He praised what he saw as 'the possibility of protest' in the film's attitude, but added that 'the point is that the protest is not an aloof, administrative or high-minded one. It is made on behalf of the people to be seen pursuing their pleasure or their livelihood any night within 400 yards of the Eros statue.'[10] Berger had written of the teenagers in Guttuso's 1953 canvas, *Boogie Woogie*, in similar terms. The paradox—a paradox Tanner seemed ready to solve—was how to avoid condescending to a generation weaned on Coca-Cola without, in turn, capitulating before their saccharine cultural products. It was a question, in other words, of harnessing the desires of the young while rejecting what a character in one of Tanner's subsequent films called 'the fake happiness of magazine covers'.

Nice Time was the sum of Tanner's work in London. After three years in England, he returned to Geneva, by way of Paris (where he rubbed shoulders with the Nouvelle Vague)—a

return that coincided serendipitously with Berger's own arrival in 1962. In Geneva the two became closer friends, if not quite peers. Berger was only three years older, but already possessed an established national reputation in England—a recognizable name and face—while Tanner was only beginning to produce shows for the SSR, the French-language Swiss television network. When Tanner approached Berger in 1966 to write the voiceover for a documentary he was making on Le Corbusier, *Une ville à Chandigarh*, he was very much the younger, lesser-known artist asking the older, more established artist for a favour.

On the other hand, Tanner was a native Swiss, while Berger was a foreigner. The same year Berger and Bostock moved to the neighbourhood of Meyrin, outside the Geneva airport, Tanner helped to set up the Swiss Film Directors' Association. He was well connected in the small world of French-Swiss culture and it was through Tanner that Berger met Jean Mohr in the first place. Over the course of the 1960s, Tanner's relative youth—both in years and spirit—also came to count for something. He seemed to be in step with the kids; and the kids, in turn, were starting to think and speak for themselves.

The events of 1968 touched everyone on the left. For Berger they were an inflection point; for Tanner they were a fuse. During the May protests, Tanner took a small TV crew to Paris, where he made the short newsreel, *Le Pouvoir dans la rue*. But it was his next film, *Charles mort ou vif* (1969), his first fiction piece, that introduced his cinema to an international audience. Considered by many a cultural bellwether (and inspired in part by conversations with Berger), *Charles* follows a respectable businessman's self-repudiation and rebirth as a bohemian hippie. After suffering a breakdown, the middle-aged Charles renames himself Carlo, befriends a young polyamorous couple, takes up residence in their ramshackle squat and watches approvingly as they drive his car off a cliff. Together he and his young friends paint big signs with revolutionary proverbs ('Demand the impossible') to be turned over like Buddhist koans.

Winning the Grand Prix at the Locarno Festival, *Charles* was Tanner's breakout, hitting both a nerve and a funny

bone. When apprehended and taken to a mental institution, in the film's final scene, Charles submits with wry acceptance. Inside the ambulance he contemplates aloud a philosophical passage—a passage bearing all the tell-tale cadences of Berger's thought: 'Saint-Just said that the concept of happiness was new in France and in the world. And we might say the same of unhappiness. The awareness of unhappiness presupposes the possibility of something different. Maybe today the conflict happiness–unhappiness, or the awareness of a possible happiness and of a real unhappiness, has replaced the old concept of destiny. Is that not the secret of our generalized malaise?' The two drivers share an annoyed glance, put on the siren, and speed off down the highway. The end.

That was Tanner's style: abrasive and energetic, philosophical but never too serious. As a solo effort, *Charles* defined one pole of what was soon to become a collaborative dialectic. It was full of the kind of devil-may-care attitude Berger had no knack for—and, under normal circumstances, no taste. But 1969 was not normal. The whole significance of May '68 for the left was that it represented a radical break from politics as usual. The youth movement was busy dismantling not only bourgeois norms, but also Marxist certitudes. Conventional political ends went out the window. The graffiti from Paris spoke volumes:

> Since 1936 I have fought for wage increases
> My father before me fought for wage increases
> Now I have a TV, a fridge, a Volkswagen
> Yet my whole life has been a drag
> Don't negotiate with the bosses. Abolish them!

Was the struggle to change society or to change life? Was the revolution in the street or in the head? Was utopia a new state or a passing moment? For several years the New Left not only held such binaries in alliance but was predicated on their inseparability. 'People who talk about revolution and class struggle', said Raoul Vaneigem, 'without referring explicitly to everyday life, without understanding what is subversive about love and what is positive in the refusal of constraints,

such people have a corpse in their mouth.'[11] The mantra of
the period, originating in feminism but with implications far
and wide, was that the personal was also political. And what
was more personal than desire?

The personal-as-political was at the heart of the Berger–
Tanner partnership, and at the centre of their first joint
work, *La Salamandre*, about a young woman whose every
fibre is focused on the refusal of norms.

Rosemonde, played by Bulle Ogier (fresh from Rivette's
L'Amour fou), is young and alluring, but the real mystery
seems to be her wholesale lack of purpose. The question of
whether or not she shot her oppressive uncle (the news story
that brought Paul and Pierre together in the first place) is
more a pretext than even a plot device. Soon the film, like the
men, turns to its more abiding interest: Rosemonde herself.
The generational satire is arch: she puts on guitar solos on
jukeboxes, orders cokes, has a poster of the Beatles, wears
miniskirts, chews gum. Any willpower she does have is exer-
cised only negatively, as recalcitrance. Her entire mission
seems to be to remain as desultory as possible, and in her
spare time headbang to rock 'n' roll. The two expressions
that capture her entire emotional landscape are *je m'en fiche*
and *j'en ai marre*!

Most of all, she hates work. (One of the recurring tags
on the Sorbonne walls: *Ne traivaillez jamais!*) The film fea-
tures uncomfortably long shots of Rosemonde at her meat
factory job, applying plastic casing, like a condom, to the
metal phallus of a sausage tube. 'After work I always feel like
yelling or breaking something', she tells Pierre. ('Be patient',
he says dryly. 'In forty years you can retire.') The notes to the
screenplay said that Rosemonde was a creature 'physically
incapable of adapting to the conditions of everyday work',
but lack of interest in labour (otherwise so unlike Berger)
permeates the film as a whole. Pierre speaks of his dream
of being a permanent pensioner. When Paul is supposed to
be writing, he plays a game with his daughter. Ultimately
the duo's project, the television script, is abandoned. What
was supposed to be a sociological study becomes instead a

group of friends. Another slogan from Paris: *Down with the abstract, long live the ephemeral!*

In *La Salamandre* we see the incipience of the techniques, themes, symbols and tonal registers whose patchwork came to define the Berger–Tanner partnership. Many elements—actors, settings, situations—recur. One of these is Switzerland. The 'little red book' a nondescript man distributes around Pierre's neighbourhood was a true document of the time: a several-hundred-page tome written by the Committee of Spiritual Defence. Just as the middle class gave the hippies and radicals a shared enemy, Switzerland was less a place than a symbol. *Who wants a world in which the guarantee that we shall not die of starvation entails the risk of dying of boredom?* The famous Situationist lament applied almost preternaturally to the Switzerland of the early seventies. Gevena *is* that world—at once rich and life-sucking. (It was also deeply patriarchal: not until 1971, the year in which *La Salamandre* was made, were Swiss women granted the vote.)

The existentially enigmatic blonde was a trope of the European art film, but for Berger and Tanner, as for Pierre and Paul, Rosemonde was also a political possibility, however inchoate. It is here that the dialectical jostling of their collaboration comes into sharpest relief. Play or work? Emancipation or resilience? Just as the script's occasional impulse to speechify (Berger) had been modulated and softened by irony (Tanner), the reverse was also true: Tanner's sarcasm, embodied in Pierre (played by the outsized ironist Jean-Luc Bideau), cedes slowly to Berger's wisdom, embodied in Paul (the poetic Jacques Denis). As Paul and Rosemonde traverse the city by tram, he speaks the closest thing the film has to a thesis: 'The freedom to be yourself is systematically denied to too many people', he says, his fist in his hand. *La Salamandre* is not theorized agitprop, but its gestures are always in the direction of politics. It is as if it is perpetually *on the verge* of the political.

In 1971 the prospect may have been enough: Berger and Tanner's first collaboration was an ode to friendship, youth and rebellion made at a time when such qualities seemed to augur something in themselves. But it was also tacitly, and

more uncomfortably, a refusal of aims. The film, just like its heroine, stayed blissfully rudderless—a contradiction the English critic George Melly expressed in ideological terms. 'How would she', he said of Rosemonde, 'with her flashes of insight and obstinate exercise of whim, her flirtation with criminality, her neurotic messiness, get by under the more rigid bureaucracies of the Left? Has Marxism room in its tidy bed for randy little anarchists? There's never been any indication of it in practice.'[12]

When Berger approached Tanner in late 1973 to see about embarking on another project, he was in the process of leaving his marriage. Their second collaboration, *Le milieu du monde*, was in turn about a man incapable of leaving his. It was also a film, true to allegorical form, about two people of different nationalities coming together to share in a temporary union of contraries.

Far more than *La Salamandre*, *Le milieu du monde* bears Berger's imprint. The film charts the 112-day rise and fall of a disruptive, potentially liberatory affair between a provincial Swiss politician, Paul, and a migrant Italian waitress, Adriana. Gone is the bohemian milieu of Tanner's first films. We are now in the provincial hills of the Jura, a place of nondescript cafés, petrol stations, and offices. And while *Charles* and *La Salamandre* had been loud and rambunctious, the emotional palette of *Le milieu du monde* is sombre. The temperature is cold (it was filmed in winter), the reflection of a change in authorial temperament. In its combination of dispassionate modernism, historical analysis and sex, the film's aesthetic strategy derives fundamentally from Berger's recently completed novel. Just as *G.* begins on a note of metafiction, *Le milieu du monde* begins with a shot of its own film crew at work, followed by reflexive narration about the historical nature of cinema and the moment of the film's making.

The story of Adriana and Paul, we are told, takes place during a period of 'normalization', defined as a time that allows for the free exchange of goods *so long as nothing fundamentally is changed*. 'Hopes remain', the narrator says, 'but they are normalized into old, stereotyped attitudes …

Only words, dates and seasons change.' (Anyone familiar with Berger's essays of the period will hear his voice immediately.) The film's subsequent anatomy of the frustrated affair, evocative of Antonioni's trilogy with Monica Vitti, transposes the theory of political stasis onto the realm of sexual intimacy. Adriana wants Paul to leave his wife and children but, running for local office, he seems unable to act. His failure to take full ownership of his passion—his psychic need to compartmentalize and manage it—symbolizes the self-denial of the managerial-political class. The technocratic impulse, it is implied, whether political or sexual, necessarily thwarts any true renewal.

Berger's initial contribution to *Le milieu du monde* consisted of two long letters—essays, really—written for the principal actors (even before they were cast) about the characters they were to play. Kierkegaardian philosophical meditations more than profiles, these speculative texts allowed Berger to work through his own questions. The letter to Paul is much longer. Passion, he writes, is totalizing, and hence a man who is divided within himself cannot fully absorb its potential. To refuse passion, he says, is to refuse a *totality*—one that connects the self not only to the beloved but to the whole world, its miracles but also its mysteries. To deny passion, as Paul does, is to fear the entrance of the unknown into the self, to maintain the illusion that what is chaotic and wild only lives *outside*. 'If a person has been conditioned or has conditioned himself to treat the unknown as something exterior to himself', Berger says, 'against which he must continually take measures and be on his guard, that person is likely to refuse passion ... To locate the unknown as being out there is incompatible with passion. Passion demands that the unknown be recognized as being within.'[13]

Berger wrote his letter to Paul in a Strasbourg café in the winter of 1973. He had a lot on his mind. Around the same time, almost certainly on the same trip, he visited another town in Alsace to look at the Grünewald Altarpiece. He had been to Colmar ten years previously, in 1963, shortly after he had moved to Switzerland and started a family. It is a biographical fact elided in the essay he ultimately wrote of his

experience, but it is there as penumbra, the personal leaning on the political. In the ten years since his first visit, so much had changed, he said,

> not at Colmar but, generally, in the world, and also in my life. The dramatic point of change was exactly half-way through that decade. In 1968, hopes, nurtured more or less underground for years, were born in several places in the world and given their names: and in the same year these hopes were categorically defeated. This became clearer in retrospect. At the time many of us tried to shield ourselves from the harshness of the truth. For instance, at the beginning of 1969, we still thought in terms of a second 1968 possibly recurring.
>
> This is not the place for an analysis of what changed in the alignment of political forces on a world scale. Enough to say that the road was cleared for what, later, would be called *normalization*. Many thousands of lives were changed too. But this will not be read in the history books.[14]

Given such profound historical disappointment, the meaning of the altarpiece—the crucifixion painted on wooden panels originally commissioned for a hospice—had taken on new significance. The painting was still about pain, but the *meaning* of the pain, as well as the hope and love which might alleviate it, had shifted, undergoing a kind of transubstantiation. The reappraisal forced Berger out of intellection and into feeling. 'There is no exemption from history', he wrote at the end of the essay. 'The first time I saw the Grünewald I was anxious to place *it* historically ... Now I have been forced to place myself historically. In a period of revolutionary expectation, I saw a work of art which had survived as evidence of the past's despair; in a period which has to be endured, I see the same work miraculously offering a narrow pass across despair.'[15]

The experience of re-visitation has been the site of deep feeling for countless poets and writers over the years. When Wordsworth returned to Tintern Abbey, he too was at a crossroads, forced to take stock of his life. Like him, Berger was at the precipice of new attachments. The early 1960s seemed suddenly far away. A decade later the question was

not how to see the world through dry and open eyes, as it had been, but how to see it through what he called 'the empathy of love'. The personal and the historical had grown intertwined in tragedy, but the work of art, and its own endurance through time, radiated hope. As was his astonishing gift—to himself and to others—Berger could follow that hope and write himself back to safety.

Like visiting an altarpiece, it means one thing to fall in love—to begin a family—when the future is bright; something far different when it is not. Not worse, just different. Perhaps more redeeming, and thus durable.

Berger and Tanner's third and final film, *Jonah Who Will Be 25 in the Year 2000*, became their most beloved, their energies most in sync. Berger was working on the idea, about a group of friends, a communal farm, and the decision to have a child, when he and his new wife, Beverly, had themselves moved to the country and they too were expecting. Just like Jonah, the boy born at the end of the film, Berger's own son, Yves, would turn twenty-five in the year 2000.

Berger called *Jonah* 'a comedy, sometimes in colour and sometimes in black-and-white, about preparing to leave the twentieth century'.[16] An ensemble piece following eight Genevans who save an organic farm from real-estate developers, the film was in fact less story than mosaic; the premise was built not around conflict but *convergence*: the coming-together of ideas (leitmotifs of food, animals and time recur) as well as friends. Even before he had the screenplay in hand Tanner had secured the participation of the actors, and drove out to Berger's new home in the Haute-Savoie with their photographs. Together they began to formulate each character (whose names all begin with Ma) around a series of questions. What happened to the generation of 1968 in the harsh decade that followed? How to outlive political failure? What remained of the 'the great synthetic prophecy' of the left?

In laying out the ensemble, Berger and Tanner referred to each character as a *petite-idéogramme-poétique*: each temperament a sketch, each a possible response to the post-utopian condition. There is a gardener, a teacher, a sexual explorer, a

cynic. It is as if the perspectival network of a cubist painting has become a network of dispositions, each actor embodying a *point of view*, each playing a role in a drama of ideas. 'A temperament is partly the result of social conditioning', Berger had written ten years earlier, in his monograph on Picasso:

> But writers have not paid enough attention to the way history can be subjectively active in the creation of a character. I say *subjectively* because I am not talking about the direct effect of historic events or trends, but about the historical content residing in particular character-traits, habits, emotional attitudes, beliefs: and how this content, which may be highly inconsistent in objective terms, then expresses itself through the formation of a specific character. In common speech the truth of this is recognized when outstanding cases are being considered: 'He is ahead of his time', 'He belongs to another period', 'He should have been born during the Renaissance', etc. But in fact the same applies to every character. The whole of history is part of the reality which consciousness reflects. But a character, a temperament, is maintained by emphasizing certain aspects of reality—and therefore history—at the expense of others.[17]

All of the characters in *Jonah* are at once of their time—the doldrums of the 1970s—and ambiguously either ahead of or behind it. In their late twenties or thirties, they are all trying to salvage something of the revolutionary spirit in a world that has gone back to normal. Each one, to use Berger's terminology, emphasizes a 'certain aspect' of what is possible. With the sole exception of Max, the film's token Trotskyist and lovable grump (played again by Jean-Luc Bideau), they have all decided to be optimists. They think of politics not in theoretical terms but in relation to their own small acts and dreams. A checkout girl undercharges pensioners; a trade unionist starts a progressive school; a high school teacher illustrates revolutionary history with a sausage. (The scene remains the most iconic synthesis of Tanner's and Berger's distinct temperaments: the kids laugh at the gag but then they are taught a lesson.)

Jonah switches between colour and black-and-white, emphasizing the movement between imagination and fact. One black-and-white scene fantasizes a banker turned into a pig; another shows Max aiming a gun at his reflection, only to fire it at a ticking clock instead. Interspersed are printed quotations (Rousseau, Paz, Piaget) and archival footage of historical events. It may sound grand in scope, but it is more like a patchwork. The canvas is local. Rousseau, a native Genevan, is conjured only when the characters pass his statue on the tram. Everything about the film is centripetal. The climactic scene convenes the cast for a festive meal on the farm. On the soundtrack we hear song and laughter. The film's closing image is the mural drawn by the commune's children of the adults, and of Jonah, the child born, a collective prophecy of the eight friends and lovers.

The utopian interest in community runs throughout Berger's late fiction to such an extent that we can take it for granted; but in the 1970s it came as something of a surprise. His work before *Jonah* had explored the individual far more than the group. The film was a pivot, but also a mixed blessing. On the one hand, *Jonah* emphasized the power of communion at a time of fragmentation. On the other, it signalled the contraction of utopian longings from total social transformation to the texture of the everyday. 'So vegetables are politics now!' Max exclaims—a moment of prescience long before the organic or slow food movements.

Was localism a betrayal of politics? Or was it a sensible correction to a facile idea of progress?

Two years before *Jonah*, Tanner made a small film, *Le retour d'Afrique*, that had addressed the dilemma head-on. With recurring refrains from Aimé Césaire's epic of homecoming, *Cahier d'un retour au pays natal* (a poem Berger and Bostock had just translated), and based on a story Berger had told him (about two friends who planned to travel the world but instead never left their apartment), Tanner's film—'a kind of unrecognized or unformulated collaboration'—was also a political parable. When a jaded Swiss couple hold a potlatch before their planned move to Algiers ('Europe has force-fed

us with lies', one of them says), they find themselves unex-
pectedly stuck in limbo. Waiting for word as to whether their
trip can happen, and too embarrassed to tell anyone they
haven't left, the couple stay on in their empty flat, exiles in
their own city. Bored on a mattress, listening to the radio,
laughing and crying, the journey becomes, perhaps predict-
ably, inward rather than outward. By the end they have come
to a realization: the Algerian life they imagined for themselves
would have been an escape, more flight than fight.

Often clumsy by today's standards, *Le retour d'Afrique*
testified sincerely on a subject—middle-class political longing
—that would now be treated with either scorn or satire.
Tanner and Berger took it seriously. And from the very ambi-
guity of the feeling they fashioned a fable of regeneration,
both political and libidinal, through the focalization of ener-
gies. At times aesthetically confused, its ideological trajectory
is strikingly clear. From Third Worldism the film boomerangs
back to the most local of problems: tenant organizing and
childcare. And while some critics found the drama provin-
cial—Vincent Canby called it 'intelligent, humane and just
a tiny bit irrelevant, at least to someone who does not share
the feeling that he is being overwhelmed by the boredom of
life in Switzerland today'—its think-global-act-local message
resonated with other viewers, notably young First World
activists.[18] An influential new journal on the American left,
Jump Cut, featured a glowing review, pointing out that the
title, *Return from Africa*, could also be read as an appeal:
'For what Tanner seems to be saying to his young, white,
semi-hip bourgeois audiences is this: While one can learn
from and contribute to the Revolution by immersion in
Third World politics, the real fight is where you are and who
you are. Start where you can be most effective.'[19]

The prescription, sobering yet hopeful, was apt. But it was
difficult to sustain. As the seventies wore on, any roll-up-
your-sleeves alacrity became harder and harder to muster.
People were thrown back into their own lives. The mood
soured. Bitterness often crept in. Many burned out. 'Maybe
I'll visit a few middle-sized cities,' says one ex-radical vaguely
in Robert Kramer's *Milestones*, a film of the same historical

moment as *Jonah* and in many ways its rawer, more desolate American twin. 'Revolution is not just a series of incidents', says another, 'but a whole life.'

Once the visionary gleam fades, any light at all becomes a beacon.

Released in 1976, *Jonah* was a hit. Pauline Kael and Serge Daney praised its vigour and freedom; David Denby likened Tanner, once thought of as a lesser Godard, to a Renoir of the seventies. The film enjoyed a surprisingly long run throughout Europe and North America. Berger and Tanner seemed to have managed the impossible: to have turned the residual melancholy and regret of a generation into quiet affirmation and resolve.

But the film was also a comedy made at a time when the left had little to smile about. While articles in the mainstream press fawned over Tanner's 'Merry Marxist Guerillas', hardliners saw the sharpening of a contradiction. Tellingly, *Jump Cut*, having once praised their work, fell out with Tanner and Berger. With a still from *Jonah* on its cover, one issue put the matter bluntly: 'Subversive Charm or Reactionary Nostalgia?'

The film split the left. In an animated defence, Robert Stam called it a 'dialectical music of ideas', comparing it to Vigo's *Zero de conduite*, Godard and Brecht. Unlike so many overtly political films, *Jonah*, he said, was not a bitter pill to be swallowed but a celebration of warmth, community, play— all impulses that, among other things, bring people to the movies.[20] The film 'was not made for leftists', Stam pointed out, 'it was made for a mass audience. It tries to appeal to what is revolutionary in most people: in all those, at least, who have no direct stake in oppression.'[21]

A co-authored rebuttal took a different view. Under the acerbic title, 'Subversive Charm Indeed', the essay spoke for a more austere faction. Berger and Tanner, they said, had dismissed Marx in favour of Rousseau, offering up the vague assurance that it was 'all right to drop out and put your hope in your children'. People were pissed off. 'It's damned hard to feel very good about anything when decaying capitalism

seems so very bent on destroying as much human life as possible.'[22]

Self-righteousness aside, the article advanced two principal arguments worth considering. The first was that the optimism of *Jonah* masked an insidious bargain, flattering the self-satisfaction of a disillusioned audience through the smug if discreet elision of class. Seen in this light, *Jonah* was little more than a 'light-weight, slightly progressive' exercise in cultural tourism (or appropriation), where middle-class artists got to dress up as farmers and peasants. The second critique pertained to what they saw as the film's 'blatant, inexcusable sexism'.[23] This was hard to deny: the evidence was right there on the screen. Women disrobe and emote; men think and discuss. 'Tanner can claim any excuse he wants,' the article concluded, 'but he has made a movie that shows complete ignorance of women's struggles over the last ten to fifteen years.'[24]

Far more than Berger, Tanner was the public face of the film. In interviews he took an agnostic stance. 'There is no real message here', he said. 'I'm not trying to tell people what to do or think. I'm not a priest or a politician. *Jonah* is just about what happened to people after 1968. There are some hopes in the film, because the characters are not just sitting back and wanting to belong to the silent majority. They want to move forward, in some small way.'[25] Berger stayed out of the debate, but he was the one who had drawn the film's blueprint. In the preliminary notes he outlined what he and Tanner were attempting through a metaphor. The characters were never supposed to be paragons of the left:

> In the whale, which is history, there are eight characters like eight Jonas. All of them are *ridiculous*. We must never forget this. They are ridiculous, sometimes stupid, sometimes blind, often dishonest and petty in their obsessions. We must allow that aspect of them which is immediately dismissable by the bourgeois to be fully presented. Yet it is in their ridiculousness that their little prophesies lie. And their prophesies save them from some of the self-destructions and murderous guilt of the society to which they belong. Yet they are not comrades

together. They are too individualistic. They bicker and disa-
gree. All that they recognize that they have in common is a
certain aberrance.[26]

There is a revealing if predictable irony here. The very quali-
ties Berger anticipated would be dismissible by the middle
class were the ones that unsettled the more unforgiving of his
comrades. *They are too indulgent! Too irresponsible!* To use
Berger's own phrase: *They are ridiculous!*

It is a contradiction the film turns over and over. In one
scene Max, Marco and Matthieu chop vegetables for dinner.
'Because it's a time of disillusion you go back', Max says.
'Everyone is looking for an escape: the body, nature, sex,
onions, lotus flowers. Small consolations in a world which is
said to be unchangeable.'

'You don't allow for little pleasures?' Marco asks.

'Little pleasures? Everything's little. Little gimmicks. Little
tricks.'

'We have to sacrifice for the future. Shit!' says Marco. 'It's
the old trick of revolutions. It's what capitalism has always
preached. It's you who is living in the past. You want a new
1905, or 1917, or 1968.'

Kneading dough, listening all the while, Matthieu pipes up:
'You make me sick with all your talking. It's so simple. We
work to earn a living. With our work, they make a profit. And
with the energy left over we try to fight the system.'

Jonah thus left the aporias of commitment unresolved even
as it sided tonally with a humble, playful optimism. A joke
or a song was the logical terminus of contradiction more
often than any synthesis. The effect could be heartening to
some but offensive to others. For those who thought political
art should theorize revolution or depict oppression it was a
betrayal of privilege. For those tired of cardboard slogans it
was proof of *innocence*—the refusal to capitulate to an over-
intellectualized bitterness. The deep psychic effects of most
films cannot be measured; for *Jonah* we may have a clue. In
the late 1970s a startling number of parents, including future
filmmakers Alfonso Cuarón and Fernando Trueba, named
their sons—what else?

'The open secret' of the Berger-Tanner films, according to Todd Gitlin, was their sincerity. The characters had nothing up their sleeves: they were 'without either sin or guile'. Most dramas of political failure dwell in guilt or outrage; *Jonah* invited participation. 'They pose the issue', Gitlin said, 'suppose you really decided to live decently, and deliberately, and with a radical freedom, after '68, after Vietnam, after Nixon —then what?'[27]

As the movie circulated through the art houses of New York, Berkeley, London, Madrid, the political signposts grew opaque. The road into the future was heading into mist. It was no longer so easy to apply a moral dualism to events. 'You complicate things', Madeleine tells Max, 'dividing everything in two: the good, the bad, the useful and harmful. You think like a court of law, always judges and lawyers.' Politics, people were saying, was no longer about organizing. It was about self-expression, the body, identity, our everyday choices and lifestyles.

Jonah sits on a hinge between political epochs. It crystallized the mood on the left when the present-day fault lines were being drawn. Can pleasure be politicized? What is liberation and what is indulgence? What is an opiate and what is a stimulant? When is the local merely a refuge?

The questions remain. They continue to haunt any personal bid for utopia: from intentional communities to acid trips in the mountains and the experience of love, friendship, or the decision to have a child, a utopian wager on the most intimate of scales. Fittingly, the questions remain open. 'The uses to which one can put a life', as Berger wrote, are there to be discovered as much as deduced. The same indeterminacy applies to *Jonah*. We are left with a freeze-frame of a boy. We do not know the person he will become.

'Who doesn't possess his own blue suit?' asked César Vallejo. 'Who doesn't eat lunch and climb on the streetcar / With his cigarette arranged for and his pain the size of a pocket?'

Although Berger and Tanner remained friends, *Jonah* was their last collaboration. It marked both the pinnacle of their

partnership and its final step—an act of synthesis that was also an impasse. It was Berger who first recognized this. The decision, he said graciously, was reached 'by mutual agreement, although I think it was actually myself who first formulated the idea that it would probably be better for us not to work together for the moment.'

In the years that followed, Tanner entered a depression. He emerged with *Messidor* (1979), an inconsolably bitter film about two lesbian runaways (later the inspiration for *Thelma and Louise*). In its incessant anti-patriarchal excoriations, *Messidor* was about as direct a response as possible to the feminist critique that had been levelled at *Jonah*. And the response continued. Whether he thought about his own work this way or not, Tanner's entire subsequent trajectory can be seen as a protracted wrestling with the accusations of sexism and naivety, exploring destructive female anti-heroes and anhedonic, disoriented men. Parables of detachment replaced the gleeful irreverence of his youth. 'I knew the characters', wrote Serge Daney of Tanner's late cinema, 'having seen them come and go: they were flawed and bad in '68, then armchair idealists, then, in '85, embittered, dissatisfied hippies, that's all.'[28] The assessment is harsh, but it does speak to a dwindling in the work, an inability to match not only his previous collaborations, but to recover the energy and inspiration of the films he had made individually beforehand.

Berger, for his part, emerged from *Jonah* moving in a different direction. He began learning from his new neighbours, the aging farmers in the valley where he and Beverly Bancroft had settled. In conversation he would later play down his role in *Jonah*, while holding up the work with Jean Mohr from the same moment, *A Seventh Man*, as the book he was proudest of.

And yet the instability of some collaborations, just like marriages or movements, can be part of their beauty. For a brief interval, Tanner's and Berger's purposes overlapped. The films they made were unique in spirit, ideas and tonality. Together they struck a fresh chord that was tender and bright: a major seventh.

7

Beyond Ideology

When I sitting heard the astronomer where he lectured with
 much applause in the lecture-room,
How soon unaccountable I became tired and sick,
Till rising and gliding out I wander'd off by myself,
In the mystical moist night-air, and from time to time,
Look'd up in perfect silence at the stars.

 Walt Whitman

In one of his last articles for the *New Statesman* Berger
places the reader beneath a beech tree and asks her to look
up at the leaves. It is a sunny afternoon, and there is a slight
breeze that moves the lighter branches. He asks the reader to
focus on what she sees. 'Through half-closed eyes you gaze
up. They are half-closed because you are watching intently.'[1]

That intention, however, can vary. Over the course of the
essay—written when he was thirty-two and published in
the spring of 1959—Berger considers five different 'ways of
looking' at the scene above: as a philosopher, an engineer, a
poet, a lover and a painter. Each way of looking brings out
different aspects of the physical world and situates the viewer
in a different relation to that world. The engineer begins to
measure and count; the lover luxuriates; the philosopher
extrapolates. The painter studies the sheer presence of colour
and the angles of the boughs, 'like a fitter, not like a mathema-
tician'. Each orientation follows different movements of the
perceiving mind, so that seeing is understood as an activity—
almost a *skill*. It can be modified and trained. Our perception

of what surrounds us merges with the rest of our being in a reciprocity that is dynamic and continuous. 'The world is inseparable from the subject', said Merleau-Ponty, 'but from a subject who is nothing but a project of the world.'[2]

The chiasmus speaks to a series of dialectics that ran through Berger's own life projects: between inner and outer, the body and nature, the self and history. He possessed a rare gift. Though not a professionally trained philosopher, he was sustained rather than defeated by such antinomies, which he tried to keep together through various means—sometimes through the sheer force of rhetorical willpower; sometimes through quieter affirmations of faith; sometimes through radical gestures of self-definition; sometimes through carefully crafted works of art.

There were many ways in which Berger was a writer. He was by turns a critic, a polemicist, a theorist, a collaborator, a novelist, a poet. It was this variety that defined his trajectory as much as it defined certain individual works. Berger simply refused to accept divisions so many others of his generation thought undeniable. The multiplicity of the work should not be seen as a mark only of restlessness. It was more like an ongoing philosophical wager. How to connect fields and regions of experience far too often kept separate?

'Five Ways of Looking at a Tree' remains one of Berger's most lyrical essays from a period otherwise burdened by the fevered abstractions of argument. Perhaps for this reason, it was also one of his most prescient. A 'way of looking', understood as an attitude, orientation or worldview so intrinsic to the person it coloured perception and became almost a way of *being*—this was central to Berger as he enlarged his understanding of the political and its intercourse with the aesthetic. 'Every way of looking at the world', he wrote later in 1959, 'implies a certain relationship with that world, and every relationship implies action.'[3]

A way can be both a means and a path. The flexibility of his framework let Berger travel as far as he did over the 1960s. The fundamental triangle of perception–orientation–action had supple joints. It mediated between form and content, vision and belief. But it was also a construct as vulnerable as

it was pliable. And it rested on a philosophical fault line that widened over the course of the following decade in direct proportion to the collapse of an actionable radical politics. A new term—*ideology*—came to predominate. The old postwar polemics Berger had done so much to surmount were turning into new ones, within Marxism, between structure and experience.

For a time Berger was a core participant in the ideological critiques of the early 1970s. Perhaps ironically, this is what made him so famous. His four-part series, *Ways of Seeing*, first broadcast by the BBC in early 1972, became the most influential arts programme of the decade. With each thirty-minute episode, Berger subjected the gentleman's tradition of art, like a regal statue, to a succession of historical-materialist attacks: the form of the oil painting, he said, embodied not tactile virtue but the possessiveness of mercantile capitalism; the nude was not a humanist celebration of the body but a product of male voyeurism; the language of visual advertising, no matter what its content, reinforced a system driven by envy and the fear of social ostracism; and, most fundamentally, a love of art was nothing but a cultural alibi for the European ruling class.

All this is ideology writ large. The argument was anthropological and sweeping. Berger spoke of stripping art of its 'false mystery' and 'false religiosity'. The opening scene, now infamous, was practically an icon of sacrilege. In what looks like the National Gallery Berger takes a scalpel to Botticelli's *Venus and Mars*. He is wearing trousers and a seventies shirt. The incision is played up on the soundtrack—it is the first beat of the show—before fading into voiceover. 'With these programmes I want to question some of the assumptions usually made about the tradition of European painting,' Berger says, 'that tradition which was born about 1400, died about 1900.' The metaphor is plain. To question is to dissect: it is to see beneath and beyond.

One by one, Berger cuts open the stale chestnuts of connoisseurship to reveal symptoms of a larger disease: patriarchal European capitalism. He famously (and convincingly) reads Holbein's *The Ambassadors* and Gainsborough's *Mr and*

Mrs Andrews as little more than visual puff-pieces. Or *The Judgement of Paris* as an early Miss Universe contest. 'European means of representation', he wrote in an essay later adapted for the script, 'refer to the experience of taking possession. Just as its perspective gathers all that is extended to render it to the individual eye, so its means of representation render all that is depicted into the hands of the individual owner-spectator. Painting becomes the metaphorical act of appropriation.'[4] Berger in turn re-appropriates. The show cuts and pastes to make a real-time collage in support of its argument. The technique may now be widespread; at the time it was brazen. The works that have participated in the construction of a tradition, once that tradition has been dismembered, are at once orphaned and judged guilty by association. Whatever may have remained of the *beaux arts* curriculum before the show, barely a plinth was left standing afterwards.

The demolition was a watershed. Martin Jay spoke of *Ways of Seeing* as a 'gauntlet' thrown down, after which 'the study of visual culture has never been the same'.[5] Griselda Pollock referred to the 'moment' of Berger's intervention—1972—as a kind of methodological primal scene: the humanities turning away from the aura of formalism towards what would soon become its dominant mode, namely 'the analysis of power and the deconstruction of classed, raced, and gendered meanings'.[6] Within a few years journals such as *Screen*, *Art Forum*, *Critical Inquiry* and others were following up where Berger had left off, elaborating on, revising, and soon moving beyond his own overstated and often oversimplified lines of argument. (Laura Mulvey's famous essay on the male gaze, for instance, appearing in 1975, can be read in just this way—as an application of Berger's feminist thesis to the gendered spectatorship of classical Hollywood.)[7] Meanwhile, in classrooms throughout England and America, *Ways of Seeing* became, as one professor put it, 'instant syllabus material'.[8] The show proved remarkably efficient: in only two hours, entry-level arts students could be culturally detoxed, their slates wiped clean for the more sophisticated critical methods to come. The broadcast, in this sense, relives its own 'moment' semester after semester. The feminist

media scholar Jane Gaines spoke not only for a generation of academics but for so many of their students when she acknowledged Berger's formative influence. 'We learned from him', she said, 'that basic assumptions about everything—work, play, art, commerce—are hidden in the surrounding culture of images ... They are not what they first appear to be, but can be made to reveal their secret.'[9] To study art was never again to be about nodding in appreciation, but rather hunting for what Gaines called 'the political key to crack the code'. It was a kind of unmasking. In place of canon worship, Berger taught what came to be known, pedagogically, as *critical seeing*. How do images conceal their deeper significance? How are social relations inscribed in the very forms by which a subject is treated? What role does art, or the idea of a love of art, play in the broader transmission of power?

Berger's answers led more by example than anything else. They were influential certainly not because of their rigour nor the specific content of any analysis. Rather, when taken collectively, they heralded a new *mood*, a new style of thought. Along with the concurrent uptake of the Frankfurt School, Foucault and others, *Ways of Seeing* helped usher into the academy a particular intellectual stance: the *critical* stance. Remember, Berger says at the end of the first episode, 'I am controlling and using for my own purposes the means of reproduction needed for these programmes. I hope you will consider what I arrange—*but be sceptical of it*.' It is a rhetorical ploy, of course, as others have noted, but it was also an imperative that fitted within the soon-to-be-dominant school of critique. The series, and the book that was later adapted from it, worked like a grenade. Together they helped clear the ground for the subsequent rise in the academy of visual studies, cultural studies, media studies, and so forth.

Once again, Berger had arrived at the right moment. His timing was deft. New constituencies were placing new pressures on the museum and the university. Institutions were ripe to be remade. But, once again, Berger wouldn't stay long. The irony is twofold: first that radical subversion was soon to become an academic orthodoxy and second that one of its original subversives was never going to deliver the keynote

at the Association for Art History. Berger had always been averse to institutional life, and yet, through the sheer magnetism of his own televisual presence—the deep squint, the excitable brow, the famous stare—he became the first face and master of ceremonies to a peer-reviewed party he was soon to walk out of. Having tossed the grenade, he let others sort through the rubble.

Ways of Seeing was certainly the most influential art-critical project of the 1970s, arguably of the whole postwar period. But for its author it was something of a fluke. It represented one belligerent and structuralist extreme of his style. Berger himself never considered it a major work. It was his last serious move in the polemical mode. And throughout the show there are hints not only of exceptions to his rules (in the great masters of the tradition) but that perhaps it was in these exceptions that the whole raison d'être of art resides.

This was a line of thought submerged by the show's provocations. But it was one that became far more evident in Berger by the end of the decade. In this sense the seventies were clarifying. The concept of a way of seeing, pitched so delicately and deliberately on a dialectic, was slowly being turned into a decision: ideology or experience, Eagleton or Williams, Thompson or Althusser. And however confusing the intellectual landscape was when Berger made Ways of Seeing—I don't think he could have then imagined anyone genuinely arriving at Marxism except through humanism—the subsequent rise of structuralism, and then post-structuralism, surely brought home the extent to which the New Left was over.

Two essays are particularly revealing of the sea change. The first, 'The Work of Art', was a review of Nicos Hadjinicolaou's Art History and Class Struggle, published in England in 1978. This was the first real encounter between Berger and a work of confident Althusserian method. He was brought up short. As with his early breaches of party doxa in the mid-fifties, Berger expresses at the outset the complexity—both personal and theoretical—of his reactions.

These reactions are fundamentally hostile. He describes the tool of visual ideology as 'an elegant if abstract formula', but

he cannot give himself over to it. According to the precept, once it has become absolute, we are, Berger says, 'like blind men who have to learn to allow for and overcome our blindness, but to whom sight itself, whilst class societies continue, cannot be accorded.'[10] The result was a theory that eliminated the experience—the act and mystery—of making or looking at art.

Berger admits that his own argument in *Ways of Seeing* was weak at the very point at which the tool of visual ideology fails: the exceptional work. A great work of art can almost be defined by the inability of any purely ideological analysis fully to account for its power. 'For me', Berger confided to a friend at the time, 'there are works of art, and these are the only ones which continually engage me, which remain mysterious. Which, by their nature, extend beyond explanation.'[11] (Or, as Braque put it, 'The only thing that matters in art is what cannot be explained.')[12] Of course, Berger understands the potential for tautology and subjectivity in all of this, but he remains insistent. 'I would beg Hadjinicolaou and his colleagues', he ends his review by writing, 'to consider the possibility that their approach is self-defeating and retrograde, leading back to a reductionism not dissimilar in degree to Zhdanov's and Stalin's.'[13]

For Berger, as for many others, the emergence of *theory* was in fact a sign of political closure. It fixated on constraint instead of activity, closed systems instead of process, false consciousness instead of revelation. The prevalent attitude combined a hip, slightly haughty wariness with self-referential tail-chasing. In this there was a powerful sense of déjà vu. What Berger had once feared was happening to painting in the 1950s—that it was turning in on itself, that it was committing suicide, that it was losing the world for the laboratory—was exactly what he saw happening to Marxism in the late 1970s. Whether this was understood as theory-for-theory's-sake or as part of a broader 'hermeneutics of suspicion', what Berger was quick to intuit others would soon discover: that critique on its own would eventually run out of steam.[14]

A second essay demonstrating how far Berger had travelled over the course of just a few years came in 1983. Titled 'The

Production of the World', the essay recounts his hesitation before attending the biannual meeting of the Transnational Institute in Amsterdam. In 1974 Berger had been one of their first fellows. But by the early 1980s the days of anti-colonial struggle already seemed far away. People were worn out:

> I almost decided not to go. I felt too exhausted. My exhaustion, if I may so put it, was as much metaphysical as physical. I could no longer hold meanings together. The mere thought of making connections filled me with anguish. The only hope was to stay put. Nevertheless at the last minute I went.
>
> It was a mistake. I could scarcely follow anything. The connection between words and what they signified had been broken. It seemed to me that I was lost; the first human power—the power to name—was failing, or had always been an illusion. All was dissolution. I tried joking, lying down, taking a cold shower, drinking coffee, not drinking coffee, talking to myself, imagining faraway places—none of it helped.[15]

In a state of anomie, Berger left the conference to meet a friend at the Van Gogh museum across the street. He went there not to look at the paintings—'at this moment, I told myself, you need Van Gogh like you need a hole in the head'—but because the one friend who could take him home would be there.[16]

This is the premise of the essay. As he passes through the 'gauntlet' of the museum, he finds an unexpected curative. In Van Gogh's paintings 'reality had been confirmed'. And the anguish Berger had experienced so frightfully in the conference room, his 'vertigo of nothingness', drops away. The effect was so immediate that it was as if, he says, he had received an intravenous shot.[17]

What Van Gogh revealed to Berger was not just the *thereness* of the world, but the ongoing work—physical, aesthetic, spiritual, passionate—needed to keep the world present, at hand, and to keep oneself embedded within it. This was manifest in the brusque materiality of the canvases themselves, as Van Gogh tried to get as close as possible to what they depict: *The Potato Eaters, The Cornfield with a Lark, The*

Ploughed Field at Auvers, *The Pear Tree*. What the Dutch painter offered was a thick description of the universe shot through with compassion. His work, as Berger later put it, was 'strictly existential, ideologically naked'.[18] The same hands the peasants used to eat, they used to plant what they ate. The same energy moving from the sun to a flower Van Gogh meant to bring out in the energy of his paint. Not the screen of ideology, then, but the pullulating, visceral activity of the world. Reality itself was a form of creation, Berger concluded, and because of this it was best approached through what he called 'the labour of being'.

If the essay from 1978 represents his ultimate rejection of ideology, the 1983 essay points to a new tack—a new metaphysic—towards which he was already turning. Work is the dominant theme of Berger's latter period, and he did much of it, never really stopping until he died. 'Nature is energy and struggle', he wrote. 'Visibility is a kind of growth.'[19] After the long hangover of the New Left, what work meant was not revolution or critique, but participation in the ongoing production of existence. 'As soon as one is engaged in a productive process', he wrote in an essay on Leopardi, 'total pessimism becomes improbable. This has nothing to do with the dignity of labour or any other such crap; it has to do with the nature of physical and psychic human energy. Expenditure of this energy creates a need for food, sleep and brief moments of respite.'[20] There was a metabolism in this that led, however gradually, to renewal. 'Inexorably', Berger said, 'work, because it is productive, produces in man a productive hope.'[21]

The essay in Amsterdam can be read a number of ways. It is at once a parable of anxiety and grounding, a personal account of post-structural nausea, an affirmation of the intimate power of painting—and an allegory for Berger's own exit from the larger auditorium of metropolitan debate.

Ways of Seeing, it turns out, was not only an intervention but a farewell. By the early 1980s, he had more or less excused himself from the centres of intellectual discussion. Soon professors would have little more to learn from him, and Berger, for his part, little more to learn from them. Every

once in a while an essay would find its way into a new subfield —'Why Look at Animals', for example, taken up by animal studies—but by and large he was of little use. He was too embarrassingly earnest, too uncritically sincere; for many he was too unselfconsciously masculine. So while a generation of theorists discoursed away about the sign and the signified, Berger had wandered off on his own.

He all but abandoned the critical mode. His ambitions now expressed themselves not so much through any single creative work, but in a life project out of which, almost like by-products, arose a range of stories, poems, missives and sketches. The tone grew intimate and caring. The scale switched rapidly from the smallest of observations of the natural or animal world to the metaphysical.

In 1959 Berger wrote that he judged a work of art by 'whether or not it helped men in the modern world claim their social rights'.[22] In 1985, as part of an introduction to a book of essays, he repeated the claim. But he added a new one: 'Art's other, transcendental face raises the question of man's ontological right ... the transcendental face of art is always a form of prayer.'[23]

In the mid 1970s Berger began a new life—and a new family—in a small mountain village outside Geneva in the Haute-Savoie. He was close to fifty. It was in the Giffre River Valley that he began what he called his 'second education'. Many of his older neighbours continued to live by agrarian methods more or less unbroken for centuries. Berger started to work alongside them. They became his teachers. 'It was like my university', he said. 'I learnt to tap a scythe, and I learnt a whole constellation of sense and value about life.'[24] The title of the trilogy he wrote over the following sixteen years, a mixture of stories, poems and essays about the disappearance of the peasantry, came from the Bible: 'Others have laboured / And ye are entered into their labours.' But it was also an anthropological signature, an expression of his own method and metaphysic—almost a theology.

At first Berger and Beverly Bancroft did not live in the village of Quincy itself, but up the road in an old farmhouse.

The ground floor was an unused cow barn; in the kitchen an iron furnace burned coal and wood. Even so, the house was frigid in the winter. There was running water, but no way to heat it except on the stove. The toilet was in an outhouse across the driveway. There was no telephone. Upstairs Berger kept a study with a desk, typewriter and books; from the window the massif of Mont Blanc was visible in the distance. It was a short walk to the village, but there was no commerce there. The nearest grocer and post office were several miles down the main road along the river.

For some, the move was a retreat. It was seen by many as quixotic—Tolstoyan. Here was one of England's most renowned leftists living in the French countryside when Thatcher was ascending to power, the welfare state crumbling, and coal miners out on strike. Whenever he visited London, which he did about once a year, there was always the inevitable question. 'What are *you* doing over *there*', in one friend's paraphrase, 'with romantic ideas about peasants, when you should be over here at the sharp end of the class struggle?'[25]

To others it was an aesthetic capitulation, a nostalgic turn away from the rigorous modernism of his novels. In a remarkable conversation—remarkable for its intimacy and frankness—commissioned in 1983 by Channel 4, a regal and silver-streaked Susan Sontag, sitting across a small table from Berger, continually pressed her friend on this point. 'But haven't you changed, John', she said again and again. Berger seemed taken aback. 'Well, I have had to relearn how to write', he admitted, half reluctantly and half with a recalcitrant pride.

However native he may have gone in the foothills of the Alps, he of course always had the privilege of leaving, of travelling, of his education, of his friendship with important artists and publishers. Berger's French, for that matter, remained faltering and heavily accented to the end. He was never more than an hour's drive away from Geneva, one of the most cosmopolitan cities in Europe, where his ex-wife and two grown children lived. And by the mid 1980s he was dividing his time between the Haute-Savoie and a suburb of

Paris, where he had a new companion, the Ukrainian-born writer Nella Bielski, a woman Beverly shared him with.

Despite all this, the move to the country was anything but a caprice. Even those friends who could be sceptical—who may first have looked askance at what they saw as rural gentrification or fashionable country squatting—had to admit, once they visited, that he had indeed found a new and fitting home. Berger shared in the life of the village. He helped with the haymaking during harvest, visited the higher pastures when it was time for the cows to graze, accompanied woodcutters as they felled trees, picked the apples to be pressed into cider, and drank the gnôle that was passed around at local celebrations. He participated in and was part of the gossip that made up the social fabric of the valley. He did not own land at first, choosing instead to rent his house from a neighbouring farmer, who became a friend. 'I feel at home here in a way I have felt nowhere else,' he told an American journalist who made the pilgrimage in 1981. 'Certainly not in England. I don't feel French particularly, but I do feel at home in this village, accepted for who I am.'[26]

A retreat implies an escape—either to surrender or to rest. Berger did neither. If anything, the spectre of the charge made him work harder: not only with his writing, but with all he did that was not at his desk. 'I didn't have a wish to get away', he said. 'I had a wish to meet something. Yes, I had a wish to meet and know more about rural life. Not in contrast to urban life, or as a relief from urban life'.[27] It was not a question of getting away from one thing but of getting close to another. And the very idea that the rural was, perforce, a *getaway* spoke to what he saw as the historical solipsism of the urban professional class.

Berger made sure his life in Quincy was immersive rather than picturesque. The list of subjects he found in Millet, whose reputation he came to defend, constituted his own newly chosen chores: scything, sheep-shearing, splitting wood, potato-lifting, digging, shepherding, manuring, pruning.[28] The French painter was not a sentimentalist, he argued, but an agitator stuck in a bourgeois form. And so disruptive was his desire to bring the 'previously unpainted experience' of

the peasantry into the gilt-framed tradition of the oil painting that any failure on his part only demonstrated the difficulty of the task.[29] How to represent an experience so immediate to one class of people and so foreign to another? The viewer of the landscape would always be *in front of* what the farmer lived *within*.

In order to break free from the scenic, the physicality of labour had to be lived in and felt before it could be seen, let alone depicted. It was a question of authenticity. Anyone without calluses on their hands could not tell of the experience of mowing a field. And anyone who had not lived through a mountain winter could not write of the cold. Berger's income came from his books, of course, but he also spent days outside, working the land in the sun and rain, living the seasons along with his neighbours. And the twin affects he sought out, ancient as day and night, were the bodily sensations of effort and exhaustion.

In conversation Berger always said that *A Seventh Man* was the pivot. When researching that book, he spoke to hundreds of migrants from the southern peripheries of Europe: Portugal, Spain, Greece, Turkey. Almost all of the men had come to work in factories or mines or public works. They lived on the outskirts of cities. The particulars of this new life, Berger said he could picture. But what they had left behind, the life of their parents and of their village, he said he could not. Nearly all of them were the sons of peasants. 'When they talked, I realized a great deal of what they were feeling I couldn't locate', he said. 'I was ignorant. I wanted to try to get over that ignorance.'[30]

Knowledge, in this case, meant experience—not only the experience of agrarian labour, but integration into the social commons. The two went together, and together they made up village life. 'The best way to get to know peasants is not by talking but by doing things, working together', he said. 'If you are, as I was, prepared to get dirty with them, clean stables and work the fields and so on—and do these things ludicrously badly, so that they are master and you the idiot— if you can do this, the distance can be overcome, a closeness felt.'[31] (A generation above him, the French philosopher and

mystic Simone Weil had advised something similar: it was only by spending 'whole days doing exhausting work side-by-side peasants,' she said, that they opened up and 'heart-to-heart talks' became possible.)[32] At the height of his international fame, after *Ways of Seeing* and the Booker prize, after a decade or more of restless travel, having only nominally been based in Geneva but without any real sense of permanence, after a crisis and a divorce, Berger found in the working life of Quincy not only a home but an anchor: a *community*.

There are usually only one or two times in a life of such deep belonging. If it happened more often, it would not be so special. On leaving England, Berger had left the first social whole of which he was an integral part: a postwar milieu of studios, galleries, clubs, salons, debates. 'I felt myself a distinct member of that community', he said decades after leaving it. 'Not the art world', he was quick to clarify, 'but of several hundred or a thousand painters and their friends.'[33] Twenty years later, his new community was in the Giffre River Valley and consisted of his neighbours and their families—one urban, the other rural, yet both predicated on the shared premises of work.

'There is an inescapable kinship between farming and art', observed the American conservationist Wendell Berry, 'for farming depends as much on character, devotion, imagination, and the sense of structure, as on knowledge. It is a practical art.'[34] In his first book on Renato Guttuso, Berger had noticed something similar. The extent to which the land in Italy had been worked, almost every acre of it ploughed or terraced, suggested to him a correspondence between the craftsmanship of husbandry and Guttuso's own paintings, of which every inch had been similarly turned over. Landscape, in this sense, can be both a noun and a verb. Guttuso, Van Gogh and others were special because they recognized this—the *activity* of the trees and the fields and the artist—an affinity Berger brought out in his early fiction. 'It is a large canvas, 2 by 3 metres', he wrote in *A Painter of Our Time*. 'That is the equivalent of tilling 10 hectares.'[35]

If Berger spent his formative years drawing men at work, he was now drawn into the work itself. And as he did this, and

settled down, what he had once said of art—the sympathies he had expressed for the local, the regional, for images of labour and the camaraderie of collective effort—returned as prophecies for his later life. After a peripatetic middle period, with an aesthetic focus on global modernism, Berger's later writing returned to an idea from his earliest campaigns: the textural particularity of place.

Berger's attack on abstraction during the 1950s had been that it was a placeless, cosmopolitan style. It existed nowhere. This is what the autonomy of art really meant, he said: not the freedom to experiment but the windowless, off-site feel of the laboratory. 'There are Yugoslav Dufys, Canadian Miros, Cuban Mondrians', he wrote of the 1952 Biennale, 'all working in their own countries yet all subscribing to a diffused international style, which can no more produce a tradition of art than Esperanto can produce a tradition of literature.'[36]

Painting, for Berger, was rooted in the experience of sight, and sight was rooted in the local and particular. Visibility takes place somewhere. In order to deal with the appearances of the world, the artist must begin with the appearances of a given town or field or face. 'Painting and sculpture are essentially local arts', he said in a talk given in the 1950s, 'they depend upon their local context—the national tradition, the people, the light, the landscape, the architecture for and from which they have been created.'[37] In an outline for a manifesto-like book that was never published, he planned to dedicate a chapter to the 'Falseness of Art with a capital A' and the 'advantages of local and national against international culture'.[38] In his first novel Berger put the matter bluntly: 'Cosmopolitanism and formalism feed together', he wrote. 'Look at the nonsense written about Cézanne. He's an abstracting theoretician only so long as you forget Provence and ignore that saint of mountains. Then you see that he was doing the same thing as Chardin: looking at nature so hard that his gaze began to revolve it, like a stream a mill wheel. Or Piero della Francesca. His skies and hills look sublime in London. In Umbria they are less extraordinary than buses.'[39]

The American art market was like American agribusiness. It belonged to a global historical process whose net effect was the depletion of regional difference, leaving behind a vague, centreless sprawl where nothing ever changed except, as Italo Calvino once said, the name of the airport.[40]

Berger's most beloved essays from the late 1970s and 1980s moved in the opposite direction. They returned painters to the place of their origins: the Thames and his father's barbershop for Turner; the cliffs of Le Havre for Monet; the light and canals of Delft for Vermeer; the Drôme for Ferdinand Cheval. These are Genesis stories of a sort. They search for what Berger called the *address* of a landscape: the way the character of the land 'determines the imagination of those born there'.[41] It was not a question so much of identity or pride, but of perception, what Gaston Bachelard referred to as 'the poetics of space': a phenomenology of location. In the work of Courbet, for example, the hills of the Jura become more than a subject: they are a palpable philosophy. The limestone and moss, the dark green, the lateral light of the forest. All these combine to produce a sharp 'lawlessness' of vision, as if to see the world from a dense woodland is to challenge 'the chosen ignorance of the cultured'.[42] In a long essay on Iberian painting, Berger spoke of the 'wound' left by the defoliation of the Spanish interior, an injured scepticism he could sense in artists as otherwise distinct as Velásquez and Goya. Even religion he understood this way. 'In the Sahara one enters the Koran', he wrote. 'Islam was born of, and is continually reborn from, a nomadic desert life whose needs it answers, whose anguish it assuages.'[43]

In *Ways of Seeing*, Berger had appeared before a blue screen. It was not the colour itself that was the point— although some claimed the blue accentuated his guru-like presence as if he were Moses framed by the sky—but rather to lay bare the technical device of television, to emphasize the *nowhereness* of the film studio. Whereas Kenneth Clark travelled from place to place in *Civilisation*, Berger focused his attention on the form itself. What the modern media did, and what his show was self-consciously doing, was to sever an artwork from its original context, stripping it of what Walter

Benjamin famously called its *aura*, thus rendering the image reproducible, transportable, tokenized. In place of appreciation, Berger had taught critical seeing. But in the years after the broadcast he was quietly but just as radically teaching something else: a kind of intimate and collaborative vision. Rather than elevate painters to the canon (something he was never any good at) Berger brought the canon down to earth. It was a subversive act of critical hospitality. Neither placing the masters art-historically, nor defining them ideologically, he instead integrated their work into the *experiential commons*: the common experience of a barbershop or a forest or the outskirts of a town. His late essays form an intimate map where the milestones of art help to reveal the lived territory of our shared experience.

This was in stark contrast to the intellectual fashions of the time. What Althusser called the ideological state apparatus, or what Foucault meant by regulative power, was a pervasive, unapproachable force. It was at once everywhere and nowhere. Like original sin, it had, in Richard Rorty's summary, 'left an indelible stain on every word in our language and on every institution in our society. It is always already there, and cannot be spotted coming or going.'[44] The sole remedy was never-ending vigilance. 'Only interminable individual and social self-analysis', Rorty said, 'and perhaps not even that, can help us escape from the infinitely fine meshes of its invisible web.'[45]

Ideology is precisely that which cannot be seen or met; whereas the visible implies an encounter: between light and the retina, the world and the body. Berger's later writing elevated this to a principle of existence. He said he wished only to write of the 'common moments', the sites of rendezvous and confluence. In an age otherwise characterized by belatedness and alienated repetition, his whole project was to return art to its origins, to rediscover the aura of shared moments and places, and to reinvest experience with a sacred meaning that the instant culture of capitalism had removed from it. It was a personal, artistic and intellectual programme of re-enchantment. There was in his language a profound space and silence, sometimes Delphic. 'Within nature space is not

something accorded from the outside', he once wrote, 'it is a condition of existence born from within. It is what has been, or will be, *grown into*.'[46] Likewise, the deep quiet of his later writing was not a cessation or a parenthesis in a larger din, but a surrounding condition, a form of active, attentive listening, something tenuously held. He was at his best when admiring and noticing. While art historians constructed elaborate floodlights, built scaffolding around the canvas, or else put it through x-rays in order to fix it indisputably in the official record, Berger did something different. He held up a candle to a detail of the painting and whispered: 'Look!'

Of course, of all the places one was missing: the modern city. It is true that Berger sometimes wrote of the urban, but he never did so convincingly, or at least not approvingly. The same year he moved to the Haute-Savoie he overcame his fear of flying to visit New York, but what he found there was like the lower rung of hell. This was the mid 1970s, and the city's sidewalks were 'worn and stained like interiors'; each soul had been 'turned inside out' and made ragged. Manhattan, he concluded, was full of people 'resigned to being betrayed daily by their own hopes'.[47]

Anyone who has wandered Times Square in a blue mood will sympathize with the sentiment. But what was absent, as in *A Seventh Man*, were the joys, the freedoms, the exciting anonymities or chance encounters the city permits. Whether in his novel *King*, about a shantytown and its homeless residents, or in *Lilac and Flag*, the third of his trilogy set in an imagined capital, the plight of his urban characters was always heavy: it was to salvage a site of integration out of the city's indifferent, anonymous, often tragic chaos.[48] Modern cities, for Berger, were not natural homes—and especially not for writers. 'The metropolises of our world are corrupt', he once told an interviewer. 'And I don't say that in a kind of Bunyanesque way that cities are places of evil. But they are especially corrupt in the ideological field. That's to say the field in which intellectuals work—and it seems to me one has to remain extremely lucid and extremely principled.'[49] In cities, he once said, people get together to swap opinions; in the countryside they sing.

And as with any map, there were edges. Europe defined the contours of his universe. The Mediterranean and Maghreb to the south; Palestine and Anatolia to the east; Lisbon and Galicia to the west; the Eurasian steppe, and then Scandinavia and Lapland and the Hebrides to the north. In the middle was his own village and Geneva, like the hub of a spinning wheel. Imagine, for a moment, if Berger had settled somewhere not in the Savoie but in Seattle, or Lima, or Japan. It doesn't fit. He was a European writer through and through. Even as his work found a readership in all of those places, was translated and disseminated all over the world, he remained until his death profoundly—literally—Eurocentric.

This is not a value judgment, but a description. Berger sought out the place that was commensurate for him: his temperament, his gifts, his politics. And it was only by doing this that he was able to become the kind of writer who could be read globally. (One enabling contradiction was that, for all his interest in regional specificity, he never wrote in dialect: language could never be the foundational glue of a people. Berger English is almost like Business English or sub-titled English, a hybridized and distilled *lingua franca* free of wordplay.)

The world outside Europe was like the world outside the village to the villager: a vast unreality. And the Europe he was most at home in was a federation of provinces and landscapes rather than states. He had no faith in political frontiers. The Haute-Savoie had a long history of changing hands. Berger's network was a network of peripheries. The most important book he wrote in old age, *Here is Where We Meet*, catalogued the many islands of the European archipelago: Lisboa, Geneva, Krakow, Islington. The title of the most important book from his peasant phase could be that of any of his many stories or essays: *Once in Europa*.

After *Ways of Seeing* Berger became obsessed with another subject. Time was the corollary to place—its variable presence a riddle as old as thought. 'What, then, is time?' wondered Augustine of Hippo. 'If no one asks of me, I know; if I wish to explain to him who asks, I know not.'

Berger tried to explain it to himself. He filled up notebooks with diagrams, aphorisms, quotations. He corresponded with philosophers, physicists, mystics, poets, psychologists. He read Plato, Hegel, Darwin, Bergson, Heidegger. Time became his recurring philosophical theme—a muse, a conundrum, a wellspring of possibility.

G. had already broached the subject. The Greek-Australian critic Nikos Papastergiadis observed that the novel was 'an exploration of three moments in time: childhood, sexuality and revolution, all of which stand either outside or directly opposed to the homogeneous calendar time'.[50] As with the élan vital of sex, Berger pursued a political analogy, as if historical frustration could seep into the very experience of seconds and minutes. 'Every ruling minority needs to numb and, if possible, to kill the time-sense of those whom it exploits', he wrote. 'This is the authoritarian secret of all methods of imprisonment.'[51]

From this initial seed came an entire philosophical project that outlasted the novel by decades. 'I've been working on the time essay', he wrote to a friend in London in the late 1970s. 'It was turning into a short book with many illustrations. A bit like *Ways of Seeing*—except only occasionally about art. But now I've decided to leave it and pursue at full pace the stories.'[52] Perhaps fittingly, the time essay kept getting pushed back. Later he wrote of his plans for 'an evocative "confession" about time. The images will help the evocation. It is not a classical, philosophical essay. It is a way of taking the reader inside a mind or a life trying to reflect upon itself.'[53]

Instead of *Ways of Seeing*, the time book was going to be something more like *Ways of Keeping Time*—or *Ways of Being*. Like vision, time itself may have a cultural basis. The fundamental intuition was that the nineteenth century, with its legacy of positivism and chronometry, had bulldozed what for millennia was lived with as varied, uneven, mysterious. It was the temporal equivalent of perspective. Modern science now proposed a merciless and uniform process to which everything was subject: dirt, insects, plants, cells, bodies, cultures. There was an impressive, fine-tuned precision to this, but also a spiritual violence. What Mircea Eliade called the 'Great Time' of

traditional societies—a timeless and archetypal present—had been undone by the accelerations of modernity. People everywhere entered a new age of progress and anxiety. The shift, at once technological and metaphysical, was as extreme as the appearance of agriculture or the invention of metal.

Berger's interest in the peasantry was itself an act of historical resistance. 'It's an extraordinary thing, this area', he said of the valley he had moved to. 'You drive fifty miles from Geneva, and in some ways you've driven a couple of centuries.'[54] But the cliché of *going back in time* was less important than the idea of touching a *different kind of time*. Almost every human unit of duration has been predicated on the fact of natural recurrence: even the word 'culture' derives from the Indo-European root meaning to revolve or to dwell. 'To live', Wendell Berry wrote, 'to survive on the earth, to care for the soil, and to worship, all are bound at the root to the idea of a cycle.'[55]

Time has a texture—a feeling and a shape. From living among farmers, Berger came to appreciate this. In the 'Historical Afterword' to his first collection of peasant stories, *Pig Earth*, he draws a distinction between two ways of life and two conceptions of human destiny. In a culture of survival like that lived by subsistence farmers, the passage of time, like the earth itself, works as a palimpsest: each season, each harvest or slaughter, pushes what he calls the thread of tradition through the eye of a needle. Past, present and future all coexist—they are interbred with the revolution of the sun, or the life cycle of an animal.

In a culture of progress, however, such as that of corporate capitalism, time loses this centripetal anchor. With its ever-advancing technology, its obsession with innovation and youth, its phobia of death, its recurring need for new profits, commodities and markets, the modern economy creates its own 'instant culture', a perpetual state of anxious anticipation. Time becomes a liquid commodity, a series of disconnected seconds in which deals can be transacted. The future, rather than 'a sequence of repeated acts for survival', is now envisaged as a zone of limitless expansion, so potentially unlike the present as to be unimaginable.[56] And the process of modern

history, the passage from generation to generation, comes to signify not a chain of communion but the site of irrevocable loss and departure. (Such a framework is behind the title of Papastergiadis's study of Berger, *Modernity as Exile*, as well as a number of books written in the same mood and moment, such as David Lowenthal's *The Past Is a Foreign Country*.)[57]

Berger never wrote the time book he first set out to write. But he did come back to it. *And Our Faces, My Heart, Brief as Photos*, published in 1984, was the result of a decade's worth of thought. Less a treatise than a handcrafted chapbook, it is barely a hundred pages long, as if its own subject (time itself) had left behind only what was essential. There is a smooth, lapidary quality to the language. Gone is the monumental modernism of *A Seventh Man* or *G*. And yet the slim volume—a mix of philosophy, art criticism and poetry—may be just as formally inventive, as heterogeneous, and as global as anything he ever wrote.

Like previous works, it employs a range of registers: not a montage this time, but a *mélange*. Berger repurposes passages from his essays for *New Society* and the *Village Voice*, interleaving these, now unmarked, with poems, aphorisms and conjectures—many original, others borrowed. There are quotations from Novalis, Camus, Marx; meditations on Rembrandt, Caravaggio, Van Gogh; reproduced verse by Yevgeny Vinokurov, Cavafy, Anna Akhmatova. The book seems to exist in a state between waking and sleeping, moving from fable-like visions (first there was a hare, then a kitten, then a glow-worm) to journal-like entries from a life as it is being lived: a visit to a post office, a walk in the hills, reflections on the death of a friend. The ordinary traffics side by side with the metaphysical. The prose is dense with propositions: 'If there is a plurality of times, or if time is cyclic, then prophecy and destiny can coexist with a freedom of choice.'[58] 'The poet places language beyond the reach of time: or, more accurately, the poet approaches language as if it were a place, an assembly point, where time has no finality'.[59]

The voice was new. The book, and the 1980s more generally, marked the emergence of what Ben Ratliff called the 'casual-oracular sound' that came to define Berger's late

style.[60] If *Ways of Seeing* was a televisual salvo, or else a mass paperback printed in boldface, *And Our Faces* was more like a jar of gathered wildflowers. The pronouns *our* and *my* are resonant. Responding to the unique tone of the book, Louise Fili, then the art director of Pantheon, called Berger in France and asked him to write out the title in his own handwriting. For several editions this became the cover: a cursive and lowercase lettering printed on special charcoal-grey stock.

'Intimacy', Berger once wrote, 'implies having time on one's hands.'[61] Written partly for Nella Bielski, with whom he was in love, his own book on time had (as perhaps only Barthes also had) a tender philosophical wisdom at its core: heartache as knowledge. As in the late Barthes, there can be a sense of privacy so intense that the prose disperses into its opposite and becomes, paradoxically, anonymous. Berger's meditation on Caravaggio, as the painter of desire, begins in just this way: 'One night in bed you asked me who was my favourite painter. I hesitated, searching for the least knowing, most truthful answer. Caravaggio. My own reply surprised me.'[62]

The scene holds a clue to what makes the late Berger so irresistible to younger readers (including myself): aging need not be bitter; there is always room for surprise; thought and desire, discovery and self-reflection move in tandem; past geniuses and present confidants seem to sit around the same table. 'According to whether we are in the same place or separated one from the other, I know you twice. There are two of you', Berger writes to his beloved. 'What changes when you are before my eyes is that you become unpredictable. What you are about to do is unknown to me. I follow you. And with what you do, I fall in love again.'[63] The voice belongs to a man approaching sixty—a man who has three children, who has lived through historical hopes that turned into failures and back into hopes again. But it is also the voice of a man newly enraptured.

And Our Faces was the primer not only for Berger's mature style but also for so many of his later themes: love, loss, exile, pain, the principle of hope, the search for home. All of these were linked in his mind. The twentieth century—what he called the century of disappearances—had brought

them together. 'I only recently recognized,' he said in the early 1980s, 'looking back over my work to date, that all my writing really is about emigration of one kind or another.'[64] The recognition only deepened with time. In 1995 he told the BBC's Jeremy Isaacs that 'the first underlying theme' from which he 'can't get away' was the experience of emigration and exile. 'But emigration in the very broadest sense', he added, 'of people being displaced ... either voluntarily or forcibly.'[65]

The question of leave-taking, whether a departure or a return, whether by choice or circumstance, was there from the beginning. It was present in his first novel, *A Painter of Our Time*, in his early friendships with the European (largely Jewish) émigrés of postwar London, and in his growing interest in the fate of migrant workers. It may even have been there from birth: in his father's own unspoken trauma carried back from the Western Front. And it was of course there in his most self-defining act: the decision, taken in his early thirties, to leave England for good.

The philosophical power of Berger's late work derived not so much from the newness of the theme—it was not new—but from his growing awareness of its larger human significance. 'Ours is the century of enforced travel', he wrote. 'The century of people helplessly seeing others, who were close to them, disappear over the horizon.'[66] The experience of departure was at once archetypal, historically specific, and deeply private. The names of his own 'Poems of Emigration', gathered in *And Our Faces*, provide a sense of this: 'Village', 'Earth', 'Leaving', 'Metropolis', 'Factory', 'Waterfront', 'Absence', 'A Forest I Knew'. The poem that follows, a kind of coda, is named for Walter Benjamin: 'Twentieth Century Storm'.

But why photographs? Why connect the instrument of the camera so centrally to a philosophy of history and the heart? The answers are complex. Partly it was because its twin essential ingredients—time and light—were at the heart of his own ontology. The shutter, like the eye itself, is the door through which the world enters:

Perhaps at the beginning
time and the visible,
twin markers of distance,
arrived together,
drunk
battering on the door
just before dawn.[67]

But it was also because the photographic image had a special relation to the modern, the age of exile and displacement, and its ambivalent consolations. André Bazin spoke of the camera, an invention of the nineteenth century popularized in the twentieth, as a defence against loss. 'Photography', he wrote, 'does not create the eternal; it embalms time. It simply places time beyond the reach of its own decay.'[68] The camera brings the evanescent into the realm of the permanent. It creates a new temporality—what Geoff Dyer, similarly transfixed by the medium, called the *ongoing moment*.[69]

Many writers have noted the strange, sometimes poetic, often shocking effects the photographic image is capable of. In his Nobel speech, for example, Octavio Paz spoke of being 'expelled from the present' by the viewing of a photograph as a young boy.[70] His family garden had been for years—like the village in Berger's cosmology—the centre of the world. 'Time was elastic', Paz said of his *locus amoenus*. 'All time, past or future, real or imaginary, was pure presence.'[71] But when he was shown a picture from a North American magazine, of soldiers marching through Manhattan, the effect was to 'refute' his existence, to 'literally dislodge' him from the present. 'From that moment time began to fracture more and more', he said. 'And there was a plurality of spaces ... I felt that the world was splitting.'[72]

That bifurcation is, again, simultaneously archetypal, specific to a consciousness, and quintessentially modern. It was at the core of Berger's imaginative sympathy for the figure of the migrant, a sympathy in precise dialectical relation to the migrant's rooted *other* and historical forebear: the peasant. (It is a dialectic comparable to the relation between photography and its own ancestor, painting.) What the migrant lives

when he leaves his village is, Berger writes, 'the extreme form' of a more general, modern experience.[73] And photography, like the transport and communication technologies it grew up alongside, may have a double function. In this it is like emigration itself. A picture can both disturb and assuage. It can break the spell of a present innocence, but it can also preserve that innocence, or at least the trace of it, for an uncertain future. The photographs carried by a traveller remind him of all he has left behind. The faces in them, now carried inside as absence, belong to an *elsewhere* in both time and space where his loves may reside.

'Emigration', Berger says, 'does not only involve leaving behind, crossing water, living amongst strangers, but, also, undoing the very meaning of the world … to emigrate is always to dismantle the centre of the world, and so to move into a lost, disoriented one of fragments.'[74] But there can also be a moment-to-moment reassembly, a provisional remaking and salvaging. 'Why add more words?' Berger asks at one point. All modern historians have written about emigration, modernization, the creative destruction of the market. 'To whisper for that which has been lost', he decides. 'Not out of nostalgia, but because it is on the site of loss that hopes are born.'[75]

In an age of 'transcendental homelessness'—the phrase belongs to the young Lukács—what poetry, painting, romantic love, religious faith, the continued habits of the displaced and the social movements of worldwide solidarity all strive for is the recognition of a newly constituted makeshift shelter. They are in search of a world, however momentarily repaired.

A reminder of the phoenix-like intensity of life is what Berger found when he wandered into the Van Gogh museum on Paulus Potterstraat in Amsterdam. He entered lost in a daze. He came out repatriated to the world. 'Art is either a social practice to maintain illusions', he wrote, 'or it is a glimpse of what lies beyond other practices, beyond them because it is not subject to the tyranny of the modern view of time.'[76] *Ways of Seeing* focused on the first; almost everything he wrote after *Ways of Seeing* focused on the second.

Berger's move to the Haute-Savoie changed him irreversibly. He branched off from the mainstream of the intellectual left. He remained committed, but he matured. By the mid 1980s he had shifted his weight from ideology to experience, from the critical gesture to the amorous touch, from a position of scepticism to one of belief—even faith. 'Today's culture', he wrote, 'instead of facing mysteries, persistently tries to outflank them.'[77]

In an age after the fall, he came to espouse a theology of compassionate focus. It was an ongoing collaboration with what was continually met through the senses. He was not a Platonist. The visible was not a smokescreen, but more like a surface—a membrane. 'The act of painting', he wrote in 1987, 'is a response to an energy which is experienced as coming from behind the given set of appearances. What is this energy? Might one call it the will of the visible that sight should exist?'[78] A decade later he was continuing this line of thought. In an essay dedicated to his son, Yves, then away at art school, he spoke of a 'strange area' into which his theories had taken him. In this strange place the boundaries not only between objects but between the self and the world were in flux. 'When a painting is lifeless,' he told his son, 'it is the result of the painter not having the nerve to get close enough for a collaboration to start. He stays at a copying distance … To go in close means forgetting convention, reputation, reasoning, hierarchies and self. It also means risking incoherence, even madness. For it can happen that one gets too close and then the collaboration breaks down and the painter dissolves into the model.'[79]

The work of art was about learning to *let in*: an aesthetic of hospitality, of openness and nearness, that moved all the way down from the state to the home to the self. As a yearning, it has been a part of Western poetry since at least the early Renaissance: from the divine presence in Donne ('break, blow, burn and make me new') to the natural presence in Wordsworth ('a sense sublime / Of something far more deeply interfused') to the democratic multitudes in Whitman ('none can be interdicted / None but are accepted, none but are dear to me'). It was also there, of course, in Van Gogh. In a later

essay Berger spoke of the 'lack of contours' around the Dutch painter's identity—a gift that, in the end tragically, 'allowed him to be extraordinarily open, allowed him to become permeated by what he was looking at'.[80]

Ways of Seeing may have had a broader impact than anything else Berger ever made. The broadcast and paperback undid entire disciplines. A surprise attack, they rattled the museum and the humanities, shaking them free from anachronism, pushing them towards a new age of critique. And yet Berger's later writing, the voice and feel of it, is surely more beloved. Its influence runs deeper. Not nearly as many people bought *And Our Faces, My Heart, Brief as Photos* as they did *Ways of Seeing*. But as is said about the Velvet Underground, so many of those who did went on to become writers. The field of 'creative nonfiction', the so-called 'unclassifiable' work that bends genres, collapsing travelogue and essay, memoir and theory—all this would be unimaginable without his example.[81] Berger found a new readership, a more peripheral but wider-ranging network of fellow-travellers outside the nerve centres of the modern economy. He was an indefatigable encourager of young talents. The number of forewords he contributed to books by lesser-known writers and photographers and artists is almost too long to tabulate. He was always ready to work together, or to assist.

Maybe in some sense he did go off to tend the world's garden. But the 'second education' he spoke of was not only an apprenticeship in the ways of a European peasant culture soon to be extinct. It concerned a new way of writing and a new way of inhabiting a place. Merleau-Ponty said that 'true philosophy consists in re-learning to see the world'.[82] In a very tangible and local sense, this is what Berger did, and he shared it with his readers. The sense in his late writing—all forty years of it!—is of a long, walking conversation with a friend. The speech is intimate and plain, but the route rarely direct. A line of thought, refined over decades, will give way to a memory or, more often, a story. Sometimes it will be interrupted by the unexpected arrival of a natural sight: a bird, a river, a tree. But the conversation will always double back towards the direction of practical wisdom so that, by the end of the

walk, on returning into the larger world, certain fundamental questions have been—however partially or temporarily—clarified. Where are we going? Why are we here? How should we live?

In *Ways of Seeing*, at the end of his polemic against the oil painting, Berger speaks of another Dutch painter—Rembrandt. 'To be an exception,' he writes, 'a painter whose vision had been formed by the tradition ... needed to recognize his vision for what it was, and then to separate it from the usage for which it had been developed. Single-handed he had to contest the norms of the art that had formed him. He had to see himself as a painter in a way that denied the seeing of a painter. This meant that he saw himself doing something that nobody else could foresee.'[83]

To demonstrate 'the degree of effort required' to do this, Berger contrasts two self-portraits: one painted when Rembrandt was a young man, newly married, and the other thirty years later, long after he had been widowed. In the first he is 'showing off'. His talent may be felt, but it remains 'no more than the style of a new performer playing a traditional role'.[84] It is an advertisement for itself. In the later self-portrait, so much has changed. 'He has turned the tradition against itself', Berger writes. 'He has wrested its language away from it. He is an old man. All has gone except a sense of the question of existence, of existence as a question.'[85]

8

The Shape of a Valley

All flesh is grass
and the reality of love is there
wild flowers in the field
and all flesh blooms
no longer than a flower ...

Isaiah 40:6

To reach the village of Quincy, you will usually begin from either Geneva or Chamonix. The broad valley that connects the two—the silt-laden Arvre running west from Mont Blanc into Lac Léman—took shape during the last ice age. For centuries the ravine was a regular stop on the European Grand Tour. It was here, for example, that Wordsworth travelled after his second year at Cambridge and, in the wake of the Jacobin uprising, found in a hilltop monastery 'silence visible and perpetual calm'. Or, twenty-five years later, where Shelley paused to peer into 'the everlasting universe of things'. Today Chamonix is a resort. It is home to mountaineers, extreme skiers and, during the high season, hundreds of tinted buses carrying tourists in and out. Most come for the views. If you take the cable car up to the massif—the glaciers already greatly diminished by climate change—you can see the summits of the Swiss, French and Italian Alps. On clearer days, from other vistas further west, you can make out the buildings of Geneva, the investment banks and grand hotels hugging the lake.

There is a train that runs along the Arvre (it was opened in 1890), but to get to Quincy you will have to come by car—

or motorcycle. The closest station is in the town of Cluses, now a local hub with apartment blocks, factories and a McDonald's. From here you follow a ribbon of switchbacks up the valley to the north. After a few kilometres the traffic will calm. The smog clears, and the air grows cooler. In winter you might pass a group of cars with ski racks. In summer it will be quieter.

As you crest the ridge, a loose network of higher valleys, more sparsely settled, spreads outwards from the River Giffre. There are old villages here, each one with a church, a small square, a post office, a souvenir shop, often a stone bridge. A kilometre north of one of these, in the commune of Mieussy, a local road passes through a gap between two rock-faces. There is a pond that opens onto a meadow. This is Quincy. It is a small and unremarkable town with perhaps forty or fifty chalets strewn around a hook in the road. Any fewer and it would not be on a map. There are no shops or restaurants or even crossroads. Often a lone tractor will be making its slow way up or down the blacktop.

The immediate terrain is not precipitous but rolling. In summer it is always abundantly green. Even today there are no fences, only stone sidings, wild grass, pastures, greenhouses, orchards, gardens. In the middle-distance are steeper slopes, most far too jagged for ski lifts, that form a wide basin around the sky. There is a balance in this. Each turn to Quincy is onto a thinner road. The quiet is profound but the village does not feel cut off. There is a strong sense, implicit in the landscape, of being at once held within a pocket of earth and yet never hemmed in: the fields both enveloping and open.

It was here that Berger spent the last forty years of his life.

'To be rooted', wrote Simone Weil, 'is perhaps the most important and least recognized need of the human soul.'[1] It was 1943, and she was writing from London. She of course knew of the evils of nationalism: German bombs had exploded in the same city where she was then working for the French Free government. But she also knew that, without the nourishing attachments of place, the spiritual core of life

risked unravelling. The threads that connect one year to the next, the body to the earth, would begin to fray.

When Berger moved to Quincy he sought a new beginning. He wanted to improve himself, possibly to simplify himself too, and to learn. He was an expatriate. He may not have known how long he would stay, or that one day he would be buried in the village graveyard, his funeral held in the nearby Église Saint-Gervais-et-Saint-Protais. But I think he did know, however instinctively, the direction world history was turning and that he was after something durable. By the mid 1970s the global left was in retreat. The Cold War had been all but won; the long march of finance capital was just getting underway. In such a climate—and he would later liken it to a new dark age—Berger grew impatient with around-the-corner thinking.[2] He prepared himself for the long haul, searching for living reminders of survival and resistance, pockets where communal ways of life were themselves perseverant.

The picture we get from his peasant stories of the 1970s and 1980s is of a people, however threatened or vestigial, whose recalcitrant habits form more than a museum piece: they may in fact be a beacon in the darkness. 'Working is a way of preserving the knowledge my sons arc losing', says one farmer in a story, a bit like Wordsworth's Michael.[3] Berger's own way of working was similar. The land endures, like the body or a page, as a site of memory. And the ageing farmhands of his fiction—the foragers, the shepherds and woodcutters, the widows and grandfathers—remain tenaciously local. Their lives record a shared history set apart, like the hills above Grasmere—a set of valleys pockmarked by incident.

Work was indeed the central theme, at least at first. The lives of Berger's peasants were defined by toil. They spent weeks in the fields, in their sheds, or with their animals. But they were neither heroes nor victims. More mischievous than brave, more musical than morose, they moved through life as if to the beat of a brass band in a Kusturica film. There were archetypes: the virile and conspiratorial old man, the headstrong spinster, the impassioned madwoman. He wrote of accordion-players, cheesemakers, orphans, cripples, all possessing a cunning ingenuity, at times a wild recklessness or

a carnivalesque glee. ('A peasant', wrote the Palestinian poet Taha Muhammad Ali, 'the son of a peasant / there lies within me / a mother's sincerity / and a fishmonger's guile.')⁴ Most of all, their lives were marked by a stubborn refusal to accept what was said by government planners to be good for them— or else inevitable. They had no tolerance for what the French call *le business*. They were, in the strictest sense, ungovernable. In his own manner, with his own tangle of contradictions, Berger was not that different. In his heart he was one of them.

'I always have the feeling that my mind is at its limit!' he told a friend in 1976, two years into his long residency in the Haute-Savoie, busily at work on this new kind of writing.⁵ At first he was torn between essays and stories, but in the end, he said, 'I think ... narrative carries further.'⁶

It carried him over two decades. Any work, in order to be sustained, requires discipline. But *Into Their Labours*—the trilogy begun in 1974, its first instalment, *Pig Earth*, published in 1979, the second, *Once in Europa*, in 1987, and the third, *Lilac and Flag*, in 1990—took more than tenacity and diligence. (Though it did take extreme reserves of both: Berger said he would rewrite some of the stories, revising them by hand, upwards of two dozen times.) For the books to be written, their author needed to remake his own life from scratch. It required not only a will, then, but an open willingness. And every poem or story, every description or piece of dialogue, testifies to a prolonged encounter between a writer and the place he came to love—a community that changed him, entirely.

Berger became a storyteller. The designations of novelist and critic no longer fitted. When *Pig Earth* was first published, he even appeared in the jacket photograph wearing a rustic hat, as if to announce a new look. Characteristically, there were polemics to get him going. In the pages of *New Society* he railed against the novel as a middle-class form: he called it 'NATO literature'. The business of fiction, he said, with its tournaments of ambition and bestselling evasions, belonged to the overfed worlds of London and New York. He looked elsewhere: the magical realism of Gabriel García Marquez; anthologies of Russian and Italian folk-tales; the

work of Naguib Mahfouz and Tayeb Salih. In those parts of the world where the harshness of life still brought people together, there remained intact a common totality, a shared set of aspirations, such that a narrative complicity was still possible. 'The task of the storyteller', he said, 'is to know these aspirations and to turn them into the very strides of his story ... Then in the silent spaces ... both past and future will combine to indict the present.'[7]

Berger also set great store in the late writing of Walter Benjamin, whose essay 'The Storyteller' became an article of faith. For Benjamin, writing in the 1930s, the folk-tale was a disappearing form. It belonged to a pre-capitalist mode of life, when experience still passed from mouth to mouth, and narrative was meant not simply to entertain but also to instruct. Buried in every real story, Benjamin said, was some kernel of practical knowledge—not an 'answer to a question', but rather a 'proposal concerning the continuation of a story which is just unfolding'.[8] Sometimes in Berger's late fiction the takeaway was surprisingly direct: 'I will tell you which men deserve our respect', a peasant woman says to her daughter. 'Men who give themselves to hard labour ... Men who are generous with everything they own. And men who spend their lives looking for God. The rest are pigshit.'[9] At other times the story's wisdom was far more mysterious, even numinous: a rapt marvelling. Whether in an abattoir before dawn or the Chauvet Cave, Berger was always attuned to a darkness that, he once wrote, 'precedes sight or place or name'.[10]

Benjamin was himself ambivalent about the status of story-telling. Like much of his late writing, the sense of temporality was nonlinear. He seemed to want, at one and the same time, to place the folk-tale in an idealized past and yet also to deny that its decay was merely a symptom of modernity. Rather, he said, the 'productive secular forces of history' were extracting—*uprooting*—the practice of narrative from the loam of a shared or living speech. This was part of a larger dispersal. 'The art of storytelling is reaching its end', he said, 'because the epic side of truth is dying out.'[11]

For Benjamin, as for so many writers since the first

romantics, there was a beauty to evanescence. And although Berger seemed to take Benjamin at his word, adopting the essayist as an intellectual forebear and originary source, there were in fact several currents flowing into his thought that, whether claimed or unclaimed, also flowed into Berger's. One of these was the romantic anti-capitalism of the Heidelberg left, and the visionary work of a man who was himself the son of Friesian peasants: the German social philosopher Ferdinand Tönnies. Active in the late nineteenth and early twentieth centuries, Tönnies was, like Berger, troubled by the disappearance of traditional peasant villages (for him, in his native Schleswig-Holstein). And the book he wrote in response to this, *Gemeinschaft und Gesellschaft*, published in 1887, came to permeate the imagination of the subsequent generation of German-language writers, from Max Weber and his Heidelberg circle to the young Lukács, Ernst Bloch, and indirectly Benjamin himself.[12]

What Tönnies proposed in *Gemeinschaft und Gesellschaft* (translated roughly as 'Community and Society') was an abstract dualism we all instinctively understand: between the purer, rooted, more organic life of a village (or neighbourhood) and the mechanized, fragmented, money-driven life of the newer market cities and towns. For Tönnies, the division was absolute. Based on a natural economy of matter and energy, the village was held together by the social mortar of trust and ritualized through the bonds of kinship, religion, tradition and mutual aid. The city, by contrast, was structured on centralization, the superficiality of relations, egotism, speculation and profit. Tönnies was trained as a Hobbes scholar, and the fundamental irony he saw was that the onrush of capitalist civilization actually returned people to the state of nature. When society became no different from a machine, the result was a wilderness of all against all: the so-called law of the jungle.

The essential binary held—still holds—powerful sway. We encounter it when we fight against the gentrification of our neighbourhoods, or when we hear Joni Mitchell sing of paradise and a parking lot. Like all binaries, it has of course been scrutinized and deconstructed, shown to rest more on

idealization than fact, let alone nuance. The peasant villages, we are told, were no utopias. They were closed-minded and back-breaking. And like Gramsci's formulation of the national-popular, or the very concept of indigeneity and indigenous rights, *Gemeinschaft* has been accused of being dangerous, of containing a latent paternalism and exclusivity. Most troublingly, Tönnies, a social democrat, watched in horror as Hitler appropriated his concept in the 1930s, turning it into *Volksgemeinschaft*: the people's community. (Tönnies protested vehemently only to see his professorship removed when the Nazis took power just before his death.)[13]

All the crushing paradoxes of history are entangled here. 'Every rise of fascism', Benjamin famously said, 'bears witness to a failed revolution.' And every gutting out of tradition, every diaspora, releases energies that career unpredictably forwards. The left and the right, God and the Devil, occupy the same field (which in turn gives the centre the chance to lump both under the same umbrella). Berger's belief in tradition—in continuity—was itself continuous: it went back to his youth. His early campaigns had already met with accusations of nostalgia and menace. But while certain dualisms were accepted as axiomatic, others he rejected as pure diversion. Between reactionary fear and cosmopolitan arrogance there must, he said, be a third way. This was his faith: not a mild, middle-of-the-road centrism but a radical tack towards unflinching hospitality—an imagining-otherwise of the very concept of community.

From adolescence to old age, Berger was anti-fascist and anti-racist down to his bones. So many of his heroes—Walter Benjamin, Max Raphael and Simone Weil, among others—had been Jewish refugees whose lives met with tragic ends. Anya Bostock, his wife and the mother of two of his children, fled Vienna for London after the Anschluss, after hearing Hitler and Goebbels speak to a city crowd. ('Hitler would be inconceivable', Weil wrote, 'without modern technique and the existence of millions of uprooted men.')[14] Though Berger never faced that trauma first-hand, he was never far away from its indirect presence. The twentieth century, he said, was a century of banishment. And the longing he felt for an

idealized, rooted *Gemeinschaft*, a longing he was finally able
to live out, was always for a community imagined to exist
outside the machinery (and reifications) of the state. It was for
a collective, fundamentally, of outsiders. The vision ran like
a double-helix through his work. And the peasant villages he
first wished to defend in the 1970s were as marginalized and
targeted, as stateless, and as defiant, as the two communities
for which he later came to advocate: the Zapatistas and the
Palestinians.

'You asked me once', wrote Taha Muhammad Ali, 'What
do you hate, and *who* do you love?'

> And I answered,
> from behind the eyelashes
> of my surprise,
> my blood rushing
> like the shadow
> cast by a cloud of starlings:
> 'I hate departure ...
> I love the spring
> and the path to the spring,
> and I worship the middle
> hours of morning.'[15]

The problem was not the attachment to a home or to a
people. The problem was the heedlessness of power, politi-
cal opportunism, the appetites of greed. As Berger embraced
a newfound religious feeling in his late writing, he began to
refer to the existence of evil. He often spoke of God.

Amid the general hum of professional letters—the catered
conferences, the speaker fees—his could sound like a voice
in the wilderness. The injustice of the present, Berger said,
was not only material but spiritual: it was both at once. He
hated capitalism because it exploited the poor; but he hated it
also because it destroyed what he loved. It severed human life
from the earth, the past, the dead, animals, tradition, memory,
ethics. 'The poverty of our century is unlike that of any other',
he wrote. 'It is not, as poverty was before, the result of natural
scarcity, but of a set of priorities imposed upon the rest of the

world by the rich. Consequently, the modern poor are not pitied—except by individuals—but written off as trash. The twentieth-century consumer economy has produced the first culture for which a beggar is a reminder of nothing.'[16]

The report Weil produced for the French Free coalition was called *L'Enracinement*. In English it was later translated as *The Need for Roots*. But in French it was a verb: to *take* root, to *become* rooted.[17]

Berger's first collection of peasant fiction, *Pig Earth*, was, among other things, a record of that process. Written from 1974 to 1978, the stories appeared in the order of their composition so that, as an explanatory note had it, 'the reader may accompany me, and we can make the journey side by side'.[18]

At times, like many recent transplants, he was eager to show off the new dirt under his fingernails, the fresh stains on his trousers. 'Life is liquid', he writes in the first story, set in a slaughterhouse, and the book lists a catalogue of fluids: milk, urine, mucus, fermented cider, 'the frivolous sound of running water'.[19] The observations were often graphic, embodied, tendril-thin. Sometimes they were meant to shock: the opening image is of the down rushing blood spilling from the neck of a slaughtered cow which, for an instant, 'takes the form of an enormous velvet skirt, whose tiny waist band is the lip of the wound'.[20]

Throughout there was the strenuous performance of a new kind of knowledge: from the network of ceiling hooks in an abattoir down to the sprig of fur on a fetlock or the hidden recesses of a forest. 'She knew under which pine trees the cyclamen grow', Berger writes of Lucie Cabrol, the dryad-like forager whose multiple lives are told in the book's final story (later made into a successful play by Simon McBurney). 'She knew on which distant precipitous slope the first rhododendra flower. She knew by which walls whole settlements of snails come out of hiding. She knew where the yellow gentians with the largest roots grow on the mountainside where the soil is least rocky so that digging them is a little easier. She worked and scavenged alone.'[21]

In passages such as these, *Pig Earth* vehemently—actively

—resists the charge of an aloof romanticism. But such a move-
ment can double back on itself. How different is Lucie Cabrol
from the Old Cumberland Beggar or the Leech Gatherer?
Almost every vignette emphasizes work, death and dirt.
Physical descriptions of animals recur, magisterial in their
vividness. (Here the collection can be usefully read in relation
to Chagall's 1911 work of pastoral cubism, *I and the Village*,
where goat and man stare back at each other, a woman milks
a cow, and a farmer with a scythe returns home.) But just as
there is the pastoral of the peaceful view, there can be the
pastoral of bare feet in the muck. Brute materiality, it turns
out, can also be idealized. Even shovelling out the shit of an
outhouse can be turned into a romantic badge of honour.

In the early 1980s, the London-based magazine *Granta*,
which first published several of Berger's peasant stories,
coined the term 'Dirty Realism' to refer to the wave of North
American regionalists—Raymond Carver, Richard Ford,
Jayne Anne Phillips—then arriving on British shores.[22] In its
own peculiar way *Pig Earth* was an alloy—a work of dirty
magical realism. The book begins with the quotidian: the
slaughter of a cow, the death of a widow in old age, the birth
of a deformed calf. It ends with the murder of a madwoman
with an axe, and all the 'remembered dead' rising from their
graves in a carnival of resurrection.

But this, too, may have been overcorrecting. Like anyone
getting the hang of a new skill—whether scything a field or
writing of scything a field—Berger tended to tilt from one
extreme to the other. In the literature of 'El Boom', the magic
was said to be realist precisely because it expressed a com-
munity's real superstitions and beliefs: Alejo Carpentier once
pointed out that levitations and magical cures were, in parts
of the Caribbean, nothing out of the ordinary.[23] For Berger,
the newly arrived outsider, it remained a *technique*, more lit-
erary than cultural, and borrowed, perhaps, from Macondo
or Chagall or the Romany Balkans—hardly home-grown in
the French Alps.

Pig Earth, despite its flaws, is a gorgeous work. But its beauty
derives most of all from the prismatic sense of its author's own
personal transformation—the *becoming-authentic* rather

than the *already-authentic*—which allows the absence at its centre to be recast as a form of tact. The land, the animals, the work and chores: all of these were in full focus. But the lives of the people Berger had come to live beside, their hopes and losses, were only slowly coming into view. Most characters stayed on the level of a set of gestures. As he says of the wrinkles of an ageing cowhand, the creases on his face 'remained mysterious, unrelated to any story, like the lines on the bark of a tree'.[24] Berger was a quick learner. After a few years he could write convincingly of the forest or of the spring-loaded feel of a stun-bolt. He could write of a procession of ghosts in the afterlife. But he could not yet write of the common experience of a rural family, or of the feeling of belonging.

Once in Europa, his second book of peasant fiction, marked a breakthrough. No longer seen from an anthropological perch, the liquid of life took a new shape. 'There is one true colour', said Chagall, 'not only in art.'[25] The stories, dedicated to Berger's new love Nella, trace destinies as well as moments, the contours of both etched by acts of intimate attachment. In one we read of a son's devotion to his dying mother, the piercing cavity of his grief, and the balm he finds in music. Another follows the misplaced desire of a wilful peasant for a middle-class housewife. The sensuous, cinematic 'The Time of the Cosmonauts' recounts the confused love, precociously maternal, a young woman feels for both an old shepherd and an orphaned woodcutter. Though set in different keys and time signatures, the stories all evoke Murnau's description of his great film *Sunrise*, itself a parable of rural continuance. Each is a song of two humans.

From its inception, *Into Their Labours* was meant to arc from the village to the metropolis, from a way of life that was soon to be lost to the life that was coming to take its place. *Once in Europa*, the trilogy's middle book, was pitched between the two extremes, between *Gemeinschaft* and *Gesellschaft*, a porous mixture written when Berger was himself travelling back and forth between Quincy and Paris. Perhaps for this reason, it remains one of his great achievements, as dialectical as any argument, and more beautiful.

The fear of romanticism was gone. 'I am a romantic—without any question,' he said in 1984. 'I see it as something positive ... If one denies too much those subjective intuitions which romanticism is about and which are frequently expressed in love then something withers. The consistent, logical political line cannot bring them back.'[26]

Gone too was the over-arduous conjuring of the land, its granular texture, the muscular evocations of sheer substance. In its place Berger's neighbours could finally come into view, as if the poem of tanned hides that begins the collection, 'The Leather of Love', referred also to the skin of his own writing hand, whose calluses of past use now allowed for a nimble ease, a gentle endearment in the present. 'Only the work of twenty summers can make a scythe as light as this,' he had said of Lucie Cabrol's blade towards the end of *Pig Earth*.[27] Well into his fifties, over a decade into his new life in the Haute-Savoie, the same could at last be said of his writing. He became at ease in the effort. The novella-length title story, 'Once in Europa', begins with a description of a wild poppy: the opening of its bud and the slow transformation of the petals from light pink to scarlet. 'It is as if the force that split the calyx', Berger writes, 'were the need of this red to become visible and to be seen.'[28]

It was the opposite of a certain model of genius, in which the work turns evermore arcane until it is meant only for itself. Berger's writing opened up. It grew more hospitable, increasingly *familiar*. The result was, in every sense of the word, marvellous: 'You were listening. You were in the story. You were in the words of the storyteller. You were no longer your single self; you were, thanks to the story, everyone it concerned.'[29]

After his death in early 2017, the official obituaries remembered Berger as a stoker of controversy: a polemicist and troublemaker. The truth is that the figure who emerged from the culture wars of the 1970s was a writer defined less by what he was against than by what he loved. As a storyteller and philosopher he came to possess a bedrock faith in the redemptive political value of our sensual and communal lives,

and a belief that a sense of wonder before the small details of the physical world would somehow lead back to a deeper knowledge of where we were heading together. In a letter to a friend, he once said that the impulse to write a story 'comes as a kind of energy, like a light, which is a little landmark in a darkness'.[30] There was a slow, irrepressible heliotropism at work over Berger's long writing life. Where he went was all the more remarkable because of how he got there.

Maybe the love ethic had been present all along, if only in seed, but it was not until the late work that its deep colour came out. A novel, *To The Wedding*, from 1995, was propelled by it.[31] Written in the wake of a family tragedy, at the height of the Aids crisis, the book begins with a makeshift epigraph tracing a poignant hierarchy of grace:

> Wonderful a fistful of snow in the mouths
> of men suffering summer heat
> Wonderful the spring winds
> for mariners who long to set sail
> And more wonderful still the single sheet
> over two lovers on a bed.

The shape of the inscription is a pinnacle of sorts: a teleology. In Berger's career there had been stories of shared labour and of restless travel, but now, as an old man, the seasons traversed, he could finally tell stories of the heart (with the transcendence of love—the sheet like the sail of a ship—as the gathering force).

From libidinal fixation, he turned to what was rarer. Tender intimacy, far more than fucking, became his focus. And if in *G.* the writing could be brusque or lurid, there was at times, in the later prose, a sweetened taste, sometimes a willed, sentimental simplicity. He was unafraid of being precious. Perhaps he had earned the right. Perhaps, too, he had gained the courage. At the end of an essay about his mother, he recounted what he had learned from her. Love, she often told him, was the only thing that mattered. 'Real love, she would add, to avoid any factitious misunderstanding.'[32]

In his old age Berger came to speak in a way so many men—

not just male writers—shy away from. It was the opposite of Hemingway or Humphrey Bogart or Raymond Carver. The pain in Carver, like the love, was always indirect by degrees. Berger just talked about love. The directness at times failed, and in the weaker passages the very sincerity of the prose could be overwrought—an affectation. (Set in in the imagined city of Troy, cobbled together from fragments of different metro-areas, *Lilac and Flag*, the final book of his trilogy, fails for just this reason: there is a saccharine vagueness that dissolves on the page.)[33] At its best, though, Berger's writing took the form of a whispered prayer that had the power to uplift. It was like the graffiti on a construction wall that bell hooks remembered would raise her spirits when she walked to work in New Haven, lost in her own sea of grief: 'The search for love', it read, 'continues even in the face of great odds.'[34]

Like Berger, hooks, in her own book on the subject, placed this most intimate of pursuits within a larger frame. What hooks described as a 'wilderness of spirit so intense we may never find our way back home again' had become, she observed, the natural habitat for a generation.[35] By the 1990s young people everywhere had been trained to see love as a crutch—or else an intoxicating drug. It was either for the weak, the gullible, or the 'hopelessly romantic'; or it was a fleeting feeling that could not be counted on. Inspired partly by the teachings of Erich Fromm (another writer, and Jewish émigré, of the Heidelberg left), hooks used her immense sway among activists to try to redefine what was meant by the emotion.[36] Love is a verb, she said. It is not a passive feeling but an act: the act of attentive care. Berger would have agreed. Weil would have, too: 'Love for our neighbour,' the French philosopher wrote in 1942, 'being made of creative attention, is analogous to genius.'[37]

The conclusion is not new. It is just that in the present it can seem new. So much of contemporary art revels in the opposite relation: indifference and cruelty. From Francis Bacon to Lars von Trier, this is perhaps the dominant tradition of our times. For some it amounts to a form of indirect protest, a 'violent return to life', or else a so-called negative aesthetics

that works to expose the ugly shadows lurking in the dark closet of our illusions.[38] Within any community, any family or couple, it is argued, there are fissures, violent deficiencies that can be traced back to our most basic philosophical attachments, whether to wholeness or to presence or to home.

It is a compelling line of thought. But for many, and for Berger in particular, its logic was fundamentally compromised by its privilege. What has been called an art of cruelty can afford to heap suffering onto suffering because it grows out of luxury and its misery is cheap. In fact, the whole hipster complex—the anhedonic detachment, the casual ironic distance so often remarked on as the default mode of the postmodern—first gained widespread currency during the postwar decade of Berger's youth. It was simply the negative side, he had said then, the more culturally garlanded side, of American power. It may still be true: the two go together, soft and hard, like two hands washing each other.

Berger moved along a different track altogether. Of the long line of modern thinkers for whom the defeat of political ideals was a kind of personal genesis—and it is hard not to think of Wordsworth standing there at the source—he was perhaps unique. He was never disillusioned. He certainly never let go of his politics, which remained, until his death, a powerful source of self-belief. 'Someone inquires: are you still a Marxist?' he said as he approached eighty. 'Never before has the devastation caused by the pursuit of profit ... been more extensive than it is today ... Yes, I'm still among other things a Marxist.'[39]

Where others may have seen a polarity, or a contradiction, he instead saw something more like a capacitor. It is not that he gave up politics for art, or the globe for the valley (the revolution for daffodils), but rather that he looked for fresh sparks that could jump the divide: small glints or flickers in the dark. He once spoke of 'two things that are so deeply inside me that they are hardly even at the level of informed ideas. One is a relation to what I have always felt to be the "mystery" of art. The other is a gut solidarity with those without power, with the underprivileged.'[40] The two were not the same, but for him they were inextricable. A Möbius-like

circuit was at the instinctual core of his heart. One of his favourite koans, from as far back as his twenties, came from Gorki:

> Life will always be bad enough
> for the desire for something better
> not to be extinguished in men.

The sentiment worked like a gyroscope: it helped to stabilize him through storms that would have sunk other ships.

'In Giotto,' Weil wrote, 'it is not possible to distinguish between the genius of the painter and the Franciscan spirit; nor in the pictures and poems produced by the Zen sect in China between the painter's or poet's genius and the state of mystical ecstasy; nor when Velásquez places on the canvas his kings and beggars, between the painter's genius and the burning and impartial love that pierces to the very depths of people's souls.'[41]

Berger's writing was special because it was generous. It shared those moments of restabilization which were also, every one of them, moments of encounter: encounters with a painting, a stranger, a lover, an animal, a ghost. (In the end several of these would come together in a single essay, as when he wrote of a cypress in Lisbon, a cleaning lady he had just met, the ghost of his mother, and the martyrs of past wars in the first story of *Here Is Where We Meet*.) Each piece of writing was like a daguerreotype of place and time, memory and politics, history and emotions. The plate of the photon-egative may be small, but the light entering it comes from the whole of the cosmos.

In old age his primary mode of communication became the dispatch or the sketch—footholds in a world that had lost its bearing. He wrote to Subcomandante Marcos of two herons circling the sky near his own house. When he visited Palestine later in life he wrote not only of the Intifada but of flowers and stones. In a treatise on delocalization he paused to notice a group of donkeys grazing in a local pasture. 'Four burros in a field, month of June, year 2005', he jotted down, as if naming the sight was in itself an act of protest.[42] The

language of reason ceded more and more to the cadences of faith. After the passage of NAFTA, he produced what was, in effect, a religious–mystical document, 'Twelve Theses on the Economy of the Dead', which set out a map of the no-longer-living and the yet-to-be-born.[43] In its visions and demands it was a work of metaphysical scripture; but as scripture it was also to be nailed to the entrance of the IMF or World Bank.

Ultimately he came to speak of hell. 'Suppose', he said 'that we are not living in a world in which it is possible to construct something approaching heaven-on-earth, but, on the contrary, are living in a world whose nature is far closer to that of hell; what difference would this make to any single one of our political or moral choices?'[44] The only change, he said, 'would be the enormity of our hopes and finally the bitterness of our disappointments'.[45] What *was*, for Berger, pointed always, however implicitly, towards what *should be*. 'You really want to know about hell,' Michel, the French communist says in *Once in Europa*, 'it's here ... Who says hell has to stay the same? Hell begins with hope. If we didn't have any hopes we wouldn't suffer ... Hell begins with the idea that things can be made better.'[46]

Cynicism is often a scab: beneath it is a scar. But even those sensitive to the lyricism in Berger's late writing sometimes found it hard to complete the loop back around to see the political future he envisioned. They may have shared his sympathies, but those sympathies were, in their minds, essentially laced with regret. 'To me,' wrote Salman Rushdie in the late 1980s, 'his ideas have meant more than his dreams.'[47]

There was undoubtedly an elegiac paradox at work in the late Berger. With *Into Their Labours* he attached himself to a community just as it was passing from the earth. In her review, the novelist Angela Carter expressed what other readers probably felt: these were stories, she said, about a 'final divorce' between people and the land. Though their voice might not be pessimistic, the vision was essentially tragic.[48] Once the small farmer is made redundant, it soon follows that everywhere outside the city that is not a tourist resort will become a checkerboard of industrialized monocrops and ghost towns.

It is a process we continue to see unfold: entire regions and people left behind, helpless yet kept dependent, agglomerations of nowhere.

For Carter, the entire spirit of *Into Their Labours* was permeated with this sense of loss. 'Soon', she wrote in a pithy summary, 'nostalgia will be another name for Europe.'[49] It was a charge Berger often wrestled with. Nostalgia had nothing to do with it, he said again and again. It wasn't only the past he was talking about, but the pain in the present, and the principle of hope.

Marx called religion the soul of a soulless world, but for Berger faith was always at the root of the struggles for social justice, and even of Marxism as he understood it. For Simone Weil, too, it was not religion but revolution that was the opiate of the people. (Such a thought was partly what drove Berger to live alongside peasants to begin with, and how he explained their importance to his fellow Marxists, who persisted, as he put it, in a 'continually reformed, disappointed, impatient progressive hope of an ultimate victory.')[50] That the tragic dimension of life had been so often shut out of revolutionary utopian thought—and with it other human constants such as the desire for love and the need of community —was precisely, he posited, what had allowed the great utopian experiments to go so horribly astray once that thought had first been systematized, and what he called the soul of revolution gave way to the operator of the state.

What is repressed, of course, returns. For generations since the French Revolution, the spirituality of those struggling for social justice had been left implicit. 'The explanations of the men and women concerned were materialist', Berger said. 'Yet their hopes and the unexpected tranquillity they sometimes found in their hearts were those of transcendent visionaries.'[51] Their faith, though unclaimed, was kept close, like 'an illegitimate but loved child who was never given a name'.[52] (Maybe this is why orphans reappear so often in his fiction: they are a mark not only of neglect but of a nameless hope.) And the tragedy of political history for Berger's generation lay in the slow usurpation of that faith until there was none left—nothing but a blanket cynicism remained, and it was

only in poetry, or else in secret, in what he called enclaves of the *beyond*, almost like hiding places, that such a faith could still be touched and shared.

'Can there be any love without pity?' asks one of his characters.[53] It is a question many of us would not think to pose. And yet the whole current of feeling in Berger's late writing derived from his need to ask it. The stories recount imprisonment, disease, collapse, disfigurement, exile. But they also relay endurance, the recovery of belief, defiance in the face of extinction, shared moments of reprieve. They take up the great religious themes—isolation and communion, faith and doubt, passion and suffering—and in their parabolic structures resemble a New Testament. But in their spirit they are modern, and embody what he later called, amid the rubble and bulldozed homes of the West Bank, an attitude of 'undefeated despair'.

Commitment in these instances means more than adopting a position. It means more than being for or against. It is a quality, like compassion or resilience, that can only express itself over time—and over time tends towards its stronger, more pious cousin, *conviction*. '"Amazing Grace" begins sad', Berger writes in *Once in Europa*, 'and gradually the sadness becomes a chorus and so is no longer sad but defiant.'[54]

In the same story, Michel, the communist with a red motorbike from Czechoslovakia, is made paraplegic by an accident in the local factory. After thirty-seven operations he is given metallic legs and two feet 'like flatirons'. 'You've only got one life, they say, so better make the most of it.'[55] He is speaking to the woman he has come to love, a widow whose life has also known the 'long years' that follow a loss. 'It's not true, Odile', he tells her. 'We had to learn to live a second life ... The first one was over forever and ever ... I had to learn how to live—and it wasn't like learning for the second time, that's what's so strange, Odile, it was like learning for the first time. Now I'm beginning my second life.'[56] The final story of *Pig Earth*, a testament to its author's own reinvention, was named after the 'Three Lives' of its heroine. Berger certainly knew what it meant to have more than one.

Was it nostalgia? There was unquestionably a sentimentalism,

both personal and political, that he distilled over the years. At moments it turned Confucian—the Zen of hope. But his politics were more complex than people often gave him credit for. Sentimentality is usually a flaw of adolescence, whereas in the late Berger it derived at least partly from experience. Like Odile, the old peasant woman hang-gliding over the valley where she has spent her life, marking its joys and losses, the births and deaths, Berger tended always to think of the *longue durée*: his historical vision ran the gamut of generations.

Such a perspective is, of course, a benefit—a distinction—conferred by age. But for Berger it may have had more atavistic origins. Maybe it was latent in his genes. 'Each of us comes into the world', he wrote in a play with Nella Bielski, 'with her or his unique possibility—which is like an aim, or, if you wish, almost like a law. The job of our lives is to become—day by day, year by year—more conscious of that aim so that it can at last be realised.'[57]

In his mid-twenties, an art critic new to the job, Berger had a premonition of what that possibility might one day be. In an exhibition of Russian Jewish émigrés—Chagall, Soutine, Zadkine and others—he was suddenly gripped by the exilic feeling that ran through their art. 'To assess such work', he said, 'if one responds to its impetus as strongly as I do, is difficult.'[58] Trying to wrap his mind around the emotive amalgam of their vision, he kept moving in circles. The work was intoxicated with sensuous colour, and yet, behind that sensuousness, there was also, he sensed, the burden of a 'tragic responsibility'. Conversely, behind each canvas he could touch the presence of an 'indefinable ache', and yet, in each brushstroke, find a record of its assuagement, the safeguarding of value. 'Nostalgia is usually the result of boredom or languid regret', he wrote near the end of his review, 'whereas in Jewish art it is the result of acute suffering and intense yearning. Jewish nostalgia does not imply the sense of something hopelessly lost, but rather something almost hopelessly desired. The only paradoxical way I can put it, is to say it amounts to a nostalgia for the future'.[59]

The phrase is prophetic. Insofar as anything endures, *Into Their Labours* will come to be seen in future years in just

such a light. In the ashes of the New Left, and the embers of the Cold War, the utopian experiments had failed, both materially and spiritually, leaving behind nothing but the cold machinery of the market. And yet there were survivors who resisted what others took to be inevitable. The essays and stories Berger wrote from Quincy record a window of historical reckoning, of learning and relearning, that was also a point of inflection, a turning upward.

Speaking of his peasant neighbours, Berger once wrote that 'his ideals are located in the past; his obligations are to the future, which he himself will not live to see'.[60] They were the opposite of opportunists; in many ways they were saints.

Coming-of-age narratives, so-called novels of formation, tend to leave off with a set of new accommodations. An adult stability has been entered into—a calling answered or a settlement brokered. Becoming has matured into being. A life has reached, as it were, its cruising altitude.

Other narratives end with not attachment but severance. An overburdening situation has been sloughed off. The horizon beckons. The hero packs up and leaves. In either case there is nothing more to be said.

When Berger moved to Quincy, aged forty-eight, he in a sense did both. The home he found there signified at one and the same time a final break with the country of his birth (he was never going back) and also the first step towards constancy (he wasn't going anywhere else). He took root, settling into the person—the creative voice and identity—he would remain until his death. He went on writing for decades, of course, but he had fashioned a vessel with which to sail the years.

And there were passing storms: the fall of the Berlin Wall, the conflict in Yugoslavia, NAFTA and the Zapatista uprising. Still, the great Cold War was over, and presumably history itself had come of age—it, too, had hit cruising altitude.

Then, one morning, the attacks of 9/11. The end of history lasted barely a decade! Berger was in his seventies. He could have gone in so many directions. He could have entered retirement, tended his garden, taken up tennis. He could have

added his name to the statements of liberal consensus circu-
lating in support of the American military response. He could
have just kept on with intermittent art criticism.

In retrospect, with each passing year, what he *did* do
becomes as extraordinary as it should have been unsurpris-
ing: he spoke up. Far from lapsing into centrist apologias
(then de rigueur for all the aging men of letters), the political
fury of his youth began to flow again; only now it carried
with it the experience and authority of decades. Who else
could have written of Hiroshima in the months after the
attack, comparing it without fear or spite to the fireball in
Manhattan, each a bookend to the American half-century?
And who else could have made such a comparison without
sounding shrill or heartless?

At a time of frenzy Berger brought perspective: he became
a compass in a hurricane. (Once, half-a-century earlier,
Stephen Spender had called him a 'foghorn in a fog', an unin-
tended compliment.) 'It takes about six half-truths to make
a lie', Berger wrote a month into the Iraq War, just after
Baghdad had fallen.[61] Much of what he said has since become
obvious—as it should have been then. But he also asked ques-
tions to which he admitted he did not know the answer: 'Is
it more evil', he asked, 'to kill deliberately than to systemati-
cally kill blindly?'[62]

Just as he did in his twenties Berger once again tried
to chart—to imagine—a third way. The polarity was no
longer between Washington and Moscow but within a
'global crossfire of ... two fanaticisms.' Even as early as
1989, in response to the Rushdie affair, he took the unpop-
ular position of calling for restraint on the part of Western
publishing elites. 'Otherwise', he wrote, 'a unique 20th
century Holy War, with its terrifying righteousness on both
sides, may be on the point of breaking out sporadically
but repeatedly—in airports, shopping streets, suburbs, city
centres, wherever the unprotected live'.[63] He predicted
so much of what has since become our present reality:
resurgent nationalism, the voraciousness of the neoliberal
economy, the sense of historical unmooring. 'How long can
this moment last?' he said a year after the fall of the Berlin

Wall. 'All the imaginable dangers of history are waiting in the wings—bigotry, fanaticism, racism.'[64]

It would be easy to search, philologically, for precedents, whether in the 1844 manuscripts or in Ernst Bloch's inspired distinction between the 'hot' and 'cool' currents of Marxism. But Berger's passion, though it may have found confirmation in such examples, almost certainly derived from somewhere deep inside him: in his gut, as he would say. And what he articulated during the first decade of the twenty-first century was as wholesale an analysis as we have yet been offered of the destructions wrought by our civilization. The blunting of the senses; the hollowing out of language; the erasure of connection with the past, the dead, place, the land, the soil; possibly, too, the erasure even of certain emotions, whether pity, compassion, consoling, mourning, or hoping. 'It is not only animal and plant species which are being destroyed or made extinct today', he wrote, 'but also set after set of our human priorities. The latter are systematically sprayed, not with pesticides, but with ethicides.'[65] There were hollow words: freedom, democracy, terrorism. And then there were real words: *Nakbah* (catastrophe); *saudade* (longing); *agora* (forum); *Weg* (the woodcutter's path).

In old age Berger drew flowers, but he also penned some of the most searing protests against the war on terror and the war on the poor. His last collection, *Hold Everything Dear*, was anything but daffodils. The bibliographic categories, next to the ISBN, are telling:

1. Security, international. 2. War—Causes. 3. Equality. 4. Power (Social sciences).
5. International economic relations. 6. War on Terrorism, 2001.

He said he wanted to hold in his world picture the struggles of people everywhere, from Baghdad to Chicago, Sardinia to Tehran, Berlin and Alicante to Mali and Kabul. He wrote of Pasolini's film *La Rabbia*, which he qualified as 'inspired by a fierce sense of endurance, not anger'.[66] The Italian poet and filmmaker looked at the world, he wrote, with 'unflinching

lucidity'. And he did this because 'reality is all we have to love. There is nothing else.'[67]

His detractors called it grandstanding. They said it was 'all noble peasants or faceless oppressors'.[68] At moments they were right. There were certain contradictions, as there are for all of us, that he did not want to face. His intelligence had a front and a back side, like that of any public figure. But for so many—and not just intellectuals—his missives were part of the night sky: they were like stars to be guided by. 'In every case', Benjamin said, 'a storyteller is someone who has counsel for his readers.'[69] What Berger said was not always right, but what he said was always worth thinking about. He hit upon a vernacular idiom that could travel. His late essays were translated and reprinted all over the world.

'Some fight because they hate what confronts them', he once wrote. 'Others because they have taken the measure of their lives and wish to give meaning to their experience. The latter are likely to struggle more persistently.'[70] These may seem counterintuitive words today. So much of what confronts us does inspire a sense of urgency new to a generation. But as we prepare to dig in with all the tenacity and solidarity we can muster, there will also be parallel and more personal fronts. To struggle is not only to struggle against one's oppressors or opponents; it is also to struggle to keep the multiple layers of our loyalties intact. Berger taught us that it is possible neither to channel the complexities of experience into the sureties of ideology nor to seek refuge under an art-for-art's-sake canopy of culture. If you are prepared to do so, as he was, you can live a whole life out in the open.

The romantics wrote at the time of enclosure. Berger wrote, he said near the end of his life, during the period of the Wall. The toppling of the one in Berlin was only a façade of freedom. New ones everywhere were already planned to go up:

Concrete, bureaucratic, surveillance, security, racist walls. Everywhere the walls separate the desperate poor from those who hope against hope to stay relatively rich. The walls cross every sphere, from crop cultivation to health care. They exist

too in the richest metropolises of the world. The wall is the front line of what, long ago, was called the Class War.

On the one side: every armament conceivable, the dream of no-body-bag wars, the media, plenty, hygiene, many passwords to glamour. On the other: stones, short supplies, feuds, the violence of revenge, rampant illness, an acceptance of death and an ongoing preoccupation with surviving one more night—or perhaps one more week—together.

The choice of meaning in the world today is here between the two sides of the wall. The wall is also inside each one of us. Whatever our circumstances, we can choose within ourselves which side of the wall we are attuned to. It is not a wall between good and evil. Both exist on both sides. The choice is between self-respect and self-chaos.[71]

The vision is stark and unrelenting. The militancy of his youth was back, and with it the moralism—but also the power.

'How useful are Berger's Manichean absolutes in the real world of partial truths and incomplete solutions?'[72] The question is Geoff Dyer's, and it is a real one. It is there for each of us to answer. Many sympathetic to the lyricism of the late work, whether in the taste of fruit as described in *Here is Where We Meet* or the drawings of *Bento's Sketchbook*, are likely to balk at his rhetoric, while the more militant activists driven onward by his example may pass over the description of light in a Monet landscape, at once astounding and calm, or of the ibex and chamois in the Chauvet Cave, figures painted 30,000 years before the invention of modern politics.

Berger wrote for multiple publics. He instinctively knew how to bend and not to break. But he also understood that there do come junctures, moments of truth, throughout a life. In contemplation it is easy to *see* multiple sides; in practice there is often one that must be taken.

Berger knew this. Now we are learning it anew. Sometimes you have to choose.

Acknowledgments

This book was written in a number of places with the support of a great number of people: friends, teachers, archivists, other writers, my family. It would never have got off the ground were it not for the initial encouragement of my advisors at Yale: Dudley Andrew and Katie Trumpener. For their support, trust, and ideas along the way, I am deeply grateful. I would like to thank others at Yale: Katerina Clark and John MacKay for their feedback; as well as Moira Fradinger, Amy Hungerford, David Bromwich, Peter Cole and Charles Musser. I learned a great deal from all of them.

Plane tickets are not cheap. Because crossing an ocean was usually involved in the many trips I made to write this book, a series of grants were especially valued: a Paul Mellon Centre fellowship; a Robert M. Leylan Dissertation Fellowship; and, more recently, an H. H. Powers Travel Grant. London was the center of this book's archival universe—especially the newly available John Berger archive at the British Library. I am grateful to the attendants at the library for all of their help. I also bear a tremendous debt to Tom Overton, the cataloguer of the archive, for his assistance, hospitality and enduring friendship. Our long conversations about Berger (and football), whether at the staff eatery or back in Stoke Newington, were a highlight of my many months in England. I would also like to thank the librarians at the Yale Center for British Art; the University Archives at UCLA; Senate House Library; Michael Palazzolo at Oberlin; Nadia Roch at the Cinémathèque Suisse; and the many archivists at the British Film Institute.

Alongside the archival work, my research was given context by a series of interviews and conversations with the artists involved. Many thanks to Alain Tanner and Jean Mohr for making time to host me at their houses in Geneva; to Mike Dibb for our discussions in London and copies of hard-to-find BBC programmes; and to Richard Hollis for an invaluable conversation about graphic design at his home studio. I also had memorable conversations with Susan George, Saul Landau, Paul Barker, David Levi Strauss, Nikos Papastergiadis, John Christie, Geoff Dyer, Colin MacCabe, Ben Lerner, James Hyman, Bruce Robbins, Alix MacSweeney, Lawrence Weschler, Gareth Evans and others. A very special thanks to John and Beverly Berger for their hospitality in Quincy and, more recently, to Yves.

On this side of the Atlantic, I am grateful to Daniel Fairfax for our ongoing dialogue about aesthetics and politics; Tim Ellison for his notes on drafts of several early chapters; and Kathryn Hutchinson for her useful feedback after listening to parts of this book on our porch. Other friends who lent a hand in one way or another include Grant Wiedenfeld, Sara Beech, Marc Linquist, Jasmine Mahmoud, Mimi Chubb, Rachael Rakes, Ryan Conrath, Chris Stolarski, Seung-hoon Jeong and Laura Macomber. For being such great friends during the writing of this book I would like to also thank Max Lansing, DeMarcus Suggs, Anna Morgan, Adam Kaufman, Katie Lorah, Jeremy Dalmas, Quentin Notte, Hunter Jackson, Maeve Johnston, Adam Rachlis, Bonnie Chau, Ramy Dodin, Sitar Mody, Diana Mellon, Brandon Finegold and everyone in Brussels. Sections of this book grew out of articles first published in *Guernica Magazine* and *Jump Cut*, and I am grateful to the editors of both publications. At Oberlin, I must single out my student research assistant Asher Shay-Nemerow for his generous insight, collegiality and hours and hours of hard work—not to mention a team-building excursion to a climbing gym. I wish to also acknowledge the support of my students as well as my colleagues Grace An, Pat Day and Geoff Pingree.

On a very personal level I am grateful to Jill, for hosting me in Madison just as the seed for this book was sprouting, and

to Tina and Tati for being such wonderful Brooklyn neighbours. This book would not have been completed without the help of my mother, Barbara, a truly inspiring woman and scientist. Her limitless generosity is a godsend. And of course, Amy, whose unwavering good humour and bedrock of support (not to mention patience) are blessings.

Notes

Introduction

1. Andrew Forge, 'In Times of Sickness' (review of *Permanent Red*), *Spectator*, 28 October 1960.
2. John Berger, 'A Truly European Writer' (review of *Leavetaking* and *Vanishing Point*), *New Society*, July 1967, Vol. 10, No. 249.
3. John Berger, *And Our Faces, My Heart, Brief as Photos* (New York: Vintage, 1984), p. 67.
4. Sartre's essays from *Les Tempes Modernes* were collected and first published as *Qu'est-ce que la littérature* in 1948. See Jean-Paul Sartre, *What is Literature? and Other Essays* (Cambridge: Harvard University Press, 1988 [1948]). Roughly fifteen years later, Adorno fired back in defence of non-partisan 'autonomous' art that celebrated its own aesthetic space, nothing to do with the short-termism of politics. The best plays of Brecht, he argued, were the least didactic. See Theodor Adorno, 'Commitment' (1962), *New Left Review* I/87–88 (September–December 1974). Between the two thinkers there may have been more common ground than was acknowledged. Adorno famously said that no great novel could be anti-Semitic. 'At the heart of the aesthetic imperative', Sartre wrote, 'we discern a moral imperative.'
5. Quoted in Julian Spalding, *The Forgotten Fifties*, exhibition catalogue, 31 March–13 May 1984, Graves Art Gallery, Sheffield, p. 14.
6. From an unpublished interview with John Berger conducted by Paul Delany in May 1977—transcript shared with the author.
7. Janine Burke, 'Raising Hell and Telling Stories' (interview with John Berger), *Art Monthly* 124 (1989).
8. Delany interview with Berger.
9. Ibid.
10. The quote is from a public conversation between Berger and Laurie Taylor held at the Southbank Centre on 25 May 2011. It has since circulated in articles and obituaries. See, for example,

Tom Overton, 'John Berger, Marxist art critic and Booker Prize-winning novelist—Obituary', *Daily Telegraph*, 3 January 2017.

11. Berger told the story in a number of interviews. The quote is from an interview with Berger conducted by Nigel Gray in March 1984. Berger clarifies that his preference for their company was 'not for any ideological reason, or not primarily for that; not because politically I wanted to identify with "the struggle of the working-class" (because my political consciousness, in a formulated way, really occurred later), but because I preferred the way they related to one another, and sometimes to me'. See Nigel Gray, *Writers Talking* (Fremantle: Fontaine Press, Australia, 2016), p. 63.

12. John Berger, 'The Painter and His Rent', BBC radio broadcast, 18 November 1959.

13. John Berger, 'Exit and Credo', *New Statesman*, 29 September 1956.

14. From correspondence between Eskell and Paul Delany, shared with the author.

15. Dyer is rephrasing an assertion he made in the preface to his own study of Berger. See Geoff Dyer, *Ways of Telling* (London: Pluto, 1986). See also Geoff Dyer, 'Editor's Introduction', in John Berger, *Selected Essays* (New York: Pantheon, 2001), p. xii.

16. 'I can think of no other writer whose critical standing is as uncertain —as *unworked through*—as John Berger's. The problem has to do with the range of his work'. Geoff Dyer, 'Into Their Labours', *Brick: A Literary Journal* 37 (Autumn 1989), p. 41.

17. Ben Ratliff, 'The Song of John Berger', *NYR Daily*, 12 January 2017.

18. Joan Didion, 'Why I Write', *New York Times*, 5 December 1976.

19. John Berger, 'Artists and Critics', *New Statesman*, 4 April 1953.

20. Sontag's quotation appeared on the American editions of many of Berger's books published during the 1980s and 1990s.

21. Dyer, 'Editor's Introduction'.

22. Forge, 'In Times of Sickness'.

23. T. S. Eliot, 'Preface' (1952) in Simone Weil, *The Need for Roots* (London: Routledge, 2002), p. viii.

24. James Salter, *Burning the Days* (New York: Random House, 1997), p. 203.

25. Quoted in Christopher Hitchens, 'Susan Sontag', *Slate*, 29 December 2004.

26. Quoted in Paul Bonaventura, 'Master of Diversity', *New Statesman*, 12 November 2001.

27. Eleanor Wachtel, 'An Interview with John Berger', *Brick: A Literary Journal* 53 (Winter 1996), p. 38.

28. Czesław Miłosz, *The Witness of Poetry* (Cambridge: Harvard University Press, 1983), p. 94.

29. W. G. Sebald, *On The Natural History of Destruction* (New York: Modern Library, 2003), p. 190.

1. The Battle for Realism

1. For a discussion of the competition, see Martin Harrison, *Transition: The London Art Scene in the Fifties* (London: Merrell, 2002), pp. 68–71; James Hyman, *The Battle for Realism: Figurative Art in Britain During the Cold War 1945–1960* (New Haven, CT: Yale University Press, 2001), pp. 159–60. Robert Burstow has extensively researched the contest. See Robert Burstow, 'Cold War Politics', *Art History* 12: 4 (December 1989); Robert Burstow, 'The Limits of Modernist Art as a "Weapon of the Cold War": Reassessing the Unknown Patron of the Monument to the Unknown Political Prisoner', *Oxford Art Journal* 20: 1 (1997). Burstow is referencing the influential article, Eva Cockcroft, 'Abstract Expressionism, Weapon of the Cold War', *Artforum*, vol. 12, no. 12 (June 1974).

2. This is quoted in the Tate catalogue entry for Reg Butler, 'Working Model for the Unknown Political Prisoner'. The entry, which includes a detailed description of the contest and controversy, can be accessed at tate.org.uk.

3. The mastermind of the competition was Anthony Kloman, a US cultural attaché who worked with his own staff inside the ICA. The funding was provided by John Hay Whitney, later the American ambassador to Britain, who was involved with the CIA.

4. Quoted in Hyman, *Battle for Realism*, p. 159. See also Michael Clegg, 'Art and Humanism: An Act of Vandalism in the Cold War', *Versopolis*, at versopolis.com. At trial, Szilvassy pleaded guilty but remained defiant. The chairman of the court, noting the defendant had 'suffered much' under totalitarian rule, ultimately processed a discharge. Clegg has traced Szilvassy's fate: in 1967 he emigrated to Canada, where he pursued a career as a photographer and muralist.

5. Reporting from the 1952 Venice Biennale, Berger wrote: 'One's impression, in gallery after gallery, is of fragmentary pictures somehow produced by *guesswork*—based on vague memories of the masterpieces of the last seventy years.' The only exception was the tent of Italian Social Realists: 'a straight answer among thousands of polite evasions'. John Berger, 'The Biennnale', *New Statesman*, 2 July 1952.

6. John Berger, 'Unknown Political Prisoner', *New Statesman*, 21 March 1953.

7. Ibid.

8. Ibid.

9. These quotations are from the letters pages of the *New Statesman*, under the title 'Artists and Critics'. The discussion continued over several issues: 28 March, 4 April, 11 April and 18 April 1953.

10. See Frances Stonor Saunders, *The Cultural Cold War: The CIA and the World of Arts and Letters* (New York: New Press, 1999), pp. 247–53; Hyman, *Battle for Realism*, pp. 166–8.

11. Interview with Harry Weinberger, conducted 17 March 1995, 'National Life Story Collection: Artist's Lives', British Library Sound Archives.

12. The composition emphasizes a contrast between the towering geometries of scaffolding and the relative smallness of the workers, sketched in Lowry-like outlines. Curiously, in its visual strategy it partially resembles Reg Butler's maquette later denounced by Berger. But here the contrast is optimistic: the building is a testament to joint effort rather than ominous big brothers.

13. From an unpublished interview with John Berger conducted by Paul Delany in May 1977—transcript shared with the author.

14. From an unpublished interview by Deborah Cherry and Juliet Steyn (intended for *Art Monthly*), conducted in 1982. Transcript held in the John Berger Archive at the British Library under 'Unpublished Theses & Interviews 1981–1988'.

15. I simplify, of course, but such simplifications held powerful sway in the public's imagination, and it is furthermore always in the nature of oppositional discourse to simplify, to caricature one's enemy, and thus to create false dichotomies from which artists and thinkers will later spend years trying to extricate themselves.

16. Anthony Blunt, 'The École de Paris and the Royal Academy', *New Statesman*, 20 January 1951. Other writers have compared Blunt to Berger. See Geoff Dyer, *Ways of Telling* (London: Pluto, 1989), pp. 10–11; Christopher Green, 'Anthony Blunt's Picasso', *Burlington Magazine*, January 2005, pp. 32–3.

17. Blunt, 'The Ecole de Paris and the Royal Academy'.

18. John Berger, 'Present Painting', *New Statesman*, 17 November 1951.

19. Ibid.

20. These quotations are from two articles: John Berger, 'For the Future', *New Statesman*, 19 January 1952; and John Berger, 'The Young Generation', *New Statesman*, 25 July 1953.

21. Berger 'For the Future'.

22. John Berger, 'The Necessity of Uncertainty', *Marxist Quarterly* 3: 3 (July 1956).

23. Berger continued: 'If Bacon's paintings began to deal with any of the real tragedy of our time, they would shriek less, they would be less jealous of their horror, and they would never hypnotise us, because we, with all conscience stirred, would be too much involved to afford that luxury.' John Berger, 'Francis Bacon', *New Statesman*, 5 January 1952. He made similar points in other articles: 'So many paintings based on fantasies owe what little power they have to their negative effects; one feels that their vision is different only because it is wilfully odd—not because of some overpowering discovery.' John Berger, 'Various Exhibitions', *New Statesman*, 16 February 1952.

24. Berger's independence was both a virtue and a drawback: it allowed him to pursue a flexible theorization, but it also meant

that he regularly found himself in the middle of ideological crossfire, and often felt compelled to side with what would have been the party line. As Berger tried to carve out a middle ground between Washington and Moscow while simultaneously expressing a cautious sympathy for the latter, the spectre of contradiction presented itself along every avenue of his thought.

25. Hyman explains: 'Proposed by Berger in early 1952, *Looking Forward* was very much the vision of one man. The exhibition initially began as a collaboration with Hugh Scrutton, the director of the Whitechapel Gallery from 1947 to 1952, but with the arrival of his successor, Bryan Robertson, in May 1952, the young critic was given an increasingly free hand.' Hyman, *Battle for Realism*, p. 116.

26. Raymond Williams, 'Realism and the Contemporary Novel', *Universities and Left Review*, Summer 1958.

27. See Hyman, *Battle for Realism*, pp. 113–19, 175–8.

28. Neville Wallis, 'Cousins of Courbet', *Observer*, 5 October 1952.

29. Myfawny Piper, review in *Time and Tide*, 25 October 1952.

30. Benedict Nicolson, 'Looking Forward', *New Statesman*, 11 October 1952.

31. David Sylvester, 'The Kitchen Sink', *Encounter*, December 1954.

32. Ibid.

33. Richard MacDonald and Martin Stollery, 'Interview with Dai Vaughan: Between a Word and Thing / You Encounter Only Yourself', *Journal of British Cinema and Television* 8: 3 (December 2011).

34. See the chapter 'Yankee Doodles' in Saunders, *Cultural Cold War*. See also David Caute, *The Dancer Defects: The Struggle for Cultural Supremacy During the Cold War* (Oxford: Oxford University Press, 2005). Both books provide extensive, overarching chronicles of what Caute refers to as 'an ideological and cultural contest on a global scale and without historical precedent'. In 1952, the Congress for Cultural Freedom's *Festival of the Twentieth Century* was held in Paris. Also in 1952, the Museum of Modern Art began to promote its collection abroad with five-year grants from the Rockefeller Brothers Fund. Hyman also speaks of a period of 'mobilization' that began in 1952.

35. Alfred Barr, Jr, 'Is Modern Art Communistic?' *New York Times Magazine*, 14 December 1952. Barr begins his article by noting: 'Modern political leaders, even on our side of the Iron Curtain, feel strongly and express themselves eloquently against modern art.' He quotes Truman, who called it 'merely the vaporings of half-baked lazy people', and Eisenhower, who remarked after looking at an abstract mural at the United Nations building: 'To be modern you don't have to be nuts.' In 1949 the Republican Senator George Dondero announced to Congress that all modern art was communistic, and thus a threat to American values. This was the tide Barr wanted to turn.

36. John Berger, 'The Missing Example', *New Statesman*, 5 February 1955.
37. Berger, 'Artists and Critics', 4 April 1953.
38. The first editorial set out a conjuncture: 'Three men have died— Mussolini, Hitler, and Stalin; and with them the mythologies of an epoch. The last surviving fable was exposed only yesterday in Eastern Germany and Czechoslovakia, where real factory workers unambiguously dissociated themselves from a hypothetical Proletariat, achieving by that simple action what a thousand subtle arguments could not do: the destruction of the Marxist-Leninist creed.' From 'After the Apocalypse', *Encounter* 1: 1 (October 1953).
39. Barr's article features over twenty images sorted into categories: 'Hated and Feared' in both Soviet Russia and Nazi Germany, and 'Admired and Honored' under each regime.
40. 'After the Apocalypse', *Encounter* 1: 1 (October 1953).
41. Berger spoke of this 'alliance' in an interview decades later: 'All three of us were concerned with opening up the rather prescribed British cultural situation to wider historical and political questions and issues. Ken was introducing Brecht to England, unknown in England before. We were all of us very involved in the peace movement. We all had to fight our editors very frequently. We were all close friends. That was the alliance.' From Cherry and Steyn, unpublished interview for *Art Monthly*.
42. See Hyman, *Battle for Realism*, pp. 84–5. In a letter to Hyman, the painter Derrick Greaves recalled, in Hyman's paraphrase, that 'the discussion was not always about politics and that the evenings were an opportunity to meet specialists in many fields'. See also Julian Spalding, 'The Forgotten Fifties', in *The Forgotten Fifties*, exhibition catalogue, 31 March–13 May 1984, Graves Art Gallery, Sheffield, pp. 38–40. Spalding notes that 'internal disputes' arose between Berger's friend, the militant painter Peter de Francia, 'who wanted more structured meetings', and George Fullard, who 'played the joker and disrupted everything'. Berger also discussed the club in an interview with the author.
43. 'Everyone was there', remembered Doris Lessing in an apocryphal but revealing anecdote. 'The place was full, it buzzed, it jumped, it vibrated. What a good idea, we all thought, how clever of John Berger to have thought of it, and of course there must be many more such occasions.' But when Berger called everyone to order to make a speech, guests started heading for the door. '"Not again", people were saying. "We've been here before, too often." And so ended a brave attempt; but if politics had not intruded, we would all be there yet.' Doris Lessing, *Walking in the Shade: Volume Two of My Autobiography—1949–1962* (New York: HarperCollins, 1992), pp. 221–2.
44. See Hyman, *Battle for Realism*, p. 229. One of the co-founders of the *Universities and Left Review* (later the *New Left Review*), Raphael Samuel, remembers the excitement he experienced when

visiting the Geneva Club as a third-year student at Oxford. The mission of the *New Left Review* was partly modelled on the club.

45. Cherry and Steyn, unpublished interview for *Art Monthly*.
46. From a typewritten document, apparently a book proposal, contained in the John Berger Archives at the British Library, '1950s Typescripts + MS'.
47. Berger, 'Artists and Critics', 4 April 1953.
48. John Berger, 'A Socialist Realist Painting at the Biennale', *Burlington Magazine*, October 1952.
49. John Berger, 'Public Sculpture', *New Statesman*, 4 July 1953.
50. Raymond Williams aptly expressed the distinction: 'The concept of tradition has been radically neglected in Marxist cultural thought … not only because it is ordinarily diagnosed as superstructure, but also because "tradition" has been commonly understood as a relatively inert, historicized segment of a social structure: tradition as the surviving past. But this version of tradition is weak at the very point where the incorporating sense of tradition is strong: where it is seen, in fact, as an actively shaping force.' Raymond Williams, *Marxism and Literature* (Oxford: Oxford University Press, 1977), p.115.
51. John Berger, 'The Temptations of Talent', *New Statesman*, 25 October 1952.
52. John Berger, 'Direct Communication', *New Statesman*, 29 March 1952.
53. Berger, 'Public Sculpture'.
54. John Berger, 'Exit and Credo', *New Statesman*, 29 September 1956.
55. This comment was made in particular reference to Herbert Read in Berger, 'Artists and Critics', 4 April 1953.
56. John Berger, 'The Siege of the Ivory Tower', *New Statesman*, 19 February 1955.
57. See John Berger, 'The Child, the Mystic and the Landlady', *New Statesman*, 3 March 1956.
58. John Berger, 'The Painter and His Rent', BBC radio broadcast, 18 November 1959.
59. John Berger, 'The Unrecognised', *New Statesman*, 7 January 1956.
60. John Berger, 'Aunt and Arbiter', *New Statesman*, 15 January 1955.
61. Herbert Read, 'Correspondence: "Aunt and Arbiter"', *New Statesman*, 22 January 1955.
62. John Berger, 'Isolation and Freedom', *New Statesman*, 11 August 1954.
63. For a detailed discussion of this idea, see David Forgacs, 'National–Popular: Genealogy of a Concept', in Simon During, ed., *The Cultural Studies Reader* (London: Routledge, 1993).
64. The *Times Literary Supplement* did dedicate two notable articles to Gramsci—one in 1948 and another in 1952, both published anonymously. Two key figures who were aware of Gramsci during the early 1950s were Hamish Henderson and Eric Hobsbawm. See David Forgacs, 'Gramsci and Marxism in Britain', *New Left*

Review I/176 (July–August 1989). Forgacs writes: 'Although Gramsci's work did not go completely unnoticed in Britain in the two decades after his death, it made a negligible impact before it first appeared in book form in 1957'. See also Geoff Eley, 'Reading Gramsci in English: Observations on the Reception of Antonio Gramsci in the English-speaking World 1957–82', *European History Quarterly* 14 (1984). It is significant that Eley begins his history in 1957, with the rise of the New Left.

65. John Berger 'The New Nihilists', *Labour Monthly*, March 1957, pp. 123–7.

66. Berger, 'The Child, The Mystic and the Landlady'.

67. Quoted in Kate Crehan, *Gramsci, Culture and Anthropology* (Berkeley, CA: University of California Press, 2002), p. 159. For a further discussion of this problem, see Alastair Davidson, 'Intellectuals', in Gino Moliterno, ed., *Encyclopedia of Contemporary Italian Culture* (London: Routledge, 2000).

68. This initiative is discussed in relation to Renato Guttuso's work in Lara Pucci, '"Terra Italia": The Peasant Subject as Site of National and Socialist Identities in the Work of Renato Guttuso and Giuseppe De Santis', *Journal of the Warburg and Courtauld Institutes* 71 (2008), pp. 315–34. I am indebted to Pucci for further information about these initiatives. See also Lucia Re, 'Realism and Italian Neorealism', *Calvino and the Age of Neorealism* (Palo Alto, CA: Stanford University Press, 1990).

69. John Berger, 'Dear Enemy…', *Tribune*, 26 September 1952. The letter is satirical: 'You are the man who kills art in the welfare state. You are the pampered worker who cares for nothing but football pools and fish and chips. You are the brute whose indifference to the finer things of life keeps scores of painters and artists starving in garrets and corrupting in advertising agencies. That, at least, is how the story goes. As an art critic and a painter, I have been brought up to despair of you—you scoundrel.' The tonal conceit of the letter fails. But Berger's unembarrassed honesty in voicing the unspoken prejudices of the class to which he belongs—and disowning those prejudices—is, at least partly, commendable.

70. *Drawn from Life* was broadcast by Granada in 1961–62. Episodes can be viewed at the BFI archives. Years later Berger would conduct a similar experiment with an even more naive audience when, in *Ways of Seeing*, he showed a reproduction of Caravaggio's *Supper at Emmaus* to a group of schoolchildren.

71. Both quotes are from 'Notes on Broadcasting: Selling Millions the Idea of Culture (From Our Special Correspondent)', *The Times*, 9 December 1961. The reviewer quotes Doris Lessing's negative review in the *New Statesman*. After her attack, Lessing apparently received 'a shower of abusive letters'. *The Times* recounted the story, adding: 'It says much of Mr Berger's standing as a national figure that he should be allotted this kind of championship.'

72. Berger differed in an important way from many of his peers: while

he did possess strong, sentimental sympathies for working-class culture, as well as an antipathy to the 'corrupt brightness' of mass entertainment, he was not arguing for culturalism as such, nor did he want to see a return to folk traditions. Berger would have rejected F. R. Leavis's belief that culture should be in the hands of an elite minority, but he would also have been uncomfortable, though in a different way, with a purely homespun understanding: culture as nothing more than the customs of a neighbourhood. Berger's anthropological line of thought only went so far. Art was a by-product of larger social forces, he said, but it was a special kind of by-product. The artist was neither a layman nor an outsider; he should be, following Gramsci, more like a *representative*.

73. John Berger, *Renato Guttuso* (Dresden: Verlag der Kunst, 1957).

74. In one of his first television appearances, as a guest alongside Kenneth Clark, Berger told Clark of the popular admiration Guttuso's works inspired, relaying anecdotes of peasants copying his paintings onto their homes and wheelbarrows. Guttuso's work could be enjoyed, in his words, both by Bernard Berenson and a Sicilian peasant. In a text accompanying one of Guttuso's exhibitions in London, Berger likewise spoke of Italian townspeople replicating his paintings in a public arrangement of flowers. This need to emphasize the native, popular celebration of the work reflected Berger's own critical preoccupations. Guttuso was an artist who 'owes much to Cubism and Kokoschka, yet he is a painter loved by people who have never heard of either'. Berger, 'Missing Example'. Also see John Berger and Benedict Nicolson, 'Guttuso: A Conversation', *New Statesman*, 19 March 1955.

75. Guttuso's interest in the peasantry likely played a role in sparking Berger's. The Italian painter spoke of 'Sicilian peasants who hold the primary position in my heart, because I am one of them, whose faces come in front of my eyes no matter what I do, Sicilian peasants so important in the history of Italy'. From the text accompanying Guttuso's painting *Occupazione delle terre incolte in Sicilia*, included in the 1950 Venice Biennale.

76. This is a rough translation of the original German. Berger, *Renato Guttuso*, p. 7.

77. Calvino elaborates on this: '"Neo-realism" was not a school … It was many voices combined, mostly voices from the provinces, a many-sided revelation of the different Italys that existed, a revelation also, and in particular, of the Italys that had been least explored by literature. Without this variety of different Italys, each of them unknown to the other, or which we believed were unknown to each other, and without this range of dialects and local forms of Italian which were to be leavened and moulded by the literary language, "Neo-realism" would have never existed.' Italo Calvino, *The Paths of the Spiders' Nests* (New York: Ecco Press, 2000 [1947]), p. 9.

78. Quoted in Harrison, *Transition*, p. 12.

79. Perhaps the experiential, rather than ethnic, nature of the local is one means by which Berger's credo resists the reactionary charge it might otherwise acquire. Like 'tradition' and 'the people', localism possesses a political malleability. It can notoriously bend either to the populist left, towards community spirit and cultural pride, or to the populist right, towards xenophobia, depending on the uses to which it is put. In recent decades, Gramsci's concept of the national–popular has become a subject of criticism for precisely these reasons: for containing latent tendencies towards exclusivity. This critique prompts two clarifications. First, Berger's calls for localism were always calls for *rootedness*—for being embedded in the particulars of one's environment—and against the kinds of reifications, ethnic or otherwise, on which exclusions are most often based. Second, the emphasis for Berger and Gramsci was always on the integration of regions historically *excluded* from the national project. As one scholar explains, 'Whereas the Italian nation was formed in opposition to what was imagined as a cultureless South, Gramsci argues that no nation-building project will be successful if it does not integrate all the popular classes and groups into an active conception of their identity as people in the place. It therefore acknowledges difference as an active component of the national–popular, and resists an idea of ethnic purity (unsurprisingly, given that Gramsci was himself a Sardinian of Albanian descent).' Steven Jones, *Antonio Gramsci* (London: Routledge, 2006), p. 38.

80. From 'Arts Programme', date unknown, held in the John Berger Archive at the British Library, '1950s Typescripts + MS'. Itemization of the world's cities was a regular trope of Berger's anti-cosmopolitan writing from the 1950s—for example: 'Contemporary art fashions are the same in Rome as in Paris, Tokyo, Los Angeles, and London.' John Berger, 'Italian Diary', *New Statesman*, 2 August 1958.

81. Berger continues: 'Formalist art is one of the results of the destruction of local and national cultures by monopoly capitalism. Thus it has inevitably become "cosmopolitan" art. But the American-dominated market for cosmopolitan art becomes increasingly competitive. France, Italy, Japan, Germany, Spain, Finland, the Argentine, and many other countries are all competing with almost identical goods. There are, therefore, nothing like enough sales to support the majority of artists working in any one country. It is an ironic situation because it means that thousands of painters produce *official* art and yet have to eke out a living "as though they were in romantic revolt".' From a manuscript held in the British Library Archive under '1950s Typescripts and Misc'.

82. Berger, 'The Unrecognised'.

83. John Berger, 'The Glut in Art', *New Statesman*, 7 August 1954.

84. Berger, 'Aunt and Arbiter'. Berger's reference here is to a book the critic Francis Watson had published in 1939.

85. 'The majority of these works are no more sentimental or unoriginal than the majority of contemporary works in the Biennale at Venice', he wrote. 'Nor is Mr Griffiths any more parochial than those who officiate there, doing less work with a hundred times more self-importance.' John Berger, 'The Cosmopolitan and the Village Pump', *New Statesman*, 31 August 1954.

86. Berger, 'The Child, the Mystic, and the Landlady'. Berger's response to Van Gogh's question gives an indication of his state of mind: 'It may seem mad at the moment, but until it seems sane art will remain a luxury trade or a hobby to which a few dedicated artists, who deserve better, will tragically sacrifice their lives.'

87. John Berger, 'The Impossible Student', *New Statesman*, 11 September 1954.

88. It is telling in this respect that David Sylvester later measured the 'damage' Berger did strictly in terms of cash value: 'He was a very effective writer and a very good broadcaster,' Sylvester said, 'but meanwhile, a painter like Francis Bacon couldn't sell any pictures in this country. The standard price of a Bacon at the Hanover Gallery in the early 1950s was 300 or 350 pounds, and nobody was buying them. Here was a great painter and Berger was too damn stupid to see that. Too prejudiced, too bigoted, too puritanical. He was also too simple and schematized. He didn't like any abstract art. What a clown!' Quoted in Carl Freedman, 'About David Sylvester', *Frieze*, 9 September 1996.

89. John Berger, 'Polish, German, Italian', *New Statesman*, 19 May 1956.

90. George Orwell, *1984* (London: Signet Classics, 1950), p. 267. The quote has long since passed into circulation independently of the novel.

91. John Berger, 'Fernand Léger and the Future', *New Statesman*, 18 December 1954.

92. John Berger, 'Fernand Léger: A Modern Artist—I', *Marxism Today*, April 1963.

93. Ibid.

94. John Berger, 'L'Envoi for Léger', *New Statesman*, 27 August 1955.

95. From the 1955 exhibition catalogue of the Beaux Arts Quartet at the Heffer Gallery in Cambridge. 'It should be stressed that they themselves never had any intention of forming a group, nor of inscribing themselves under any particular faction … The more one studies these four young painters, the more different they appear.' Quoted in James Hyman, 'Derrick Greaves: Paintings and Drawings 1952–2002', James Hyman Gallery, London, 2003.

96. Harrison and Hyman both agree on this. 'Despite the short-lived support of John Berger for Social Realism', Harrison writes, 'its chief exponents, John Bratby, Jack Smith, Edward Middleditch and Derrick Greaves, did not share his faith in Marxism, nor, apart from Bratby, did they sustain their interest in Social Realism beyond 1956.' Harrison, *Transition*, p. 14.

97. Patrick Procktor: 'There was something Derrick Greaves had said at a Young Contemporaries meeting that made me laugh: he confessed to the audience, "I was a teenage social realist".' Quoted in Harrison, *Transition*, p. 72.
98. John Berger, 'Gods and Critics', *New Statesman*, 5 June 1959.
99. John Bratby, 'Painting in the Fifties', in *The Forgotten Fifties*, p. 46.
100. The introduction begins: 'Of the seventeen painters in this, none speaks for the others any more than he paints for the others. In principle their individualism is as uncompromising as that of the religion of Kierkegaard whom they honor. For them, John Donne to the contrary, each man is an island.' Alfred H. Barr, Jr, 'Introduction', in *The New American Painting as Shown in Eight European Countries 1958–1959*, Museum of Modern Art, 1959.
101. David Sylvester, 'A New-Found Land', in *Vision: 50 Years of British Creativity* (London: Thames & Hudson, 1999), p. 21.
102. 'For their own sake these slashed, scratched, dribbled-upon, violated canvases would not be worth taking seriously. The disturbing fact is that many intelligent, talented people do take them seriously.' John Berger, 'The Battle', *New Statesman*, 21 January 1956.
103. Ibid. Years later Berger would repeat the analysis, though striking a more wistful, sympathetic note: 'The suicide of an art is a strange idea. Yet I am bound to start with it, if I'm to talk about the story of Jackson Pollock and his wife, the painter Lee Krasner.' John Berger, 'A Kind of Sharing' (1989), in Geoff Dyer, ed., *The Selected Essays of John Berger* (New York: Pantheon, 2001), p. 527.
104. John Berger, 'Robbed', *New Statesman*, 28 February 1959.
105. Berger, 'Exit and Credo'.
106. Ibid.
107. John Berger, 'Wanted—Critics', *Universities and Left Review* 1: 2 (Summer 1957).
108. Ibid.

2. The Crisis of Commitment

1. John Golding, 'A Lost Opportunity', *New Statesman*, 8 December 1956. Only three years later, Golding published the monograph, *Cubism: A History and an Analysis 1907–1914* (London: Faber & Faber, 1959), which was an important reference for Berger's own writing on the movement.
2. Golding, 'Lost Opportunity'.
3. John Berger, 'Correspondence: Death of a Hero', *New Statesman*, 15 December 1956.
4. Philip Toynbee, 'Correspondence: Death of a Hero', *New Statesman*, 22 December 1956.

5. 'Although nearly all Socialists seem to agree in condemning the Soviet intervention in Hungary as wrong and morally indefensible', read one article in the *New Statesman* in January 1957, 'it is nevertheless true that the recent events in Hungary face left-wing Socialists with an appallingly difficult problem of judgment. This is not only because it is still very difficult to be sure about the facts, but also because the facts, as far as they are at present known, are not open to simple explanation.' G. D. H. Cole, 'Reflections on Hungary', *New Statesman*, 12 January 1957.

6. John Willett, 'Correspondence: Death of a Hero', *New Statesman*, 5 January 1957.

7. Hobsbawm wrote: 'It is difficult to reconstruct not only the mood but the memory of that traumatic year, rising, through a succession of lesser crises, to the appalling climax of the Soviet army's reconquest of Hungary, and then stumbling and wrestling to an exhausted defeat through months of doomed and feverish argument ... Even after practically half a century my throat contracts as I recall the almost intolerable tensions under which we lived month after month, the unending moments of decision about what to say and do on which our future lives seemed to depend, the friends now clinging together or facing one another bitterly as adversaries, the sense of lurching, unwillingly but irreversibly down the scree towards the fatal rock face ... Probably the simplest way of putting it is that, for more than a year, British communists lived on the edge of the political equivalent of a collective nervous breakdown.' Eric Hobsbawm, *Interesting Times: A Twentieth-Century Life* (New York: Pantheon, 2007), pp. 205–6.

8. John Berger, 'Correspondence: Death of a Hero', *New Statesman*, 12 January 1957.

9. Stuart Hall, 'Life and Times of the First New Left', *New Left Review* II/61 (January–February 2010).

10. Ibid.

11. Arnold Wesker, *Chicken Soup With Barley* (London: Methuen Drama, 2011), pp. 71, 74.

12. John Berger, *Here Is Where We Meet* (New York: Vintage, 2005), p. 86.

13. Janine Burke, 'Raising Hell and Telling Stories', interview with John Berger, *Art Monthly* 124 (1989).

14. Quoted in Hobsbawm, *Interesting Times*, p. 205. The quote is from Wesker, *Chicken Soup with Barley*.

15. John Berger, 'Afterword' (1988) in *A Painter of Our Time* (New York: Vintage, 1996 [1958]), p. 198.

16. Ibid.

17. Berger, *Painter of Our Time*, p. 23.

18. Ibid., p. 36.

19. Anthony Blunt was also an admirer of Peri. In a 1970 exhibition catalogue, Blunt wrote that Peri 'had been through the hard training of constructivism; he was aware of all the most advanced

schools had to offer; but he was determined to create an art which should not appeal only to a limited and intellectually snobbish group ... But to the end he suffered from a feeling of frustration.' Quoted in Lynda Morris, 'Realism: The Thirties Argument', *Art Monthly* 35 (April 1980), p.7. For further discussions of Peri's work and life, see Mathew Palmer, 'Peter Peri (1898–1967)—An Artist of Our Time?', *Eger Journal of English Studies* X (2010); Paul Stirton, 'Frederick Antal and Peter Peri: Art, Scholarship and Social Purpose', *Visual Culture in Britain* 13: 2 (2012). Both articles invoke Berger's novel to discuss Peri's biography.

20. Eleanor Wachtel, 'An Interview with John Berger', *Brick: A Literary Journal* 53 (Winter 1996), p. 35. Berger goes on to say: 'When I wrote a novel about a fictional painter, this time to tell a story, it wasn't really such a shift. I think it was only a development.'

21. Quoted in Gordon Johnston, 'Writing and Publishing the Cold War: John Berger and Secker & Warburg', *Twentieth Century British History* 12: 4 (2001), pp. 432–60. Johnston provides a detailed account of the publication history of the novel based on research in the Secker & Warburg archives.

22. Berger, *Painter of Our Time*, p. 132.

23. Ibid., p. 165.

24. Here is one example: 'June 18: ... The canvas has come, but remains unpaid for. I want the painting to look as fresh, as unstruggled with, as new wet paint on a front door. / June 20: Desires, like foliage are blown away. / June 21: Have borrowed £20 from Max.' Ibid., p. 127.

25. Ibid., p. 134.

26. What Germaine Bree wrote in relation to Sartre applies just as well to Lavin: 'Sartre is emotionally and imaginatively involved with abstractions. They take on for him concrete, autonomous, personified shapes and enter into conflict with one another. They are Hugo-like figures, whose gigantic duels are always about to seal the fate of the human race.' Germaine Bree, *Camus and Sartre: Crisis and Commitment* (New York: Delacorte, 1972), p. 109.

27. Berger, *Painter of Our Time*, pp. 17–18.

28. Italo Calvino offers an intriguing analysis of this mirroring effect: 'Philosophy and literature are embattled adversaries. The eyes of philosophers see through the opaqueness of the world, eliminate the flesh of it, reduce the variety of existing things to a spider's web of relationships between general ideas, and fix the rules according to which a finite number of pawns moving on a chessboard exhaust a number of combinations that may have been infinite. Along come the writers and replace the abstract chessmen with kings and queens, knights and castles, all with a name, a particular shape, and a series of attributes ... So at this point the rules of the game are turned topsy-turvy, revealing an order of things quite different from that of the philosophers. Or, rather, the people who discover these new rules of the game are once again the

philosophers, who dash back to demonstrate that this operation wrought by the writers can be reduced to the terms of one of their own operations, and that the particular castles and bishops were nothing but general ideas in disguise.' Italo Calvino, 'Philosophy and Literature' (1967) in *The Uses of Literature: Essays* (New York: Harcourt Brace, 1982), pp. 39–40.

29. Fredric Jameson, *Sartre: Origins of Style* (New York: Columbia University Press, 1984), p. 2.

30. Berger, *Painter of Our Time*, p. 102.

31. Ibid., p. 146.

32. For an especially useful summary, published the same year as Berger's novel, see George Steiner, 'Marxism and the Literary Critic', in *Language and Silence: Essays 1958–1966* (New York: Atheneum, 1967).

33. John Berger, 'Frederic Antal – A Personal Tribute', *Burlington Magazine* 96: 617 (August 1954).

34. John Berger, 'Courbet's Art and Politics', *New Statesman*, 30 May 1953.

35. John Berger, 'Dusk and Dawn', *New Statesman*, 31 March 1956.

36. Andrew Forge, 'In Times of Sickness' (review of *Permanent Red*), *Spectator*, 28 October 1960.

37. The two terms are aptly summarized by Ernst Fischer: 'Art is necessary in order that man should be able to recognize and change the world. But art is also necessary by virtue of the magic inherent in it.' Ernst Fischer, *The Necessity of Art* (New York: Verso, 2010).

38. Berger, *Painter of Our Time*, p. 148.

39. Ibid., p. 142.

40. Ibid., p. 92.

41. Ibid., p. 85.

42. Ibid., p. 133.

43. John Berger, 'Vincent, Their Vincent', *New Statesman*, 20 April 1957.

44. Julian Barnes, 'Selfie with Sunflowers', *London Review of Books*, 30 July 2015.

45. Berger, *Painter of Our Time*, p. 76.

46. Ibid., p. 17.

47. Ibid., p. 23.

48. Ibid., p. 24.

49. John Berger, 'Peter Peri' (1968), in Geoff Dyer, ed., *The Selected Essays of John Berger* (New York: Pantheon, 2001), p. 172.

50. Berger, *Painter of Our Time*, p. 100.

51. 'The moments—which if I relate them well enough—will join countless others lived by people I do not personally know.' John Berger, 'Mother' (1986), in *Selected Essays*, p. 493.

52. Raymond Williams, 'Realism and the Contemporary Novel', *Universities and Left Review*, Summer 1958.

53. Ibid.

54. John Berger, 'The Prague Student', *New Society*, 13 February 1969.

55. Stephen Spender, 'Mixing Politics with Paint', *Observer*, 9 November 1958.
56. Arnold Kettle, 'A Painter of Our Time', *Labour Monthly*, March 1959.
57. Paul Ignotus, 'Fiddler of Our Time', *Encounter*, February 1959.
58. Ibid.

3. Art and Revolution

1. Perry Anderson writes: 'Two problems have dominated the struggle for socialism in Britain from the turn of the fifties onwards: "affluence" and the "cold war". These issues have provided the deepest experience of the European Socialist movement in our time.' Perry Anderson, 'The Left in the Fifties', *New Left Review* I/29 (January–February 1965). Several histories echo this analysis. Falling variously on the spectrum from liberal to left, see Tony Judt, *Postwar: A History of Europe Since 1945* (New York: Penguin, 2005); Donald Sassoon, *One Hundred Years of Socialism: The West European Left in the Twentieth Century* (New York: New Press, 1996); Geoff Eley, *Forging Democracy: The History of the Left in Europe 1850–2000* (Oxford: Oxford University Press, 2002); and Eric Hobsbawm, *The Age of Extremes: A History of the World, 1914–1991* (New York: Vintage, 1994).
2. Kingsley Amis, *Socialism and the Intellectuals* (London: Fabian Society, 1957); Anthony Crosland, *The Future of Socialism* (London: Jonathan Cape, 1956).
3. John Berger, 'Exit and Credo?' *New Statesman*, 29 September 1956.
4. John Berger, 'Staying Socialist', *New Statesman*, 31 October 1959.
5. Ibid.
6. John Berger, 'The Banale', *New Statesman*, 16 August 1958.
7. John Berger, 'The White Cell', *New Statesman*, 22 November 1958.
8. John Berger, 'Only Connect—II', *New Statesman*, 27 February 1960.
9. Heinrich Wölfflin, *Principles of Art History* (Mineola, NY: Dover, 1950 [1915]), pp. 154, 11.
10. The quote appears as an epigraph to his final essay on cubism. Quoted in Geoff Dyer, ed., *The Selected Essays of John Berger* (New York: Pantheon, 2001), p. 71.
11. John Berger, 'Masters and Decadents', *New Statesman*, 26 July 1952.
12. John Berger, 'The Necessity of Uncertainty', *Marxist Quarterly* 3: 3 (July 1956).
13. Ibid.
14. Ibid.

15. Ibid.

16. Ray Watkinson, 'Discussion: The Necessity of Uncertainty', *Marxist Quarterly* 3: 4 (October 1956).

17. A. M. D., 'Discussion: The Necessity of Uncertainty', *Marxist Quarterly* 3: 4 (October 1956). This writer only signed his initials. 'To claim a special place for an artist in the Party is to perpetuate his position in class society. Indeed, the plea for such special dispensation is in itself a symptom of the class outlook— the favouritism and the isolation of this artist and that.' Another writer, using the alias Polybius, pointed out that 'the concept of uncertainty must never be allowed to deteriorate into a wilful or slapdash and eclectic acceptance of new styles.'

18. I am quoting from the English translation: V. Ivasheva, 'Revisionism of Marxism in Britain', transl. Dorli Meek, *The New Reasoner* 7 (Winter 1958). Ivasheva was a professor of English Literature at Moscow State University. I am grateful to Katerina Clark for pointing this out.

19. Ibid.

20. Quoted in Alex Zverdling, *Orwell and the Left* (New Haven, CT: Yale University Press, 1974), p. 11.

21. John Berger, 'A Jerome of Photography', *Harpers*, December 2005.

22. 'John Berger's Reply', *Marxist Quarterly* 3: 4 (October 1956).

23. From the first editorial: 'Those who feel that the values of a capitalist society are bankrupt, that the social inequalities upon which the system battens are an affront to the potentialities of the individual, have before them a problem, more intricate and more difficult than any which has previously been posed ... That is the problem of how to change contemporary society so as to make it more democratic and more egalitarian, and yet how to prevent it degenerating into totalitarianism.' Stuart Hall, Gabriel Pearson, Ralph Samuel and Charles Taylor, 'Editorial', *Universities and Left Review* 1: 1 (Spring 1957).

24. Quoted in John Berger, 'The Star of Cubism', *New Statesman*, 1 March 1958.

25. Ibid. This was one of Berger's favourite quotes, and recurs throughout his work.

26. Ibid.

27. Ibid.

28. Brandon Taylor, 'Demystifying Picasso', *Art Monthly*, no. 42 (1 November 1980). In this useful essay Taylor reviews a reissue of Berger's monograph on Picasso alongside a new translation of Max Raphael's *Proudhon, Marx, Picasso*.

29. John Berger, 'Controlling the Spin', *New Statesman*, 27 December 1958.

30. Ibid.

31. Andrew Forge, 'In Times of Sickness', *Spectator*, 28 October 1960.

32. John Berger, 'A Dialectical Masterpiece', *New Statesman*, 21 February 1959.

33. John Berger, 'Italian Diary', *New Statesman*, 2 August 1958.
34. Berger, 'Only Connect—II'.
35. This note was found inside a proof copy of *Corker's Freedom*, and shared with the author. The letter, dated 23 December 1963, is addressed to 'Mr Wilson', presumably Angus Wilson.
36. For an overview of Bostock's biography and achievements, see Tom Overton, 'Life in the Margins', *Frieze*, 27 February 2017; Sonia Lambert, 'Anya Berger obituary', *Guardian*, 6 March 2018.
37. Jameson refers to Christopher Caudwell and Ersnt Fischer as occupying a *genetic* tradition of Marxist criticism: 'The criticism practiced then was of a relatively untheoretical, essentially didactic nature, destined more for use in the night school than in the graduate seminar, if I may put it that way'. Fredric Jameson, *Marxism and Form* (Princeton, NJ: Princeton University Press, 1971), p. ix.
38. David Caute describes the conference on Kafka as a 'stepping stone' to the Prague Spring. Quoted in David Caute, *Politics and the Novel During the Cold War* (London: Transaction, 2010), p. 238.
39. Ibid., p. 236.
40. John Berger, 'Problems of Socialist Art', *Labour Monthly*, March–April 1961.
41. Ibid.
42. Ibid.
43. John Berger, *Art and Revolution: Ernst Neizvestny and the Role of the Artist in the USSR* (New York: Pantheon, 1969), pp. 51–2.
44. Quoted in Ernst Fischer, *The Necessity of Art* (London: Verso, 2010), p. 131.
45. Maurice Merleau-Ponty, 'Indirect Language and the Voices of Silence' (1952), in Galen A. Johnson, ed., *The Merleau-Ponty Aesthetics Reader* (Evanston, IL: Northwestern University Press, 1993), p. 114.
46. Stanley Mitchell, 'Marxism and Art', *New Left Review* I/23 (January–February 1964).
47. Berger, 'Staying Socialist'.
48. I take inspiration here from David Bromwich and his analysis of Wordsworth's poetry of the 1790s. Of the curious elision between childhood and revolution in Wordsworth's thought, Bromwich writes: 'These different times are never far apart in his view, and it dawns on us that what Wordsworth cannot say about the revolution he will often consent to say about his childhood, and what he cannot say of childhood he will say of the revolution.' David Bromwich, *Disowned by Memory: Wordsworth's Poetry of the 1790s* (Chicago: University of Chicago Press, 1998), p. 2.
49. Edwin Mullins, 'Politico as Critic', *Listener*, 4 November 1966.
50. John Berger, 'Picasso' (1954–55), in Dyer, ed., *Selected Essays*, p. 31.
51. The comparison is obviously contentious, capable of producing endless art-historical arguments. Curiously, the poet John Ashbery

more or less agreed with Berger. (See John Ashbery, 'The Art', *New York Magazine*, 12 May 1980). Equally curious, the most prescient rebuttal I have found to the comparison is from an otherwise laudatory review of the book written by Alan Wallach (then a graduate student, subsequently a distinguished professor). What Berger says of the Fra Angelico, Wallach writes, 'is true enough ... although it should be pointed out that Fra Angelico, even in the example Berger illustrates, never fully realized the discoveries of the Renaissance in his paintings. Furthermore, *Still-Life with Chair Caning* ... is not as free of the artist's temperament as Berger believes. This collage is pervaded with doubt about appearances; and the chair-caning is not real chair-caning but oil cloth with a caning pattern printed on it; and it has been suggested ... that the rope that served as the collage's frame is a pun upon the sculptured rope mouldings used in antique art. The playfulness of the entire work is summed up by the word "JOU" prominent at the top of the chair-caning oil cloth.' With this, Wallach pin pointed exactly what Berger passed over in cubism, and what he later recoiled at in postmodernism: the mischievous punning and playfulness. Despite his misgivings, Wallach praised the book as 'the most telling single commentary on Picasso yet written'. Alan Wallach, 'A Critical Re-evaluation of Pablo Picasso's Art', *Columbia Daily Spectator*, 10 May 1967.

52. John Berger, *The Success and Failure of Picasso* (New York: Pantheon, 1989), p. 70.

53. Ibid.

54. Ibid., p. 61.

55. Clark expands on this idea: 'Socialism occupied the real ground on which modernity could be described and opposed; but its occupation was already seen at the time (on the whole, rightly) to be compromised—complicit with what it claimed to hate. This is not meant to be an excuse for the thinness and shrillness of most of modernism's occupation of the *un*real ground. There could have been (there ought to have been) an imagining otherwise which had more of the stuff of the world to it. But I am saying that modernism's weightlessness and extremism had causes, and that among the main ones was revulsion from the working-class movement's moderacy, from the way it perfected a rhetoric of extremism that grew the more fire-breathing and standardized the deeper the movement bogged down on the parliamentary road.' T. J. Clark, *Farewell to an Idea* (New Haven, CT: Yale University Press, 2001), p. 9.

56. Brandon Taylor, 'Demystifying Picasso', *Art Monthly*, 1980. I am grateful to Taylor's essay for elucidating the connection between Raphael and Berger.

57. Berger, *Success and Failure of Picasso*, p. 56.

58. John Berger, 'Painting a Landscape' (1966), in Dyer, ed., *Selected Essays*, p. 213.

59. De Francia goes on to say: 'The major Cubist painters said little

concerning either their ideas or their objectives. Compared to the later flood of manifestos and statements of the 1920s, Cubism was devoid of declarations of intention. The reticence of Braque, Léger and Picasso was due to a genuine uncertainty concerning the eventual implications of their work.' Peter de Francia, *Fernand Léger* (New Haven, CT: Yale University Press, 1983), p. 7.

60. Jean Grondin, 'Reification from Lukács to Habermas', in Tom Rockmore, ed., *Lukács Today: Essays in Marxist Philosophy* (Dordrecht: D. Reidel, 1988), p. 88.

61. Georg Lukács, *History and Class Consciousness: Studies in Marxist Dialectics*, transl. Rodney Livingstone (Cambridge, MA: MIT Press, 1968 [1923]), p. 180.

62. Ibid., p. 181.

63. John Berger, 'The Historical Function of the Museum' (1966), in Dyer, ed., *Selected Essays*, p. 95. Note the title's odd echo of Lukács and his essay, 'The Changing Function of Historical Materialism'. Berger's wife was translating Lukács at just this time.

64. Berger, *Success and Failure of Picasso*, p. 67.

65. Ibid.

66. Quoted in Berger, 'The Sight of Man' (1970), in Dyer, ed., *Selected Essays*, p. 228.

67. Michael Pollan, *How to Change Your Mind: What the New Science of Psychedelics Teaches Us about Consciousness, Dying, Addiction, Depression, and Transcendence* (New York: Penguin, 2018) pp. 131, 134. Pollan quotes Humboldt: 'Everything is interaction and reciprocal ... I myself am identical with nature.'

68. Lukács, *History and Class Consciousness*, p. 204.

69. John Berger, 'The Moment of Cubism', *New Left Review* I/42 (March–April 1967).

70. John Berger, 'Field' (1971) in Dyer, ed., *Selected Essays*, p. 354.

71. Ibid.

72. Berger, 'Moment of Cubism'.

73. Ibid.

74. John Berger, *A Painter of Our Time* (New York: Vintage, 1996 [1958]), p. 102.

75. In retrospect we can see the re-examination of Marxism from the late 1960s onward as moving along two fundamental axes. The first has been a reconsideration of the relationship of culture and identity to power. The second was a reconsideration of the relationship of the past to the present. It was here that Berger parted ways so significantly from Lukács, who tended to view history, as with Hegel, as a series of discrete epochs.

76. John Berger, 'Walter Benjamin' (1970), in Dyer, ed., *Selected Essays*, p. 190.

77. Stanley Mitchell, 'Introduction to Benjamin and Brectht', *New Left Review* I/77 (January–February 1973).

78. John Berger, 'Past Seen from a Possible Future' (1970), in Dyer, ed., *Selected Essays*, pp. 239–40.

79. Eve Kosofsky Sedgwick, *Touching Feeling: Affect, Pedagogy, Performativity* (Durham, NC: Duke University Press, 2003), p. 124.

80. Berger, 'Moment of Cubism'.

81. John Berger, 'Lost Prophets', *New Society*, 6 March 1975.

82. John Berger, 'Between Two Colmars' (1973), in Dyer, ed., *Selected Essays*, p. 325.

83. Berger, 'Moment of Cubism'.

84. Ibid.

4. Divided Loyalties

1. This history is based on interviews with Berger, Mohr and Tanner, as well as other articles. For a recent history, see Gavin Francis, 'John Berger's *A Fortunate Man*: A Masterpiece of Witness', *Guardian*, 7 February 2015.

2. John Berger, 'Words and Images', *Typographica* 11 (June 1965).

3. Quoted in Paul Ferris, *Sir Huge: The Life of Huw Wheldon* (London: Michael Joseph, 1990), p. 214.

4. Huw Wheldon, *Monitor: An Anthology* (London: Macdonald, 1962), p. 9.

5. Huw Wheldon, 'Television and the Arts', *Listener*, 18 February 1965, adapted from BBC 'Lunch-time Lectures', third series.]

6. Ibid.

7. For an extended consideration of their relationship and rivalry, see Jonathan Conlin, '"An Irresponsible Flow of Images": Berger, Clark, and the Art of Television, 1958–1988', in Ralf Hertel and David Malcolm, eds, *On John Berger: Telling Stories* (Leiden: Brill, 2016), pp. 269–92.

8. John Berger, *Ways of Seeing* (London: Penguin/BBC, 1972), p. 26.

9. László Moholy-Nagy, *Painting Photography Film* (London: Lund Humphries, 1969 [1925]), p. 45.

10. Quoted in John Berger, 'Cameras and Lies', *New Statesman*, 24 July 1954.

11. Ibid.

12. Ibid.

13. John Berger, 'Painting—or Photography?' *Observer*, 24 February 1963.

14. Ibid.

15. Quoted in Harold Evans, *Pictures on a Page: Photojournalism and Picture Editing* (Belmont, CA: Wadsworth, 1978), p. 255.

16. Quoted in Rick Poynor, *Typographica* (New York: Princeton Architectural Press), p. 80.

17. Berger, 'Words and Images'.

18. Ibid.

19. Both image and text, Berger writes, 'represent two variations (each involving a different discipline and medium) on the theme

of metamorphosis (landscape into flesh, male into female, and vice versa). Such metamorphoses themselves represent variations which are essential to the process of being seen. On at least one level the subject of the work is *sight*.' Ibid.

20. Ibid.
21. John Berger and Jean Mohr, *A Fortunate Man* (New York: Pantheon, 1967), pp. 12–13.
22. Ibid., pp. 14–15.
23. Ibid., p. 19.
24. Ibid., p. 78.
25. John Berger, 'Uses of Photography' (1978), in Geoff Dyer, ed., *The Selected Essays of John Berger* (New York: Pantheon, 2001), p. 293.
26. Berger and Mohr, *A Fortunate Man*, p. 64.
27. Ibid., p. 57.
28. Ibid.
29. Clive Scott, *The Spoken Image: Photography and Language* (London: Reaktion, 1999), p. 259, emphasis in original.
30. Berger and Mohr, *A Fortunate Man*, p. 113.
31. Ibid., p. 133.
32. Michael Sale, 'Review of *A Fortunate Man*', *Journal of Medical Ethics* 4: 3 (September 1978).
33. Frantz Fanon, 'Letter to the Resident Minister' (1956), in Fanon, *Towards the African Revolution: Political Essays* (New York: Grove, 1964), p. 53.
34. Berger and Mohr, *A Fortunate Man*, p. 166.
35. Ibid., p. 167.
36. Ibid.
37. Tom Maschler, 'A Valuable Life', *Guardian*, 28 April 1967.
38. Philip Toynbee, 'Review of *A Fortunate Man*', *Observer*, 30 April 1967.
39. From a BBC broadcast, *A Fortunate Man*, coinciding with the book's release. Held in the BFI archives.
40. See Phil Rosen, 'Document and Documentary: On the Persistence of Historical Concepts', *Change Mummified: Cinema, History, Theory* (Minneapolis: Minnesota University Press, 2001), pp. 225–64; Brian Winston, 'The Tradition of the Victim in Griersonian Documentary', in Alan Rosenthal, ed., *New Challenges for Documentary* (Berkeley, CA: University of California Press, 1988), pp. 269–87.
41. Bill Nichols, *Representing Reality: Issues and Concepts in Documentary* (Bloomington, IN: Indiana University Press, 1991).
42. John Berger, 'Look at Britain!', *Sight and Sound* 21: 1 (1957).
43. Roland Barthes, *Camera Lucida: Reflections on Photography* (New York: Hill & Wang, 1981), p. 3.
44. It should be noted here that Eskell valued Berger's friendship until the end. In the years just prior to his death, he described Berger to a mutual friend, the Dutch painter Friso Ten Holt, as 'one of the

dearest and kindest persons I know' and confessed that he 'could not exist without his and Anya's love and for the recognition he gave me.' From correspondence held in the British Library.

45. Heath made this comment as part of the 2005 London celebrations for Berger. It has since found its way into numerous articles.

46. Gene Feder, '*A Fortunate Man*: Still the Most Important Book about General Practice Ever Written', *British Journal of General Practice* 55: 512 (March 2005).

47. George A. Silver, MD, 'Story of a Country Doctor', *Nation*, 4 September 1967.

48. Barthes, *Camera Lucida*, p. 4.

49. Eduardo Galeano, *Open Veins of Latin America* (New York: Monthly Review Press, 1997 [1971]), p. 1.

50. Fredric Jameson, *Marxism and Form* (Princeton, NJ: Princeton University Press, 1971), p. xviii.

51. Berger, 'Words and Images'.

52. Berger and Mohr, *A Fortunate Man*, p. 110.

53. John Berger, *The Success and Failure of Picasso* (New York: Pantheon, 1989), p. 206.

54. John Berger, 'Directions in Hell', *New Left Review* I/87–88 (September–December 1974).

55. John Berger and Jean Mohr, *A Seventh Man* (New York: Verso, 2010 [1975]), p. 11.

56. Susan Sontag, *On Photography* (New York: Picador, 2001 [1977]), p. 17,

57. Ibid., p. 2.

58. Berger, 'Uses of Photography.'

59. Ibid.

60. John Berger, 'Ev'ry Time We Say Goodbye' (1990), in Dyer, ed., *Selected Essays*, p. 482.

61. Cesare Zavattini, 'Some Ideas on the Cinema' *Sight and Sound* 23: 2 (October–December 1953).

62. Quoted in Jacques Aumont, *Montage Eisenstein* (Bloomington, IN: Indiana University Press, 1987), p. 146.

63. John Berger, 'Alexander Herzen', in *The Look of Things: Essays by John Berger* (New York: Viking, 1971), p. 85.

64. For an analysis of the many tendencies within the New Left, see the chapters 'Socialism at Full Stretch' and 'Between Structuralism and Humanism' in Dennis Dworkin, *Cultural Marxism in Postwar Britain: History, the New Left, and the Origins of Cultural Studies* (Durham, NC: Duke University Press, 1997).

65. Anthony Barnett, 'Raymond Williams and Marxism: A Rejoinder to Terry Eagleton', *New Left Review* I/99 (September–October 1976). For a discussion of the larger debate within British Marxism to which Barnett's essay belonged, see Martin Jay, *Songs of Experience: Modern American and European Variations on a Universal Theme* (Berkeley, CA: University of California Press, 2005), pp. 199–215.

66. Fredric Jameson, 'Third-World Literature in the Era of Multi-national Capitalism', *Social Text* 15 (Autumn 1986).

67. Quoted in Noah Isenberg, 'Fatih Akin's Cinema of Intersections', *Film Quarterly* 64: 4 (Summer 2011).

68. Correspondence contained in the John Berger Archives, British Library.

69. John Berger and Jean Mohr, *Another Way of Telling* (New York: Vintage, 1995).

70. Ibid., p. 133.

71. Ibid.

72. John Berger, *Bento's Sketchbook* (London: Verso, 2011), p. 5.

5. A Toast to Modernism

1. John Berger, *G.* (New York: Vintage, 1991 [1972]), p. 289.

2. For a detailed reconstruction of the evening, as well as a peek into the archival research that led to that reconstruction, see Tom Overton, '"As If It Were The Only One": The Story of John Berger's Booker Prize for *G.*', in Ralf Hertel and David Malcolm, eds, *On John Berger: Telling Stories* (Leiden: Brill, 2016), pp. 189–211.

3. John Berger, 'Speech on Accepting the Booker Prize for Fiction' (1972), in Geoff Dyer, ed., *The Selected Essays of John Berger* (New York: Pantheon, 2001), pp. 253–5.

4. Ibid., p. 253.

5. The exchange is quoted in Overton, '"As If It Were The Only One"', p. 193. Though Overton refers to Max Gebler, it is likely the playwright in question was actually Ernest Gebler.

6. Berger, 'Speech on Accepting the Booker Prize', pp. 254–5.

7. Berger, *G.*, p. 127.

8. John Berger, 'Writing a Love Scene', *New Society*, 28 November 1968.

9. Berger, *G.*, p. 115.

10. See Allison Pease, *Modernism, Mass Culture, and the Aesthetics of Obscenity* (Cambridge: Cambridge University Press, 2000).

11. Quoted in Theo Richmond, 'Berger's Bet on Freedom', *Guardian*, 4 October 1971.

12. David Caute, 'What We Might Be and What We Are', *Times Literary Supplement*, 9 June 1972.

13. John Berger, 'The First and Last Recipe: *Ulysses*' (1991), Dyer, ed., *Selected Essays*, p. 467.

14. Ibid., p. 469.

15. Alex Danchev, *Cézanne: A Life* (New York: Pantheon, 2012), p. 340.

16. Berger, *G.*, p. 129

17. Ibid., p. 133.

18. John Berger, 'The Ideal State of Art', *New Statesman*, 8 October

1955. The article continues: 'And because the critic is constantly dealing with other men's practical efforts, he sees very clearly this contradiction in his own work. If he has so much imagination and energy, why does he not preserve it for his own actual creations? Or, if he must write criticism, why is he not content to remain a technical teacher and interpreter? Why, with all insight, try to lift the second rate into the first rank, or tilt at the false, who will collapse anyway, the straw coming out of their seams? Why if he seeks to improve the condition of man, write about art instead of God or politics?' These questions, rhetorical as they were, go to the heart of Berger's experience.

19. John Berger, 'The Changing View of Man in the Portrait' (1967), Dyer, ed., *Selected Essays*, p. 101.

20. Berger, *G.*, p. 137.

21. Caute, 'What We Might Be and What We Are'. Dyer's chapter on *G.* also compares Berger to Robbe-Grillet and Fowles. See Geoff Dyer, *Ways of Telling* (London: Pluto, 1986), pp. 80–94.

22. John Berger, *Here Is Where We Meet* (New York: Vintage, 2005), p. 161.

23. The question of how to end a novel follows from more fundamental questions about narrative, order and chaos. The sense of an ending, a phrase Frank Kermode popularized while *G.* was being written, was at root a sense people needed to find in life. We all, by virtue of being alive, find ourselves in the 'middest', but we still know that our lives are finite—that an end will come. From the existential dissonance of this axiom came 'considerable imaginative investments in coherent patterns which, by the provision of an end, make possible a satisfying consonance with the origins and the middle'. See Frank Kermode, *The Sense of an Ending* (Oxford: Oxford University Press, 1966), p. 17. The problem was that the less tethered to story a novel was—the more apparently formless and 'true-to-life', the more totalistic its ambitions—the more pressure would then be placed on its formal limits; for only in those limits could a design be felt. Berger once said that 'the moment when a piece of music begins provides a clue to the nature of all art'. But the same can also be said of when it ends. The end can be held in abeyance, but only for so long. In Kermode's words, the image of the end can never be *permanently falsified*. The solution for Berger, at least in *G.*, was to effectively name and enact this paradox at once. The novel ends with an abrupt and self-conscious break: 'a curtain arbitrarily and suddenly lowered upon a performance'. It was a special modernist *deus-ex-machina*: the sudden laying bare of the device.

24. Berger, *Selected Essays*, p. 254.

25. Salman Rushdie, *Midnight's Children* (London: Jonathan Cape, 1981), p. 109.

26. Quoted in Joshua Rothman, 'Lunch with Ian Fleming', *New Yorker*, 9 November 2012.

27. Berger, G., p. 29.
28. Ibid., p. 15.
29. Ibid., p. 139.
30. The headlines are from, respectively, the *Daily Mail*, the *Daily Express*, the *Guardian*, the *Sunday Telegraph* and the *Evening Standard*.
31. Quoted in Richard West, 'Berger and the Blacks', *New Statesman*, 1 December 1972.
32. Ibid.
33. Letter pages, *New Statesman*, 22 December 1972.
34. Caroline Tisdall, 'Partial, Passionate, Politic', *Guardian*, 23 November 1972.
35. Ibid.
36. Quoted in Ross King, *The Judgment of Paris: The Revolutionary Decade That Gave the World Impressionism* (London: Pimilco, 2007), p. 224.
37. In order of appearance: the *Irish Times*, 10 June 1972; the *Eastern Daily Press*, 21 July 1972; *New Society*, 6 July 1972; the *Spectator*, 10 June 1972.
38. Francis Hope, 'Arguing with History', *Observer Review*, 11 June 1972.
39. Roger Scruton, 'Love, Madness and Other Anxieties', *Encounter*, January 1973.
40. Duncan Fallowell, 'Berger on the G-string', September 1972. (Publication unknown: held in the John Berger Archive, British Library.)
41. Eunice Lipton, 'Book Review: John Berger's *Ways of Seeing*', *The Fox* 2 (1975).
42. Karl Miller, 'The Cyclopean Eye of the European Phallus', *New York Review of Books*, 30 November 1972.
43. I will leave it to others to deal with Berger's paramours and liaisons. Suffice it to say it was a part of his life. From the various private correspondences I have come across, it appears he eventually did come to the realization, however belatedly and of course differently in different circumstances, that he had at times behaved badly, or at least regretably. He once spoke of the 'proper shame' he felt for not having reciprocated the trust that had been allowed him.
44. Letter contained in 'Film Correspondence: 1974–1979', in John Berger Archive, British Library.
45. See Ian Craib, 'Sociological Literature and Literary Sociology: Some Notes on John Berger's *G.*', *Sociological Review*, 22: 3, (August 1974). Craib abuts Berger and Marcuse only to conclude that Berger's 'position' cannot be pinned down in the same way.
46. Berger, G., p. 15.
47. Ibid., p. 24.
48. Ibid., p. 40. Once the reader is primed, the quotes pile up on top of each other: 'He has seen drawings on walls asserting how she

lacks penis and testicles ... The mythical figure embodies the desirable alternative to all that disgusts or revolts him ... She and he together, mysteriously and naked, are his own virtue rewarded.' Particularly intriguing on this score is novel's relationship to what Freud called the 'Oceanic Feeling'. Here the image of the ocean recurs, not as an index of authorial ambition but of psychoanalytic desire. At the start of *Civilization and Its Discontents*, Freud posited that the sense of limitlessness, of oneness with the universe, at the heart of most religious experience may in fact be a nostalgic re-experience of the infant's early life in the womb. It would not be hard to superimpose the rubric onto Lukács's *Theory of the Novel* and its narrative of a lost age and the progressive alienation from nature. In *G.* the superimposition regards sex and totality: 'She is no longer contained within any contour, she is continuous surface'; 'her body is borderless'; 'she will acquire the value of the world: she will contain, so far as she and I are concerned, all that is outside her, myself included. She will enclose me.' Berger, *G.*, pp. 107, 117, 162.

49. See Peter Fuller, *Seeing Berger: A Revaluation of Ways of Seeing* (London: Writers & Readers, 1981); Peter Fuller, *Seeing Through Berger* (London: Claridge, 1988).

50. Fuller, *Seeing Through Berger*, p. 94.

51. I am quoting from a fascinating if unsettling YouTube video, 'Les 7 minutes de Jacob Berger', where Jacob speaks openly about the meaning of 'trauma'. The conversation from 2013 was part of a series hosted by L'École de la Cause Freudienne, a Paris-based psychoanalytic organization. Jacob discusses the personal impetus behind a film he made in the early 2000s, *Aime Ton Père* (*A Loving Father*) starring Gérard Depardieu and his real-life son, Guillaume, in an 'almost too-close-for-comfort drama about fame and family dysfunctionalism' (as the DVD synopsis has it). The son, who has 'lived his life in the shadows' of his 'communicatively distant' father ('a celebrated novelist') decides to kidnap him as he is en route to Sweden by motorcycle to collect a Nobel Prize.

52. Pamela McCallum concludes: 'Berger's novel has far less to do with an ultra-textual postmodernism that celebrates a non-referential play of signifiers than with a critical postmodernism that highlights material signifieds.' Pamela McCallum, 'Postmodernist Aesthetics and the Historical Novel: John Berger's *G.*', *Minnesota Review* 28 (Spring 1987), p. 72.

53. David E. James, 'Cubism as Revolutionary Realism: John Berger and *G.*', *Minnesota Review* 21 (Fall 1983), p. 107.

54. Dyer, *Ways of Telling*, p. 83.

55. Andrzej Gasiorek, *Post-War British Fiction: Realism and After* (London: St Martin's, 1995), pp. 79–80.

56. Maurice Merleau-Ponty, *Sense and Nonsense* (Evanston: Northwestern University Press, 1964 [1948]), p. 52.

57. John Berger, *Ways of Seeing* (London: BBC/Penguin, 1972). This text is actually on the book's cover.
58. Berger, *G.*, p. 300.
59. Ibid., p. 148.
60. John Berger, *Bento's Sketchbook* (London: Verso, 2011), p. 14. The sentence recurs throughout the book.
61. Letter from John Berger to Eva Figes, dated 27 June 1972, held in the British Library. I am grateful to Tom Overton for bringing this correspondence to my attention.

6. The Work of Friendship

1. John Berger, *A Painter of Our Time* (New York: Vintage, 1996 [1958]), p. 132.
2. John Berger, 'Speech on Accepting the Booker Prize for Fiction' (1972), in Geoff Dyer, ed., *The Selected Essays of John Berger* (New York: Pantheon, 2001), p. 253.
3. A scan of part of the application was posted to the blog of one of the TNI's archivists: 'Tutto è possibile: John Berger è Isabel', 21 October 2010, at zambrone.blogspot.nl.
4. Penelope Gilliatt, 'Passion', *New Yorker*, 31 March 1975.
5. Richard Appignanesi, 'The Screenwriter as Collaborator: An Interview with John Berger', *Cinéaste* 10: 3 (Summer 1980).
6. Sebastian Smee, *The Art of Rivalry: Four Friendships, Betrayals, and Breakthroughs in Modern Art* (New York: Random House, 2017), p. xvi.
7. Quoted in Appignanesi, 'The Screenwriter as Collaborator'.
8. Tony Kushner, 'With a Little Help from My Friends', *New York Times*, 21 November 1993. The essay was adapted for the 'Afterword' to *Angels in America*.
9. John Berger, 'Jean Mohr: A Sketch for a Portrait', in Jean Mohr and John Berger, *At the Edge of the World* (London: Reaktion, 1999), p. 14.
10. John Berger, 'Look at Britain!', *Sight and Sound* 21: 1 (1957).
11. Raoul Vaneigem, *Traité de savoir-vivre à l'usage des jeunes générations* (Paris: Gallimard, 1967). The translation, by Donald Nicholson-Smith, is from the 1983 printing by Rebel Press, London, p. 11.
12. George Melly, 'Layers of Meaning', *Observer*, 28 January 1973. The figure of speech ('the tidy bed') partakes of the same sexual-collaborative-political mapping and the same ideological marriage at the productive epicentre of the Berger–Tanner partnership.
13. The letters were written in 1973, and later published separately in the first volume of *Ciné-Tracts*, alongside essays by Stephen Heath and Dušan Makavejev. See John Berger, 'On "Middle of the Earth"', *Ciné-Tracts* 1: 1 (Spring 1977). Parts of the letters also

appear in fragments in John Berger, 'One Night in Strasbourg' (1974), in *The White Bird: Writings by John Berger* (London: Hogarth, 1988), pp. 41.

14. John Berger, 'Between Two Colmars' (1973), in Dyer, ed., *Selected Essays*, p. 325.
15. Ibid.
16. From notes held in the John Berger Archive, British Library. Berger had previously reviewed *Leaving the 20th Century: The Incomplete Work of the Situationist International* (London: Free Fall Publications, 1974).
17. John Berger, *The Success and Failure of Picasso* (New York: Penguin, 1965), p. 128.
18. Vincent Canby, 'Retour d'Afrique', *New York Times*, 17 September 1973.
19. Bernard Weiner, 'The Long Way Home', *Jump Cut* 4 (November–December 1974).
20. Robert Stam, 'The Subversive Charm of Alain Tanner', *Jump Cut* 15 (July 1977).
21. Ibid.
22. Linda Greene, John Hess and Robin Lakes, 'Subversive Charm Indeed!' *Jump Cut* 15 (July 1977).
23. Ibid.
24. Ibid.
25. Quoted in Judy Klemesrud, 'Alain Tanner: "Art Is to Break with the Past"', *New York Times*, 24 October 1976.
26. I am quoting from a dossier on *Jonah* kept in the John Berger Archive, British Library.
27. Todd Gitlin, 'Reviews: *Jonah Who Will Be 25 in the Year 2000*', *Film Quarterly*, Spring 1977.
28. Quoted in Frédéric Bas, 'The Subtle Subversion of Alain Tanner', Swiss Films Director's Sheet. Daney was reviewing *No Man's Land* for *Libération*, 30 August 1985.

7. Beyond Ideology

1. John Berger, 'Five Ways of Looking at a Tree', *New Statesman*, 23 May 1959.
2. Maurice Merleau-Ponty, *The Phenomenology of Perception* (London: Routledge, 1995 [1945]), p. 430.
3. John Berger, 'This Century', *New Statesman*, 11 July 1959.
4. John Berger, 'Past Seen from a Possible Future' (1970), in Geoff Dyer, ed., *The Selected Essays of John Berger* (New York: Pantheon, 2001), p. 241.
5. Martin Jay, '*Ways of Seeing* at Forty', *Journal of Visual Culture* 11: 2 (August 2012). This is from a special issue commemorating the fortieth anniversary of the series.

6. Griselda Pollock, 'Muscular Defences', *Journal of Visual Culture* 11: 2 (August 2012).

7. Laura Mulvey, 'Visual Pleasure and Narrative Cinema', *Screen* 16: 3 (October 1975).

8. Adam Rifkin remembers, 'As the book followed on the broadcasts, it made instant syllabus material for the under-nourished reading lists of the marxo-hegelian thing – which we were struggling to shape up and put into place in the Polys'. Adam Rifkin, 'Is Berger Burning Still?' *Journal of Visual Culture* 11: 2 (August 2012).

9. Jane Gaines, 'Ways of Seeing Everything', *Politics/Letters* 8 (May 2017).

10. John Berger, 'The *Work* of Art' (1978), Dyer, ed., *Selected Essays*, p. 431.

11. From a letter dated 27 January 1975, held in the John Berger Archive, British Library.

12. Quoted in Julian Barnes, 'Always There', *London Review of Books* 27: 24 (15 December 2005).

13. Berger, 'The *Work* of Art', p. 434.

14. For a discussion of this broader diminution, see Bruno Latour, 'Why Has Critique Run Out of Steam? From Matters of Fact to Matters of Concern', *Critical Inquiry* 30: 2 (Winter 2004). For an even more extended analysis, see Rita Felski, *The Limits of Critique* (Chicago, IL: University of Chicago Press, 2015).

15. John Berger, 'The Production of the World' (1983), in Dyer, ed., *Selected Essays*, p. 459.

16. Ibid., p. 460.

17. Ibid.

18. John Berger, 'Vincent', in *The Shape of a Pocket* (New York: Vintage, 2001), p. 88.

19. John Berger, "On Visibility" (1977), in *The Sense of Sight*, (New York: Vintage, 1985), p. 219.

20. John Berger, 'Leopardi' (1983), in Dyer, ed., *Selected Essays*, p. 457.

21. Ibid.

22. This is Berger's own paraphrase of his earlier criteria: 'Several years ago, when considering the historical face of art, I wrote that I judged a work according to whether or not it helped men in the modern world claim their social rights. I hold to that.' John Berger, 'The White Bird' (1985), in Dyer, ed., *Selected Essays*, p. 364. The exact quote from 1959 is: 'Does this work help or encourage men to know and claim their social rights?' John Berger, 'This Century', *New Statesman*, 11 July 1959.

23. Berger, 'White Bird', p. 364.

24. Lewis Jones, 'Portrait of the Artist as a Wild Old Man', *Daily Telegraph*, 23 July 2001.

25. From Anthony Barnett's introduction of Berger at an event held on 14 September 1982 at the Institute for Contemporary Arts, London. 'John Berger and Anthony Barnett, in conversation', held in the British Library Sound Archives.

26. Adam Hochschild, 'Broad Jumper in the Alps' (1981), in *Finding the Trapdoor: Essays, Portraits, Travels* (Syracuse, NY: Syracuse University Press, 1997), pp. 55–6. The profile originally appeared in *Mother Jones*.

27. 'John Berger Talking to Richard Cork', *Third Ear*, BBC Radio 3, 4 February 1992.

28. John Berger, 'Millet and the Peasant' (1976), in Dyer, ed., *Selected Essays*, p. 299.

29. Ibid.

30. 'John Berger Talking to Richard Cork', BBC Radio 3.

31. Quoted in Gerald Marzorati, 'Living and Writing the Peasant Life', *New York Times*, 29 November 1987.

32. Simone Weil, *The Need for Roots*, trans. Arthur Willis (London: Routledge, 2002), p. 87.

33. Interview with Paul Brennan. Transcript held in the John Berger Archive, British Library. The interview was conducted in the late 1970s.

34. Wendell Berry, *The Unsettling of America: Culture and Agriculture* (San Francisco, CA: Sierra Club, 1997), p. 87.

35. John Berger, *A Painter of Our Time* (New York: Vintage, 1996 [1958]), p. 55.

36. John Berger, 'The Biennale', *New Statesman*, 5 July 1952.

37. Berger continues: 'Perhaps to some extent the same applies to all the arts, but because the language of painting or sculpture is more particular than that of music, and far less explanatory than that of literature, the problem is more acute. Of course, Shakespeare can be performed in Tokyo. But Lear could not have been written by a man aiming at the audiences of international theatre festivals. No self-respecting artist paints consciously for world-reproduction yet.' From a manuscript contained in the John Berger Archive, British Library, 'Undated–Unbound Published Articles'.

38. From a draft for a book proposal held in the John Berger Archive, British Library, '1950s Typescripts + MS'.

39. Berger, *Painter of Our Time*, p. 139.

40. Italo Calvino, *Invisible Cities* (New York: Harcourt, 1974), p. 128.

41. John Berger, 'A Story for Aesop' (1986), in Dyer, ed., *Selected Essays*, p. 507.

42. John Berger, 'Courbet and the Jura' (1978), in Dyer, ed., *Selected Essays*, p. 335.

43. Berger, 'Story for Aesop', p. 503.

44. Richard Rorty, *Achieving Our Country: Leftist Thought in Twentieth-Century America* (Cambridge, MA: Harvard University Press, 1998), p. 94.

45. Ibid.

46. John Berger, 'Romaine Lorquet' (1974), in Dyer, ed., *Selected Essays*, p. 351.

47. John Berger, 'Manhattan' (1975), in *The White Bird: Writings* (London: Hogarth, 1988), pp. 61–7.

48. See John Berger, *King: A Street Story* (New York: Vintage, 2000); John Berger, *Lilac and Flag: An Old Wives' Tale of a City* (New York: Vintage, 1990).
49. Interview with Paul Brennan.
50. Nikos Papastergiadis, *Modernity as Exile: The Stranger in John Berger's Writing* (Manchester: Manchester University Press, 1993), p. 176.
51. John Berger, *G.* (New York: Vintage, 1991 [1972]), p. 72.
52. Correspondence with Anthony Barnett, dated 16 March 1976. John Berger Archives, British Library.
53. From a letter dated 20 December 1981. John Berger Archive, British Library.
54. Quoted in Hochschild, 'Broad Jumper in the Alps', pp. 52–3.
55. Berry, *Unsettling of America*, p. 87.
56. John Berger, 'Historical Afterword', *Pig Earth*, (New York: Pantheon, 1979), p. 204.
57. David Lowenthal, *The Past Is a Foreign Country* (Cambridge: Cambridge University Press, 1985).
58. John Berger, *And Our Faces, My Heart, Brief as Photos* (New York: Vintage, 1984), p. 34.
59. Ibid., p. 29.
60. Ben Ratliff, 'The Song of John Berger', *NYR Daily*, 12 January 2017.
61. John Berger, 'Christ of the Peasants' (1985), in Dyer, ed., *Selected Essays*, p. 534.
62. Berger, *And Our Faces*, p. 79.
63. Ibid.
64. Quoted in Hochschild, 'Broad Jumper in the Alps', p. 56.
65. 'Face to Face: John Berger', *Late Show with Jeremy Isaacs*, BBC, 2 October 1995.
66. John Berger, 'Ev'ry Time We Say Goodbye' (1990), in Dyer, ed., *Selected Essays*, p. 474.
67. Berger, *And Our Faces*, p. 34.
68. André Bazin, 'Ontology of the Photographic Image', in *What is Cinema?*, transl. Timothy Barnard (Montreal: Caboose, 2009), p. 8.
69. Geoff Dyer, *The Ongoing Moment* (New York: Pantheon, 2005).
70. Octavio Paz, 'In Search of the Present', Nobel lecture, 8 December 1990.
71. Ibid.
72. Ibid.
73. Berger, *And Our Faces*, p. 65.
74. Ibid., pp. 56–7.
75. Ibid., p. 55.
76. John Berger, 'That Which Is Held' (1982), in Dyer, ed., *Selected Essays*, p. 488.
77. John Berger, *Here Is Where We Meet* (New York: Pantheon, 2005), p. 132.

78. John Berger, 'A Professional Secret' (1987), in Dyer, ed., *Selected Essays*, p. 540.

79. John Berger, 'Steps Towards a Small Theory of the Visible (for Yves)', in *The Shape of a Pocket*, p. 16.

80. John Berger, 'Vincent', in *The Shape of a Pocket*, p. 92.

81. The writer David Levi-Strauss asked a similar question at the end of the 1990s: 'Where would any of us be without the example of John Berger? I mean, any of us who care about the conflicted relation between art and politics, and who crave a radical criticism that is both accessible and deep, embodied and informed.' David Levi-Strauss, 'Correspondents', *Nation*, 3 February 1997.

82. Maurice Merleau-Ponty, 'What is Phenomenology?' (1956), in Leonard Lawlor and Ted Toadvine, eds, *The Merleau-Ponty Reader* (Evanston, IL: Northwestern University Press, 2007), p. 67.

83. John Berger, *Ways of Seeing* (London: Penguin/BBC, 1972), p. 110.

84. Ibid., p. 111.

85. Ibid., p. 112.

8. The Shape of a Valley

1. Simone Weil, *The Need for Roots*, trans. Arthur Willis (London: Routledge, 2002 [1949]), p. 43.

2. Just recently, Berger made this very clear: 'It seems to me that ... what we have been living in the last twenty-five years is the beginning of a new dark age ... in an illuminated age, although nothing is certain, there is a ... sense of direction into the future ... And that road is a guide for political action ... in a dark age there is no such road. There are only paths.' See Colin MacCabe, 'A Song for Politics: A Discussion with John Berger', *Critical Quarterly* 56: 1 (April 2014).

3. John Berger, *Pig Earth* (New York: Pantheon, 1979), p. 75.

4. Taha Muhammad Ali, 'Fellah', in *So What: New and Selected Poems 1971–2005*, trans. Peter Cole (Port Townsend, WA: Copper Canyon, 2006), p. 143.

5. Correspondence with Anthony Barnett, dated 16 March 1976. Held in the John Berger Archive, British Library.

6. Ibid.

7. John Berger, 'Stories Walk Like Men', *New Society* 37: 724 (1976).

8. Walter Benjamin, 'The Storyteller: Reflections on the Works of Nikolai Leskov', *Illuminations*, trans. Harry Zohn (New York: Schocken, 1968), p. 86.

9. John Berger, *Once in Europa* (New York: Vintage, 1992), p. 149.

10. Berger, *Pig Earth*, p. 21.

11. Benjamin, *Illuminations*, p. 87.

12. Ferdinand Tönnies, *Community and Civil Society* (Cambridge:

Cambridge University Press, 2001 [1887]). For an overview of Max Weber's circle at Heidelberg, see Michael Löwy's useful chapter 'The Anti-Capitalism of Intellectuals in Germany', in Michael Löwy, *Georg Lukács: From Romanticism to Bolshevism* (London: New Left Books, 1979), pp. 22–66. Löwy's work has been particularly helpful in bringing to light the many confluences discussed in this chapter.

13. See José Harris, 'General Introduction', in Tönnies, *Community and Civil Society*, pp. ix–xxx.

14. Quoted in Pankaj Mishra, '*The Need for Roots* Brought Home the Modern Era's Disconnection with the Past and the Loss of Community', *Guardian*, 13 August 2013.

15. Taha Muhammad Ali, 'Meeting at an Airport', *So What*, trans. Peter Cole, p. 123.

16. John Berger, 'The Soul and the Operator' (1990), in Geoff Dyer, ed., *The Selected Essays of John Berger* (New York: Pantheon, 2001), p. 574.

17. The Gallimard first edition with title and subtitle read: *L'enracinement: Prélude à une déclaration des devoirs envers l'être humain*. It was released as part of the Collection Espoir, supervised by Albert Camus.

18. Berger, *Pig Earth*, p. 13. The note was removed from subsequent editions.

19. Ibid., pp. 2, 40.

20. Ibid., p. 2.

21. Ibid., p. 153.

22. See Bill Baford, ed., *Granta* 8, 'Dirty Realism: New Writing from America' (Autumn 1983).

23. Alejo Carpentier, 'On the Marvelous Real in America' (1949), in Lois Parkinson Zamora and Wendy B. Faris, eds, *Magical Realism: Theory, History, Community* (Durham, NC: Duke University Press, 1995), pp. 75–88.

24. Berger, *Pig Earth*, p. 65.

25. Chagall writes: 'For me life divides itself into two parts—Life and death—and for me whatever is not an inner truth is death. But maybe—to be a little more concrete—or, if you prefer, more truthful, one must use the word "love", because there is one true color, not only in art, but in life.' Quoted in Benjamin Harshav, *Marc Chagall and His Times: A Documentary Narrative* (Palo Alto, CA: Stanford University Press, 2004), p. 561.

26. Geoff Dyer, 'Ways of Witnessing' (interview with John Berger), *Marxism Today*, December 1984.

27. Berger, *Pig Earth*, p. 124.

28. Berger, *Once in Europa*, p. 92.

29. John Berger, 'Stories' in John Berger and Jean Mohr, *Another Way of Telling* (New York: Vintage, 1995), p. 286.

30. Letter to Gianni Celati dated 17 February 1995.

31. Berger, *To The Wedding* (New York: Vintage, 1996).

32. John Berger, 'Mother' (1986), in Dyer, ed., *Selected Essays*, p. 497.
33. John Berger, *Lilac and Flag: An Old Wives' Tale of a City* (New York: Vintage, 1990).
34. bell hooks, *All About Love: New Visions* (New York: Perennial, 2001), p. xv.
35. Ibid., pp. x–xi.
36. Erich Fromm, *The Art of Loving* (New York: Harper Perennial, 2006 [1956]).
37. Berger references this quote in an essay on Géricault: John Berger, 'A Man with Tousled Hair', in *The Shape of a Pocket* (New York: Vintage, 2001), p. 175.
38. For a discussion of Francis Bacon and Nietzsche see Maggie Nelson, *The Art of Cruelty: A Reckoning* (New York: W.W. Norton, 2011), pp. 3–14.
39. John Berger, 'Ten Dispatches About Place' (June 2005), in *Hold Everything Dear: Dispatches on Survival and Resistance* (New York: Vintage, 2007), pp. 119, 127.
40. Dyer, 'Ways of Witnessing'.
41. Weil, *Need for Roots*, p. 232.
42. Berger, 'Ten Dispatches About Place', p. 127.
43. John Berger, 'Twelve Theses on The Economy of the Dead' (1994), in *Hold Everything Dear*, pp. 3–5.
44. John Berger, 'Leopardi', in Dyer, ed., *Selected Essays*, p. 456.
45. Ibid.
46. Berger, *Once in Europa*, p. 144.
47. Salman Rushdie, 'Fog and the Foghorn', *Guardian*, 6 February, 1987.
48. Angela Carter, 'John Berger and the Passing of Village Life', *Washington Post*, 29 March 1987.
49. Ibid.
50. John Berger, 'Historical Afterword', in *Pig Earth*, pp. 212–13.
51. Berger, 'The Soul and the Operator', p. 573.
52. Ibid.
53. Berger, *Once in Europa*, p. 141.
54. Ibid., p. 107.
55. Ibid., p. 133.
56. Ibid.
57. John Berger and Nella Bielski, *A Question of Geography* (London: Faber, 1987).
58. John Berger, 'Jewish and Other Painting', *New Statesman*, 12 December 1953.
59. Ibid.
60. Berger, 'Historical Afterword', p. 201.
61. John Berger, 'Let Us Think About Fear' (April 2003), in *Hold Everything Dear*, p. 59.
62. John Berger, 'The First Fireball', *Guardian*, 28 June 2002.
63. John Berger, 'Two Books and Two Notions of the Sacred', *Guardian*, 25 February 1989.

64. Berger, 'The Soul and the Operator', p. 575.

65. John Berger, 'The Chorus in Our Heads or Pier Paolo Pasolini' (June 2006), in *Hold Everything Dear*, p. 89.

66. Ibid.

67. Ibid.

68. 'The problem is the deep phoniness of the whole conception', Sam Leith wrote of Berger's novel *A to X*, 'its gross sentimentality (all faceless oppressors and noble peasants); its intoxication with its own portentousness.' Sam Leith, 'Review: *A to X* by John Berger', *Daily Telegraph*, 15 August 2008.

69. Walter Benjamin, 'The Storyteller', in *Illuminations*, p. 86, translation slightly modified by the author.

70. John Berger, 'Revolutionary Undoing' (1969), in Dyer, ed., *Selected Essays*, p. 230.

71. John Berger, 'A Master of Pitilessness?' (May 2004), in *Hold Everything Dear*, p. 94.

72. Geoff Dyer, *Ways of Telling* (London: Pluto, 1986), p. 134.

Index